Beginning at the

END

Beginning at the

END

Decadence, Modernism, and Postcolonial Poetry

ROBERT STILLING

Harvard University Press

Cambridge, Massachusetts · London, England 2018

Second printing

Library of Congress Cataloging-in-Publication Data
Names: Stilling, Robert, 1977– author.
Title: Beginning at the end : decadence, modernism,
and postcolonial poetry / Robert Stilling.
Description: Cambridge, Massachusetts : Harvard University Press, 2018. |
Includes bibliographical references and index.
Identifiers: LCCN 2017047224 | ISBN 9780674984431 (alk. paper)
Subjects: LCSH: Decadence (Literary movement)—Developing countries. |
Postcolonialism and the arts. | Postcolonialism in literature.
Classification: LCC PN56.D45 S75 2018 | DDC 809/.911—dc23
LC record available at https://lccn.loc.gov/2017047224

For Mom, Dad, and Tom

Contents

Decadence and Decolonization

IN "FURTHER NOTES ON EDGAR POE," published in 1857, Charles Baudelaire wrote presciently of the future of colonial literatures: "Assuming that new literatures will arise among the immense colonies of the present age, we shall most certainly witness spiritual accidents of a kind to baffle the academic mind." The peculiar conditions of the new American republic, for instance, a nation "at once young and old" because of its colonial ties to Britain, were those in which "a nation *begins* with decadence and starts off where the others leave off—a phenomenon which may well repeat itself with variations."[1] These were the conditions, Baudelaire argued, that allowed a poet as startling as Poe to appear. While Baudelaire's prediction about the recurrence of such conditions may have seemed fanciful at the time, it bore fruit roughly a century later as colonial states across Asia, Africa, and the Americas began to assert their independence from declining European empires. In *The Wretched of the Earth* (1961), Frantz Fanon argued that after independence, a newly empowered native bourgeoisie, in mimicking Western modes of thought, risked following the West's "path of negation and decadence without ever having emulated it in its first stages of exploration and invention." Rather than "jumping ahead" into modernity, the artists, poets, and thinkers produced under

such conditions were "in fact beginning at the end," skipping the inventive phase of youth for a premature senility, and opting for a "borrowed aestheticism" rather than a new vocabulary of liberation.[2]

This book argues that for a diverse group of writers and artists from across the formerly colonized world and its diaspora, including Chinua Achebe, Agha Shahid Ali, Derek Walcott, Yinka Shonibare, Wole Soyinka, Bernardine Evaristo, and Derek Mahon, the notion of beginning at the end, of being caught between the decadence of old European empires and the unformed possibilities of postcolonial cultures, marks one of the most important founding conditions for a postcolonial poetics. For such writers and artists, the idea that postcolonial art would skip the inventive phase of youth for a "borrowed aestheticism" thought more typical of empires in their last days haunted their attempts to carve out a place for the arts in postcolonial society. This concern for the problem of postcolonial decadence gave shape to the relationship these writers imagined between art and national culture as they negotiated between their own sense of the demands of form and craft and the pressure to conform to a revolutionary politics on behalf of "the people." As the rift between the interests of postcolonial artists and the interests of postcolonial nations widened, the oppositional aesthetic sensibility of decadence offered a position from which to assert the autonomy of the imagination against the apparent failures of cultural nationalism. The cosmopolitan and transnational modes of affiliation often associated with literary decadence likewise enabled these writers and artists to reclaim beauty and artifice as means to extend their art beyond the limitations of the nation-state. A literary stance once attributed to the metropolitan elites of declining European powers offered instead a powerful vehicle for postcolonial critique. A historical notion often attached to the decline of individual nations and empires offered a means to forge connections to a more global vision of the literary world.

While Baudelaire scoffed in 1857 at the notion that art declined along civilization's course from youth to old age, early anticolonial thinkers such as Fanon embraced this idea as a tool with which to root out lingering European influences, identifying the nineteenth-century doctrine of art for art's sake as a primary obstacle to the formation of a revolutionary national literature. The literature produced by the ed-

ucated classes in the colonies during the initial phases of decoloniza-
tion, Fanon argued, was a literature of "unqualified assimilation." It
appeared wearing the borrowed clothes of the "Parnassians, the Sym-
bolists and the Surrealists." Such "florid writing" could only "reassure
the occupying power." Because the "artisan style" of such writing "so-
lidifies into a formalism which is more and more stereotyped," what
was needed was a "poetry of revolt," a poetry that could think history
from the perspective of the whole nation, not that of the individual
artist, a poetry that understood "that nothing can replace the reasoned,
irrevocable taking up of arms on the people's side."[3]

Writing in Trinidad in the early 1960s, the poet Derek Walcott ex-
pressed a similar concern, arguing that the greatest dilemma facing
West Indian artists in the wake of political independence was that of
decadence. According to Walcott, "Decadence begins when a civiliza-
tion falls in love with its ruins," when a romantic attachment to the
deteriorating colonial order threatens to overwhelm the postcolonial
imagination.[4] In lambasting the "flabby Victorianism" of West Indian
art of the 1960s, Walcott argues that when independence is "handed
prematurely" to a people who still yearn for the "mother-country, . . .
the next phase is one of enervation."[5] In this sense, to begin at the end
was to end at the beginning, to fail at the outset to extricate the post-
colonial imagination from either the ruins of late empire or the nos-
talgia for precolonial societies. For the Nigerian novelist and poet
Chinua Achebe, however, it was less cultural enervation than the
sheer corruption of Nigeria's ruling elite in the 1960s that had pushed
his country toward what he called an "era of great decadence and de-
cline," one that began with the rigged handoff of power to Britain's
chosen successors at independence, worsened through a brutal civil
war, and fed off the nation's corrupt petrol economy well into the
twenty-first century.[6] The problem for writers and artists in the after-
math of political independence, it appeared, was less the lingering
effects of European decadence than it was a new, second wave of post-
colonial decadence that threatened to drown out postcolonial art before
it had a chance to begin.

During the initial phases of decolonization, writers and intellec-
tuals in the colonized world frequently positioned themselves in rela-
tion both to the primary decadence of European empires and to the

secondary decadence of postcolonial societies. While they conceived of decadence as a historical condition, one reminiscent of the fate of former imperial powers such as Rome, Athens, or the Mughal Empire, they came to adopt the view, common in nineteenth-century Europe, that the historical decadence of a civilization could be detected in its art and literature, some chief characteristics of which were understood to be excessive refinement, formalism, sexual perversity, and ironic detachment. While this idea has its roots in Désiré Nisard's 1834 study of poets of the Latin decadence *(Études de moeurs et de critique sur les poètes latins de la décadence)*, which was critical of such tendencies, later figures of the Decadent and Aesthetic movements embraced them. Postcolonial thinkers later defined a new postcolonial poetics against ideas and movements associated with fin-de-siècle Europe generally, such as dandyism, symbolism, impressionism, and the doctrine of art for art's sake. The fin-de-siècle artists who made decadence a symbol of their age, such as Arthur Symons, Walter Pater, Aubrey Beardsley, Joris-Karl Huysmans, and Oscar Wilde, had inadvertently made their age a symbol of decadence, one that writers and critics of the postcolonial era exploited, fairly or not, as an emblem of the artistic tendencies they sought to overcome. To evoke ideas and figures associated with fin-de-siècle Europe in a postcolonial context was, initially, to raise the specter of decadence as an immediate threat to postcolonial culture.

Following the lead of anticolonial thinkers such as Fanon, Aimé Césaire, and Léopold Senghor, critics of this period dissociated new artistic endeavors both from the social and artistic decay they imagined in Europe's metropolitan centers and from the backward-looking cultural products of the colonial periphery that they sought to combat. Under their guidance, the literature of decolonization would march forth under the banners of social realism and political commitment. Their repudiation of decadence in the arts came to represent an attempt to distance anticolonial movements generally from still-dominant European cultural institutions. The embrace of realism and political commitment went hand in hand with the repudiation of artistic decadence, which became inseparable from efforts both to define historically youthful postcolonial states against their aging former masters and to police continuing symptoms of neocolonial influence.

The persistent, if misleading, image of the Decadent movement as the detached and rarefied product of Europe's dying culture is in no small part a legacy of the movement's first critics and advocates.[7] In the 1893 essay "The Decadent Movement in Literature," Arthur Symons famously catalogues the movement's allegedly defining features. It has "all the qualities that mark the end of great periods, the qualities that we find in Greek, the Latin, decadence: an intense self-consciousness, a restless curiosity in research, an over-subtilizing refinement upon refinement, a spiritual and moral perversity."[8] The movement's "effeminate" and "over-civilized" heroes, like the protagonist of Joris-Karl Huysmans's 1884 novel À rebours, represent the "last product[s] of our society," a "civilization grown over-luxurious, over-inquiring, too languid for the relief of action."[9] In the movement's revolt against the "ready-made" orthodoxies of the era, its poets pursue "singularity for singularity's sake." Its critics, such as Walter Pater, display a "morbid subtlety of analysis" and "curiosity of form." Its most occult fictional experimenters, such as the hero of Auguste Villiers de l'Isle-Adam's 1890 play Axël, revel in their "remoteness from any kind of outward reality." The outgrowth of this end-of-an-era sensibility is a protean "disease of form," at once precise and indistinct in its exploration of new sensations, fixing the "last fine shade" of experience, but only fleetingly. Its poetry is "vague, intangible, evanescent." Its ideal is to become a "disembodied voice, and yet the voice of a human soul."[10]

Symons's insider narrative of European cultural decline relies on an understanding of the temporality of empire that is based largely on the example of Rome. In presenting the work of a limited sample of mostly male, predominantly French writers as "the most representative literature of the day," Symons takes for granted the notion that the experiments of a marginal set of metropolitan artists can be read as the most telling index of a civilization drifting toward collapse.[11] For strategic reasons, anticolonial writers and artists were inclined to take this story of Europe's cultural decline at face value, relating this insular narrative of a continent grown "over-luxurious" directly to Europe's exploitation of territories and peoples overseas. For many anticolonial writers, the idea that Europe was suffering from a long decline was taken as axiomatic, as though stressing the point would hasten their

liberation from a dying continent. Aimé Césaire opens his 1955 *Discourse on Colonialism* by arguing that a civilization that justified colonialism was already a "decadent," "sick," and "dying civilization."[12] In introducing Fanon's *Wretched of the Earth*, Jean-Paul Sartre contextualizes Fanon's essays as a response to a continent grown "fat" and "pale" on its riches. "You can see it's the end," Sartre remarks. "Europe is springing leaks everywhere." As Sartre saw it, Europe's decline enabled the rising agency of decolonizing movements, which were grabbing the reins of history from Europe's hands and, in turn, furthering its decline: "In the past we made history and now it is being made of us. The ratio of forces has been inverted; decolonization has begun; all that our hired soldiers can do is to delay its completion."[13] In this sense, Sartre anticipates Dipesh Chakrabarty's argument in *Provincializing Europe* that to dissolve a monocultural conception of history as "the history of Europe" is to open a space for newly heterogeneous narratives.[14] In welcoming Europe's decline, anticolonial writers were happy to recast Europe's historical decadence as an opportunity to decenter Europe's position in an unfolding, pluralistic view of world history.

In associating fin-de-siècle aestheticism with the last, postwar gasp of European imperialism, anticolonial writers extended the conventional period boundaries of decadence as a reigning idea in European art by half a century, subsuming modernism under a longer *durée* of artistic decline. That is, they strategically described modernism as an index of Europe's faltering grasp on its empires. In doing so, they provided themselves with a ready means of differentiating the art of new national cultures from that of Europe as they regrounded postcolonial art in indigenous traditions. The Senegalese writer and political leader Léopold Senghor, a chief proponent of Negritude, illustrates the antiaestheticist tone of many anticolonial movements worldwide when he argues that because the arts in Africa "are functional and collective, African literature and art are *committed*." He goes on to declare that "in Africa, art for art's sake does not exist. All art is social."[15] Achebe likewise argues that "it was an extremism to talk of 'art for art's sake,' which is simply to say that even if the world was falling into ruin, the artist should be carving his little piece of ivory, as Jane Austen would say."[16]

Between the 1930s and 1960s, such antiaestheticism flourished among philosophers of decolonization such as Césaire, Fanon, and the Pakistani poet Faiz Ahmed Faiz, all of whom appealed, in one way or another, to notions of social realism or utility in the arts. Their prose writing reinforced to varying degrees the mechanistic association of decadent art with the decadence of certain classes within society, blaming artists and writers working in nonrealist or overtly European modes for holding back the process of social transformation. The authors of the manifesto of the Indian Progressive Writers' Association, which was published in English in the February 1936 issue of the *Left Review*, state that "the object" of their association is "to rescue literature and other arts from the priestly, academic and decadent classes in whose hands they have degenerated so long; to bring the arts into the closest touch with the people; and to make them the vital organs which will register the actualities of life, as well as lead us to the future."[17] Césaire likewise asserts that "it is an implacable law that every decadent class finds itself turned into a receptacle into which there will flow all the dirty waters of history. . . . It is with their heads buried in the dunghill that dying societies utter their swan songs."[18]

In opposing art for art's sake to socially functional art, such anticolonial thinkers were reformulating an orthodoxy promulgated widely in early twentieth-century Marxist criticism. The Russian critic G. V. Plekhanov, for example, labeled art that separated itself from social realities as inherently decadent.[19] Likewise, in the 1910 essay "Aesthetic Culture," György Lukács expressed the hope that socialism would sweep away the excessive refinements of aestheticism, which, he argued, had turned art against life, though he seemed to doubt that such a "healthy persecution of art" was likely to succeed.[20] Walter Benjamin argues that the doctrine of *l'art pour l'art* produced a substantively empty poetics that exhibited the "profane glimmer" of the commodity but was alienated from both the people and the means of production, leading him to compare Stéphane Mallarmé unfavorably with Baudelaire.[21] As Matei Calinescu points out, neither Marx nor Engels ever proposed the idea that decadent societies necessarily produced decadent art. Nevertheless, the idea took hold in Marxist criticism in part because of its crude reductionism. It provided a powerful rhetorical tool with which to bludgeon the bourgeoisie by pointing to

the decadence of its preferred art, just as it would provide a powerful tool for anticolonial writers both to resist the imposition of European artistic standards and to marginalize the influence of an emerging native bourgeoisie.[22]

In two 1973 essays, Achebe explains that because African writers are "late starters" in the race of modern literature, "we must now have our own debate on art for art's sake."[23] Achebe cautions, however, that the terms of this debate are largely imposed from outside, flowing from the same "European mainspring" supplying both modernist aesthetes and their Marxist, cultural-nationalist critics: "Each side hurls invective over the hill into the other camp. *Monstrous philistines! Corrupt, decadent!*"[24] The artist, Achebe argues in a 1985 interview, should avoid either form of extremism: "Now if you criticize or condemn the extremism of bourgeois society, which is satisfied to free art from social responsibility, and then move right across the spectrum to the other end . . . and say that no art is possible unless it is committed to something you define, that is also a fallacy."[25]

In the essay "Africa and Her Writers," Achebe locates the origins of aestheticism "somewhere in the history of European civilization," when artists turned away from the idea that art should be "good and useful" and instead became "accountable to no one." While it is true, Achebe argues, that Poe's ideas in "The Poetic Principle" had recently fallen out of favor, "the romantic idea of 'the poem written solely for the poem's sake' still exerts a curious fascination on all kinds of people."[26] Achebe further suggests that the roots of art for art's sake may lie in the feudal system of the Middle Ages, during which the aristocracy "were able to buy over the artists in the society through diverse bribes, inducements, and patronage." Over the course of "many generations," common culture "stagnated," while "the high culture, living so long in rarefied reaches of the upper atmosphere, became sick." In light of Europe's cultural stagnation, the African writer "feels called upon to save Europe and the West by giving them Africa's peculiar gifts of healing [and] . . . emotion."[27] To Achebe's chagrin, however, the European example came to provide an implicit point of comparison for the corruption of culture that occurred under the military regimes that ruled Nigeria after independence.

At the moment when India stood on the cusp of independence, Jawaharlal Nehru saw decadence across a longer *durée* not just as a defining feature of Europe's present condition but as part of a continuing cycle of growth, decline, and "inter-imperial" competition that had also defined Indian history for two millennia.[28] In *The Discovery of India* (1946), Nehru describes, for example, a decline from the "Golden Age" of the sixth-century Gupta era to a period of cultural stagnation in the ninth century, in which "India was drying up and losing her creative genius and vitality." While Nehru accounts for the destabilizing effects of foreign invaders and competition with the Greek, Arab, Persian, Chinese, and Roman empires, he posits that "a huge, well-developed and highly civilized country like India cannot succumb to external attack unless there is internal decay, or the invader possesses a higher technique of warfare." Nehru repeatedly finds the evidence for such internal decline in the styles of art and architecture that precipitated the end of various ruling formations. While Nehru's history covers two thousand years, his view of India's repeated periods of internal decay and vulnerability to outside interference can be read as an attempt to make historical sense of Britain's dominance during the colonial era, which coincided with the decline of the Mughal Empire. His longer view provides historical perspective on India's national independence struggle: "There are repeatedly periods of decay and disruption in the life of every civilization, and there had been such periods in Indian history previously. But India had survived them and rejuvenated herself afresh, sometimes retiring into her shell for a while and emerging again with fresh vigor."[29]

Nehru's understanding of decadence as a historical concept also provides perspective on the competition between the Cold War powers of the United States and the Soviet Union. In a passage critical of the United States, he cites Thucydides to suggest that the "history of Athens is full of lessons of the incompatibility of democracy with empire, of the tyranny of a democratic state over its colonies, and the swift deterioration and fall of that empire."[30] While Nehru devotes a whole chapter to the topic of declining birth rates in the West, his comments touch on a more general sense of enervation in Western societies: "It would seem that the kind of modern civilization that developed first

in the West and spread elsewhere, and especially the metropolitan life that has been its chief feature, produce an unstable society which gradually loses its vitality. Life advances in many fields and yet it loses its grip; it becomes more artificial and slowly ebbs away." Nehru notes that this phenomenon is "nothing new." Imperial Rome "was much worse."[31]

While Nehru appears to subscribe to a diffusionist model of cultural transmission in this passage, in which "this model" of modernity begins in the West and spreads elsewhere, Partha Chatterjee argues that Nehru's theorization of history helps to provincialize Europe's achievements and render them unexceptional. It does so by suggesting that there is "nothing organic or essential in European civilization which has made it dynamic and powerful"; rather, "every civilization . . . has periods of growth and periods of decay."[32] What emerges in Nehru's scattered reflections on the problem of decadence is the clear urgency of organizing the next phase of Indian society to avoid, or at least to stave off, a similar fate. The crisis that this two-millennia-long history leads up to is the inevitable problem of managing decadence after independence, with an understanding of decadence both as an organic turn in the cycles of world history and as an immanent problem of modernity. Having studied Oswald Spengler's *The Decline of the West* (1918) in the 1930s, as well, possibly, as Edward Gibbon's *The History of the Decline and Fall of the Roman Empire* (1776–1789), Nehru shares with modernist European writers what Vincent Sherry has shown to be a widespread suspicion that modernity works against itself, that the leading edge of progress leads inevitably to decline.[33] As Chatterjee notes, within the "mature ideological form of nationalist thought" that Nehru develops in *Discovery of India*, this was above all a problem for the state, and Nehru's solutions would be primarily practical and economic. What was necessary was "to create a new framework of institutions which can embody the spirit of progress or, a synonym, modernity."[34] Nevertheless, Nehru's writing demonstrates that midcentury nationalist thinkers, in contemplating the prospect of metropolitan modernity following independence, were as much concerned with the problem of decadence as European intellectuals had been in the preceding decades.

Justin Quinn argues that during the subsequent decades, the "Cold War synchronized culture across the globe, leading to similar themes, forms, and critical maneuvers. Poetry, a discourse routinely figured as distant from political concerns, was profoundly affected by the ideological pressures of the period."[35] For small-state poets such as Derek Walcott, an inter-imperial conception of decadence allowed him to make sense of the United States' rising influence in the Caribbean during this period. In a 1974 essay, Walcott describes the Caribbean artist as living in the shadow of not one but two empires, that of the United States, which is "economically benign yet politically malevolent," and that of the British Empire, which "has passed through and over" the Caribbean. For Walcott, the Caribbean artist, like Baudelaire's Poe, is caught between the ambitious spirit of the relatively young American states and "the bitterness of the colonial experience."[36] Quinn argues that Walcott's "analogy between British imperialism and US behavior during the Cold War obscures more than it illuminates" because the Cold War divide was "based on ideology, not nation, religion, or ethnicity," and the British and the Americans had different motivations for expanding their territories and influence.[37] Nevertheless, Walcott's historical conception of imperial growth and decline allowed him to situate the Caribbean artist between the waning of one empire and the waxing of another, with the aim of standing apart from both. Even when the grounds for comparison appear strained, decadence stands as one important lens through which Third World poets made sense of their place in relation to the larger ideological conflicts that ushered in a new era of American imperialism.

For the Belfast-born poet Derek Mahon, Irish poetry, too, is caught between its bitter colonial experience under British rule and the cacophony of a new American empire that grows increasingly decadent as it grows more globally influential. In his poem "America Deserta," he echoes Baudelaire's notes on Poe: "Not long from barbarism to decadence, not far / from liberal republic to defoliant empire," suggesting that America, too, is headed for decline.[38] For a number of twenty-first-century writers and artists, "decadence" does not simply describe the decline of a single civilization. Rather, "decadence" names the tectonic friction between rising and falling empires and the condition under

which the art of those nations and cultures caught between them is produced. In the 2003 work *Scramble for Africa*, the Anglo-Nigerian artist Yinka Shonibare reimagines the moment at the 1884 Berlin conference when European empires carved up Africa for themselves. However, in a striking visual display that defies historical realism, Shonibare redresses the delegates in African textiles to give Africa, in effect, a seat at the table. In the 2001 verse novel *The Emperor's Babe*, the poet Bernardine Evaristo describes the journey of a refugee family that flees the collapsing Nile kingdom of Kush in the early third century to find a new home in Roman Londinium, then a fledgling city in the "wild west" colony of Britannia.[39] It is there, at a far-flung imperial outpost that, despite its youth, is already showing the cracks of decline amid Roman excess, that Evaristo's young protagonist, Zuleika, decides to become a poet.

Despite the propensity of early anticolonial writers to view decadence in the arts primarily as a symptom of the historical decadence of various imperial formations, as disillusionment with postcolonial regimes set in, postcolonial writers and artists were increasingly willing to make use of the fin-de-siècle decadents' most critical and oppositional tools, their wit, satire, paradoxical formulations, attention to form, resistance to realism, sexual dissidence, and revisionist approach to history, to critique what they saw as the failures of postcolonial societies. In the process, postcolonial artists submitted texts by Baudelaire, Pater, Wilde, Huysmans, Henry James, and the writers of the *Yellow Book* era to new scrutiny, discovering new uses for the social radicalism of what seemed like a thoroughly outmoded aestheticism. Contrary to what Leela Gandhi has called the "anti-aestheticist fallacy" within certain corners of postcolonial thought, these later writers and artists reclaim the supposed detachment of aestheticism against the most doctrinaire formulations of "committed" art.[40] Through the elaborate and intricate intertextual connections these writers and artists forge between their present moment and the previous fin de siècle, these artists reinvent fin-de-siècle aestheticism as a means of capturing the "worldliness" of postcolonial and diasporic experience while drawing attention to the lingering legacy of colonialism in the contemporary literary and artistic establishment.[41]

To write in a decadent mode familiar from European literature, even ironically, as Walcott does in his depiction of a declining planter aristocracy in his play *The Last Carnival* or as Wole Soyinka does in satirizing the profligacy of Nigeria's oil-boom years in his play *Opera Wonyosi,* is to stand apart from failure, corruption, and social exclusion, to distance oneself from the extremes of cultural nationalism and romantic revolutionism, to reject neocolonialism and the latest trends in European modernism, and to redefine modernism as an extension of European decadence even while reproducing certain modernist techniques, such as its heteroglossia and apocalypticism.[42] The ironic embrace of a mode of writing heavily associated with European excess represents an attempt to grapple with the unexpected temporality resulting from the collapse of postcolonial hopes into a new period of premature decline, contrasting the long life cycle of empire with the comparatively short life cycle of postindependence idealism.[43]

As time went on, however, postcolonial writers and artists claimed new affinities with decadence and aestheticism, rediscovering the radical politics and cosmopolitanism of figures such as Oscar Wilde, while reenvisioning decadence as a platform for social change. Just as post-Victorian decadents such as Max Beerbohm and Vernon Lee cultivated a "critical detachment from the contemporary" by means of their anachronism and aloofness to the chauvinism, nationalism, and commercialism of the early twentieth century, the postcolonial art and literature of decadence could also be seen to advance "progressive models of cosmopolitanism and sexual dissidence."[44] As Joseph Bristow remarks, Wilde in particular "has become a figure upheld for his distinctly oppositional qualities—as an Irishman who at times felt decidedly at odds with an English literary culture to which he never fully belonged, as a man martyred for his sexual intimacy with other men, and as a maverick who refined his unrivaled wit through epigrams that turn received wisdom on its head."[45] It was for these reasons that Wilde and his cohort became such appealing figures for later postcolonial artists as they questioned the aesthetic orthodoxies of both the Euro-American artistic establishment and anticolonial criticism. By the turn of the twenty-first century, poets and artists such as Walcott, Ali, Mahon, Shonibare, and Evaristo would reground a reinvigorated decadent sensibility in the history of empire, colonialism,

and transatlantic slavery, significantly revising our understanding of the colonial roots of earlier decadent literature in the process.

One of the most surprising features of the literature of postcolonial decadence is the prominence of Oscar Wilde at those very moments when questions of postcolonial literature's commitment to politics seems most urgent yet most unstable. His presence can be acutely felt at those points of contention where the postcolonial adherence to an earnest realism comes into question. Achebe's defense of the seriousness of African novels illustrates this point. In his criticism, Achebe exhibits a preference for realistic representation. In the context of Nigeria's postindependence national decline, Achebe suggests that the "writer is often faced with two choices—turn away from the reality of life's intimidating complexity or conquer its mystery by battling with it. The writer who chooses the former soon runs out of energy and produces elegantly tired fiction." Unlike "art from some advanced societies," African art "must never be allowed to escape into a rarefied atmosphere but must remain active in the lives of the members of society."[46] Social detachment, a tired elegance, and a rarified atmosphere characteristic of "advanced societies" are all thinly coded markers for the problem of literary decadence, which Achebe presents as the fate a committed African writer must guard against.

Of those African novelists grappling with the corruption of civil society, Achebe singles out Ayi Kwei Armah for failing to face such difficulties directly. While Achebe praises Armah for his "command of language and imagery," he censures Armah's novel *The Beautyful Ones Are Not Yet Born* for its tired elegance, calling the novel a "sick book," with a "pale and passive" protagonist who "wanders through the story in an anguished half-sleep, neck deep in despair and human excrement."[47] In denouncing this excremental mode of writing as detached, individualist, and disengaged, Achebe figuratively likens Armah's work to the nineteenth-century doctrine of "art for art's sake," which he explicitly rejects in the opening gambit of his essay as *"just another piece of deodorized dog shit."*[48] Through the figure of shit, Achebe casts Armah's existentialist style as the postcolonial manifestation of an artistic ideology known in its sanitized, nineteenth-century form as aestheticism.

While Achebe attempts to provincialize aestheticism as a product of Europe's peculiar class history, his essays contain more than a whiff

of Wildean irony and paradox. For example, Achebe takes issue with the Nigerian critic Sunday Anozie, who, in Achebe's view, casts the moral seriousness of Christopher Okigbo's and Achebe's own writings as a by-product of African culture's "underdevelopment," implying that "the artist has no business being so earnest," as Achebe puts it. To the contrary, Achebe contends, "The missionary who left the comforts of Europe to wander through my primeval forest was extremely earnest. He had to be; he came to change my world. The builders of empire who turned me into a *British protected person* knew the importance of being earnest; they had that quality of mind which Imperial Rome before them understood so well: *gravitas*. Now, it seems to me pretty obvious that if I desire to change the role and identity fashioned for me by those earnest agents of colonialism I will need to borrow some of their resolve. Certainly I could not hope to do it through self-indulgent levity." Achebe's allusion to Wilde's most frivolous of plays, *The Importance of Being Earnest*, does double duty. On one hand, Achebe employs the phrase to castigate the rapacious earnestness of the imperialist. And yet, by associating imperialism with the self-indulgent levity of Wilde, Achebe plays the earnest, anticolonial nationalist against the frivolous decadence of late empire, paradoxically affirming his own deadly earnestness with biting irony that is remarkably Wildean. This serious frivolity becomes critical to the decolonizing act of "changing the role and identity fashioned" for the postcolonial artist by the "agents of colonialism." Wildean irony becomes as critical a tool as gravitas in the postcolonial artist's literary self-fashioning.[49]

The unexpected appearance of Wilde at such moments illustrates the paradoxical role that figures associated with "decadent" European literature have played in the politics of postcolonial literature. Because Wilde is so often caricatured as occupying extreme positions on a set of aesthetic, political, and social issues that also happen to be of urgent concern to postcolonial artists, to mention Wilde—even ironically or, as often happens, in code—is to focus critical attention on these issues, even when one takes the opposite position. Because Wilde is perceived variously as an advocate of art for art's sake, an opponent of realism, a proponent of historical revisionism, a model of sexual dissidence, and a marker of the West's decline, no other figure better calls into question a laundry list of assumptions about the ethical

responsibilities of the artist, including the value of individual artistic autonomy, the legitimacy of nonrealist modes of expression in the advancement of national culture, the disavowal of homosexuality in colonial and postcolonial societies, the responsibility of postcolonial writing to revise received colonial histories, and the legitimacy of Western metropolitan culture as a model for emerging nations. These, then, are the central issues I address throughout this book.

Because Wilde so succinctly distills and memorably communicates the aesthetic debates of the colonial era, his mere mention serves as a ready heuristic for this key set of issues. For Walcott and Shonibare, for instance, Wilde's insistence that life imitates art more than art imitates life foregrounds their resistance to social realism and their propensity to absorb and reimagine European artistic traditions. For Mahon, Shonibare, and Evaristo, Wilde's assertion that one's only "duty" to history is "to rewrite it" invites a radical reimagining of colonial history and the foundations of contemporary literary and artistic institutions.[50] For all the figures I examine in this study, Wilde's critical departure from realism enables new approaches to historical revisionism. For Achebe, *The Picture of Dorian Gray* captures the asymmetrical relation between Britain's imperial self-representation and the caricatured degeneracy it unloads onto Africa. For Ali, Dorian Gray's habit of collecting exotic goods highlights the colonial relation underlying both the decadents' love of rare objects and the decimation of the Indian textile industry. Because Wilde's positions on art's relation to society are both so quotable and so multivalent, Wilde's witty, ironic, and paradoxical formulations, expressed in epigrammatic sound bites, allow later writers to draw sharp lines of debate, employing Wilde as both foil and ally. Wilde is not the only figure who draws attention to such issues, but for many Anglophone postcolonial writers and artists, he is the best known and most recognizable.

Postcolonial writers and artists employ a host of other, sometimes cliché ideas and tropes associated with fin-de-siècle culture as emblems of the asymmetrical relationship between Europe's declining empires and the colonial world. As Richard Gilman argues, the idea of decadence is inherently relative; it measures a decline or falling away from an imagined high point toward some new low. However, these points of comparison often prove illusory: the Golden Age by which the present

decadence is measured often appears rosier in memory than it likely was in fact.[51] It is for this reason, as Charles Bernheimer points out, that the term "decadent" exhibits such extraordinary "semantic mobility." It comes to be defined by its ability to subvert any stable standing point from which to define its essential elements. Bernheimer argues, therefore, that it "is not the referential content of the term that conveys its meaning so much as the dynamics of paradox and ambivalence it sets in motion."[52]

Faced with such multiplicity in the term's potential contents, Matthew Potolsky redefines decadence not as a concrete set of tropes but as a characteristic mode of reception by which individual writers formed alternative, imagined communities and counterpublics against the grain of reigning notions of national belonging.[53] This idea goes a long way toward explaining the fertility with which the postcolonial figures in this study evoke the Decadent movement to construct their own literary genealogies against the grain of various calls to formulate a national literature. Many of the works I discuss in this book never explicitly define decadence, even though they presume that their audiences will know it when they see it. Nevertheless, all of the works I address here relate the idea of decadence, regardless of its content, to the specific historical conditions of societies emerging from the long shadow of empire, especially as they redescribe decadence in the arts as both symptom and cause of the failure of postcolonial societies to cast off that shadow.

It is perhaps because "decadence," like "progress," describes the trajectory between relative, even arbitrary points and because its contents are so difficult to pin down that it proves so pervasive as a term that enables comparisons between disparate cultures and historical periods. It allows for synchronic comparisons between cultures emerging, like spokes on a wheel, from the same declining empires around the same time, even as it allows for comparisons between historical formations that may rise and fall centuries, even millennia apart. As a concept ripe for comparative critical projects, however, it demands both flexibility and specificity. Its appearance in sometimes contiguous and sometimes disjunctive contexts provides striking flashpoints that allow us to imagine a global literary geography. It tempts us to trace new patterns of transmission and circulation. My approach

here, then, is a pragmatic attempt to understand how the concept of decadence arose and was deployed across a handful of different contexts, taking note of important similarities across cultures without attempting either to impose a global theory of what "decadence" means to these various artists or to enforce an artificial uniformity with regard to the work it does within these different contexts.

Though an exhaustive account of decadence as an idea in postcolonial literature, art, and criticism would have to include a wide range of fiction, drama, and film, and this book describes concepts applicable across those genres, this study focuses primarily, though not exclusively, on poetry. I focus largely on poetry because it was poetry, especially as it was influenced by Euro-American modernism, that fell under particular suspicion during the early period of decolonization as an elite and detached mode or writing not suited for "the realist work of narrating the nation; a handicap only exacerbated when the verse was executed in the language of the conqueror."[54] For example, for Chinweizu, Onwuchekwa Jemie, and Ihechukwu Madubuike, the authors of the 1980 volume *Toward the Decolonization of African Literature*, the university-trained poets of Achebe's generation were infected with what they call the *"The Hopkins Disease,"* the symptoms of which they saw as the immature imitation of the clotted prosody, dense textual allusiveness, figurative obscurity, and distorted syntax of the modernist poetry of Gerard Manley Hopkins, Ezra Pound, and T. S. Eliot.[55] Theirs was an "alien technique, based on an alien sensibility that is rather too formalist—ambiguity for ambiguity's sake, alliteration for alliteration's sake, sprung rhythm for sprung rhythm's sake, etc." In these critics' view, this excessive attention to form obstructs African poets' attempts to present "thoughts, actions, emotions, or moods that are rooted in the traditional African setting."[56] This "devotion to artificial complexity and gratuitous obscurity" in modernist poetry, while fine for Europe, "goes against the grain of African poetic tradition," particularly oral tradition.[57] According to these critics, Christopher Okigbo's early use of pictograms, for example, "hark[s] back to the wild and purposeless experimentation of some decadent Western poets," while some modern Nigerian poets' "willful use of allusions" amounts to "a decadent mannerism which no self-respecting audience will put up with."[58] For the sake of cul-

tural decolonization, these critics argue, "this kind of exercise in senseless narcissism, this publicly enacted retreat into a private language must stop."[59]

Likewise, in the 1983 essay "Modernist Fallacies and the Responsibility of the Black Writer," the Jamaican novelist Michael Thelwell asks why "any black person, representative by definition of a culturally oppressed people," would "espouse the obsessively subjective and private" preoccupations of literary modernism. The problem with modernism, according to Thelwell, is that it reflects the "aesthetic elitism of bourgeois sensibility." The modernists, he argues, eschewed the more socially responsible realism of the nineteenth century and trafficked instead in "formalist experimentation for its own sake," celebrating "aestheticism" and the "cult of the individual consciousness." Modernist style signaled a "retreat into emptiness," while the high modernists themselves, figures such as Eliot, Pound, Marcel Proust, André Gide, Gertrude Stein, James Joyce, Sigmund Freud, and Virginia Woolf, were merely "self-obsessed, unpleasant, and eccentric." Moreover, modernism's tendency to cannibalize and parody prior literary works rather than create new "interpretations of cultural reality" offers, at best, a kind of "harmless necrophilia" and, at worst, "the central evidence of decadence in a literary tradition." The idea that modernism was necessary to convey the fragmentary nature of the human condition likewise represented the "most outrageous and transparently self-serving excrement ever served up in the interest of justifying decadence." For Thelwell, the defining characteristic of Euro-American modernism is its decadence, and decadence becomes the opposing term against which the responsibilities of black writers are to be defined.[60]

But while Thelwell asserts that modernism represents "an expression of deep malaise in European bourgeois culture," he is chiefly concerned with what happens when modernism spreads out of Europe, "infecting" the sensibility of black writers as it is reinforced by the "Western critical establishment."[61] As he writes, "It would be of little concern to me that modernist dogma lay over the West like a toxic cloud impoverishing the literature and reducing the phrase 'critical thought' to a hollow mockery. The problem, however, is that, like other of the West's toxic wastes, it seeps out of Europe and America and

poisons the wellsprings of the Black World—a most insidious form of
cultural colonialism. As a result of modernism's effect, our literature
is in danger of bypassing maturity and plunging directly from infancy
to decadence."[62] In making this argument, Thelwell overtly recalls
Fanon's assertion in *The Wretched of the Earth* that colonial subjects
who indulge the sins of bourgeois alienation are beginning at the end,
leaping over the inventive phase of youth for a later phase of cultural
senility. And while Thelwell grounds his critique in his own experi-
ence as a black Caribbean writer at odds with the New Critical dogma
of the American academy, he imagines the threat of decadence as a
global phenomenon, one that impinges on the development of black art-
ists everywhere. The fundamental question for Thelwell is whether
the category of "artist" is compatible with that of "cultural nationalist"
or "political writer." For the modernists, Thelwell argues, art and po-
litical engagement were contradictory pursuits, while, in contrast, "any
black novelist who is not consciously and purposefully a cultural na-
tionalist is an aberration."[63]

In arguing against what he saw as the navel-gazing narcissism and
obscurity of modernist poetry, Thelwell enlists an unlikely ally, Oscar
Wilde: "'A little sincerity is a dangerous thing,' said Oscar Wilde, 'more bad
poetry having been created out of sincere feeling than from any other
source.'"[64] To quote Wilde in an essay on the artistic responsibility of
black writers might strike one as a bit ironic, given that Wilde had as-
serted in the preface to *The Picture of Dorian Gray* that "no artist has
ethical sympathies" and that an "ethical sympathy in an artist is an
unpardonable mannerism of style."[65] However, the thrust of Thelwell's
argument is clear: as a genre, modernist poetry was so earnestly self-
indulgent as to be beyond salvaging, so much so that even that most
preeminent of aesthetes, Wilde, would agree. Insofar as the literary es-
tablishment continued to concoct ever more elaborate defenses of
modernist poetry's obscurity, that establishment threatened to drag
the novel down with it into the mire of literary decadence. In this
sense, "decadence" comes to stand not just for a toxic set of aesthetic
standards that seeps across geographic borders but also for a kind of
intergeneric undertow threatening to drown out the work of socially
conscious black novelists.

Though Thelwell focuses his attention on the novel, his essay has clear implications for the development of postcolonial poetry. Among the three epigraphs that open the essay, Thelwell includes one from Walcott: "A writer dies inside when he betrays, like a paid spy, the rhythm of his race."[66] That Thelwell would enlist Walcott in the project of cultural nationalism may seem nearly as ironic as his citation of Wilde, given that Walcott's entanglement with Euro-American modernism and his aversion to some of the more racially exclusive forms of cultural nationalism have been sources of controversy throughout his career. As Patricia Ismond noted in 1971, for a number of Caribbean critics, Walcott was seen, fairly or not, as a "poet's poet, the kind of luxury we can ill afford, and which remains Eurocentric," especially as judged against the more overtly Afrocentric work of the Barbadian poet Kamau Brathwaite.[67] Whether Walcott lives up to Thelwell's vision of black cultural nationalism is a subject I will address in Chapter 2. In the meantime, it appears evident that for all the dismissal of aestheticism, formalism, and modernism as threats to the authentic expression of black culture by critics such as Thelwell and Chinweizu, Jemie, and Madubuike, these critics only highlight, despite themselves, the importance of decadence as a concept against which they fashion their notions of black cultural authenticity.[68]

In this sense, decadence persists as a key term in the ongoing development of postcolonial thought as it questions the suitability of different forms and genres as expressions of cultural nationalism in the aftermath of empire. For Ali, for example, an allusion to Wilde's interest in exotic textiles from the Orient fits with his larger effort to reclaim "images that would seem too lush to an American poet—images that recur shamelessly in Urdu poetry" but that would be considered unsuitable for a poetics constrained by modernist minimalism.[69] For Shonibare and Evaristo, Wilde's subversive, Anglo-Irish dandyism and queer historical revisionism suggest a means by which to claim a place for an African presence in contemporary British art. Similarly, for Walcott, decadence comes to define the Caribbean artist's choice between the revolutionary nationalism of Trinidad's Black Power movement and the detached, international style of late-modernist abstraction. For the Northern Irish poet Derek Mahon, the idea of

decadence draws attention to the changing politics of the Irish literary archive in the face of new media technologies, globalization, and Americanization.

The diversity of such figures illustrates that the literature of decadence circulated more widely and was read more carefully than critics of either fin-de-siècle or postcolonial literature have yet fully acknowledged. It is therefore necessary to expand the limited geographic framework within which critics of literary decadence have conventionally treated their object of study. At the same time, the work of these writers and artists challenges critics of postcolonial poetry and art to take seriously ideas and styles long dismissed in anticolonial thought as inherently apolitical or counter to the aims of an engaged and committed artistic practice. Just as Vincent Sherry has persuasively uncovered a "legacy of avoidance and deflection in the critical tradition" that has obscured modernism's interest in decline and decay, this book undertakes a similar task with regard to postcolonial literature, working to map an alternative, if partial, genealogy of decadence as it emerges in case studies of postcolonial poetry and art from Nigeria, the West Indies, South Asia, Ireland, and Britain.[70]

While the concept of decadence often attaches itself to linear historical narratives of decline, it might also be considered, as Norman Vance argues, through spatial metaphors of "decentered fragmentation or failed connection, in extremity and marginality."[71] The word "decadence," as Richard Ellmann observes, "began to be used in England about 1850, as if the distentions of empire necessarily entailed spiritual decline and fall."[72] While Sherry has foregrounded modernism's reinvention of decadence in its "imaginative attraction" to the "ideals of empire" at the moment those ideals appeared to be crumbling, for the writers considered in this book, the distensions of empire were less an imagined possibility than a manifest reality, presenting an urgent crisis in the arts for those who witnessed the dissolution of empire firsthand.[73] What Walcott calls empire's "chasm-deep surrendering of power" or what Wole Soyinka refers to as "the tawdry decadence of a far-flung but key imperial frontier" can be considered as much a function of the distended, fragmented, and decentered geography of late empire as it is a function of empire's temporal diminishment.[74]

 Such a spatial conception of decadence challenges the national bor-
ders within which studies of literary decadence have so often been
confined, despite decadent literature's being "fundamentally interna-
tional in origin and orientation."[75] Indeed, as Liz Constable, Matthew
Potolsky, and Dennis Denisoff note, "decadent textual strategies inter-
fere with boundaries and borders (national, sexual, definitional, his-
torical, to name but a few) that criticism normally relies upon to make
its judgments, producing . . . a 'perennial decay' of those boundaries
and borders."[76] In *A Baedeker of Decadence,* George C. Schoolfield like-
wise notes that in decadent works "there is frequently a sense that a
national culture, having flowered, is bound for mongrelization or an-
nihilation."[77] Nevertheless, the chapters of Schoolfield's own *Baedeker*
consider the decadent writing of different national traditions almost
entirely within their own separate silos.[78] The same holds true of the
routinized manner in which contemporary anthologies of decadent
writing, such as those published in the Dedalus series, reinforce the
reigning national literary paradigms that decadent literature seems
most intent on contesting.[79] While the choice to remain within na-
tional borders reflects the exigencies of translation and publication, it
has the unfortunate effect of stifling consideration of the ways decadent
texts themselves routinely undermine such a strict adherence to
national traditions and narrows the frame in which new strains of
decadence might be discovered beyond fin-de-siècle Europe.
 Recent criticism has begun to work against the grain of this nation-
alization of literary decadence. Regenia Gagnier, for example, has
productively reconceived decadence as a model for understanding indi-
vidualism in the context of globalization as the assertion of the part
over the whole.[80] In recognizing the problem of "placing decadence"
globally, Alex Murray and Jason Hall note that a "truly global de-
cadence would," for example, "have to read Huysmans and Wilde
alongside" fin-de-siècle Latin American, Russian, and Filipino mod-
ernisms.[81] David Weir notes that in the United States, a sense that
manifest destiny had run its course, leaving only the prospect of a long
national decline, contributed to the emergence of an oppositional
culture of American decadents around the turn of the century. How-
ever, because the United States had no Baudelaire or Huysmans of its

own, the American decadents "had no choice but to derive their idea of decadence from European models," producing a "secondhand" imitation of European decadence.[82] (This would be much the same problem Walcott would confront in developing his own understanding of New World decadence.) Alex Murray likewise argues that for New Yorkers, "Decadence was perpetually somewhere else; true sophistication and glamour were found in the capitals of Europe while that which emerged in New York was always a bastard progeny." The "great achievements of New York Decadence," such as its landscape writing, were therefore "hybrid" and "synthetic."[83] Given the cosmopolitan leanings and cross-cultural borrowings of so much self-described decadent literature, it would seem that such examples of hybridity, transnationality, and "bastard progeny" ought to be considered central to the story of literary decadence, not marginal to it.[84]

Working from a different set of transnational connections, Shu-mei Shih has suggestively argued that Chinese writing in the 1920s and 1930s looked to *The Picture of Dorian Gray* and the *Yellow Book* to describe the condition of a nation under the thumb of Japanese oppression. To write in a decadent mode was to express the weakness of the nation through the weakness of decadent subjectivity.[85] In this way, an artistic style that might be seen as detached, amoral, and apolitical could in fact reflect the shame of the colonized condition. In another vein, Kristin Mahoney demonstrates how the Beardsley-esque drawings of Anglo–South African artist Beresford Egan serve as a "powerful example of the fascinating transformations Decadence underwent as it circulated globally in the twentieth century."[86]Adopting the more global perspective of these critics then—I say "more" because no study such as this by a U.S. academic can come near to achieving a truly global perspective—the story told in *Beginning at the End* is a necessarily transnational one, shuttling between Europe and its former colonies just as it shuttles between time periods, further demonstrating how decadent writing can serve as a means to reach beyond national and temporal boundaries toward far-flung artistic communities.[87]

If, as Susan Stanford Friedman argues, the respatialization of literary geography requires reperiodization, then a new geography of literary decadence offers an opportunity to reconceive the conventional divisions between Victorian, modernist, and postcolonial literatures

through their tangled relations of affiliation, repudiation, and ambiva-
lence.[88] Given the sense of temporal and spatial relativity built into the
term "decadent," a decadent poetics in the postcolonial era is always
in some sense what Édouard Glissant calls a "poetics of relation," born
of similar, if disjunctive, conditions of imperial and linguistic domi-
nance across various colonized cultures. Glissant himself defines his
idea of a globally extensive and cross-cultural "poetics of relation"
against the poetics of "depth" he finds in the metropolitan poetry
of Baudelaire or the poetics of "language-in-itself" he attributes to
Stéphane Mallarmé. Ironically, it is by returning to Baudelaire and
metropolitan fin-de-siècle writing that a poet such as Walcott, for ex-
ample, scrambles the trajectories of center and periphery built up by
structures of imperial dominance, just as Glissant envisions.[89]

Keeping in mind that the historical periods imagined within
works of art and literature are often blurrier and more surprising
than the delineations of the critic, this study builds on an increasing
number of works that bridge the gap between decadence and mod-
ernism, including works by Jessica Feldman, Cassandra Laity, David
Weir, Ronald Bush, Heather K. Love, Vincent Sherry, and Kristin
Mahoney.[90] Similarly, this book follows a number of period-bridging
works in the field of "modernist postcolonial studies," including
works by Simon Gikandi, Jahan Ramazani, Charles Pollard, Michael
Malouf, Peter J. Kalliney, and Nathan Suhr-Sytsma.[91] While such
studies usefully uncover how postcolonial writers revise modernism's
fragmentary poetics, its notions of tradition and history, its transat-
lantic solidarities, its occasional decolonizing impulses, and its sys-
tems of patronage and publication, these studies have largely focused
on the usual high-modernist suspects, leaving aside their decadent
and aestheticist precursors. Likewise, they often leave aside the question
of modernism's early pursuit of aesthetic autonomy, "the most ma-
ligned of modernist principles," exploring instead postcolonial appro-
priations of modernism's catalyzing, hybridizing energies.[92] As Simon
Gikandi has written of Caribbean writers, many postcolonial writers
cannot "adopt the history and culture of European modernism, espe-
cially as defined by the colonizing structures, but neither can they
escape from it."[93] As it turns out, while critics such as Sherry, Laity,
and Bush have had to work against the grain of various modernists'

attempts to cover the tracks of their decadent inheritance, many post-colonial writers have long suspected modernism's roots in literary decadence and built that suspicion into their own hybrid and creolized revisions of high modernism. For some of these writers, decadence serves as the overarching rubric under which the varieties of Euro-American modernism can be understood as products of late empire.

In reading postcolonial and decadent writers in tandem, this study adopts a transnational approach to literature that draws on the work of Jahan Ramazani, Rebecca L. Walkowitz, Wai Chee Dimock, and Paul Gilroy and is indebted to the contrapuntal approach of Edward Said.[94] If one aim of *Beginning at the End* is to reexamine the boundaries between various periods and approaches, one might ask why I choose to retain the term "postcolonial" at all, as opposed to the more broadly construed "postmodern" or "global Anglophone." The answer is simply that in the texts I examine, the relation these poets and artists imagine between their contemporary moment and varying histories of empire, the nation, and art is one of imperial aftermath. Or, to borrow Wallace Stevens's phrase, these are texts in which the imagination is "always at the end of an era," even as these various writers and artists struggle to extricate themselves from that sense of an ending.[95] My aim is not to pin down any of these writers or artists as "postcolonial" artists alone. Indeed, some might reject that label. Rather, the idea of the "postcolonial" proves indispensable, if not wholly sufficient, to describe their responses to their respective historical and geographic positions.

As Stephen Cushman argues with regard to American poetry, some poets tend to "overvalue the formal aspects of their art" by overestimating "the synecdochic relationship between those formal aspects" and larger ideas about national culture.[96] Postcolonial critics and poets similarly invent enabling "fictions of form" linking the formal aspects of literary or artistic works to the fate of nations and empires. Indeed, it is through such ideologically pressured notions of form that postcolonial writers often link certain modes and styles with the condition of historical decadence, just as they would associate certain forms with the "revolutionary" or "progressive" trajectories of new national cultures. It is partly for this reason that ideas about form and formalism become so heavily contested in the postcolonial era, and labels such

as "decadent" and "revolutionary" become so unstable and subject to reversal. Whether one rejects formalism or embraces it, the stakes of literary form seemed inextricably tied to the fate of emergent national cultures; literary and artistic forms become freighted with the responsibility to realize new cultural conditions. As Agha Shahid Ali writes, "If one writes in free verse—and one should—to subvert Western civilization, surely one should write in forms to save oneself *from* Western civilization?"[97] Ali writes half in jest, but his comment makes clear the high stakes that have been attached to questions of form in postcolonial thought, even among those who reject formalism.

Each of the chapters in this book takes up questions of form, realism, cultural nationalism, historical revisionism, sexuality, and cultural decline with respect to a different array of literary and artistic traditions from South Asia, Africa, the West Indies, Britain, and Ireland, often drawing contrasts between early postcolonial writing by figures such as Fanon, Senghor, Achebe, Faiz, Walcott, and Soyinka and more recent work by writers and artists such as Agha Shahid Ali, Walcott (again), Yinka Shonibare, Bernardine Evaristo, and Derek Mahon, the later of which provide the main focus for each of the following chapters. A brief epilogue examines Wilde's relevance to current debates over systemic racism in the art world and art's relation to state authority, as seen in works by Walcott, Medbh McGuckian, and Robin Coste Lewis. Despite the sense of exhaustion, enervation, and secondariness that often accompanies the notion of decadence, all the texts examined here are also endlessly innovative, offering new relations between present versions of a global imaginary and that fin-de-siècle sense of fin du globe. Taken together, these chapters aim to stimulate what I hope will be a new awareness of the ways in which ideas about decadence and aestheticism have developed beyond the usual disciplinary confines of fin-de-siècle Europe, shedding new light on some familiar territory while breaking down the walls that separate current periodizations of literary decadence from the contemporary literature and art of postimperial aftermath.

A brief look at Achebe's writing about the decades after independence will illustrate the earnestness with which the threat of decadence was treated. Though Achebe is best known for his novels, his representation

of the dashed hopes of poetry in the early days of independence dem-
onstrates how early postcolonial writers came to redefine decadence
to capture their disillusionment with postcolonial society.

By Achebe's own account, the years leading up to Nigeria's inde-
pendence were good ones. He graduated from Ibadan University, found
work with the Nigerian Broadcasting Corporation, and published his
most acclaimed novel, *Things Fall Apart*, in 1958. Achebe counted
himself among a "lucky generation" of writers such as Christopher
Okigbo, J. P. Clark, and Wole Soyinka who took advantage of new
schools and new opportunities in the arts and the civil service in a
country rapidly marching toward independence. It was the "dawn of a
new era," as Achebe later recalled, a moment that offered both ideo-
logical and practical challenges for young Nigerian intellectuals.[98]
When Nigeria won its independence from Britain in 1960, its future as
a republic seemed bright, if not assured.

And then things fell apart. Achebe recounts in his 2012 memoir
There Was a Country that within six years of independence, "Nigeria
was a cesspool of corruption and misrule."[99] A series of crises, including
a "bungled transfer of power," a military coup in 1966, and pogroms
that killed hundreds of Igbo Nigerians, eventually sparked a bloody
thirty-month civil war between Nigerian federal forces and the would-
be breakaway republic of Biafra, resulting in the death of more than a
million people.[100] Even after the Biafran cause was lost, a reunified Ni-
geria's initial hope for renewal fell short of its promise. As Achebe
wrote forty years later, Nigeria was "plagued by a home-grown enemy:
the political ineptitude, mediocrity, indiscipline, ethnic bigotry, and
corruption of the ruling class," corruption made worse by the country's
oil boom. "A new era of great decadence and decline was born,"
Achebe declared. "It continues to this day."[101] Within a few short years,
the dawn of a new era had led to the end of an era, a "lucky generation"
had become a tragic generation, and decadence and decline became
central terms in postcolonial literature's response both to the prac-
tical failures of postcolonial regimes and to the idea of revolutionary
nationalism generally.

As Susan Andrade has observed, the collapse of democratic civil so-
ciety in a number postcolonial African states appeared to extinguish
the initial cultural energies released in the process of decolonization:

"From the late 1950s to the early or mid-1960s, decolonization radiates the world with idealism and energy, even though in Africa that energy is spent by 1968, leaving only decay and waste."[102] As the initial fervor of nationalist independence movements waned and as democratically elected governments were overthrown across the continent, "writers from all over independent Africa grappled with how to represent failure at the level of the nation."[103] Achebe was not the only African writer to confront this era of disillusionment.[104] Afam Ebeogu observes that "the poetry of this period . . . is post-colonial in more than a mere temporal sense for its words and rhythms reflect not only the spirit of exuberance that heralded independence, but also a growing disenchantment with the dismal performance of African politicians."[105] In Achebe's writing about this time, he registers his grief, shock, and anger at the tragic events of the postindependence years, events that took the lives of some of his closest associates, most notably the poet Christopher Okigbo.

During the civil war, Achebe turned to poetry as the genre in which to wrestle with the problem of civil disorder, publishing his first volume of poems, *Beware Soul Brother*, shortly after the war in 1971.[106] Achebe turned to poetry both for artistic reasons and out of necessity. During the war, Achebe served Biafra as an unofficial roving ambassador, helping to provide a rationale for the break with Nigeria.[107] As the fighting worsened, Achebe's family was forced to relocate numerous times. Both Achebe's apartment complex and the site of his publishing house, the Citadel Press, were destroyed.[108] Writing fiction under such conditions proved impossible. The briefer span and sharper language of poetry offered Achebe a way to grapple with events in their immediacy. As Achebe explains, "there is some connection between the particular distress of war [and] the genres that I have employed in that period."[109] Despite the urgency of conditions that incited this turn toward poetry, as Irele notes, Achebe's poems "have rarely been noticed . . . nor viewed as imbued with the same urgency of tone and vision as the narratives." The lack of critical attention to Achebe's poetry was due in part to the fact that though the "poems owe their inspiration to events related to the Nigerian scene, . . . their idiom points us away from an indigenous aesthetic, and instead toward the modernist legacy of English verse."[110]

In Fanon's writing, a revolutionary national literature is heavily associated with the figure of youth, while the adoption of "tragic" Western poetic modes leads to that prematurely aged sensibility he describes as decadent.[111] The revolutionary poet who rejects European forms develops "a vigorous style, alive with rhythms, struck through and through with bursting life." Such a style "reveals the need that man has to liberate himself from a part of his being which already contained the seeds of decay."[112] However, it is precisely in the figure of prematurely aged youth that Achebe develops a postcolonial understanding of decadence, one that employs modernist modes of expression to suggest that the very seeds of Nigeria's decay were planted at the nation's founding. Decadence, in this sense, has less to do with the purportedly detached formulations of art for art's sake so much as it heralds a loss of faith in the revolutionary ideals that drove thinkers such as Fanon.

Vincent Sherry has called the figure of declining youth the "signature conceit" of 1890s decadence.[113] It is a figure familiar, for example, from William Butler Yeats's representation of male 1890s poets such as Beardsley, Ernest Dowson, and Lionel Johnson as a "tragic generation" forced to maturity too soon and prematurely faded.[114] However, Sherry persuasively argues that the figure of ruined, wasted, or elderly youth is inextricably related "to the political history of failed revolution."[115] The "rejuvenating force" imagined in Wordsworth's figure of the "spot of time," for example, which yoked together adult maturity with the energy of youth, unraveled as history failed to live up to the revolutionary promise of the early part of the nineteenth century.[116] As Sherry argues, the sense of loss attached to the ongoing failure of revolutionary romanticism became the defining condition for a poetics of aftermath. By the time Pound comes to write *Hugh Selwyn Mauberley* in 1920 or Eliot writes "Gerontion" in the aftermath of the First World War, the figure of "ruined youth is not just a literary conceit." It has been "made real in the historical experience" of a generation of writers who saw millions of young people cut down by the war.[117]

Something similar occurs in Achebe's writing during the collapse of Nigerian society. This failure is acutely figured in Achebe's response to the loss of Christopher Okigbo, who died fighting for Biafra in August 1967. Achebe writes that Okigbo fell "in Ekwegbe, close to Nsukka,

where his poetry had come to sudden flower seven short years ear-
lier."[118] As a poet who, in Achebe's view, made a decisive turn away
from European modernism toward his African heritage in his later po-
etry, Okigbo represented the possibility of a rejuvenating poetics com-
patible with a revolutionary politics. In responding to the failure of that
short-lived possibility, Achebe takes the stance of the long-lived rem-
nant left behind to witness the demise of revolutionary possibility and
to suffer through its barren aftermath.

This can be seen in Achebe's poem "Mango Seedling," which was
first published in the *New York Review of Books* in May 1969, nearly
two years to the date after Biafra declared independence. The poem,
which is dedicated to Okigbo's memory, was published alongside an
article by Conor Cruise O'Brian that decries Biafra's deteriorating hu-
manitarian crisis and laments its diminishing prospects for indepen-
dent statehood.[119] The poem's paratexts thus identify Okigbo's death
with the imminent foreclosure of Biafra's national aspirations, then
under severe strain from the Nigerian military. To mourn the prema-
ture death of a poet, then, was to anticipate the premature death of a
nation.

In the poem's opening, the speaker watches a mango seedling take
root in the unpromising soil of a concrete ledge overhanging a modern
office building:

> Through a glass windowpane
> Up a modern office block
> I saw, two floors below, on wide-jutting
> concrete canopy a mango seedling newly sprouted
> Purple, two-leafed, standing on its burst
> Black yolk. It waved brightly to sun and wind
> Between rains—daily regaling itself
> On seed yams, prodigally.[120]

Though Achebe's language is straightforward, his initial prosody
relies heavily on alliteration, consonance, and internal near rhyme
("*concrete canopy a mango*"; "*burst / Black yolk*"). There's a line of as-
sonant troches ("Úp a módern óffice blóck") and a scattering of forceful
spondees ("wíde-jútting"; "twó-léafed"). Forgoing exact rhyme or
repetition, the verse projects novelty and variation. The allusion to the

"prodigal son" also recalls Okigbo's *Heavensgate*, in which the speaker identifies himself as a "prodigal."[121]

However, this onward-and-upward poetic sensibility soon collapses into a poetics of foreclosure characterized by repeated rhetorical questioning and a figurative foreshortening of the life cycle:

> For how long?
> How long the happy waving
> From precipice of rainswept sarcophagus?
> How long the feast on remnant flour
> At pot bottom?[122]

As the poem turns back on this question of duration—"how long?"—it also enacts a dying fall from "precipice" to "sarcophagus," from precarious hope to premature grave. The initial bursting moment of promise, which hitched together the maturity of advanced "modern" architecture with the organic sprouting of youth, gives way to a sense of this moment's inevitable end. Already, the seedling's birthplace, an office block that symbolizes Africa's assimilation to Western modernity, is revealed as a tomb. The meager soil of the modern cannot support life for a seedling that has begun its life at the end.

The reigning trope of "Mango Seedling," that of youth withered in its prime, can also be found in the poetry of Achebe's contemporaries, most notably in Wole Soyinka's 1967 volume *Idanre and Other Poems*. His poem "Season," for example, imagines a harvest in which "Laden stalks / Ride the germ's decay."[123] His poem "Harvest of Hate" similarly captures the violence that followed the 1966 coup by speaking of a "heritage of blighted futures."[124] Likewise, in "Easter," a poem whose title would appear to gesture toward resurrection, unripe mangoes are described as "coquettes / To the future decadence."[125] In each of these poems, the idea of decay is embedded in the very moment of germination, explicitly linking the figure of unripe youth, prematurely withered, with the foreclosure of national aspirations.

In the second section of "Mango Seedling," the speaker entertains the possibility that renewal and replenishment may come from nature, but such hopes are disappointed when the rain fails to "rise in power / And deliver its ward in delirious waterfall / Toward earth below." Nature, the "prime mover" behind all life, fades in its impotence, too

weak to bring off a new birth. The poem's final lines modulate into a modernist poetics of aftermath:

It went from purple to sickly green
Before it died.
 Today I see it still—
Dry, wire-thin in sun and dust of the dry months—
Headstone on tiny debris of passionate courage.[126]

The fading of the seedling's life "from purple to sickly green" indexes the fading of both poetic and political possibility. In the "dust of the dry months," Achebe alludes to the dried out, prematurely aged poetics of Eliot's "Gerontion": "Here I am, an old man in a dry month, / Being read to by a boy, waiting for rain." The allusion reinforces the affective stance of a speaker who witnesses a lost cause from a distance, as in Eliot's reference to the battle of Thermopylae: "I was neither at the hot gates / Nor fought in the warm rain."[127] Though Okigbo was Achebe's age-mate, the speaker of "Mango Seedling" adopts the aged stance of Eliot's "Gerontion," left with the "Thoughts of a dry brain in a dry season."[128] The poem adopts a stance that, as Fanon might describe it, "is already senile before it has come to know the petulance, the fearlessness or the will to succeed of youth."[129] Achebe's seedling never bears fruit. Biafra's independence struggle was born in the spring of 1967, but Okigbo was dead by the end of that summer.[130]

 Though Achebe's poem does not exhibit the wit and ennui that critics have come to associate with decadent poets such as Wilde, Baudelaire, or Symons, Achebe's poem nevertheless hovers between two registers of decadence as it came to be understood in a postcolonial context. On one hand, Achebe employs the figure of wasted youth to decry those very conditions of postindependence society he describes as decadent, the rapid decline from revolutionary promise to corruption and civil disorder. On the other hand, by evoking the prematurely aged poetic stance of Eliot's high modernism, he courts the condemnation of those critics who see modernism's style and allusiveness as foreign legacies of Euro-American decadence. In this sense, Achebe positions his speaker between the (alleged) aesthetic decadence of Euro-American modernism and the civil decadence of postindependence Nigeria. "Mango Seedling" does not sound or read like fin-de-siècle decadent poetry,

but the idea of decadence is integral to its imaginative stance toward
the lost revolutionary possibility of Biafra as figured in the image of
youth wasted before its time.

Achebe also addresses the failure of revolutionary promise in *Ant-
hills of the Savannah* (1987), the one novel he published after the civil
war. The novel takes place in the fictional West African country of
Kangan, but its events are clearly inspired by those of Nigeria after
1960. The novel follows two main characters—Chris, a government of-
ficial, and Ikem, a poet and newspaper editor—as they negotiate the
treacherous political waters of a nation seized by a military dictator-
ship. Near the end of the novel, Ikem is arrested and shot after giving
a speech critical of the government. Chris then flees for his life with a
few of Ikem's poems in hand.

The novel criticizes Africa's dictatorial rulers as "late-flowering me-
dieval monarchs, even the Marxists among them."[131] In lumping
together Marxist dictators and "late-flowering medieval monarchs,"
Achebe denounces the hijacking of revolutionary politics by decadent
dictators, giving voice through Ikem to a politically radical, yet anti-
revolutionary politics. As Ikem argues,

> The sweeping, majestic visions of people rising victorious like a tidal
> wave against their oppressors and transforming their world with the-
> ories and slogans into a new heaven and a new earth of brotherhood,
> justice and freedom are at best grand illusions. The rising, conquering
> tide, yes; but the millennium afterwards, no! New oppressors will
> have been readying themselves secretly in the undertow long before
> the tidal wave got really going.
>
> Experience and intelligence warn us that man's progress in
> freedom will be piecemeal, slow and undramatic. Revolution may be
> necessary for taking a society out of an intractable stretch of quag-
> mire but it does not confer freedom, and may indeed hinder it.[132]

Revolution, though occasionally necessary, holds within it the poten-
tial for immediate corruption despite the romantic, millenarian hopes
that drive the revolution. This is a position Ikem repeats in his last,
fatal speech to a university audience: "My critics . . . quote Fanon on
the sin of betraying the revolution. They do not realize that revolutions
are betrayed just as much by stupidity, incompetence, impatience and

precipitate action as by doing nothing at all."[133] The seeds of postcolo-
nial decay, Ikem argues, can be found in the revolutionary character
of decolonizing movements from their very beginning.

Against such a danger, Ikem opts not for revolution but for gradual
change: "Even a one-day-old baby does not make itself available for
your root-and-branch psychological engineering, for it comes trailing
clouds of immortality. What immortality? Its baggage of irreducible in-
heritance of genes. That is immortality."[134] So much for the revolu-
tionary spot of time. The "clouds of glory" that trail after Wordsworth's
figure of youth in his ode "Intimations of Immortality from Recollec-
tions of Early Childhood" are reduced in Achebe to a "baggage of ir-
reducible inheritance of genes."[135] This is the essential glut of human
inheritance, built up by human biological history, that can only be al-
tered ever so slightly around the tailing fringe, never wiped clean by a
revolution in the political realm. Ikem presents history as a series of
diminishing returns, a stiflingly cumulative history whose funda-
mental character cannot be altered by revolutionary idealism. Ikem
calls for a "new radicalism" that is "clear-eyed," as opposed to the sort
of radicalism that hardens into orthodoxy, for "orthodoxy whether of
the right or of the left is the graveyard of creativity."[136] However, what
this "clear-eyed" new radicalism sees is the diminished possibility for
revolutionary creativity at the tail end of a human narrative whose
story is already largely fixed in place.[137]

After Ikem's murder, Chris flees to a region of the country less
friendly to the ruling regime. During his journey, he reads those few
of Ikem's poems he managed to salvage. As he reads, Chris is struck
by "the searing accuracy of the poet's eye," which "was primed not on
fancy but fact" in a seeming fusion of poetry and realist prose.[138] Shortly
after reading Ikem's poetry, Chris falls into an altercation with a po-
lice officer, who shoots him fatally in the chest. Whatever revelation
in Ikem's poetry gave Chris the courage to stand up to government cor-
ruption leaves him dead. In the wake of these deaths, Chris's lover,
Beatrice, wonders of Chris and Ikem, "Were they not in fact trailed
travellers whose journeys from start to finish had been carefully pro-
grammed in advance by an alienated history? If so, how many more
doomed voyagers were already in transit or just setting out, faces fresh
with illusions of duty-free travel and happy landings ahead of them."[139]

The image of fresh-faced travelers doomed from the start trailing clouds of history, however, repeats the trope of postcolonial nationhood as a death in birth, as decadence in germination, as beginning at the end and ending at the beginning.

Achebe repeatedly figures the failure of the nation through the eclipse of the romantic, male, revolutionary poet. Ikem is murdered. Chris is killed after reading Ikem's poetry. A minor character, Dick, explains how he founded a literary magazine called *Reject* that only accepted poems rejected by other magazines. "In under two years we exploded the pretensions of the poetry establishment and their stuffy party organs. It was the most significant development in British poetry since the war."[140] The joke is obvious: the most significant development in British poetry as its empire went into decline was the secondary recycling of material rejected by various "party organs," presumably for not meeting their ideological standards. Another secondary character, John Kent, whom Ikem describes as an "aborted poet," is deported back to Britain.[141] Read at a glance, his name reminds one of the prematurely departed John Keats. This might sound far-fetched until one turns to the last page of the novel, where Beatrice sums up her experience in Keats's well-known formula from "Ode on a Grecian Urn."[142] As she reacts to the news of Chris's death, she responds, "Truth is beauty, isn't it?"[143] What does this final turn to Keats signify? A return to revolutionary romanticism? A newfound hope for political truth in the domain of the aesthetic? Whatever the case, through the repeated image of young poets wasted before their time, Achebe signals in prose the uncertain position of poetry as a genre capable of offering a revolutionary vision for the nation amid the conditions of corruption and civil disorder that he came to define as Nigeria's postcolonial decadence.

1

Agha Shahid Ali, Oscar Wilde, and the Politics of Form for Form's Sake

IN AN 1888 REVIEW in the *Woman's World* magazine, the journal Oscar Wilde edited from 1887 to 1889, Wilde praises Ernest Lefébure's illustrated manual *Embroidery and Lace*, heralding the volume as an index of positive cross-cultural exchange between East and West in matters of textile design and fabrication. Wilde notes, "Persia has sent us her carpets for patterns, and Cashmere her lovely shawls, and India her dainty muslins finely worked with gold thread palmates, and stitched over with iridescent beetles' wings." China and Japan, too, have offered products notable for their ingenuity of design and "colour combination." However, Wilde steps back from mere technical matters to ask a broader cultural question. While he notes that in his own day "the influence of the East is strongly marked," he goes on to wonder with some skepticism "whether we have yet learned to make a wise use of what we have acquired."[1]

Nearly a century later, the Kashmiri American poet Agha Shahid Ali, upon discovering Wilde's interest in Eastern textiles in the pages of *The Picture of Dorian Gray*, asks a similar question. In a poem titled "The Dacca Gauzes," Ali, who was born in New Delhi in 1949 and raised in Kashmir, seizes on a reference in Wilde's novel to a variety of diaphanous, cotton muslin fabric that was once woven in Bengal and popular among elites of the Mughal court. Ali's poem begins with an

37

epigraph from Wilde's novel—"for a whole year he [Dorian Gray] sought/to accumulate the most exquisite/Dacca gauzes"—and weaves Wilde's words into the first lines of his poem: "Those transparent Dacca gauzes/known as woven air, running/water, evening dew."[2] As it turns out, the phrases Ali borrows from Wilde, "woven air" (*bafthowa*), "running water" (*abrawan*), and "evening dew" (*shubanam*), were more than just poeticisms; they were the names by which specific varieties of muslin fabric were known and marketed in India, the West, and elsewhere.[3] However, in describing how remnants of this sensuous material were passed from one generation to the next, only to be lost to history, Ali refers to the craft of gauze weaving as "a dead art now, dead over/a hundred years." As he writes, "'No one/now knows,' my grandmother says,//'what it was to wear/or touch that cloth.'"[4]

As Ali's poem reveals, the reason the craft of weaving these fabrics became a "dead art" has to do with some of the more brutal industrial practices reportedly undertaken by the British during the colonial era. After commenting on the extraordinary quality of this fabric to the touch, Ali recounts how bits of the fabric were divided up as they were passed down through the family:

> Years later when it tore,
> many handkerchiefs embroidered
> with gold-thread paisleys
>
> were distributed among
> the nieces and daughters-in-law.
> Those too now lost.

While the story here is an intimate one, the scarcity registered in this diminishing inheritance marks a wider breakdown in the system by which these fabrics once circulated in India and abroad. Indeed, Ali goes on to deliver the "facts" that account for the textile's rarity:

> In history we learned: the hands
> of weavers were amputated,
> the looms of Bengal silenced,
>
> and the cotton shipped raw
> by the British to England.[5]

In an interview, Ali comments that his goal in this poem was not nec-
essarily to "write back" to the West as a postcolonial subject or to "rep-
resent what the British did." Rather, what engaged Ali "was a horrific
act, sure, but only as it was passed down to us, thus becoming legend,
and it became tied up with a ravishing imagery and family history."[6]
In bringing the material history that resulted from British atrocities
in South Asia together with the sort of "ravishing imagery" that re-
flects Wilde's admiration for Eastern textiles, Ali's poem indicates that
nineteenth-century aestheticism and postcolonial representations of
colonial history are entangled in ways that complicate our under-
standing of both periods.

If one looks, for example, at the earliest typescripts of the poem,
which can be found among Ali's papers at Hamilton College, where he
taught for a time, one discovers that Ali's original title was not "The
Dacca Gauzes" but "Reading *The Picture of Dorian Gray* in Kashmir."[7]
This title evokes the possibility of a transnational reading practice, one
that would allow us to think critically about what it means both to
read *The Picture of Dorian Gray* in the subcontinent and to read the
subcontinent in *Dorian Gray*. For both Wilde and Ali, the sensuality
and abstract design of fine textile work offer a material alternative to
realism and mimesis as means to represent the ravages of history.

Ananya Kabir has argued that because Ali understands language to
be ephemeral, he sees it as necessary to "reach beyond language to ob-
jects" to capture histories not available to verbal memory. Kabir also
argues that in reaching for an artifactuality more durable than mere
"writtenness," Ali hopes to "evade temporality and decay."[8] Neverthe-
less, Ali takes the decay of material artifacts as a figure for the longer
temporality of decay to which poetry is also subject. As Ali writes in
one of his ghazals, "I heard the incessant dissolving of silk—/I felt my
heart growing so old in real time."[9] In this couplet, the dissolving of
silk figures the emotional decay of the subject. In reaching for an arti-
factuality that is fragile over a *longue durée*, Ali ironically poses such
slow decay against the immediacy of representation captured by the
live-news cliché "in real time." In doing so, Ali differentiates poetry,
the news that stays news, from the live-feed news of the moment. How-
ever, to link poetic figuration with artifactual decay is also to figure

the decay to which the ghazal as a form has been vulnerable as it was passed down for centuries from Arabic to Persian to Urdu and to English. In this way, the nondurable quality of the decorative arts provides a resource for figuring the potential for decay in the circulation of poetic forms as they are translated across languages and cultures, subject to the same historical processes as material artifacts.

Amitav Ghosh posits that "the formalization of the ghazal may well prove to be Shahid's most important scholarly contribution to the canon of English poetry."[10] For poets from Persia, Northern India, and the Ottoman Empire, the ghazal, a tightly rhymed form consisting of thematically independent couplets, served for centuries as one of the primary vehicles for the expression of same-sex desire through its conventionalized adoration of the beloved, often ambiguously described as a beautiful young male.[11] When Ali seeks to rescue what he calls "Real Ghazals in English" from the "surrealistic" free-verse experimentalism to which the form had been subjected by American poets such as Adrienne Rich, he does so for what he calls "a seemingly conservative" but "increasingly radical reason," that of "form for form's sake."[12] In announcing his intentions to return the Anglophone ghazal to its formal roots, Ali does so in language that deliberately echoes the seemingly detached, nineteenth-century formulation of "art for art's sake." Moreover, in discussing his translations from Urdu of ghazals by the renowned Pakistani poet Faiz Ahmed Faiz, Ali again alludes to *The Picture of Dorian Gray*. He recalls that his "first sensuously vivid encounter" with Faiz's poetry came through the voice of the classical Indian ghazal singer Begum Akhtar, to whom Ali was devoted and whose enormous popularity made her a household name across South Asia and beyond. "Unlike so many other ghazal singers, who clothe words until they can't be seen," Ali writes, "she stripped them to a resplendent nudity. If she clothed them at all, it was in transparent muslins, like the Dacca gauzes: 'woven air, running/water, evening dew.' "[13]

Given the familiar charges of decadence and exoticism frequently associated with Wilde's novel, Ali would seem only to exacerbate concerns about Orientalism among postcolonial critics by likening the ghazal to fabrics employed by Victorians to exhibit the West's taste for exotic goods from the East. Curtis Marez, for example, has argued that Wilde's interest in exotic goods "reconfirmed an imperial division of

labor between British subjects and non-European objects."[14] Moreover, in figuratively stripping Faiz's ghazals to "a resplendent nudity" and then reclothing them in words borrowed from Wilde, Ali would seem to double down on the accusations of decadence, perversity, and elitism that have dogged ghazal poetry for more than a century.

Attitudes toward ghazal poetry have tracked closely with attitudes toward homosexuality: where the East was criticized by Westerners as decadent, homosexuality and the traditional literary forms that expressed it were disavowed in the name of modernization. When expressions of homosexuality resurfaced, they were disavowed again as imports of a decadent West. The disavowal of homosexuality likewise haunts nationalist disavowals of the courtly traditions in which ghazal poetry thrived. As Aamir Mufti notes, for "nationalist writers" of the nineteenth and early twentieth centuries, the ghazal "became something like an icon of the vast distances separating the *ashraf* Muslim elites" from the general populace. The form was held suspect both by Marxist writers of the Progressive Writers Association and by those committed to the "intellectual demands of modern poetry" in "the name of art for art's sake."[15] Faiz, whose work deeply influenced Ali's, became a key theorist of decadence during the debates that broke out over the politics of poetic form among the first generation of postcolonial poets, employing the idea of decadence to battle both the leftovers of feudal Mughal social structures and the postmodern theories of Western critics.

In the 1990s, amid the battles over neoformalism in American poetry, Ali argued that the ghazal articulates contemporary experience not despite its association with outmoded feudal traditions but because of it. In doing so, Ali charmingly dared his critics to come after him: "I found it tantalizing to strike a playful pose of Third-World arrogance, laced with a Muslim snobbery."[16] For Ali to repurpose Wilde's words to describe modern ghazal poetry, then, is a deliberate provocation, one that requires a deeper examination of the shifting politics of form from the colonial era to the present that have given shape to Anglophone poetry in its transnational trajectories between Britain, South Asia, and America.

In tracking the strange, overdetermined career of "form" as an idea in Western thought, Angela Leighton observes how, even when form

was kept at its most pristine remove from the exigencies of the real world, the "crack in the glass, the fissure in the crystal, was always there, as a reminder of the breakableness of form in the face of actual human violence."[17] To trace the idea of form from Wilde through the colonial era to Faiz and Ali is to expose intertwined histories of colonial brutality, cultural nationalism, and the reaction against cultural nationalism in the name of art. It is to follow shifting attitudes toward sexuality, industrialization, and modernization that go as far back as the 1857 Sepoy Rebellion, an event that led to the destruction of the once-courtly world of Urdu ghazal poetry. The consequences of events in India reverberated in the politics of Anglo-Irish aestheticism, especially in Wilde's writing and editorial work on the decorative arts. By tugging at these various threads of Mughal decadence, Wildean aestheticism, and postcolonial nationalism, Ali's poetry teaches "the Western reader how to decode South Asian aesthetic gestures that have been centuries in the making" while restoring disavowed elements of a poetic tradition associated with a purportedly decadent Muslim aristocracy and considered unsuitable for the project of cultural nationalism.[18] Ali's poetry articulates a capacious and cosmopolitan role for formalism, a role that "allows in its scope," as Sara Suleri Goodyear writes, "decadence, mysticism, history, and politics—within the elegant construction of a single line."[19] At the same time, Ali's turn to Wilde reopens a conversation about aestheticism as an artistic doctrine intimately concerned with the politics of production in a colonial context, allowing one to rediscover in Wilde's aestheticism a defense of traditional modes of artisanship, be it handcrafted textiles or handcrafted lyrics, against the cultural logic of industrialization in both Europe and South Asia.

Stephen Burt has argued that by "connecting forms, allusions, and cultures distant in time and space," Ali's poetry not only registers its transnational trajectories, establishing new meanings in new contexts, but also seeks, through its highly self-conscious literariness, to take part in the larger conversation of world literature. The contingent and fragile networks of "form, allusion, and tradition" that Ali weaves into his poetry about the conflict in Kashmir, for example, distinguish his poetry from "journalism" or "unadorned, or moralized war reportage." Ali's poetry, Burt argues, aspires to join a network "of estimable cre-

ations that speak to one another across national, continental, and linguistic bounds and that can do ethical as well as critical work because of the manner in which they cross those bounds."[20] By reading Wilde and Ali's work in tandem, one can make legible just one of the many ways Ali's poetry does ethical work by crossing such boundaries. Though Ali was likely not familiar with all of Wilde's critical writings, by reading Wilde's statements on the decorative arts in light of Ali's poetry, and vice versa, I hope to uncover the shared context of colonial industrialization that gave shape to debates over the politics of poetic form between their two eras in both Europe and South Asia. To see how artifacts such as fine textiles might serve as a locus for debates over aestheticism in poetry, one has to understand how and why gauzes from Dacca would make their appearance in *The Picture of Dorian Gray* in the first place.

By the end of the nineteenth century, the Victorian public's hunger for South Asian artifacts had reached a high point, spurred on by popular displays by the British East India Company, the world's fair, and the South Kensington Museum. As Carol Breckenridge notes, illustrated manuals such as Lefébure's *Embroidery and Lace* allowed collectors to name their acquisitions and to "fabricate myths of origin and genealogies for them."[21] Wilde turned to such manuals to fabricate his own mythologies for the origins of exotic textiles. In doing so, he emphasized the difficulty of finding materials of the highest quality. In chapter 11 of *Dorian Gray*, for example, Wilde recycles material from his review of *Embroidery and Lace* for an epic, *ubi sunt*–style homage to fabrics recorded in legend but lost to the ages: "Where was the great crocus-coloured robe, on which the gods fought against the giants, that had been worked by brown girls for the pleasure of Athena? Where the huge velarium that Nero had stretched across the Colosseum at Rome. . . . He longed to see the curious table-napkins wrought for the Priest of the Sun." Wilde's mock-epic tribute goes on for several pages, reflecting Dorian Gray's sadness at "the ruin that Time brought on beautiful and wonderful things." And yet Wilde's lament for these lost textiles (some worked by "brown girls") has a serious edge, reflecting the material conditions of fine goods under British imperium.[22]

As Wilde's novel indicates, many of the fabrics that Dorian Gray sought to add to his collection had apparently become virtually extinct, causing Dorian to go to great lengths to acquire the best examples from India, Java, China, Hungary, Sicily, Georgia, and Japan: "And so, for a whole year, he sought to accumulate the most exquisite specimens that he could find of textile and embroidered work, getting the dainty Delhi muslins, finely wrought, with gold-thread palmates, and stitched over with iridescent beetle's wings; the Dacca gauzes, that from their transparency are known in the East as 'woven air,' and 'running water,' and 'evening dew.' "[23] While Dorian Gray's full list of acquisitions reads like one of the exhibition catalogues from which Wilde plundered his materials, the rare, handmade fabrics he mentions nevertheless met their fate within a wider context of trade and production that would have been known to Wilde.[24] "Woven air," "running water," and "evening dew," for example, were the names by which Dacca muslins were commonly advertised by import companies such as the Regent Street firm of Farmer and Rogers, from which customers such as Wilde's sometime friend the artist James McNeill Whistler could acquire them. Whistler sought to convey the beauty of such fabrics in his 1874 painting *Harmony in Grey and Green*. In arranging this portrait with the young girl's mother, Whistler conveyed instructions (through his own mother) that the usual muslin used for ladies' evening dresses would be all right, but it would "be better to get fine Indian muslin—which is beautiful in colour. . . . Perhaps Farmer and Roger[s] may have it[;] they often keep it."[25]

But if London firms commonly advertised such materials, why would it take Dorian Gray a whole year to acquire the most exquisite samples? Some hints can be found in nineteenth-century accounts of the Indian textile industry. An 1851 textile manual suggests that the "very fine muslins of Dacca" had been "made to order" for "persons of rank and wealth in India" but that the demand had fallen sharply since "the time of the Mogul court."[26] An 1858 report emphatically declares that the "manufacture" of these delicate gauzes had become "totally lost," likewise noting that the demand for the fabric had "declined with the decay of the court."[27] Given that the British had only just crushed the Mughal court in the aftermath of the 1857 Sepoy Rebellion, to call the court merely decayed makes for a remarkable instance

Cotton textile, embroidered muslin, Dhaka, 1855. Width: 84 cm. South and South East Asia Collection, 0214(IS). Photo: Richard Davis. © Victoria and Albert Museum, London.

of historical understatement. An 1877 report in the *Morning Post* notes that the Prince of Wales received fine muslins as a gift on the occasion of his visit to India. However, the article reports that textile production in Bengal had become so limited by competition with European-manufactured cloth that a patriotic association had sprung up to promote the wearing of Indian-made cloth, anticipating a link between native artisanship and cultural nationalism later employed by Gandhi.[28] One 1884 article in the *Graphic* opines that the only good art to be found in India had been done in antiquity and that modern Indians were so incapable of producing anything fine that the gutting of native industries by European manufacturers was little to be regretted, with the sole exceptions of their pearl jewelry and the "celebrated Dacca Muslins."[29]

A commentary on the 1886 Colonial and Indian Exhibition further sums up the then-commonplace notion that the making of Dacca muslins was a lost art. While the "dew of the evening," "running water,"

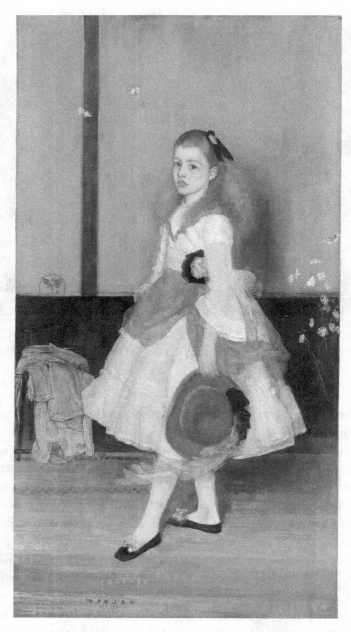

James Abbott McNeill Whistler (1834–1903), *Harmony in
Grey and Green: Miss Cicely Alexander*, 1872–1874. Oil
paint on canvas. Support: 1902×978 mm, frame: 2215×
1300×100 mm. Tate Collection (N04622). Bequeathed by
W. C. Alexander, 1932. Digital Image © Tate, London, 2017.

and "woven air" had once been "brought to England for the wear of wealthy ladies, at a fabulous price," now, alas, they are manufactured "at a fourth of their original price, and consequently a quarter of their delicacy and beauty."[30] It appears, then, that the decline in quality and availability of fine Dacca muslin was no secret of Dorian Gray's but an often-told story known to readers of the popular press, the Prince of Wales, elegant ladies, and exhibition goers. Those fabrics still being advertised under the names "woven air," "running water," and "evening dew" might have been antique remnants acquired at some expense, coarser varieties then made in India, or imitations made in Britain, and not of the quality Dorian Gray or Whistler would have demanded.

The fabric's rarity, however, had less to do with the decline of the Mughal court or an innate degeneration of Indian artisanship than it did with Britain's destructive trade policies. In the sixteenth century, the legendary cotton industry of Bengal had drawn traders from all over the world, including the Portuguese, Dutch, French, and English, and Dacca was a thriving city. However, after "the British East India Company wrested control of Bengal from its Muslim rulers in 1757, the line between trade and outright plunder faded." An "elaborate network of restrictions and prohibitive duties" shut the weavers out of the British market and reduced independent artisans to a kind of wage slavery. As one English merchant commented, the weavers were subjected to "fines, imprisonment, floggings, [and forced] bonds." By 1835, the governor general of the East India Company reported that the "misery" produced by British policy "hardly finds parallel in the history of commerce. The bones of the cotton-weavers are bleaching the plains of India."[31]

The decimation of the Indian textile industry fueled a resentment of British rule that lasted for generations: "According to popular legend, the British cut off the thumbs of the weavers in order to destroy their craft."[32] A 2008 article in the *Calcutta Telegraph* attributes the 1857 uprising to the anger fomented by such stories of British atrocities: "The British had chopped off their forefathers' hands in Bengal a generation ago, so the weavers of Mahua Dabar in Awadh cut off a few British heads during the turmoil of 1857."[33] While the facts behind such legends are uncertain, the poverty and ruin among the Bengali weavers

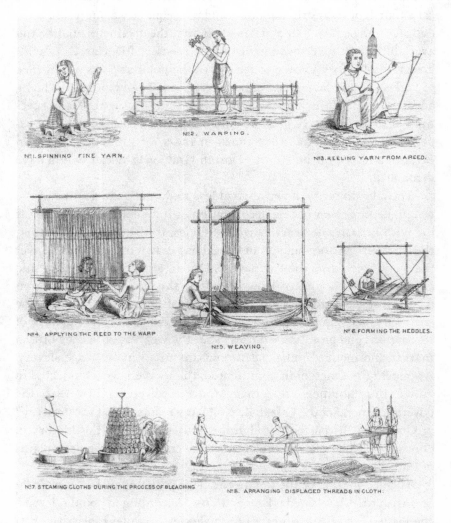

Nº1 SPINNING FINE YARN.

Nº2. WARPING.

Nº3.REELING YARN FROM A REED.

Nº4. APPLYING THE REED TO THE WARP.

Nº5. WEAVING.

Nº 6. FORMING THE HEDDLES.

Nº7 STEAMING CLOTHS DURING THE PROCESS OF BLEACHING.

Nº8. ARRANGING DISPLACED THREADS IN CLOTH.

PROCESSES IN THE MANUFACTURE OF DACCA MUSLINS.

"Processes in the Manufacture of Dacca Muslins," from J. Forbes Watson,
The Textile Manufactures and the Costumes of the People of India
(London: George Edward Eyre and William Spottiswoode, 1866).
Photoduplication: Harvard University Library.

was widely reported. By the 1890s, the gauzes that Wilde refers to were no mere baubles on display at the South Kensington Museum. They had already become symbols of the industrial decimation induced by British trade policy. In the popular imagination, such fine Indian arts had been romanticized, like the legendary fabrics of ancient Rome or Egypt in Wilde's novel, as emblems of a once refined civilization now fallen into decline, rendering the decay of decorative art generally as a popular figure for the longer temporality of civilizational decadence. In answer to the question "where are the fabrics of yesteryear?" one must answer, they were destroyed by mechanical industrialization within the colonial system, though the British often attributed that destruction to a decadence internal to India (weak rulers, a degenerate people, etc.). For Wilde to mention the Dacca gauzes in his novel is not just to illustrate the lengths Dorian Gray would go for aesthetic pleasure; it is to signal how one of the chief qualities the decadents prized, rarity, was a product of Britain's destructive industrial policies. Such policies were enabled, the aesthetes argued, by a lapse in the British public's taste, as demonstrated by the public's myopic preference for cheaper, coarser goods. This was a lapse that Wilde, among others in the Aesthetic movement, would seek to correct.

While *The Picture of Dorian Gray* omits the details behind the gauze's rarity, readers of the *Woman's World* would have been familiar with Wilde's arguments, both from articles he wrote himself and from those he edited for the magazine.[34] In his review of *Embroidery and Lace*, Wilde encourages his readers to take up the example of Eastern design as a model for what might be accomplished artistically not by industrial machines but by hand. In seconding Lefébure's opinion that the extinction of handmade goods would be "an obvious loss to art," for the machine "cannot do what the hand does," Wilde implicitly warns that the industrialization of Britain was destroying at home what British colonial policy had already destroyed abroad: the artistic quality of handmade goods.[35]

Multiple articles in the *Woman's World* depict fine weaving, needlework, and lace making as dying arts eclipsed by newer industrial methods, resulting in the poverty of the best artisans, many of whom were Irish women. One article notes that the art of needlework survives in Ireland but questions whether it is possible "to live a decent

human life, properly fed, housed, and clothed" on the wages provided.[36] Another article on poplin weavers in Dublin depicts the weavers inhabiting "desolate rooms" with "rows of dusty, unused looms," suggesting that the problem lies in the public's taste for cheap goods: "theirs is the fault if an industry so useful, so interesting in itself, its origin, and its location, is allowed still further to decay."[37] Another article on hand weaving in western Donegal reports that there is "excellent cloth spun on the hillsides by the women, and woven by the parish weavers in hand-looms," but the fabric can no longer be purchased "at reasonable prices."[38] An article on fine lace making in France takes the elegiac tone of these articles to its most Paterian extreme, calling the lace makers "survivals of an industrial—rather, an artistic—phase passing away." As the author writes, "Sad as is the decay of beautiful industries from an economic point of view, the gradual perversion of taste thereby indicated is a fact more melancholy still. . . . The decadence of hand-made lace at Le Puy had a most serious effect on the material well-being not only of the town but of the neighbouring villages, indeed of the entire department. . . . What a degeneration!"[39] When Wilde wonders whether the West has made wise use of techniques employed in the East, he does so in the context of a decline in artisanship in both Europe and Asia as a result of the mechanization of the textile industry, colonial restrictions on trade, and changing markets at home and abroad, with some hope that a diversification of technique might help revive interest in a dying industry of handmade goods. For Wilde, the forward advance of industrialization accompanied the leading edge of decadence in the decorative arts.

However unrealistic Wilde's hopes for a revival of artisanship might have seemed, the Aesthetic movement's arguments eventually found favor with some in the British government, altering policy toward the Bengali weavers and motivating an attempt to save the rural Indian handloom industry by popularizing more efficient methods of weaving. The viceroy himself, Lord Curzon, noted the forceful appeal of the "artistic point of view," suggesting that the "market is being lost by short-sighted parsimony, and by the indulgence in vulgar and semi-Europeanised designs."[40] The viceroy's comments make the Aesthetic movement look uncharacteristically like an effective political program. Though a proposed scheme to reform the industry did not work out, it

shows how dire things had become that ideas promoted by Wilde might be tried in order to save it. Aestheticism, which found its nemesis in social reformism, reveals itself as an alternative set of reformist principles by arguing that what is good for art is good for the people.

Though the articles in the *Woman's World* focus on textile production in Europe, they amplify concerns that applied to other parts of the colonial world. Such concerns can be read in the dreamlike procedures of Wilde's short story "The Young King." "The Young King," originally published in 1888 and revised in 1891, is a fable about an illegitimate boy prince who becomes heir to the throne of a fictitious kingdom. As he is groomed for his coronation, he falls in love with finely made exotic objects, and like Dorian Gray, he sends his agents to great lengths to acquire them, "some to Persia for silken carpets and painted pottery, and others to India to buy gauze and stained ivory." For his coronation, he orders a "robe of tissued gold," a "ruby-studded crown," and a pearl-encrusted scepter. On the eve of his coronation, however, he is plagued by three dreams of the misery that results from his newly acquired tastes. In one, he dreams of "standing in a long, low attic, amidst the whir and clatter of many looms," which is inhabited by gaunt-looking weavers with faces "pinched with famine." The weavers lament that their children whither while the rich "make slaves of the poor." When the young king asks what it is they toil to make, they reply, to his horror, that it is the golden robe for his coronation. Distressed by his dreams, the young king refuses to wear robes woven "on the loom of Sorrow." He is glorified instead by rays of divine sunlight, which transfigure his modest country clothing into coronation robes and render him Christ-like in the eyes of all who behold him.[41]

"The Young King" offers "a powerful critique of all forms of injustice," showing "how essential economic exploitation is to the maintenance of privilege." The "misery of the gaunt weavers" in the young king's dream "can be read as an indictment of the inhumane conditions that underpinned the lucrative textile industry of Wilde's day," while other elements of the story suggest how "Wilde drew on his Irish background to criticize the values of the British metropolis."[42] In doing so, however, Wilde draws an implicit parallel between the difficulties faced by textile workers in Europe and the colonized world. Indeed, Wilde's tale contains a mish-mosh of Orientalist tropes, with a litany

of miseries including wars, famines, and plagues in Afghanistan, India, and Egypt that may as well have been ripped from the headlines. Wilde's image of famished weavers might have been informed as much by reports of hardship among Bengali weavers as it was by the reports of the hardships of textile workers in England, France, and Ireland that appeared under his editorial guidance in the *Woman's World*.

Despite Wilde's interest in the material conditions under which beautiful objects are produced, critics such as Douglas Mao and Regenia Gagnier have been more inclined to characterize the Aesthetic and Decadent movements as reflecting and exaggerating consumer practices under industrial-era market capitalism.[43] While it is true, as Mao observes, that Wilde refuses the idea that a life should be judged by the "vulgar test of production," arguing that the "mission of the aesthetic movement is to lure people to contemplate, not to lead them to create," the question of *how* aesthetically pleasing objects are produced nevertheless holds a critical place in Wilde's discussion of the ends and means of art.[44] In "The Soul of Man under Socialism," for example, Wilde advocates for the notion that the state should produce useful objects so the individual can be free to create beautiful things.[45] Though Wilde's positions on such matters were often contradictory, in his distaste for poorly made goods, Wilde roundly rejected the logic of consumer capitalism, lamenting, "As things are now, the worker diminished to a machine is the slave of the employer, and the employer bloated into a millionaire is the slave of the public, and the public is the slave of its pet god, cheapness."[46] What matters, then, is not the quantity of production but the quality. Moreover, Wilde agrees with the Arts and Crafts movement that "before we can have really good bookbinding," for example, "we must have a social revolution" that would pry the means of production out of the hands of the capitalist and put it back in the hands of the individual artisan.[47]

Wilde's essays argue that between the production of high art and the production of the merely useful, there lies a vast middle ground, that of the decorative arts, and it is in this area that Wilde's most practical attention to the means of producing the beautiful is focused. Wilde's critical writings distinguish between "those purely decorative arts that glorify their own material and the more imaginative arts in which the material is, as it were, annihilated, and absorbed into the creation

of a new form."[48] It is in the decorative arts, then, that material remains unconsumed by form. Rather, form in the decorative arts is embedded more intimately in its materials and vice versa.

Wilde argues that because the decorative arts are more abstract and more traditional than the imaginative arts, they are less expressive of the individual and more expressive of the age. In rejecting the limitations of the "absolute modernity of form which have proved the ruin of so many of the Impressionists," Wilde turns toward decoration and its concern with its own materials, not mimesis, as the basis of an art that is paradoxically less personal but more fundamentally affecting to its viewer: "By its deliberate rejection of Nature as the ideal of beauty, as well as of the imitative method of the ordinary painter, decorative art not merely prepares the soul for the reception of true imaginative work, but develops in it that sense of form which is the basis of creative no less than of critical achievement."[49] Wilde argues that it would be a mistake to label the decorative arts as somehow less important than the imaginative arts, as without proper training by the formal lines and patterns of the decorative, the more imaginative arts would not be possible.[50] The contemplation of decorative objects becomes a necessary step in the development of an artistic temperament and therefore serves as a prerequisite for imaginative creation: "Certainly, for the cultivation of temperament, we must turn to the decorative arts: to the arts that touch us, not to the arts that teach us," for "in creation, temperament is everything."[51] Wilde's argument amounts to more than a defense of decorative art. It suggests that the nonrepresentational nature of abstract, decorative art offers a better means to touch the very fabric of a culture than does any modern experiment in mimetic representation.

Wilde called *The Picture of Dorian Gray* "an essay on decorative art" that "reacts against the crude brutality of realism."[52] In the novel, Dorian's influence on the artist Basil Hallward, at its best, is decorative: "I find him in the curves of certain lines, in the loveliness and subtleties of certain colors." The art that Hallward strives for is not individually expressive. Rather, it has the qualities of abstract decor, not portraiture: "An artist should create beautiful things, but should put nothing of his own life into them. We live in an age when men treat art as if it were meant to be a form of autobiography. We have lost

the abstract sense of beauty."[53] In other words, the imaginative arts have lost contact with the sustaining beauty provided by decorative abstraction. Basil's failure in his portrait of Dorian Gray is that he has put too much of his own personality into the work, and through some mystical relay, the portrait has become a moral biography of the sitter. One central problem of the portrait, then, is that it has failed to live up to the abstract ideal of decoration.

From the very beginning, Wilde's novel is obsessed with decor, from the "divan of Persian saddlebags" on which Lord Henry lounges to the silk curtains that produce a "momentary Japanese effect."[54] These passages model the contemplation of decorative art as if to prepare the reader for the text's more imaginative elements. Wilde's attention to decorative art helps us understand what he means by the notion of form, which, he declares, "is everything."[55] The idea that excessive attention to form marks an artist's alienation from the material conditions of production, an idea promoted by later critics of art for art's sake, such as Walter Benjamin, ignores Wilde's interest in the decorative arts as the primary location of formal beauty.[56] Wilde's formalism is the result of a historical conception of materiality and of the fragility and susceptibility of material things to the passage of time. Wilde's defense of the decorative arts further entails a politics that is radically socialist, anticapitalist, and self-consciously utopian. While Wilde might see the creation of imaginative art as the higher-order practice, Wilde's aestheticism is nevertheless grounded in theory (if not always in practice) not in the ends of capitalist consumption but in the materiality of the thing itself, created, preferably, through the means of handicraft, not those of mass manufacture or the mass market.[57]

Wilde's antirealism, moreover, can be seen as part of an open-ended engagement with the aesthetic ideals of Eastern decorative art, at least as far as he understood them: "The whole history of these arts in Europe is the record of the struggle between Orientalism, with its frank rejection of imitation, its love of artistic convention, its dislike to the actual representation of any object in Nature, and our own imitative spirit." Where Europe has had contact with the Muslim world in particular, "as in Byzantium, Sicily, and Spain, by actual contact, or in the rest of Europe by the influence of the Crusades, [Europeans have] had beautiful and imaginative work in which the visible things of life are

transmuted into artistic conventions." That Islam's admonitions against figurative representation hover in the background of Wilde's resistance to Western realism is evident in "The Decay of Lying." As Wilde writes: "A cultured Mahomedan once remarked to us, 'You Christians are so occupied in misinterpreting the fourth commandment that you have never thought of making an artistic application of the second [prohibiting the making of graven images]."[58] In this sense, Wilde's aestheticism can be read not (or not just) as the rarified product of a detached, metropolitan cultural elite with a fashionable attachment to the Orient but as a belated, if problematic, recognition of the push and pull of Eastern and Islamic influences in European art that stretches back to the Middle Ages, with a clear preference for Eastern, aniconic decorative abstraction over the "faithful and laborious realism" of the West, which holds "no beauty whatsoever."[59]

While Ali would probably not have been familiar with the *Woman's World* or all of Wilde's critical writings, he certainly understood the larger colonial context from which *The Picture of Dorian Gray* emerged. The published version of "The Dacca Gauzes" begins with a truncated epigraph from the novel cut into a lineated tercet: "for a whole year he sought/to accumulate the most exquisite/Dacca gauzes."[60] While one might read the epigraph as merely ornamental, early typescripts of the poem show that Ali's reading of Wilde from a subcontinental perspective runs deeper than it may first appear. Over the course of several typescripts, Ali weighs just how much emphasis to give Dorian Gray in the poem itself. One version of the opening line reads, "Dorian Gray wore those gauzes from Dacca/known as woven air, running water, evening/dew," while a later typescript expands the line to read, "Not only Dorian Gray but many aristocrats of Europe/wore those transparent Dacca gauzes."[61] The poem's eventual title, "The Dacca Gauzes," was suggested by the poet Galway Kinnell, who read an early version of the poem and recommended important changes to the order and phrasing of several lines.[62]

While the published version puts the poem's focus squarely on "those transparent Dacca gauzes" and not on Wilde's protagonist, Ali continued to play with ways of linking the poem to the contexts of

colonial-era Europe and America. In public readings, Ali would introduce the poem by mentioning that Pocahontas reportedly wore a dress of Dacca muslin when she visited the court of King James: "Isn't that nice," Ali remarked, "an interesting connection between subcontinental history and American history, apart from the Boston Tea Party, since the tea was from India, you know."[63] The anecdote is charming, but it also shows how the threads of Dacca muslin (as well as the tea trade) connect the subcontinent materially to the ex-colonial Americas, whose cotton industry competed with India's. The colonial irony is that one of America's most celebrated native "Indians" would appear at court in the aristocratic drag of East Indian finery.

While Ali is eager to make such transnational connections, he is also eager not to lose the poem's connection to Kashmir. Though Ali drops any explicit mention of Kashmir from his title, he subtly restores that context symbolically in his revision. In the early typescripts, Ali echoes Wilde's exact phrasing, describing the muslin handkerchiefs as "wrought with gold-thread palmates."[64] After removing "Kashmir" from the title, however, Ali revises these lines to read, "embroidered/with gold-thread paisleys."[65] In one Hindu origin myth, Shiva carved the Vale of Kashmir in the shape of a paisley, a myth Ali employs in the later poem "A History of Paisley," which deals directly with the conflict in Kashmir in the 1990s.[66] After altering his title to "The Dacca Gauzes," Ali embroiders an emblem of Kashmir into the body of the poem, suggesting that the tear in the fabric of the gauze can be read to represent the larger tears in the political fabric of the subcontinent, which left Kashmir as disputed territory between India and Pakistan and modern Dhaka as the capital of independent Bangladesh. The history of artisan crafts registers the larger geopolitical history by which the subcontinent was colonized, won independence, and was subsequently divided.

Ali matches the subtlety of the cloth with the subtlety of his sound effects. The speaker comments that a sari once worn by his grandmother "proved/genuine when it was pulled, all/six yards, through a ring." While descriptions of the cloth often boast of how many yards could be pulled through a ring, Ali pulls his poetic line through twelve lines of enjambment before allowing it to come to rest with an end stop

on "ring." With no strict rhyme scheme or meter, he nevertheless cre-
ates faint echoes: the troches of "Dacca Gauzes," "running water,"
"woven air," and "evening dew"; the internal rhymes of "sari" and
"dowry"; the consonance of "a dead art now, dead"; the halting spondees
of "now knows" and "six yards"; and the caesuras that pause nearly
every line. The enjambment between lines and the halting rhythms
within them speak to the tension between the continuity of cultural
forms and their interruption.[67] In announcing that the manufacture of
these fabrics is "a dead art," Ali not only mourns the loss of a beautiful
family heirloom but also protests the loss of indigenous artisanship as
a result of industrialization and colonialism.[68]

At the end of the poem, Ali writes that according to his grand-
mother, today's muslins are "so coarse" that it is only when she wakes
up in autumn "at dawn to pray" that she can "feel that same texture
again." As he writes, "One morning, she says, the air/was dew-
starched: she pulled/it absently through her ring."[69] Here, the speaker
applies a test of production quality, the pulling of fabric through a ring,
to the immaterial air. For Wilde, the distinction between decorative
art and imaginative art is that the "purely decorative arts glorify their
own material," while in the imaginative arts, the material "is annihi-
lated, and absorbed into the creation of a new form."[70] For Ali, the
annihilation of decorative material carries with it a specific cultural
historicity, one the poem subtly recalls as it absorbs these lost mate-
rials into a new imaginative form, the poem itself as it evokes the even
more ephemeral form of prayer.

Those "fabrics from Dacca" make another appearance in the poem
"After Seeing Kozintsev's *King Lear* in Delhi," which was written
around the same time as "The Dacca Gauzes." In this companion
poem, Ali links the loss of artisanal crafts more directly to the endan-
gered state of poetic forms such as the ghazal under colonial rule. Ali's
poem is inspired by Grigori Kozintsev's 1971 Russian-language film
adaptation of *King Lear*, a stark, late-modernist production with a
soundtrack by Dmitri Shostakovich and a script adapted from a trans-
lation by Boris Pasternak. The poem meditates on how the suffering
of Shakespeare's dispossessed monarch evokes that of Bahadur Shah
Zafar, the last of the Mughal emperors, who was deposed by the British

after Zafar's reluctant participation as figurehead of the 1857 Sepoy Re-
bellion. Britain's retribution for that rebellion resulted in the death of
tens of thousands of Indians and the execution of Zafar's heirs.

As Ali's poem begins, the speaker exits a cinema onto the streets
of Delhi, still haunted by imagery from Kozintsev's film:

> I step out into Chandni Chowk, a street once
> strewn with jasmine flowers
> for the Empress and the royal women
> who bought perfumes from Isfahan,
> fabrics from Dacca, essence from Kabul,
> glass bangles from Agra.

The poem goes on to note how these fine handiworks once found on
the Delhi streets have been displaced by cheap commercial goods (now
"hawkers sell combs and mirrors"), just as the processions of Mughal
aristocrats give way to the poverty of modern urban street life ("Beg-
gars now live here in tombs"), and Kozintsev's *King Lear* competes
against a "Bollywood spectacular" playing at a cinema across the
street.[71]

Zafar exercised little actual political power during his reign, but in
keeping with courtly tradition, he became a well-regarded practitioner
of the ghazal. As the ghosts of 1857 impose themselves on Ali's vision
of modern New Delhi, Ali quotes in translation one of Zafar's late
ghazals (set in quotation marks, with its conventional reference to the
writer's own penname):

> I think of Zafar, poet and Emperor,
> being led through this street
> by British soldiers, his feet in chains,
> to watch his sons hanged.
>
> In exile he wrote:
> "Unfortunate Zafar
> spent half his life in hope,
> the other half waiting.
> He begs for two yards of Delhi for burial."[72]

The fact that Zafar must beg for a burial plot is bad enough, but the
moment is made more poignant because such high-quality handiworks

as those "fabrics from Dacca" would have been difficult to find in the marketplaces of a decimated Delhi, which in 1858 was all but emptied of its population as thousands fled British retribution. Even the strict formal qualities of Zafar's ghazal are lost in Ali's free-verse translation. When Ali quotes Zafar's ghazal, he makes a canny historical connection between the fate of indigenous handicrafts under colonial rule and the precarity of the ghazal after the collapse of the Mughal Empire.

For readers attuned to the link Ali makes between Dacca muslins and *The Picture of Dorian Gray*, Ali also supplies in this poem a material and affective prehistory for Dorian Gray's collecting practices, vividly rendering how the conditions of scarcity prized by the decadents are induced by such historical ruptures. With poems such as this in mind, one can begin to read literary "decadence," long thought of as the product of European metropolises such as Paris and London, as the co-product of inter-imperial historical processes within a geographic framework that extends far beyond fin-de-siècle Europe. In speaking from a position after the decline of the British Empire, Ali, as a poet of the subcontinent, mourns, and thereby salvages, the cultural products of a Mughal court forced into decline by British rule. The embrace of decadence (Wilde's decadence and Mughal decadence), then, becomes an anticolonial gesture. To understand the critical significance of Ali's mission to revive the Anglophone ghazal for the reason of "form for form's sake," one must understand how the ghazal came to be disavowed as decadent by pro- and anti-Western critics alike in the century after the Sepoy Rebellion. That is, the idea of "form for form's sake," as Ali uses it, has a history that cannot be explained by reference to the likes of Victorian decadents such as Wilde alone.

The aftermath of the Sepoy Rebellion had a devastating effect on the literary culture of India. As Frances W. Pritchett recounts, Britain's response to the rebellion "destroyed the old world of the Indo-Muslim elite" and set off a vigorous attempt at literary reform to be carried out under the "light from English Lanterns."[73] Arguing that Urdu-language poetry had fallen into a state of decadence under the Mughal court, two young reformers, Muhammad Husain, known by the penname "Azad," and Altaf Husain, known as "Hali," argued that Urdu poetry had to

become less artificial and more natural, moral, didactic, and useful. Hali argued that the Urdu language itself had become "subject to the disease of decay (zaval)," prone, like its poetry, to "artificialness of language" and "weakness" of "thought."[74] Deriving their ideas from Thomas Babington Macaulay, Matthew Arnold, William Wordsworth, Samuel Taylor Coleridge, and Joseph Addison, Azad and Hali insisted that Urdu poetry had to expand its narrow range of traditional themes or *mazmuns*, break free of its overly restrictive meters, abandon its licentious motifs and exaggerated poses, and turn toward nature, truth, and the direct expression of real emotion. The reformers looked to English literature for *"islah"* or "correction," a term used to describe the mentorship offered by elder poets to their young admirers. And though "both Azad and Hali were deeply ambivalent about the loss of the old poetry," they nevertheless systematically put their program into practice.[75]

While Azad and Hali were spurred to action by the aftermath of 1857, both developed literary theories attributing the decay of poetry not to immediate historical events but to the natural development of civilization away from its primitive roots. Azad grouped Urdu poetry into five stages, which marked the gradual decline of verse from an initial stage of natural simplicity to later stages of increasing artificiality, elaboration, frivolity, and exhaustion.[76] Hali likewise argued that cycles of growth and decline tracked the progress of civilization, echoing Macaulay's idea that "as civilisation advances, poetry almost necessarily declines."[77] Such decay seemed evident, as Pritchett writes, in the "development of certain basic elements of ghazal imagery from naturalness to unnaturalness," such that an image of "the beloved's mouth and waist, always small, become over time so minute that they vanish entirely."[78] While Azad's and Hali's ideas were not particularly original, the effects of their arguments were immediate and lasting. Late into the twentieth century, poets and critics took "naturalness" as the bar by which all poetry came to be judged. As Pritchett comments, "If Wordsworthian poetry was the touchstone of naturalness, however, the whole Indo-Muslim poetic tradition was bound to appear 'unnatural' in comparison—not just literarily decadent, artificial, and false, but morally suspect as well."[79]

Ruth Vanita and Saleem Kidwai further observe that the reformist movement in Urdu literature coincided with new attitudes toward homosexuality ushered in by the colonial legal system: "The crushing of the 1857 rebellion, followed by the official incorporation of India into the British Empire, . . . signaled the violent end of medieval India. For same-sex love, that end was signaled by the 1861 law that criminalized homosexuality."[80] While the British saw expressions of same-sex desire as decadent and degenerate, many Indians began to internalize such homophobia and to "mirror" British attitudes toward "female and child sexuality."[81] In 1893, Hali argued "that Urdu poetry on the theme of 'boy-love' was inconsequential and should be purged from the canon."[82] Moreover, the 1895 trial of Oscar Wilde had a dampening effect in India, as it had in Britain.[83] The result was the virtual disappearance of romantic love between men from poetry, as "exemplified in the twentieth-century heterosexualization of the Urdu ghazal."[84] The novelty in India of Azad's and Hali's ideas, combined with the staggering loss of the cultural knowledge that sustained poetry prior to 1857 and the disavowal of the full range of desire expressed in Urdu literature, created an environment in which, as Pritchett comments, "the direct heirs to the classical oral tradition were unable to claim their patrimony. Instead, they had to sell their birthright for a mess of all too realistic Victorian pottage."[85]

While a strict adherence to "nature" may have fallen out of favor in European modernism, in Urdu criticism, "the demand for natural, realist poetry was reinforced from the 1930s onward by the proletarian sympathies and nationalist concerns of the Progressive movement—and it persists in one form or another right down to the present."[86] It was to break free from this stifling cultural paradigm that the Pakistani poet Faiz Ahmed Faiz developed his own postcolonial theory of cultural and poetic decadence, one that provides an immediate context for Ali's attempt to recover aspects of the ghazal tradition that were attacked as decadent over the course of the previous century.

In the essay "Thoughts on the Future of *Ghazal*," reprinted in 1985 by Ali's recommendation in the *Sonora Review* under the title "Future of Ghazal Poetry," Faiz asks, "Why is it that whenever we are faced with a situation of social or political crisis or malaise, of all forms of

writing the *ghazal* is generally singled out as the prime target of criticism," and "why is it that after every onslaught the particular form re-emerges rejuvenated and refurbished?"[87] Condemned on one side by "progressives" who "equated the *ghazal* with feudal decadence, romantic dalliance, and formalistic conceits" and on the other by "subjectivists" who saw the form as "a relic of outdated, hackneyed, oriental tradition, a collection of tiresome clichés," the ghazal nevertheless "not only managed to survive, but even lured into its parlour some of the best talent in both camps."[88] Despite the strictures of the form, the ghazal endures, Faiz argues, because of its "adaptability to changing environments." The ghazal "is a chameleon, *mashuq-i-hazar sheva* in the Persian phrase, 'a beauty with a thousand wiles.'" Yet the ghazal's secret is "the secret of all lasting poetry, namely its continual adjustability to the demands for aesthetic articulation of contemporary experience."[89]

In various interviews and essays, Faiz leaves no doubt as to his opinion of Azad's and Hali's reforms, describing their imitation of Western poetry as "rubbish." "It does not have native blood and force, it is only an imitation and imitation is not creative," he insists.[90] Faiz's main objection to Azad and Hali's program has less to do with their insistence on a return to nature than with their rejection of a Muslim literary tradition in favor of a movement "actively directed and sponsored by the British elite."[91] Unlike Azad and Hali, Faiz saw no contradiction between classical *mazmuns* and the demands of the present: "One advantage in the form of *ghazal* is that you can write the old themes in old vocabulary and similes and yet be describing a contemporary reality."[92] Though Faiz defends the old conventions, he nevertheless shares the conviction that poetry should strive toward some form of mimesis, if not a direct imitation of nature, then a reflection of social conditions: "whatever is being written today is basically realistic and progressive and instead of escapism, it strives to find solutions to the problems in a rational and realistic way."[93]

The Indian Progressive Writers's Association had declared in its 1935 manifesto that its mission was "to rescue literature and other arts from the priestly, academic and decadent classes in whose hands they have degenerated so long" and "to bring the arts into the closest touch with the people."[94] Faiz shared that mission, arguing that poets

must meet the social conditions of their day head-on: "Poetry must be the most vivid expression of the most profound feelings of its age."[95] In his role as a cultural adviser to the Pakistani government, Faiz applied such ideas to the project of reconstructing a national artistic tradition. The problem of imperialism, Faiz argues, is that it perpetuates "whatever was bad, reactionary and backward looking," leaving "newly liberated countries" only the "perverted and emasculated remnants" of their own cultures. The postcolonial artist must salvage elements of that culture that are "basic to national identity," discard backward-looking elements, hold onto those elements of Western cultures that "can help to elevate national culture," and "repudiate those elements which are deliberately aimed at promoting degeneracy, decadence, and social reaction."[96] For Faiz, like his contemporaries Achebe and Walcott, the postcolonial nation begins in a state of artistic decadence, a decadence not simply imported from the West but composed of those backward-looking elements of indigenous traditions exaggerated by the colonizers. The repudiation of both homegrown and imported varieties of decadence becomes a fundamental step in the construction of a new national paradigm for the arts.

Faiz attributed the modern alienation of the artist from the communities in which they work in part to the "disintegration of the feudal system," which had assigned artists a clear social function. Because industrialization had forced the craftsman "out of existence through neglect or competition with the machine, . . . the artist is no longer in harmony with any section of the community and his isolation has driven him into subjective, non-communicative, abstract, and negative forms of expression."[97] However, Faiz argues that it would not do to return to the "cloistered," "closed shop" method of apprenticeship practiced in Mughal court culture, which had severely restricted the "appeal and accessibility" of the "classical arts."[98] Instead, what the nation needed was a more robust program of state sponsorship for the arts. State sponsorship, Faiz argues, would return the means of production to the people and correct for the collapse of the feudal patronage system.

To repudiate decadence while promoting the arts in an environment saturated with nationalist sentiment and religious orthodoxy, however, was no easy matter. Faiz had to contend with fierce criticism of all high culture as frivolous, immoral, elitist, and antireligious. To counter

these concerns, Faiz explains the opposition to the arts in dialectical terms, arguing that national attitudes toward the arts pass through distinct movements and countermovements. In the first phase, that of colonization, "native" arts were held up to "contempt and ridicule," while Western models were offered for imitation. As a consequence, the feeling among the general populace for traditional arts and handiworks was destroyed, leaving only the elite to pursue their artistic interests. "During the declining years of the Mughal Empire," Faiz argues, arts such as music and dancing were "reduced to become handmaids of dissolute courts and instruments of their decadent pleasure." Therefore, "after the downfall of the Mughals, the moral indignation evoked by these decadent practices . . . were detached from the social conditions which gave them birth and transferred, in the popular mind, to the arts themselves."[99]

Faiz goes on to argue that different factions would exploit such anti-art attitudes for political ends, first by equating all "music and dance" with their "lewd vulgarizations" and then concluding that "all art is immoral, hence anti-religious, hence ideologically unacceptable." Such attitudes, however, "opened the gates for a resolute cultural invasion by Western commercial and political agencies," robbing young Pakistanis of traditional means of self-expression and filling the void with "corrupt and perverted versions of Western culture focused on sex, violence and profligacy." The irony, Faiz observes, is that in condemning all arts equally as the legacy of a decadent feudal order, conservative moralists open the postcolonial nation-state to a second wave of neocolonial decadence: those "who are most vociferous against this deliberate perversion of our national, cultural, ethical and ideological values, are the same as have at least partially, and perhaps unintentionally, made this subversion possible."[100]

Faiz further details how accusations of decadence recur continually as a residual element of the clash between Western imperialism and homegrown national traditions. As Faiz sees it, the "breakdown of Victorian and moral social constraints" after World War I "produced a general air of emotional abandonment, intellectual freedom and creative gaiety," and an era of "romantic lyricism and art for art's sake." The global crises of depression and fascism in the 1930s, however, led to a division in the literary world between "'progressive realism' on

the one hand and 'subjective escapism' cloaked as aesthetics [*sic*] formalism on the other." This opposition spurred a "great debate" among Faiz's generation of writers between "functionalists" who believed the writer's job was to interpret "social realities" and "aesthete[s]" who "held that literature was no more than an artistic compendium of linguistic devices and the writer was no more than an engineer of words."[101] By the 1960s, nothing less than a "Cold War" had broken out between "theories of structuralism, formalism, [and] expressionism" and a "literature of commitment" grounded in "social and critical realism."[102] Faiz criticizes in particular those African and Asian artists and intellectuals who "set about solving riddles of forms, seeking satisfaction from petty exercises and words and sounds and lines and planes," justifying their work by the "half baked dogma of whatever decadence crazed Western theorists used to propagate, and refusing [to] come to terms" with either their inner truth or outer reality.[103] Such comments suggest how arguments over decadence and political commitment in the arts served as a proxy war in the larger ideological battle between the capitalist West and socialism, leaving Third World artists to negotiate their own path. Though Faiz represents himself as part of the "antithesis" to Western decadence, the logical outcome of his dialectic would be a synthesis of the aesthetically "intrinsic" and socially "extrinsic" elements of art, not the total dismissal of aestheticism but a way forward between the aesthetes and the functionalists.[104]

This ubiquitous debate among early postcolonial writers between aestheticism and social realism (broadly construed), a debate that Fanon, Senghor, Achebe, Walcott, and Soyinka all participated in, manifests itself in Faiz's writing in the seeming contradiction between his antiaestheticist rhetoric and his poetic sympathy for formalism, as demonstrated in his discussion of attitudes toward the ghazal. In praising another Progressive poet, Muhammad Iqbal, Faiz comments that Iqbal went out of his way to avoid the "decadent songsters with which our community abounds."[105] Rather, Iqbal's poetic seriousness "demolished many decadent notions regarding the function of poetry as trivial, entertainment like the notion of art for art's sake."[106] Despite his defensive rhetoric, however, Faiz declares his appreciation for the poetry of Ghalib, a product of Delhi's court culture: "The decadent literature of the later Mughal period was a product of a decadent feudal

order and not its progenitor." Faiz insists that "none of the 'modern-ists' of this era [by which he means reformers such as Azad and Hali] were able to mirror the tragedy and heartbreak of their age in their British-sponsored poetic experiments with the same suggestive truth-fulness as Ghalib's *ghazal*." Nevertheless, Faiz observes that even "Ghalib himself, felt that *ghazal* was the last flicker of a dying candle." Happily, however, the *"ghazal* not only managed to survive" efforts at reform "(clandestinely for some time through the gramophone disc and the dancing girl), but even regained its ascendancy" during "the gay twenties," an "age of romantic aesthetes."[107]

To Faiz, Ghalib offers proof that the last flower of a decadent and dying culture can be the most beautiful.[108] Moreover, a decadent art could prove *true,* even socially realistic, if it accurately reflects the cul-ture from which it emerges. Faiz goes as far as to credit the "romantic aesthetes" of the "gay twenties" with keeping the ghazal form alive under clandestine conditions. In this version of the story, the ghazal loses its character as a maligned product of a sick culture and becomes something of an underground hero, given safe haven by a new genera-tion of marginalized, bohemian poets before surfacing, once again, as an art form of the people ready to serve the interests of a newly syn-thesized national culture. Poetic forms such as the ghazal may not exist for their own sake, but they nevertheless seem to survive their exile from the public sphere in the valley of their own making, as W. H. Auden might say, among the aesthetes who justify their dedication to the form by some version of "art for art's sake." A decadent metropol-itan culture, long a haven for marginalized identities and sexual mi-norities, serves as a conservator of endangered verse forms.

For Faiz, the ghazal is a chameleon that adapts both to new social realities and to new media such as music, film, and television: "it tran-scends class barriers and, thus, comes to symbolise the 'poetic person-ality' of an age and is held accountable for all the failings of this age."[109] By the late twentieth century, then, the ghazal comes to have a dual legacy as a symbol of a lingering feudal order *and* as a pop-culture icon condemned by conservative moralists. As both chameleon and scape-goat, the form becomes a screen onto which its audience projects its own class anxieties, yet the form flaunts its chameleon-like aspect, the secret of its intrinsic construction. The very rigidity of the ghazal form

becomes the source of its adaptability and the site of countervailing political imperatives; it remains transparent to its time. By the time Ali picks up the torch from Faiz and comes to revive the ghazal in English for the "conservative" yet "radical" reason of "form for form's sake," the form has been imagined as something diaphanous and ever changing, a screen both masking and revealing the social sanctions to which it has become subject. That is, the ghazal has become something of a veil.

In the afterword to *Ravishing DisUnities*, Ali's anthology of "Real Ghazals in English," Sara Suleri Goodyear describes Ali as a poet who was "obsessed with form, which surely both licenses and explains his need to convert the ghazal into a medium available and most creatively useful to the poets of America in the present age."[110] The ghazal, in any language, is a difficult form to master. As Ali describes it, "some rules of the ghazal are clear and classically stringent. The opening couplet (called *matla*) sets up a scheme (of rhyme—called *qafia*; and refrain—called *radif*) by having it occur in both lines—the rhyme IMMEDIATELY preceding the refrain—and then this scheme occurs only in the second line of each succeeding couplet. That is, once a poet establishes the scheme—with total freedom, I might add—she or he becomes its slave. What results in the rest of the poem is the alluring tension of a slave trying to master the master."[111] Though Ali avows that he is no neoformalist ("let me assure the free-versifiers that nothing neo-formalist lurks in my true-to-form assertions"), he readily admits that he loves forms.[112] In announcing his intentions to return the ghazal to its formal roots in language that echoes the seemingly detached, nineteenth-century formulation of "art for art's sake," Ali shakes up his audience's assumptions regarding the politics of formalism. That is, he recovers formalism's radical potential by reconstituting in English a form discredited in the East and distorted in the West, hybridizing Western aestheticism with Eastern poetics in the process.[113]

While Ali asserts that the ghazal's fragmented structure of thematically autonomous couplets would "bewilder, even irritate, those who swear by neo-Aristotelianism and New Criticism," he nevertheless disappoints the antiformalist crowd, arguing that form "has been associated . . . —and quite wrongly, really—with what holds truth back,

especially political truth."[114] Quoting Faiz, Ali suggests that "there is nothing good or bad in any poetic form but the poet makes it so."[115] Faiz's defense of poetry echoes the preface to *The Picture of Dorian Gray*, in which Wilde declares, "There is no such thing as a moral or an immoral book. Books are well written, or badly written. That is all."[116] The echo might seem unintentional given Faiz's hostility to art for art's sake, but Ali takes up the echo by tackling Wilde's aphoristic preface directly in a couplet of one of his own ghazals: " 'Even things that are true can be proved.' Even they? / Swear not by Art but, dear Oscar Wilde, by exiles."[117]

Wilde's witticism, which begins in his preface with the declaration that "no artist desires to prove anything," casts doubt on factuality, realism, and logic as the arbiters of artistic truth. In his preface, Wilde goes on to remark that "no artist has ethical sympathies" and that an "ethical sympathy in an artist is an unpardonable mannerism of style," seeming to put his aestheticist ethos sharply at odds with more "committed" varieties of art.[118] Indeed, Wilde argues elsewhere that the artist "gains his inspiration from form, and from form purely," not from individual passion, much less political or social conditions, though, as I have argued, his understanding of form was deeply embedded in such conditions.[119] Ali's couplet would appear to pose European aestheticism's commitment to pure form against the harsh realities of exile, an experience familiar to those from Ali's war-torn Kashmir or Faiz's Pakistan. Indeed, he would seem to pose Faiz himself directly against Wilde, as the ghazal in question takes its *radif,* or refrain, "by exiles," from Edward Said's essay "Reflections on Exile," which describes Faiz's self-imposed exile in Beirut. As Said writes of Faiz, to "see a poet in exile, as opposed to reading the poetry of exile—is to see exile's antimonies embodied and endured with a unique intensity."[120] Ali's allusion would appear to suggest that Wilde should swear by the experience of exiled artists such as Faiz, perhaps, and not by art alone.

However, the opposition is not as clear as it might seem. Ali, who was reportedly open about his homosexuality among friends though reluctant to discuss it in interviews, would have known that Wilde spent his last years exiled in Paris after spending two years in prison for the crime of "gross indecency."[121] On the other side of the equation, Faiz,

as a practitioner of the ghazal, inherited a poetic form that often took the attractions of young men as one of its main themes. It would seem, then, that the ethical sympathies of both these artists reach out toward each other: Wilde's toward an experience of imprisonment and exile not too unlike that suffered by Faiz, who was jailed twice by the Pakistani regime, and Faiz's toward a literary form heavily associated with the love that dare not speak its name. Like any good Wildean witticism, Ali's couplet offers less opposition than paradox. In posing Faiz against Wilde, Ali deconstructs the oppositions and caricatures to which both the European literature of decadence and the Urdu ghazal have fallen prey. In this way, the juxtaposition of Faiz and Wilde neatly outlines and deliberately crosses the main lines of debate that have persisted in criticism of the Urdu ghazal for more than a century, debates over the form's alleged excessiveness, artificiality, sexual perversion, and decadence and the possibility of its containing political content relevant in a postcolonial world.

In discussing the process of translating Faiz's Urdu poetry into English, Ali observes that one has "to learn the nuances of images that would seem too lush to an American poet—images that recur shamelessly in Urdu poetry, among them the moon, the rose, the moth, the flame."[122] Ali notes that the challenge is "to point out to exclusively English speakers the moment when what they see merely as exotic is actually challenging the 'exotic.' "[123] Speaking of Salman Rushdie's images of ruby blood and diamond tears, Ali declares, "I want more such heady stuff in our poetry because it, in fear of a certain excess, has been confined to some minimalism. Indian English should become a medium for the sublime."[124] Furthermore, Ali credits Faiz for proving that a poet could turn the inward-looking conventions of Urdu poetry back toward the world, transforming poetic conventionality into political engagement: "For example, the Belovèd—an archetype in Urdu poetry—can mean friend, woman, God. Faiz not only tapped into these meanings but extended them so that the Belovèd could figure as the revolution. The reader begins to infer, through a highly sensuous language, that waiting for the revolution can be as agonizing and intoxicating as waiting for one's lover."[125] In Faiz's ghazals, Ali argues, the seeming contradiction between such sensuous language

and revolutionary politics dissolves. Tropes that smack of exoticism provide the vehicle for the ghazal's political content while challenging both modernist minimalism and Orientalist exoticism.

When Ali describes translating Faiz's poetry into English, he unabashedly sensualizes the form, teasing out the image of the ghazal as courtesan or lover, demonstrating, as he later says in his essay "Love in Ruins," how forms can be "caressed *into* cultures."[126] Ali describes Begum Akhtar's arrangements of Faiz's ghazals in the mode of the raga, a musical form with a strict progression of notes and rhythms, in terms that are decidedly seductive: "What Begum Akhtar did was to place the ghazal gently on the raga until the raga opened itself to what whispered love, gave itself willingly, guiding the syllables to the prescribed resting places, until note by syllable, syllable by note, the two merged compellingly into yet another aesthetic ethos for the Urdu lovers of the South Asian subcontinent."[127] For Ali, the process of translating the ghazal across media offers an ethos for (Urdu) lovers.

In this coupling of forms, Begum Akhtar coaxes the male-centric tradition of ghazal writing (Ghalib, Mir, Faiz) to the condition of music: "She, in effect, allowed the ghazal to be caressed into music, translated, as it were: 'You've finally polished catastrophe, / the note you seasoned with decades / of Ghalib, Mir, Faiz,' I said in my elegy for her. For unlike so many other ghazal singers, who clothe words until they can't be seen, she stripped them to a resplendent nudity. If she clothed them at all, it was in transparent muslins, like the Dacca gauzes, 'woven air, running / water, evening dew.'"[128] But if the ghazal is to be read as phallic, penetrative, opening the raga to new pleasures (at the raga's guidance), Begum Akhtar proceeds to dress the ghazal itself in a kind of drag, clothing it in fabric often used for saris and veils. By reference to Wilde, Ali imaginatively restores to the ghazal a fuller range of sexual ambiguity.

Ali playfully casts his efforts to win Faiz's approval for a new set of translations as a kind of courtship, a seduction between the younger male poet and his *ustad*, or mentor: "I wrote to Faiz in 1980 in Beirut, where he was living in exile. . . . Besides asking for permission to translate him, I told him that I would be taking liberties with the originals. But what I really did was to bribe him with a sort of homecoming. I reminded him that he had, years before my birth, stayed in

our home in Kashmir. I created nostalgia: Begum Akhtar, too, had stayed in our house. I tempted him: I had rare tapes of Begum Akhtar singing his ghazals in private concerts. In exactly a month he wrote back."[129] Ali claims to employ several wiles here: temptation, bribery, nostalgia, a promise to take liberties. With a flirtatious wink, Ali claims to have tempted the older poet, offering to re-dress his ghazals just as Begum Akhtar had, disguising his own solicitation by using Begum Akhtar's voice as a lure.

In an unpublished portion of an interview from 1990, Ali was asked if there was a question he had never been asked about his poetry that he wished had been asked.[130] Though Ali hedges that he is not sure he wants the question "to be pursued yet," he responds, " 'How does my sexuality work its way into my poetry? And why is it there, and how's it there?['] Is my choice of the let's say pronoun 'you' . . . for people like Auden and Spender, they often used the 'you' to hid [sic] their sexuality because they couldn't say 'she,' and they used 'you.' You see what I mean? And why the choice of the pronoun, how in a very subtle ways [sic] an image of something might come into my poems which is very gay. See what I mean?"[131]

The interviewer does not pursue the question further. Indeed, she silently omits this exchange in the published text of the interview. However, as Ali volunteers the point himself, it does argue that he saw his own sexuality as integral to his poetry, even if it emerged in ways that were deliberately ambiguous. One notes, too, the poetic lineage he creates for himself with prior queer poets. Given the inherent ambiguities of gender in the Urdu ghazal, Ali's dedication to this form in English seems a likely route for just such expressions of sexuality.

In this sense, one cannot help but read Ali's ghazal "For You" as a flagrant display of such ambiguity: "Did we run out of things or just a name for you? / Above us the sun doubles its acclaim for you." This opening couplet doubles down on the ambiguity of "you" by highlighting the traditional motif of hyperbolic praise for the beloved (the sun doubles its acclaim) and by stressing the anonymity of the beloved, having run out of names for "you." The succeeding couplets make a spectacle of the literariness and conventionality of such hyperbolic praise, resorting repeatedly to the traditional motif of flame (which begins with the preceding reference to the sun) to describe a beloved

whose gender remains unspecified: "What a noise the sentences make writing themselves—/Here's every word that we used as a flame for you."[132] Here, Ali demonstrates how the pleasure in the ghazal can be found in playing with conventions so widely shared and recognized among the communities formed around ghazal poetry that they appear almost self-inscribing—the sentences are writing themselves. The traditional figure of flame becomes one more substitute name for "you" as each word carries a flame for the beloved.

The "you" in this poem varies from couplet to couplet as both the subject of romantic love and the subject of historical violence, as figured by the flames brought by U.S.-driven wars in the Middle East and by Walter Benjamin's angel of history:

> The birthplace of written language is bombed to nothing.
> How neat, dear America, is this game for you?

> The angel of history wears all expressions at once.
> What will you do? Look, his wings are aflame for you.

Another couplet, without specific historical reference, resonates with the language Ali uses elsewhere to describe the victims of the conflict that engulfed Kashmir: "Something like smoke rises from the snuffed-out distance . . . /Whose house did that fire find which once came for you?" One cryptic couplet appears (to me at least) to evoke the incident that led to Wilde's being tried for gross indecency, the moment when Lord Alfred Douglas's father, the Marquess of Queensberry, left a visitor's card addressed to Wilde accusing him of "posing as somdomite [sic]," which led Wilde, tragically, to bring a claim of libel that ended up exposing Wilde to prosecution: "On a visitor's card words are arranged in a row—/Who was I? Who am I? I've brought my claim. For you." Whether or not this couplet points to Wilde (the stop between "claim" and "For you" suggests to me a legal action), it is clear that Ali plays up all the senses in which the anonymous "you" can be read: as male, as female, as the beloved, as the nation, as the subject of history, as the subject of law.[133]

Mahwash Shoaib has argued that Ali's "passion for formal lyricism" provided a means for Ali to "closet his bodily self" and that "Ali restrains his queer desire under the disguise of heightened lyricism."[134] Shoaib's reading breaks important ground in our understanding of the

queerness of Ali's poetics. But if Ali resorts to formalism to restrain his desire, he remains unabashed about infusing the Anglophone ghazal with the dance of ambiguity well known in traditional Urdu and Persian ghazals. In taking "for you" as the *radif* for this ghazal, he makes a spectacle of the formal and conventionalized recurrence of that ambiguity, ensuring that just such ambiguity carries over from the Urdu ghazal into its English iterations.

If Ali engages with poetic formalism as a means to restrain, disguise, and closet his desire, he does so by repeatedly inviting his reader to admire his carefully constructed closet. In the ghazal "About Me," Ali refers to the sexual ambiguity of "one" beloved or self: "Elusively gay but not quite presently straight, / one is stone in his own forest stream about me."[135] In "Land," the speaker identifies with the nonreproductive, antinomian sexuality of the poet of Lesbos: " 'Is my love nothing for I've borne no children?' / I'm with you, Sappho, in that anarchist land."[136] In the ghazal "Even the Rain," the speaker again identifies with disobedience in the name of dissident sexuality, voicing sympathy for Lot's wife, who fatally looked back (with nostalgia?) at the ruins of Sodom: "What was I to prophesy if not the end of the world? / A salt pillar for the lonely lot, even the rain."[137] Here, Ali transforms a biblical allusion often used to condemn homosexuality into a lament for the "lonely" Lot, his wife, and, punningly, the lonely crowd (lot). Read within the context of the AIDS crisis, which Ali addresses elsewhere in his poetry, one might read Lot's loneliness after the destruction of Sodom as a figure for the loss of those who were taken by the HIV virus, again turning a figure for the condemnation of homosexuality into one of sympathy.[138]

When Ali translates one of Ghalib's ghazals for his elegiac sequence "From Amherst to Kashmir," he does not shy away from sexually suggestive *mazmuns*, such as those involving the *saqi* (wine bearer):[139]

> Time ago I could recall
> those moon-lit nights,
> wine on the Saqi's roof—
> But Time's shelved them now
> in its niche, in
> Memory's dim places.[140]

Through translation, Ghalib's recollection of moonlit nights becomes Ali's recollection of a time when forbidden activities (particularly those involving intoxication) found prolific expression through the conventions of ghazal poetry. Similarly, in the ghazal that warns Wilde not to swear by art but by exiles, Ali returns to the figure of the saqi in what could be read as a two-line aubade, with the wine bearer as possible witness to, or perhaps participant in, the morning-after-glow: "Don't weep, we'll drown out the Call to Prayer, O Saqi—/I'll raise my glass before wine is defiled by exiles."[141] In this miniature ode to debauchery, the Muslim call to prayer seems to herald the end of an elicit liaison or activity and a plea not to weep at the arrival of some nebulous threat brought by exiles.

This juxtaposition of the sacred and the profane takes on a more explosive quality in some of Ali's other ghazals, which imagine Satan (or Iblis) through the Sufi tradition as the spurned lover of God who would not be displaced by man in his singular devotion to his creator, an idea found in the Qur'an but which Ali's notes suggest he also picked up from Joseph Campbell.[142] Indeed, it is in the realm of the sacred, in heaven and hell, that Ali locates his most sexually profane images. In the ghazal "In Arabic," Ali sings of "bisexual Heaven," where "wide-eyed houris and immortal youths" say *Yes! O Yes!* to "your each desire."[143] In the ghazal "From the Start," Ali writes, "Who but Satan can know God's sorrow in Heaven?/God longs for the lover He undermined from the start." While in "Angels," Ali returns to the theme several times: "In Inferno the walls mirror brocades and silks./Satan's legions—though fallen—are, nonetheless angels." And "Why is God so frightened of my crazy devotion to Him?/Does he think that, like Satan, I too will finesse angels?" And finally "You play innocence so well, with such precision, Shahid:/You could seduce God Himself, and fuck the sexless angels."[144] In this cluster of detached couplets, with their gestures toward Dante, Milton, and Islamic tradition, the style of hell is luxuriously embroidered and mirrored like Mughal architecture, hinting that an aristocracy in hell is still an aristocracy; religious fanaticism blends into sexual finagling; and the artifice of innocence leads to sexual debauchery.

This potent combination of faith, style, sexuality, and profane longing plays out again in a double couplet from the ghazal "God":

Of Fidelity I've made such high style
that, jealous of my perfect devotion,
even the angels come down from Heaven
and beg—beg—me to stop worshipping God.[145]

High style has such an alluring quality here that it threatens to lure the ultimate beloved, God, away from his heavenly retinue. High style, in seducing God, amounts to the most profound profanity. Ali called Faiz a rebel for rendering the beloved as the revolution. Here, Ali makes style itself a rival for the divine beloved's attention. Whereas religious moralism might once have been a source of objection to the licentiousness of the ghazal and its predilection for style over moral seriousness, Ali embraces the poet's Satanic role, rendering fidelity to style an act of "crazy devotion," a way of staying true to form and an act of moral rebellion.

A couplet from the ghazal "About Me" reinforces Shoaib's claim that Ali restrains expressions of homosexuality through his formalism: "I pull my arm out from under his sleeping head, / limited to my own form, my scream about me."[146] The push and pull of openness and restraint is more than evident in the limitations of "form," both body and poetry. Such limitations are agonizing, but their romantic context is plainly in view. We might convincingly read such moments as expressions of a formally restrained eroticism. But if we take Ali's practice of the ghazal as an attempt to encode "his native cultural memory in contemporary American literature," as Shadab Zeest Hashmi argues, then part of what Ali encodes in the American ghazal are those ambiguous expressions of sexuality most disavowed as decadent holdovers of a feudal poetics.[147] Ali ensured, through his flagrant teasing of more and less ambiguous expressions of homosexual desire, that such "exotic" motifs would not be lost in the translation of the ghazal form into English.

In 1998, Ali received a call from the writer Matthew Stadler, literary editor for the interior-design magazine *Nest*. Stadler invited Ali to contribute a poem to a collaboration between two well-known designers, Mario Buatta and Simon Dance. Buatta is popularly known as the "prince of chintz" for his lush, neo-Victorian use of fabrics and

"Dance with Buatta," *Nest*, Fall 1998. Photo: Richard Glover. Digital Imaging: Nick Buccola. Courtesy of Joseph Holtzman. Photoduplication: Hamilton College Special Collections Library.

bric-a-brac, while Dance is known for his stark, modernist minimalism. The magazine asked Buatta to redesign Dance's "austere London apartment" in virtual space with the aid of three-dimensional computer imaging. Describing Ali's role, Stadler writes that Ali would give his "blessing" to the collaboration "in a poetic form of his own invention, inspired by the equivalence of Italian *stanza* and the English 'room' and by the work of Buatta and Dance."[148] The result of Buatta's redesign of Dance's home is a lush reimagining of modernist minimalism, a draping of Indian fabrics, Chinese vases, and European tapestries across Dance's stark, white-on-white interiors. The images offer an apt metaphor for Ali's poetry. Indeed, Ali's accompanying poem, "Rooms Are Never Finished," achieves something similar, a lush reimagining of the European stanza as it is draped with the fabric of the ghazal.

"Rooms Are Never Finished," an early version of which appears in *Nest*, begins with an epigraph from Buatta: "Many of my favorite things are broken."[149] The title echoes remarks by Buatta on the unfinished quality of his designs.[150] As Ali recalls, "I was at the same time working

on a ghazal, in which my rhyme scheme [*qafia*] was the 'I' sound, like 'I,' 'sigh,' 'die,' and the refrain [*radif*] was the word 'in,' 'cry in,' 'die in.' So I said, well, why don't I discard the ghazal and create my own form, remembering the word 'stanza' in Italian means 'rooms.' So rooms are never finished. I create my own poem in which no stanza really ends; it always leads to the next room with the word 'in.' I'm telling you all this to show you how ingenious I am."[151] Ingenious indeed—in working the rhyme and refrain of the ghazal into an Italian stanza that remains "unfinished" by virtue of enjambment, Ali sets up a tension between Aristotelian ideals of unity in Western art and the "ravishing disunities" and open-endedness that define ghazal poetry in an entirely new, hybrid form of his own invention.[152]

Like muslins from Dacca, Buatta's "chintz" has a history that is not simply timeless. Derived from the "Sanskrit word meaning coloured or spotted," chintz is made using dying techniques that go back for centuries but that the West only learned to emulate using synthetic dyes in the nineteenth century. Chintz was imported to Europe by Romans, Arabs, and the Dutch and then, as interest in Indian fabrics took off in Britain, by the British East India Company.[153] As with the Dacca gauzes, the original process of manufacturing these fabrics involved techniques that were labor-intensive, requiring special knowledge and skills that later suffered with the proliferation of machine-made imitations.

Like Buatta's neo-Victorian decor, the aesthetic roots of Ali's poem are also Victorian. The dramatic monologue style of "Rooms Are Never Finished" bears a resemblance to Robert Browning's "My Last Duchess." An unnamed speaker welcomes a guest to his house ("In here it's deliberately dark so one may sigh // in peace. Please come in") and leads him through various rooms ("Upstairs—climb slowly"), pointing out interesting items along the way ("Before, / these walls had just mirrors"), interjecting questions and observations that go unanswered. Later the speaker admonishes his guest, *"Don't touch that vase!"* More creepily, the guest seems to have been drawn to the house unwillingly: "Why are you weeping, / dear friend? Hush, rare guest." There is even a gothic hint that the speaker might possibly turn out to be something of a ghost—"How one passes through such thick walls!"—or that the house is otherwise haunted by "shades" of the past

made manifest in the objects around the house, leading the speaker to long, paradoxically, for "shades that lighten a scene."[154]

The introduction of this dramatic speaker as a distinctive presence was a late addition to the poem, which, in its original publication, lacks what are now the first six lines and reads more like a tour of Buatta's virtual redesign: "But look how each room's been refurbished."[155] In adding the line "Please come in," Ali may have had Eliot's "The Love Song of J. Alfred Prufrock" in mind, with its invitation, "Let us go then, you and I."[156] In "Prufrock," Ali writes elsewhere, "we never learn who the 'he' or 'she' is. Is the speaker Eliot himself? Evocative and sensuous the poem lives in its own world and escapes biography." What Eliot leaves us with is "tradition as his marvelous mask: Hamlet, Michelangelo, Lazarus, and St. John the Baptist."[157] Ali's poem likewise inhabits its own sensuous world, though Ali's masks are Gerard Manley Hopkins, John Keats, W. B. Yeats, and T. S. Eliot.

The decor described in the poem furnishes a self-contained interior world with items brought from far-flung, possibly devastated cultures: "What city's left?/I've brought the world indoors." There is almost a pun on the idea of worldly goods, meaning both global and material, as these objects come to resemble the trade routes by which they travel: "This screen in stitches silk-routes a river/down Asia, past laughing Buddhas, China/a lantern burning burning burning for/'God to aggrandise, God to glorify.'"[158] The poem stitches its own silk route through the world of its intertextual references. Ali alludes to Hopkins's agonizing glorification of the divine in "The Candle Indoors" ("God to aggrandise, God to Glorify") and to the syncretism of Buddhism and Augustinian Christianity in "The Fire Sermon" of *The Waste Land* ("To Carthage then I came//Burning burning burning burning").[159] Hopkins's lines "Come you indoors, come home; your fading fire/Mend first and vital candle in your close heart's vault" further reverberate in Ali's "nothing/Dear! but a bare flame for you to come by//in," suggesting a reinvestment of the "fading fire" of the sacred in the secular, interior world of material objects.[160]

The speaker's collecting practices are reminiscent of the decadent collecting practices of Huysmans's Des Esseintes, who re-creates the exterior world in the confined space of his chateau, refurbishing one room as a monk's cell and another as a ship's cabin, arguing that

"the imagination could provide a more-than-adequate substitute for the vulgar reality of actual experience."[161] Ali's speaker, in proclaiming his preference for acquisition over experience, likewise remarks that "What we own betters / any tale of God's" and that the outside world is "poison": "Out there one longs for all one's ever bought."[162] There is an echo, too, of Dorian Gray's collecting practices, particularly in Dorian's penchant for collecting artifacts from decimated indigenous cultures. As Wilde writes, "He collected together from all parts of the world the strangest instruments that could be found, either in the tombs of dead nations or among the few savage tribes that have survived contact with Western civilization."[163] The decadent's collection becomes an archive of colonial decimation, a record of what Renato Rosaldo calls "imperialist nostalgia," the mournful feeling that attaches to the remains of civilizations one has been complicit in destroying.[164]

The interior world of Ali's poem takes on an apocalyptic character, warning of rains, floods, and horsemen should damage come to what seems like a well-wrought vase or urn:

> . . . *Don't touch that vase!* Long ago
> its waist, abandoned by scrolling foliage,
> was banded by hands, banded quick with omens:
> a galloping flood, hooves iron by the river's edge.
> O beating night, what could have reined the sky
>
> in? . . .[165]

Keats's "Ode on a Grecian Urn" takes a dark turn here. Whereas a "flowery tale" and a "leaf-fringed legend" haunt the "Attic shape" of Keats's vase, Ali's vase has been "abandoned" by its "scrolling foliage." In the place of sylvan scenes and "cold pastoral," one finds apocalyptic emblems.[166] The "galloping flood" by the "river's edge" recalls the horse of Yeats's "Easter 1916" that plashes on the "brim" of the "living stream."[167] Ali's poem becomes dense with wordplay, punning on "reined" and "rained." The delicacy of the vase seems the result of some prior breakage, which occurred "long ago." Its "abandoned" waist is re-"banded" in the next line, suggesting repair. The speaker's favorite things, like Buatta's, are indeed broken and "refurbished." In the well-wrought lyric space of the poem, favorite things fall apart, suggesting

that the breaking of forms, like the breaking of artifacts, correlates to some larger cataclysm.

The poem recycles the apocalyptic motifs of the ghazal that Ali had been working on at the time, later published separately under the title "In": "Doomsday is over, Eden stretched vast before me—/I see the rooms, all the rooms, I am to die in."[168] The moment could be read as an instance of self-elegy. "Rooms Are Never Finished," however, furnishes a scene for renewal: "You were/led through all the spare rooms I was to die//in. But look how each room's been refurbished."[169] Decadence, death, apocalypse, and brokenness set the stage for poetic refurbishment, not just an ending but also a beginning.

If the speaker's vase has been broken and pieced back together, so too has Ali's ghazal. Ali weaves seven separate couplets from the ghazal "In" into the body of "Rooms Are Never Finished." As Ali notes, the opening couplet of any ghazal, its *matla*, establishes the *qafia* and *radif*, the rhyme and refrain that repeat in the second line of each succeeding couplet. In the *matla* of "In," Ali quotes the same line from Hopkins, establishing the long "i" sound of "glorify" as the *qafia* and "in" as the refrain or *radif*: "Now 'God to aggrandise, God to glorify' in/the candle that 'clear burns'—glare I can't come by in." The ghazal's fourth couplet provides the images decking the banded vase of "Rooms Are Never Finished": "Galloping flood, hooves iron by the river's edge—/Heart, this beating night, how will you rein the sky in?"[170] Two other couplets (presented in reverse order) demonstrate how Ali spreads his ghazal couplets out in "Rooms Are Never Finished" by enjambment across the broader, five-line stanzas of the later poem. In "In," Ali writes,

> Ere he never returns, he whose footsteps are dying,
> Shahid, run out weeping, bring that passer-by in.
>
> When the last leaves were birds, stuck wingless to branches,
> the wind glass-stormed the season you'd left me to cry in.[171]

The expanded passage in "Rooms Are Never Finished" reads as follows:

> . . . Hush, rare guest. Once a passer-by
>
> in tears, his footsteps dying, was . . . well, I rushed
> out and he was gone. Out there it's poison.

Out there one longs for all one's ever bought,
for shades that lighten a scene: When the last leaves
were birds spent wingless on trees, love, the cage to cry

in, was glass-stormed by the North. . . . [172]

Ali preserves the *qafia* as the end rhyme of the last line of each stanza
and the *radif*, "in," as anaphora in the first. The room or stanza is never
"finished" because it always awaits the closure of the *radif* that occurs
at the beginning of the next stanza. Moreover, the poem is bookended
by two stand-alone lines. The first—"In here it's deliberately dark so
one may sigh"—functions much like the opening couplet or *matla* of
a ghazal, except that it establishes the *radif*, "in," at the beginning of
the line and the *qafia*, rhymed on "sigh," at the end, which leads back
by enjambment to the *radif*, "in peace": "In here it's deliberately dark
so one may sigh // in peace. Please come in. How long has it been?"[173]
Essentially, Ali has smashed apart his own ghazal, scattering the im-
ages and couplets across the stanzas of "Rooms Are Never Finished,"
gluing them back together, like a broken vase, using the abutment of
qafia and *radif* as seams, leaving the cracks showing in the enjambment
between stanzas. In one sense, then, "Rooms Are Never Finished"
constitutes a broken ghazal, stuck back together and expanded using
the glue of the dramatic monologue. The poem invites the reader to
come indoors, into a lyric space defined not by closure but by the con-
tinual displacement and fracturing of *qafia* and *radif* that leaves each
room open to the next. In another sense, if we treat the ghazal cou-
plets as individual broken things, the speaker's monologue becomes a
kind of decadent collection. But whereas Dorian Gray collected a va-
riety of objects, including fine Indian textiles, the speaker of "Rooms
Are Never Finished" collects the remnants of verse, placing them care-
fully within refurbished "rooms" or "stanzas."

Another sort of refrain floats through the poem focusing attention
on the hands of the laborers who produced the decorative items in the
speaker's rooms. In the second stanza, the speaker remarks, "But for
small invisible hands, no wall / would be lacquered a rain forest's
colors." Later, he observes, "Candles float past inked-in laborers / but
for whose hands this story would be empty."[174] Ali puns on the "story"
or level of the house. Without the work of these laborers, the story of

these rooms or stanzas would be empty. There are also the hands that band the vase and the declaration, "But for quick hands, my walls / would be mirrors," suggesting that without such invisible labor, this interior world would become entirely self-referential. The poem ends on an ellipsis that draws special attention to these unseen laborers—"But for small hands. Invisible. Quick. . . ."[175] The word "invisible" absorbs the ghazal refrain "in." The adjectives "small," "invisible," and "quick" evoke the deftness and skill of children's or women's labor, pointing, perhaps, to the exploitive conditions under which the speaker's chosen furnishings are manufactured, just as Wilde does in "The Young King." These invisible hands may further evoke the "invisible hand" of the marketplace, Adam Smith's famous figure for the unintended effects of free-market capitalism, even as they recall the dismembered hands of weavers in "The Dacca Gauzes." Indeed, Ali's drafts suggest that Smith's invisible hand is the key figure here.

A typescript of "Rooms Are Never Finished" in Ali's papers at Hamilton College shows Ali diligently marking the precise metrical feet and accents of the poem. Around the margins and flipside of this typescript, however, one finds extensive notes for his essay "A Darkly Defense of Dead White Males," in which Ali addresses the relationship between form, content, and political subject matter in poetry from Shakespeare to John Ashbery.[176] At the opening of the published essay, Ali declares, "Subject matter is artistically interesting only when through form it has become content. The more rigorous the form, realized formally, openly, or brokenly, the greater the chance for content."[177] The insistence that political subject matter must be realized through form before it can become content but that form can appear closed, open, or broken neatly aligns with the formal conception of "Rooms Are Never Finished," with its artful tensions between closed forms, unfinished stanzas, and broken ghazals. Ali's axiom also insists on the materiality of form: it must be "realized" before subject can rise to the level of content.

Ali's essay refers to Noam Chomsky's book *Year 501: The Conquest Continues*, which uses the example of the Bengali textile industry to demonstrate how Adam Smith's critique of capitalism in *The Wealth of Nations* has been misunderstood.[178] Chomsky highlights the conditions of the same weavers who made the Dacca gauzes to illustrate the

pernicious, not benignant, effects of the market's invisible hand. As Ali writes, Chomsky shows how "the Indians . . . were being robbed blind by the British, who had destroyed the textiles of India till the bones of Bengal's cotton weavers were bleaching the plains of India."[179] It seems evident that if Ali was reading Chomsky's writing on Adam Smith and the Bengali textile industry around the same time as he was composing "Room Are Never Finished," then the same invisible hand of the market that destroyed the Indian textile industry haunts a poem inspired by the Prince of Chintz. That is, the same market effects that ravaged the Bengali textile industry invisibly shape Ali's own careful attempt to iron out the broken ghazal structure of "Rooms Are Never Finished" right down to the scansion he marks by hand on his typescript.

The aesthetic and material economy that "Rooms Are Never Finished" inhabits is a devastatingly unequal one, in which human labor is rendered invisible except as it reflects the speaker's own sense of taste, just as the labor of Buatta's redesign is rendered invisible by the digital technology employed by *Nest* magazine. In effect, Ali offers a subversive critique of the labor practices evident in the collaboration that the poem is intended to bless, though the context of that critique has been obscured by the poem's subsequent publication and lyricization separate from its originating print context.[180] The poem suggests that as the West appropriates Eastern materials such as muslins and chintzes or poetic forms such as the ghazal, the labor and craft behind such forms and their material modes of circulation are in danger of becoming invisible. The formal arrangement of "Rooms Are Never Finished," with ghazal couplets draped across stanzas, becomes a kind of meta-figure for the history of the ghazal's transit from Urdu into English, from the sensuous interior world of Urdu court poetry to the larger world economy, a history Ali restores by embracing and reappropriating that sensuality (from Wilde, from Buatta) as it overrides modernist minimalism. Like the Dacca gauzes, the ghazal form has been torn into bits, only to be stitched back together in a new, hybrid form. It is in this sense that Ali's postcolonial notion of "form for form's sake" reaches its radical potential, restoring the history of colonial and industrial exploitation to art not by representing it directly but by putting the very brokenness of traditional forms on display, employing

the language and motifs of aestheticism to weld back together an en-
dangered verse form while making its near annihilation visible, just
as the trace of the ghazal refrain "in" is still visible in the word "in-
visible."[181] In becoming "invisible," the ghazal form itself becomes
visible once more.

In a note at the bottom of the typescript of "Rooms Are Never Fin-
ished," Ali asks, "Does art change the world? Debatable forever. Does it
enrich the world? Now that is perhaps easier to assert."[182] Ali's ques-
tions point toward the larger concern at stake in his meditations on
form: the responsibility of the artist in the face of political violence. Ali
sketches one answer to this question in response to the collage work
of the artist Masood Hussain. Hussain, like Ali, dwelt on the "agony
of Kashmir," which was devastated by warring factions through
much of the 1990s.[183] Masood's art adorns the cover of Ali's *The
Country without a Post Office*, a volume intimately concerned with
the conflict in Kashmir. Ali writes that on "seeing Masood's rav-
ishing arrangements in 1997, I manage to rescue the assurance that
the artist indeed matters, and that he does so because he seeks courage
by sitting alone by the grave, contemplating the skull, resisting the epic
cliches of exclusionary nationalisms for the far more moral sake of the
here-and-now. The here-and-now demands of the artist the most strin-
gent lyricism."[184] Ali's comments (which evoke Hamlet) suggest that
he saw stringent lyricism, not journalistic realism, as a means of re-
sisting the exclusionary nationalisms that set off a tide of violence in
his home country. One can see, then, how Ali's understanding of form
for form's sake represents not a retreat from the world so much as it
furnishes the means by which the artist can transform such devastating
subject matter into artistic content capable of addressing, and perhaps
altering, the world.

 While questions about art's efficacy in the face of nationalist vio-
lence are most urgent in Ali's writings on Kashmir, one can trace such
reflections to his doctoral dissertation on Eliot. In *T. S. Eliot as Editor*,
Ali addresses Eliot's failure to confront the rising crisis of fascism in
the 1930s. Ali recounts in detail how Eliot, in his work as editor of the
Criterion, failed to unify the "mind of Europe," slipping instead into
increasingly insular commentary on theological dogma while giving

voice to racist thinkers such as Charles Maurras and Henri Massis, with their paranoid fear of "Asiaticism."[185] Approaching Eliot's obsession with Europe from a non-European perspective, Ali argues that it was Eliot's lack of openness toward non-European cultures (in his critical, if not in his poetic, work) and his "artificial distinction between politics and political philosophy" that left him unable to confront an impending crisis of Europe's own making.[186] Eliot's stance in favor of British imperialism rendered him "unable to provide any dynamism to save the magazine," which, until it folded in January 1939, could neither "pretend that Nazism did not exist" nor "bring itself to oppose it," as the *Times Literary Supplement* put it in a line Ali quotes.[187] While Ali notes that Eliot refers to the *Bhagavad-Gita* in *Four Quartets*, Ali argues that Eliot, in his work at the *Criterion*, chose "to ignore the fact that Arjuna, his faith and reason strengthened because of Krishna's advice, finally *does* take part in the great battle of the *Mahabharata*."[188] Had Eliot been able to take off his imperial blinders, Ali argues, he might have asked a critical question. Not "what was to save Western civilization" but rather, "What was to save Europe (as well as Eliot and those of a similar intellectual persuasion) *from* Western civilization? Perhaps this is the question the editor should have had the courage to ask in the late 1930s, just as [György] Lukács, in response to World War I, has asked: 'who [is] to save us from Western civilization?' Asking the question in a similar manner, or asking an equally radical question, would have given the editor a fresh and dynamic perspective for running the magazine."[189] Ali concludes that if Eliot had expressed the same willingness to reach outside Europe for answers in his editorial practice as he did in his use of Buddhist and Hindu scriptures in his poetry, he might have shown a light through the darkness of Europe's emerging crisis.

Ali's argument in this early work of scholarship lends weight to a seemingly lighthearted comment he makes at the end of his introduction to *Ravishing DisUnities*. "I love forms," he declares, "but I do not wish to come across as some kind of rheumatic formalist. I am not, certainly not the neo-kind who wishes to save Western civilization with meters and rhymes!"[190] Nevertheless, in the last words of his introduction, he proposes, "If one writes in free verse—and one should— to subvert Western civilization, surely one should write in forms to

save oneself *from* Western civilization?"[191] In this moment, Ali answers the very question he proposes (by way of Lukács) at the end of *T. S. Eliot as Editor*. What would save "us" from Western civilization, with its propensity for crisis, collapse, and imperial brutality? Speaking as a kind of rebel aesthete, both political outsider and formalist insider, Ali proposes the writing of forms as a strategy for cultural survival in the face of Western civilization's brutality and nationalist extremism. In attaching this mode of survival to the resurrection of the ghazal for the conservative yet radical reason of "form for form's sake," Ali looks to save non-European forms from Western civilization's imperial ambitions and repeated internal catastrophes, and in doing so, he looks to save a broader notion of humanity from Western civilization. Ali suggests that to survive, Western civilization must look outside itself, to change, adapt, and open its borders in the manner that modernists such as Eliot were capable of practicing in their poetry but unable to grasp in their Europe-bound cultural theories. Luckily for Eliot's poetry, Ali writes, "Eliot's mind was too large to be confined by its own theoretical formulations."[192]

To argue that attention to poetic form might save one from Western civilization, or save Western civilization from itself, is to put great faith in the power and significance of form as a cultural idea that extends far beyond mere prosody or stanza structure. It is to shore the ruins of poetic form against social collapse, reprising a conservative modernist impulse from a radically expanded cultural perspective. So how, when confronted with the crisis in Kashmir, did Ali employ the workings of form to stitch together his own torn country? One example can be found in "A History of Paisley," in which form functions as a tool of self-repair. In the poem's epigraph, Ali invokes "the Hindu myth where Siva carves the valley as a paisley in order to commemorate his reunion with his wife, Parvati."[193] In the poem, the paisley-shaped footprints of history's victims leave their mark on both the landscape and the form: "(Look! Their feet bleed; they leave footprints on the street / which will give up its fabric, at dusk, a carpet)—" The poem's metrical "feet" likewise bleed out into the world. Yet territory torn apart at ground level is figuratively repaired by the beauty overhanging the embattled valley: "The air / chainstitched itself till the sky hung its bluest / tapestry"; and later, "It is dusk. The gauze is torn. A weaver kneels, / gathers

falling threads. Soon he will stitch the air."[194] Here, the "chainstitched" air echoes the "woven air" of the Dacca gauzes; images of the torn fabric of Kashmir are rewoven through the poetic imagination in the sky. In the variable five-line envelope stanza that Ali employs, the image of air stitching itself becomes an emblem of the form's self-sustaining and self-repairing schema. The repeating rhymes of the first and fifth lines of each stanza, like the sky and the ground, envelope the conflict between them, yet the conflict overruns any effort to contain it through the persistent enjambment from one stanza to the next. As in "Rooms Are Never Finished," these "rooms," too, are unfinished. In weaving these quintets aurally through rhyme and unweaving them visually and syntactically through enjambment, Ali weaves and unweaves the national story of Kashmir. This history of paisley, the history of Kashmir, becomes a history of form, its making and unmaking, and that history is just as precarious and prone to loss as are those transparent Dacca gauzes.

2

Decadence and the Visual Arts in Derek Walcott's West Indies

IN JANUARY 1964, less than two years after Trinidad and Tobago gained its independence from Great Britain, Derek Walcott penned an article for the *Trinidad Guardian* under the headline "A Dilemma Faces W. I. Artists." The article opens with an arresting declaration: "Decadence begins when a civilisation falls in love with its ruins."[1] Coming so soon on the heels of Trinidad and Tobago's birth as an independent nation, Walcott's assertion that the most pressing problem facing the West Indian artist is that of "decadence," a cultural ailment thought to arise at empire's end, indicates that the transition to postcolony was precarious, threatened by an undertow of colonial nostalgia. At the very moment when West Indian artists should have been looking forward to a new era of cultural modernization, they instead suffered disappointments such as the collapse of the West Indies Federation.[2] Walcott's main concern at this time appears to be not with first days but with last days and their literary and artistic symptoms. Echoing Symons's statement that decadence manifests itself with "all the qualities that mark the end of great periods," including morbid curiosity, endless refinement, and moral perversity, Walcott asserts, "Just as the last phases of a period's poetry are the elegy and the satire, one nostalgic for a great past, the other savaging the present, a love of tombs, fragments and broken sculpture, a burrowing into middens, and the

worship of excavations are a prelude to the 'dying fall.' The culture grows necrophilic; it falls in love with the dead."[3]

While the British Empire itself might have been "formally over," Walcott's early essays show how the shadow of its decline stretched across the official temporal boundary of independence, threatening to drown the West Indian artist in the midden of late-imperial modes and ruinous late-Romantic obsessions.[4] Moreover, within a landscape in which the most prominent ruins are those of sugar mills and slave plantations, not the Coliseum or the Parthenon, to elegize the past and satirize the present is to cling to empire's mythologies of its own past grandeur while dismissing the present-day culture of the Caribbean. Walcott argues that those "who claim that there is no sense of history in the West Indies, that its peoples are without that sense of the past which fertilises art as tough weeds fertilise a ruin, suffer from a longing for that decadence."[5] For Walcott, it is in the longing for ruins that decadence begins, but the postcolonial situation is one in which one longs to long for ruins. This is decadence once removed, suggesting a reluctance to look beyond empire's ruins to construct one's own sense of history as an alternative ground for art. In Walcott's view, the postcolonial artist emerges between the decadence of empire and the longing for that decadence within newly independent societies.

As the article progresses, Walcott argues that the cultural vacuum created by this longing for decadence leaves the West Indian artist vulnerable to another threat. Walcott argues that at a point when strong West Indian cultural institutions have yet to take hold, the West Indian artist begins to look to contemporary Europe and the United States for the latest artistic trends. To do so, however, is to miss the possibilities within the emerging postcolonial landscape and risk getting caught up in Europe's sense of its own decline after two world wars and the loss of its empires. Writing in the aftermath of the Cuban Missile Crisis, Walcott argues that Europe's sense of cultural exhaustion, combined with the Cold War threat of nuclear annihilation, had driven Western art to absurd levels of self-involved abstraction: "Apart from the fact that nations are like individuals, egocentric, since they imagine their deaths mean the death of the whole world, this has meant the retreat of the best art into willful incoherence, into the negations of writers like Beckett, into the theory of the 'empty canvas,' into anti-art and the

absurd." What looked to some critics like an avant-garde revolution
(in works by Samuel Beckett, John Cage, or Jasper Johns, for example)
was, to Walcott, a reductio ad absurdum: "Cultures also move from the
sublime to the ridiculous."[6]

Moreover, the dominant trends in modern art threaten to subsume
those West Indian artists who train abroad: "The artist in the West In-
dies, especially one who has studied in Europe, faces this dilemma.
Technically, he becomes skillful in the style of the mainstream, which
is now abstract expressionism, but beneath this he has a strong urge
to re-create the visible world, which is in terms of art history, undocu-
mented." Despite this urge toward documentary realism, however, the
West Indian artist "is assaulted by waves of fashion, which are almost
impossible to resist, because they come from a venerated past." That is,
those movements perceived in Europe as experimental or avant-garde
distort postcolonial art because they derive from an overly venerated
museum culture, from institutions Walcott refers to as "mausoleums"
and "shrines of tradition."[7] These increasingly abstract developments
in late-modernist art represent a moribund proposition for the West
Indian artist because they fail to capture the local landscape and re-
inforce a sensibility defined by the ruins of Western imperialism. To
long to create art in these styles is no less decadent than to long after
ruins; it is to skip a youthful phase of artistic growth not for an en-
gaged avant-gardism but for the refinements of late-modernist for-
malism. For Walcott, the arrival of late-modernist style in the West
Indies heralds the beginning of postcolonial decadence.

Throughout much of his early career, Walcott saw modernism's ad-
vance into Caribbean visual culture as an index of West Indian soci-
ety's premature collapse into decadence, a collapse that reflected the
spiritual and political malaise of the early postcolonial era as well as
the lack of practical support for West Indian artists. While Walcott
attributes the stylistic features of both modernist abstraction and avant-
garde anti-art to a late-imperial sensibility and Cold War apocalypticism,
"decadence" becomes a key term that allows Walcott to link aesthetics
to politics, enabling Walcott to ascribe the condition of West Indian
art to the social and political conditions of the Caribbean's emerging
national cultures. However, Walcott came to see those very features of
modernism that anticolonial critics commonly described as decadent—

its private obsessions, its apparent detachment, and its challenge to realism—as a necessary part of the dialectical development of a more independent, creolized West Indian aesthetic that nevertheless avoids aesthetic or political extremes. In his play *The Last Carnival* (1986), Walcott not only took modernism's private obsessions seriously but indulged them explicitly as a means to question the cultural nationalism of black revolutionary movements. Walcott saw modernist abstraction and cultural nationalism less as opposing terms, as other Caribbean critics such as Michael Thelwell did, than as twin manifestations of the same problem of artistic and cultural decadence.[8] As Walcott wrestled with the problem of decadence in his plays and poetry, he leaned toward impressionism as a fragile compromise between a modernist ethos defined by the autonomy of the imagination and the realist longing to document an undocumented West Indian landscape. In his late work *Tiepolo's Hound* (2000), Walcott rewrites the history of impressionism to circumvent European art's drift toward the private grammar of modernist abstraction and reimagines impressionism as a basis for Caribbean modernism.[9] That is, Walcott's understanding of modernism, and what he sees as the decadence of modernism, is as much a product of his thinking about the visual arts as it is a response to modernist literature.[10]

From his earliest days as a poet, Walcott situated his poetry between the ruins of European empires and the emergence of new Caribbean cultures. In his 1955 poem "Ruins of a Great House," the speaker stands by the ruins of a slave plantation in Jamaica and hears the sound that "Kipling heard, the death of a great Empire."[11] Sixty-five years later in "The Lost Empire," Walcott declares, "And then there was no more Empire all of a sudden./Its victories were air, its dominions dirt."[12] Throughout his career, Walcott played the provincial outsider witness to empire's "withdrawing roar," accepting his "function/as a colonial upstart at the end of an empire."[13] Eager to undercut empire's lingering influence, Walcott writes that the "great poets of the New World, from Whitman to Neruda," share a common vision: "Their vision of man in the New World is Adamic." The New World poet "has paid his accounts to Greece and Rome and walks in a world without monuments and ruins."[14] Nevertheless, in figuring the New World poet as Adam, Walcott defines that vision against the lingering imperial imagination,

be it that of Greece, Rome, or Britain. In doing so, he criticizes those who see "the death of civilizations" as "architectural, not spiritual; seeded in their memories is an imagery of vines ascending broken columns, of dead terraces, of Europe as a nourishing museum."[15]

Ann Laura Stoler argues that colonial ruins, such as those depicted in Walcott's "Ruins of a Great House," index "the longevity of structures of dominance, and the uneven pace with which people can extricate themselves from the colonial order of things."[16] One sees this in *Omeros*, where the "rusted cauldrons" of sugar-boiling vats and the "blackened pillars" of old plantations represent unhealed wounds in the colonial landscape not unlike that of the poem's wounded hero, Philoctete, who tends his yams in their shadow: "These are the only ruins / left here by history, if history is what they are."[17] Likewise, in *Another Life*, one finds, "In ruins, a population of ragpickers, / bent over stones, deciphering their graves."[18] While such moments may show how life goes on in the shadow of a history conceived as the history of empire, that history's shadow nevertheless lingers, never fully erased from the landscape.

In those moments when Walcott portrays Europe as a museum of (and in) ruins, he likewise figures the lingering shadow of European art over the postcolonial imagination. Later in *Omeros*, for example, the speaker is reminded of "that other Europe / of mausoleum museums," whose vain spires, fountains, and statues repeat the mantra that "power / and art were the same." "Tell that to a slave from the outer regions / of their fraying empires," Walcott writes.[19] In dismissing Europe's grip on the art world, Walcott insists on recognizing the power of the powerless to make art and establish their own sense of history. Nevertheless, Walcott continually identifies the art of the local against metropolitan glitter. Where "this small place," his native St. Lucia, "produces / nothing but beauty," "the stars / are far fishermen's fires, not glittering cities, / Genoa, Milan, London, Madrid, Paris."[20] In his late poem "In Italy," Walcott evokes the blind namesake of his native island to pose the artistic vision of the Caribbean against the declining metropolitan light of empire: "all of the cities were embers in the sun's empire, / and the night in its blindness would choose a / girl with greater vision, Santa Lucia."[21] Even in affirming the "greater vision" of the Ca-

ribbean, Walcott cannot seem to escape contrasts with an artistic sensibility defined by the twilight vision of European cities.

Walcott's writing exhibits a persistent concern for the power that prestigious metropolitan institutions exert over the postcolonial artist's vision. In his 1981 poem "Piano Practice," for example, the speaker steps off the rain-slicked steps of the Metropolitan Museum of Art in New York only to discover that "Belle Epoque Manhattan" has become "hazy" with "Impressionist clichés." The impressionist paintings inside the museum leave the speaker unable to form his own impressions; their vision of reality overrides his own sensations. The experience leaves him to contemplate "the collage of a closing century, / the epistolary pathos, the old Laforguean ache."[22] A century after the impressionists kicked off modernism in painting, the speaker finds himself belatedly trapped by a style rendered cliché by countless museum exhibitions. By Jules Laforgue's standards, then, the speaker is no impressionist. As Laforgue wrote in 1883, "L'Impressionniste est un peintre moderniste qui . . . oubliant les tableaux amassés par les siècle dans les musées, . . . est parvenu à se refaire un oeil naturel, à voir naturellement et à peindre naïvement comme il voit."[23] Walcott's speaker, however, can neither forget the images amassed by the centuries in the museum nor reconstruct a "natural eye" with which to see and paint the world. His "Laforguean ache" is like the phantom pain of a lost limb, a longing for a lost way of seeing, one more natural, more naïve, more Adamic. As a consequence, the speaker finds he can offer nothing original in his own poetry, only "the predictable / pale headscarf of the twilight's lurid silk." Failing to coax inspiration from the muse, who pleads a "headache," he strikes a tongue-in-cheek pose as a decadent suffering from the loss of his poetic powers, wondering aloud if "perhaps the *fin de siècle* isn't really finished, / maybe there's a piano playing it somewhere."[24]

In contemplating an unfinished fin de siècle, Walcott raises serious questions about how the modernists' promise to "make it new" has fared among postcolonial writers. As Heather K. Love comments, "While modernism may have destroyed the old world, it's not clear that it successfully created a new one."[25] Walcott's poem suggests an alternative narrative of European modernism that "provincializes" its

revolutionary claims.[26] That is, modernism ossifies as it goes global, threatening to become a second decadence for the postcolonial artist who, like the speaker of "Piano Practice," struggles to break the hold of a narrowly European modernist vision. In Walcott's revisionist narrative, European modernism is subsumed under the shadow of a prolonged decadence, an unfinished fin de siècle whose specter Walcott evokes to resist the dominance of modernism by highlighting its sense of failure, even as he finds himself caught within its vision.

Ironically shirking any engagement with context or history, Walcott's "Piano Practice" is ruffled only in passing by reference to the "trouble spots of the globe."[27] In such moments, Walcott acknowledges the poem's flight to New York as a retreat into the hazy clichés of a politically disengaged aestheticism. And yet another image breaks through the haze that reminds the speaker of his connection to the Caribbean diaspora:

> . . . near the Metropolitan
> a steel tenor pan
> dazzlingly practices something from old Vienna,
> the scales skittering like minnows across the sea.[28]

The poem bursts through the enclosures of its metropolitan vision with an image that is resolutely vital: the sound of a Caribbean steel drum reconfiguring the "scales" of an Old World tune. This composite figure breaks the grip of the Euro-modernist clichés in the museum and releases the speaker from his decadent languor. In this "collage of a closing century," European modernism collapses into decadence, and decadence becomes the necessary condition for the generation of a new, hybrid poetics.

The momentary slippage in "Piano Practice" from an enlivened impressionism into a belated decadence (an embalmed, museum version of the former) also has a larger significance for Walcott's oeuvre. As Clara Rosa De Lima observes, the opening of "Piano Practice," which envisions New York as an impressionist painting, can be read as "an extended metaphor of life being constructed to imitate art."[29] In this sense, "Piano Practice" echoes scores of other examples in Walcott's work in which the poet renders his surroundings as imitations of paintings. Indeed, Walcott's highly visual aesthetic is continually haunted

by the notion that life imitates art. In works such as his early autobiographical poem *Another Life*, his play *The Last Carnival*, and his 1990 epic *Omeros*, images of paintings from museums and printed reproductions provide the filter through which Walcott envisions the world. In such works, Walcott "raises the possibility that seemingly innocent first-time apprehensions of New World nature are already largely predetermined by the viewer's internalization of Western visual discourse."[30] That is, not only does Walcott evoke the idea of decadence to characterize the invasive quality of late modernism in Caribbean visual culture, but Walcott's own work appears intimately entwined with the antirealist doctrine of Oscar Wilde, who argues in "The Decay of Lying" that "Life imitates Art far more than Art imitates Life."[31]

The idea that life imitates art in Walcott's work suggests a further problem. Walcott considered himself an impressionist painter (if not a great one), finding early inspiration, for example, in the work of Paul Cézanne. In his youth, he would think of Cézanne as he looked out over "the pale orange roofs" of St. Lucia. It was "as if he knew the St. Lucian landscape," suggesting that Walcott found his own artistic vision anticipated by that of the impressionists.[32]

Walcott's own paintings can be found on several editions of his books. *Tiepolo's Hound*, for example, a book-length poem that explores Camille Pissarro's early life in St. Thomas and his subsequent contributions to French impressionism, features many of Walcott's own works. Walcott's interest in impressionism is precariously staked against what he sees as the historical drift toward abstraction and nonrepresentational forms that followed the impressionist movement. As he explains to George Handley, "My theory about painting is principally light, the theory of light, physical light. This may certainly not apply to abstract representation at all, and therefore I can be a dinosaur in terms of what my opinion is. . . . If someone in Berlin says 'nobody paints like that anymore in Berlin, and what we are doing [is a new technique],' whatever that technique is, that is a chronological concept from history that includes art. In other words, 'we have exhausted representation.'"[33] In many received accounts of art history, as impressionism broke toward postimpressionism, analytical cubism, and abstract expressionism, the dictates of form increasingly reduced representation and figuration to secondary interests. Walcott does not

contest this narrative so much as he resists the argument that later de-
velopments in Euro-American art are superior to, and should therefore
eclipse, earlier modes and styles. For Walcott, the attempt to recapture
a sense of physical light, in poetry or visual art, represents an attempt
to stave off modernist abstraction and its sense of exhaustion at the
possibilities of representation while preserving a certain independence
from the linear, chronological logic of conventional Euro-American art
history. Nevertheless, as I discuss further on in this chapter, the idea
that life imitates art continually interjects itself into Walcott's attempt
to establish impressionism as an independent West Indian aesthetic.

In the 1960s and 1970s, Walcott worked as an art critic for the *Trin-
idad Guardian,* composing hundreds of short pieces in which he re-
flects on the general state of the arts in the West Indies.[34] Many of the
journalistic pieces Walcott wrote during the early era of decolonization
demonstrate his keen interest in the problem of decadence. Walcott's
thinking on decadence in these pieces shaped his later revisionary
stance toward modernism. These pieces brought attention to the dif-
ficulty of forming a new national and regional culture without suc-
cumbing either to the mimicry of the latest fashions in the Euro-
American art world or to the postcolonial state's chauvinistic version
of black folk culture.[35] It was largely in these journalistic pieces that
Walcott began to employ the idea of decadence as a means to theorize
the relationship between artistic form and the politics of the nation or
region. As he came to grips with the idea that West Indian culture
would emerge from the shadow of a decadent empire only to fall into
the trap of a second wave of postcolonial decadence, Walcott began to
articulate a vision of West Indian art as a means of escaping both the
primary decadence of European art and the "imitated decadence" of
postcolonial societies.[36]

Walcott's earliest references to decadence are often more satirical
than serious, pointing toward familiar figures from 1890s literature.
In a 1957 series of prose caricatures called "Type Faces," for example,
Walcott satirizes the effete mannerisms of "compound" colonials who
emigrate to Europe to attend university, learn to fake accents more En-
glish than those of the English, feign their boredom at the culture of
the mother country, and, recalling "the wit of Beerbohm" and "the del-

icate wickedness of Wilde," learn to celebrate "the importance of being un-earnest."[37] Another caricature skewers the shallow wits of West Indian society, opining that their middle names may as well be "Algernon" (recalling Algernon Moncrieff from *The Importance of Being Earnest*) and that they would have a better time fitting in if "only the West Indies had had a *Yellow Book* era."[38] Light as these references are, they demonstrate Walcott's early familiarity with the aesthetic movement of the "yellow nineties." They also illustrate his willingness to use his own Wildean wit to pick apart the pretentions of his contemporaries, not least for their Anglophilia and for their ambition to find success overseas. That Caribbean artists and writers would seek success abroad at that time, however, was something of a necessity. As Walcott later put it, "One cannot make a living as an artist, yet one is aware of a vitality that comes from living in certain root areas," leaving the artist an impossible choice between poverty and exile, a situation Walcott characterized as "schizophrenic." "The more sophisticated" the poet becomes, "the more alienated is his mental state."[39] In these early pieces, Walcott critiques the consequences of an emerging national culture that cannot support its artists at home, in which success meant exile and alienation, and exile led to an imitated aestheticism that Walcott skewers, ironically, using the satirical terms of the *Yellow Book* era.

In the bulk of the articles Walcott published in the 1960s, however, he applied himself more seriously as a critical standard keeper, employing the label "decadent" to take West Indian artists to task for their imitativeness, belatedness, and idiosyncratic mannerisms (a particular pet peeve) and to account for the generally disappointing lack of state support for the arts.[40] These articles also delineate the odd temporality of postcolonial decadence, a sense that the brief period of promise that accompanied the fading days of empire had been prematurely dashed, initiating a secondary, postindependence period of national artistic decline.

In a 1960 article, Walcott writes that the new "line of development, or if you prefer decadence, in modern painting is now in the speed with which a painting can be executed while the imagination is still on fire." This modern verve—Walcott may have had Jackson Pollock's imitators in mind—results, however, in diminishing returns: "For all their

tactile rhetoric, most abstract paintings fade in power after repeated viewing. This may be because of the absence of any human meaning in non-representational art." Such a critique can easily be taken out of context, but Walcott argues that the appeal of this paradoxical "development" into "decadence" reflects a false sense of progress in Caribbean culture: "The state of painting in Trinidad is also a reflection on the confusion of its society. The conflict of individual styles, so many of them pale reflections of avant-garde work of fifty years ago in Paris, is not at all the result of rich variety, but of a lack of direction, a hesitancy about their own spiritual identity."[41] Here, the West Indian artist risks succumbing to such "pale reflections" of the Parisian avant-garde (it was postimpressionism that reigned fifty years earlier) because of a lack of spiritual clarity at the level of the society or nation. Yet newer, more abstract varieties of modernism, with their preference for action over vision, also inhibit the development of such clarity by pushing aside more representational forms that would reflect West Indian culture back to itself. (In his review, Walcott prefers the "semi-representational" work of painter Oswald Chase.) Provincializing international modernism and its descent from impressionism to nonfigurative "action painting," Walcott suggests that the modernist revolution loses force as it emanates out from Europe and the United States.[42] In doing so, it becomes both cause and symptom of artistic confusion among artists in emerging independent nations. That is, for Walcott, "decadence" does not only describe the degeneration of an individual artist's style, the diminishment of art's effect on its viewer, or a declining lineage in Euro-American art history. It also describes the kind of spiritual confusion internal to a national culture that makes it susceptible to outside influence. Moreover, it describes the transnational circulation of artistic modes as a process of exhaustion, dissipation, and diminishing returns, reflecting paler and paler versions of the original as artistic styles cross cultural contexts.

To oppose the slippery slope from abstraction to absurdity in modern art, Walcott argues that the West Indian artist must "turn his attention sideways to the landscape and people around him" and "formulate a style which is true for his own country."[43] However, Walcott warns that the desire for a more authentic, indigenous style can quickly develop into another, more homegrown variety of decadence, one that

manifests itself in an artificial African tribalism. In reviewing a performance by Haitian Bacoulou dancers in 1960, Walcott objects to the premature decadence that results from a national obsession with folk culture: "Like most West Indian blossoms, which come surprisingly early, we seem to be producing in art the flowers of our first decadence. I had best explain that the sense in which I use the word has nothing to do with Baudelaire, or Roman orgies, or black leather jackets. I am referring to the phase of quasi-folk through which our too few artists seem to be passing."[44] If this phase of "quasi-folk" culture has nothing to do with the stereotypical emblems of European decadence, it nevertheless produces a similar cultural effect, a premature diminishment of artistic force. Declaring the "contemporary inculcation of the 'African presence'" to be as "artificial" as the "flabby Victorianism" seen elsewhere in West Indian art, Walcott argues in another review that when "independence" is "handed prematurely . . . to a people who in spirit cannot help yearning for the womb of the mother-country, whether it be Africa or Portugal, China or India, the next phase is one of enervation." The rush to dig up one's roots after independence produces not a cultural renaissance but a new phase of cultural exhaustion. If an outsized reverence for European museum culture leads to a "flabby Victorianism"—what Walcott further describes as a "yearning for whiteness" that results from the continuing domination of "the library aesthetic of nineteenth-century art"—the insistence on the return to African folk traditions poses no less of a danger to the task of finding a style "true" to present-day Caribbean society.[45]

When Walcott was asked in 1971 whether he saw any use for the idea of "decolonization," he responded that the "only positive possible meaning" for the term lies in "the State's rejection of the nineteenth-century Western attitude towards the artist, which is that the role of the artist is to suffer privately and to regard himself as a sort of maimed or schizoid citizen who has chosen a tragic fate." The secondary "tragedy" is that "West Indian artists themselves accept this condition, that the end which they envisage is either final exile or self-destruction."[46] To reject this nineteenth-century view of the artist is, in effect, to reject the idea that to be a proper artist one must mimic the stereotyped image of what Yeats calls the "tragic generation" of nineteenth-century aesthetes.[47] Yet Walcott also rejects the idea that

decolonization necessarily entails going to the opposite cultural ex-
treme. The "new African romanticism," he argues, would result
only in "the exchange [of] one form of mental slavery for another"
by threatening Western notions of law and liberty with an imposed
tribalism.[48]

In this sense, Walcott frames the development of postcolonial art
much as Edmund Wilson frames the development of modernism in
"Axel and Rimbaud," the final chapter of his 1931 study *Axel's Castle*,
which Walcott appears to have known. For Wilson, twentieth-century
art was left with a choice between "symbolism" and "romanticism."
In Wilson's view, symbolists such as Villiers, Huysmans, Pater, and
Yeats pursued the imagination at the expense of reality, while roman-
tics such as Arthur Rimbaud, D. H. Lawrence, André Gide, and Pablo
Picasso pursued life at its most raw, exotic, and primitive: "If one
chooses the first of these, the way of Axel, one shuts oneself up in one's
own private world, cultivating one's private fantasies . . . ultimately
mistaking one's chimeras for realities. If one chooses the second, the
way of Rimbaud, one tries to leave the twentieth century behind—to find
the good life in some country where modern manufacturing methods
and modern democratic institutions do not present any problems to
the artist because they haven't yet arrived."[49] In "A Dilemma Faces
W. I. Artists," Walcott recapitulates Wilson's logic and several of his
same examples, mapping these same divisions onto the "jabberwocky"
of abstract art and the "negrophilia" of European primitivism. Though
Wilson's argument stops at the borders of Europe, Walcott proposes
Third World art as an alternative: "in small, germinal cultures, the pro-
cess must begin anew." It is for this reason that "the contribution of
the new Caribbean countries can never be political" or "technological"
but must be in "their art."[50] In this sense, Walcott affirms the relevance
of the arts as the one area where small nations can challenge politi-
cally and militarily dominant cultures. To do so, however, one must
oppose both the solipsism of modernist abstraction and the modernist
romance with the primitive, a primitivism that he sees reprised in the
tribalism of the "new African romanticism."

In one of Walcott's best-known essays, "What the Twilight Says,"
Walcott casts both the European avant-garde and African romanticism
explicitly in terms of their decadence. Walcott argues that Trinidadian

theater underwent a tug-of-war between the "urge towards the metropol-
itan language" and a reduction to "tribal simplicities." "Our politics, as well
as our arts, strove for sophistry, even to the point of imitated decadence.
For our frustrated avant-gardists and our radicals there was neither
enough power nor enough decadence to justify experiment; they missed
our Sade, our Grotowski or the madness of an Artaud. While others,
reactionaries in dashikis, screamed for the pastoral vision, for a return
to nature over the loudspeaker."[51] Walcott employs the idea of decadence
to liken tendencies in West Indian art to tendencies within West In-
dian politics, decrying the "imitated decadence" both of Europhile
avant-gardists and of the back-to-Africa movement. In doing so, Wal-
cott suggests a parallel between the "sophistry" of the metropolitan
avant-garde and the purist demands of black cultural nationalists for a
return to African origins. The West Indian artist is left to choose be-
tween two misguided, racially charged imitations. This double bind
gives shape to Walcott's attempt to assert the value of the aesthetic in
the Caribbean while not lapsing into either extreme. For Walcott, a too-
extreme cultural nationalism was no less decadent than avant-gardism.

And yet there are moments when Walcott suggests that decadence
offers a path forward through the dialectical reconciliation of these ex-
treme tendencies. Walcott comments that while playwrights such as
Wilde, the "Restoration wits," and Noël Coward once seemed to him
to be "artificial and unreal" and "therefore decadent," in fact, "the op-
posite is true." "Mannerists extract essences from their society, and
their decadence is merely amorality or social innocence."[52] In an ar-
ticle on the West Indian preference for tribal choreography over ballet,
Walcott argues that "the contention that one is too raw and the other
too refined, that 'decadence' and 'savagery' won't fuse," results from
mere "timidity." Walcott argues, to the contrary, that the "decadents
continue their explorations," and when "they have found out what we
are for us, we'll use it without acknowledgement."[53] This suggests
something rather different than the usual rejection of decadence found
in much of his other writing; it suggests that the arts progress through
an unacknowledged, dialectal synthesis of "decadence" and "savagery,"
the cooked and the raw. Walcott offers a surprising affirmation of the
possibilities of artistic decadence as a forward-looking direction
for West Indian art even as he anticipates the critical disavowal of the

contributions of purportedly decadent mannerists such as Wilde to West Indian culture.

Walcott makes this position explicit in comments on the literary critic Cyril Connolly. Though Connolly's criticism has an "autumnal, end-of-Empire glow of desperate survivals, a twilight air of a declining West, it is most important for the New World to take him seriously." Though his "stylistic sympathy is for the silver, the slightly gilded, the dying fall, and the phases of decadence (in such phases, syntax is its own end), he stresses certain virtues that adolescent nations, for all their muscular misguidedness, wish to ignore." Walcott goes on to argue that the values Connolly seeks to protect promise to remake the Caribbean into "the Mediterranean of the New World."[54] That is, a sympathy for the phases of decadence offers emergent nations the key to a cultural renaissance despite the technical self-absorption of decadent stylists. The Old World's lessons may be the lessons of a "silver" age of late refinement, not those of a Golden Age of new discoveries, but they can be applied toward a new Golden Age elsewhere. Though Walcott rejects the exaggerations of both the avant-garde and a faux tribalism as "decadent," he finds a use for Connolly's autumnal decadence, which seems reminiscent of what Pater describes as the "refined and comely decadence" that followed the Renaissance in France.[55] Decadence in this regard functions as a preserver of old aesthetic values, enabling the West Indian artist to resist an unthinking drift toward the extremes of either modernist abstraction or faux tribalism. This is a lesson, Walcott argues, that the more muscular cultural nationalists in adolescent nations simply cannot ignore.

Walcott's most vivid illustration of the clash between Old World decadence and the revolutionary impulse of black cultural nationalism can be found in his play *The Last Carnival*. *The Last Carnival* tells the story of a French Creole planter family in Trinidad during the rocky transition to independence. Act 1 spans the period from 1948 to Independence Day 1962. Act 2 opens in 1970 during the annual festivities of Carnival. The play's climactic sequence takes place during the "Black Power Revolution" that seized Trinidad and Tobago for fifty days from February 26 to April 21, 1970. Inspired by the American Black Power movement, the uprising spurred mass marches with

chants of "power to the people," sparked a serious mutiny within the army, and nearly brought down the government of Eric Williams.[56] It was during these events that Walcott conceived an early version of the play, which was originally performed under the title *In a Fine Castle*. Walcott has revised the play numerous times since, as recently as 1995.[57] While the most widely available version of the play was published in 1986, my reading is based in part on a 1992 typescript available among Walcott's papers at the University of Toronto.

Instead of portraying the attempted 1970 revolution directly, the play lavishes attention on the worsening eccentricities of its central character, an effete artist of the planter aristocracy whose obsession with the French Rococo painter Antoine Watteau dominates the play's first act and whose artistic legacy dominates the second. For this reason, critics have not been kind to this play. Judy Stone recounts that the "first Trinidadian reviews attacked *In a Fine Castle* with the critics' own revolutionary zeal," describing the play as " 'garrulous,' 'boring,' 'monotonous,' 'inconclusive,' 'totally pessimistic,' 'deliberately rolled weed to sell to the gullible,' in sum unreal."[58] The poet Eric Roach writes, "The French Creoles will damn him for portraying them in this Tennessee Williams twilight of rotting decadence. . . . The blacks will abuse him for mocking their new movement, their new awareness, their new identity."[59] Edward Baugh charges the 1982 version with representing the revolutionaries of 1970 as an emasculated "force hardly to be reckoned with."[60] Commenting on the 1992 production, Paula Burnett argues that the goal of such a play should be a Brechtian "reintegration of the reader-spectator into the real political world." For Burnett, however, *The Last Carnival* ultimately "fails to integrate its ideological and its aesthetic tendencies."[61]

Whether or not one judges the play to be a failure, the play makes visible an artistic impulse that resists integration into revolutionary politics, challenging the audience to consider what lessons might be gleaned from the silver refinements of late-colonial white Creole culture. In the play, the French tradition of the Watteau-esque, which stretches from Baudelaire to Henri de Toulouse-Lautrec, comes to stand in for the fatal dangers of the Wildean principle that life imitates art and that art, in representing a world that is already an imitation, "never expresses anything but itself."[62] For Wilde, because art only preserves

"the history of its own progress" and not reality, it stands apart from its own historical moment: "far from being the creation of its time," art "is usually in direct opposition to it."[63] Though Walcott's play does not advocate for such an antirealist view, it accepts the premise that as life comes to imitate art, and art only imitates itself, art slips away from its historical moment, with dangerous consequences. The play presents the decadence of the old planter aristocracy not just as a function of its declining status in Trinidadian society but also as a symptom of the increasing insularity and self-reflexivity of its artistic vision. Nevertheless, the more out of touch that vision becomes, the more it preserves an oppositional stance toward the surrounding culture that overtakes it.

The play's main character, Victor De La Fontaine, spends much of his time copying paintings by Watteau, going as far as to have Agatha, the governess he has hired from England, dress like a Watteau shepherdess so he can copy her likeness, blurring the line between art and life. Victor's obsession with Watteau echoes a fascination with the artist's work among French and British writers associated with the Decadent, Symbolist, and Aesthetic movements, including Baudelaire, Paul Verlaine, Laforgue, Pater, and Arthur Symons.[64] For these figures, Watteau embodied two contradictory artistic impulses "as the painter of a highly idealized social world" and as "an asocial melancholic distancing himself from that world."[65] He became the emblem, too, of idealized beauty captured in the moment of its passing. "How summer glides away" and "autumn pallor blooms," Symons writes in his poem "For a Picture of Watteau." Symons's mournful and melodramatic treatment of Watteau, with its attraction to the late bloom of decay, its images of attenuated passion, and its dense rhyme and alliteration, is typical of fin-de-siècle poetry's adoption of Watteau as an important predecessor:

> It is the end, the end,
> The dance of love's decease.
> Feign no more now, fair friend!
> It is the end, the end.[66]

In *The Last Carnival*, Walcott imbues Victor's musings on Watteau with much of the same mournful melodrama. Indeed, Victor's descrip-

tion of Watteau evokes a stock set of decadent tropes, portraying Watteau as a "perfume manufacturer" who dies young of consumption.[67]

Walter Pater, in *Imaginary Portraits*, suggests that Watteau's work signals the passing of an era, of which Watteau himself is but a relic. Evoking the slogans of the French Revolution, Pater writes that "People talk of a new era now dawning upon the world, of fraternity, liberty, humanity." Watteau, however, is "really of that old time—that serious old time which is passing away."[68] For Victor in *The Last Carnival*, Watteau's 1717 painting *The Embarkation for Cythera*, in which a group of aristocratic revelers prepares to set sail for the mythical isle of Venus, likewise becomes the chief emblem of that fading world of the old French aristocracy. As Victor puts it, "He painted / his whole culture as if it were a sunset, / because all embarkation is a fantasy . . . what an elegy to the light, / what a piercing sadness!"[69] Here, Victor identifies with Watteau as a relic of a bygone era for whom embarkation, which Walcott identifies with colonization, was a fantasy doomed to failure. That is, for Victor, Watteau's painting anticipates his own fate as a member of the planter aristocracy in Trinidad. It is that "elegy for light," however, a mourning for a lost way of seeing, that preoccupies Victor throughout the play. This suggests that for Walcott, Watteau's painting offers a visual shorthand for an aesthetic regime that fades along with the culture it depicts. Nevertheless, it is the siren song of Watteau's vision that Victor struggles to overcome in his own painting.

For Walcott, Watteau's vision is mediated primarily through Baudelaire, who both idealizes distant lands as paradises where everything is "order and beauty, luxury, calm, voluptuousness" ("tout n'est qu'ordre et beauté, / Luxe, calme et volupté") and exposes them as "barren" waste lands ("Cythère n'était plus qu'un terrain des plus maigres").[70] As Julie-Anne Plax observes, in "Un voyage à Cythère" ("A Voyage to Cythera"), Baudelaire "subverts the expectations set up by the Watteau-Cythera iconography. Instead of finding a haven of happiness, love, and beauty, the pilgrim in Baudelaire's voyage finds a nightmare of pain, death, and decay."[71] Walcott's 1992 typescript for *The Last Carnival* begins with a slightly misquoted epigraph from the first line of "Un voyage à Cythère"—"Mon âme, comme un oiseau, voltigeait tout joyeux." This suggests that the initial burst of joy and levity that

Jean Antoine Watteau (1684–1721), *The Embarkation for Cythera*. Oil on canvas. Musée du Louvre, Paris. Photo: Erich Lessing/Art Resource, NY.

Baudelaire finds in Watteau's idealized vision—"My heart was hovering gaily as a bird"—will likely also turn to ash in the course of Walcott's play as it does in Baudelaire's poem.[72] In Walcott's poem "Watteau" from *Midsummer*, which was written around the same time that Walcott was working on *The Last Carnival*, Walcott casts Baudelaire as a metropolitan poet diseased with a longing for the tropics induced by Watteau's idealized vision. Walcott refers to Watteau in the poem as "malaria's laureate" and to the idea of Cythera as "the disease/of elephantine vegetation in Baudelaire,/the tropic bug in the Paris fog."[73] Likewise, in his essay "The Muse of History," Walcott refers to the recurring image of Cythera in Watteau, Baudelaire, and Rimbaud as a "fever."[74] In "Les phares" ("The Beacons"), Baudelaire describes Watteau's paintings as a carnival in which "chandeliers pour down the garish light of madness on the swirling dance."[75] In *The Last Carnival*, Victor similarly describes the revelers in Watteau's painting as if they were frozen in "some paralyzed moment in a carnival." However, Victor captures Baudelaire's same sense

of disappointment. Next to Watteau's idealized vision, Trinidadian reality hardly compares: "Santa Rosa / is what you and I have for our paradise." In this sense, Walcott critiques Baudelaire's poetry as a product of individualized metropolitan longing while deploying it to expose a dynamic of idealization and disillusionment in the aesthetic "relation" between metropolis and colony.[76]

Victor's position as a planter aristocrat in the midst of a social revolution is not unlike that of the original French settlers. As the historian Bridget Brereton notes, "Some of the leading French Creoles" in Trinidad "were descended from French aristocrats who fled the French Revolution and its aftermath in St Domingue, Guadeloupe, Martinique, and St Lucia." Even under British rule, they gave their allegiance to the House of Bourbon and the ancien régime.[77] Victor's daughter, Clodia, describes the family as both inheritors of this tradition and pretenders to it, noting that their grandfather bought the title "De La Fontaine" illegitimately: "We're a faint, bastard branch of some damned duke." Theirs is a lineage based not on their purity of breeding but on their ability to imitate the real aristocracy. They even go as far as to import an entire castle stone by stone from France for their cocoa estate: "It's an imitation, a stone fantasy."[78] In the 1992 revision of the play, Victor declares that the "cocoa barons" are among the descendants of "Watteau, Lautrec and Baudelaire." In doing so, he casts the plantation economy founded by French colonials as the product of that same metropolitan vision of the tropics found in French art and poetry. He underscores this lineage by naming his own son Antoine (Tony) after Antoine Watteau. Just as Dorian Gray suggests that "one had ancestors in literature, as well as in one's own race," Victor discovers his ancestors in the art and poetry of the Watteau-esque.[79] For the De La Fontaine family, the act of imitating Watteau becomes an aesthetic means of reinforcing an imagined racial genealogy.[80]

For Victor, his family's imagined aesthetic genealogy only stifles his ability to represent the world around him. That is, the idealized vision that European art imposes on the colonial landscape obscures its reality.[81] Early in the play, Victor grapples with the representation of tropical light. When Agatha steps off the boat from England onto the dock at Port of Spain, she remarks, "The light's astonishing. So clear!" Yet Victor replies, "Glad you feel so. Damned hard to paint." Victor's

difficulty is a consequence of his artistic training. He puzzles over how
to capture the abundant light of the tropics in the styles he learned in
the studios of Paris. The exchange that follows reveals the fundamental
problem as the difficulty of overcoming the distortions of Watteau's
influence. When Agatha wonders why Victor hired her, he jokes, "I'm
an impressionist. I believe in first impressions." Yet as he further ex-
plains, his first impression of Agatha brought back memories of Wat-
teau. "Your hair was wet, your cheeks were shining," he tells her. "You
looked like a Watteau shepherdess."[82] Victor's prior knowledge of
Watteau, whose women are idealized, bucolic types, allows him to
recognize something special in Agatha. She fits the bill not because
she makes an impression but because she fits into an impression al-
ready made.

The way Victor jokingly identifies himself as a proponent of first
impressions contradicts the actual experience he recounts, in which
elements of perception stand out because they have been presented first
in art and then in life. His experience confirms not impressionist doc-
trine but the aesthetic doctrine of Oscar Wilde, who argued that life
merely "reproduces some strange type imagined by painter or sculptor,
or realizes in fact what has been dreamed in fiction."[83] Throughout *The
Last Carnival*, Victor wrestles with the contradiction between an im-
pressionism construed as a record of one's immediate encounter with
life and the aesthete's insistence that art precedes nature. By exploring
this tension in a colonial context, Walcott suggests that any attempt at
impressionism in the New World may already be distorted by prior ar-
tistic encounters.[84] Indeed, as Linda Nochlin argues, impressionism it-
self is rarely as naïve as it appears: "the whole notion that it is possible
to divorce seeing from its cognitive, emotional, and social context is as
idealistic, in its way, as any classical norm" and "could also lead to fan-
tasy and exaggeration."[85] Such concerns did not escape French impres-
sionism's first critics, such as Jules Castagnary, who warned in 1874
(thinking of Cézanne) that the impressionists would proceed from "ide-
alization to idealization," until they "arrive at that degree of romanti-
cism without bounds, where nature is no more than a pretext for
dreams, and the imagination becomes incapable of formulating any-
thing other than personal subjective fantasies, without any echo in gen-
eral knowledge . . . and without any possible verification in reality."[86]

Victor is aware of the danger that his metropolitan artistic vision risks obscuring the realities of colonial life. As he paints his copy of *The Embarkation*, he warns Agatha not to "read too many novels," because doing so will distort her view of colonial reality:

> You'll look around you and all you'll see is fiction,
> some colorful backwater of the Empire.
> Both of us want to see what we believe,
> and if you look hard enough it will become that,
> the way I can't help seeing Santa Rosa.
> It's very very hard to see things as they are.[87]

Victor's admonishment echoes a specific moment in the shift away from Victorian realism. His lament that it is hard to see things "as they are" recalls Matthew Arnold's argument that the goal of criticism is "to see the object as in itself it really is."[88] It was this statement that prompted Pater to argue that "the first step towards seeing one's object as it really is, is to know one's own impression as it really is, to discriminate it, to realise it distinctly, . . . as in the study of light, of morals, of number, one must realise such primary data for one's self, or not at all."[89] But for Victor, the process of discerning one's own impressions is impossible to separate from the impressions made by prior artists.

When Agatha notices some women stamping cocoa outside the window of Victor's studio, she asks, "You mean those women out there aren't poor?" Victor replies, "Yes. But not in the way you think they are. . . . You're moved by poverty as some minds are by music."[90] For Victor, even primary social data is channeled through a sensibility that is the cumulative product of successive aesthetic experiences: looking at paintings, reading novels, listening to music. Such aesthetic experiences can confine and distort one's perception of even basic economic conditions in the colonies.[91] For Agatha, the task of realizing her own impressions proves difficult. When Victor hands her a volume of impressionist prints, she has trouble reading the title without her glasses: "Manet? MONET? Oh, Crikey. . . . Thought it was Mooney for a sec. / Irish sign painter, Mooney? Very obscure."[92] Agatha's confusion amounts to a joke on the entire debate: the object in question refers to impressionism, and in attempting to discern it, Agatha gets the wrong impression.

As Michael Levenson observes, early modernists wrestled over whether impressionism could be understood primarily as a mode of *"civic realism,"* in which the artist fulfills his duty as a citizen of the modern world by registering "his own times in terms of his own times," as Ford Madox Ford puts it, or whether impressionism's "radical subjectivism" risked collapsing "into an egoism which no longer attempts to establish shared norms of reality."[93] As *The Last Carnival* proceeds, Victor's artistic vision falls into this very trap, collapsing into a self-reflexive egoism. This can be seen at the climax of the first act, when Victor enlists his household into the performance of a play within a play. As Carnival season arrives, the family throws a masked ball. Victor asks the members of his household to play a scene reminiscent of the commedia dell'arte while reciting Baudelaire's "Un voyage à Cythère" in front of his copy of Watteau's *Embarkation.* He asks them to do all this while dressed as characters from the Moulin Rouge era, with his brother Oswald clowning as Toulouse-Lautrec, Agatha as Toulouse-Lautrec's friend the dancer Jane Avril, and George, his butler, as Pierrot, the commedia clown famous from Watteau's paintings. Together they represent the traditional commedia triad of Harlequin, Columbine, and Pierrot, as often depicted in their later melancholy days by artists such as Watteau, Giovanni Battista Tiepolo, Adolphe Roehn, and Honoré Daumier.[94] For Victor, Toulouse-Lautrec represents a vulgarized imitation of the Watteau aesthetic: "Toulouse-Lautrec. The whorehouse Watteau," he quips. As Victor instructs his players, "In the silence, a parang band in Watteau costume comes out. You recite the poem by Baudelaire. As Toulouse-Lautrec, you see? George is a Pierrot. Aggie comes out like a Bal Musette dancer, and somehow, it is touching, sad, a moment, a moment. . . ." Victor declares that the purpose of this masquerade is to discover "one moment of stillness, one moment of meaning, in all the noise. Two minutes of silence to remind us of our origins."[95] And yet, despite his quest for originality, Victor's *mise en abyme* of references is as imitative as his own copies of Watteau's paintings.

As bizarre as the scene is, it reflects the contradictory origins of Trinidad Carnival in both the upper-class traditions of white French Creoles and in the celebration of *cannes brûlées* (the burning of sugar cane) by former slaves after emancipation.[96] Victor, by casting his

Jean Antoine Watteau (1684–1721), *Gilles*, ca. 1718–1719. Oil on canvas. 1845×149.5 cm. Bequest of Dr. Louis La Caze, 1869 (MI 1121). Musée du Louvre, Paris. Photo: Erich Lessing/Art Resource, NY.

butler, George, as Pierrot, brings Carnival's traditional reversal of hi-
erarchies to the forefront with the spectacle of a black servant cracking
a whip in his master's house.[97] Given the dense meta-theatricality of
the scene, it seems almost inevitable that Victor's fantasy would come
crashing down around him.[98] As Oswald plays to the crowd, burying
his head under Agatha's skirt, Victor flies into a rage, accusing his
brother of creolizing the purity of the scene. As Victor's performance
disintegrates, he reveals himself as a type of mad Pierrot figure, the
moonstruck clown of Laforguean symbolism, an object of pity and
parody, tragic and comic at the same time.[99] George, the servant as
Pierrot, then, becomes a displaced figure for Victor, the artist as Pierrot.
In this way, Walcott draws an unlikely analogy between the slave's fan-
tasy of overturning the master's household and the artist's fantasy of
an elusive point of origin, an idealized moment of aesthetic purity.

Victor does not survive Trinidad's transition to independence. The
last time the audience sees Victor onstage is Independence Day 1962.
Like Villiers's Axël, he realizes that reality can never live up to his fan-
tasies, so he commits suicide offstage between the acts. As Victor's
daughter, Clodia, recalls, she would find her father dressed in full Wat-
teau regalia. He would put on "the same damned record . . . and paint
to it, and sign things 'Antoine Watteau.' " In dressing as Watteau, Victor
attempts to pass off himself as the original artist and his imitations of
Watteau's paintings as Watteau originals, signing them with Watteau's
name. In the process, he loses the ability to distinguish between him-
self and Watteau, copy and original, art and life. When asked which
costume Victor donned, Clodia points to Victor's replica of Watteau's
Embarkation. By transforming himself into the painting's likeness,
Victor transforms the painting into a likeness of himself, remaking it
into a kind of anachronistic self-portrait.[100]

Matthew Potolsky argues that in decadent texts, imitation provides
a means of both establishing a sense of history and resignifying that
history. Imitation "is a fundamentally historical gesture, for it neces-
sarily looks back, whatever its larger purpose, to a prior model." And
yet, in looking back, it creates that model as a prior model. In this vein,
the "prominence of ekphrasis in decadent writing . . . explicitly fore-
grounds the unstable relationship between copy and original, art and
life."[101] As Potolsky observes, decadent texts such as *The Picture of*

Dorian Gray and Pater's story "Apollo in Picardy" often cast their protagonists as unwitting imitators doomed to repeat prior models involuntarily. However, just as revolutionary movements often take their cue from prior models, historical imitations also open alternatives "to contemporary power structures." Thus, a "fatalistic historiography that would find only madness and death . . . might also find anticipations of revival."[102]

In *The Last Carnival*, Victor's demise revolves around a similar premise, though the text's hopes for revival through revolution seem to fall prey to a similarly doomed and imitative historical process. As Victor's son, Tony, recalls, "In the end [Victor] was delirious and kept calling himself Watteau. If he couldn't get it in the painting, he'd get it from life. So once he knew he was Watteau, he didn't have to paint anymore, you see. He had done it all already. Well, after many doctors, he had one of his lucid periods, and in one of these rational periods, he did the rational thing. No more illusions. No more Cythera! He killed Antoine Watteau."[103] Victor, as both artist and subject in the world of his own self-reflexive delusions, completely closes the circle of imitation. He can get what he wants from life because he has already transformed his life into art. His copies of Watteau's work become mere copies of himself. As he takes on the qualities of a static work of art, he becomes, as Rita Felski writes of Dorian Gray, "enclosed within an invisible frame which separates him from the continuum of history."[104] Indeed, Victor telegraphs his desire to remove himself from historical time at the play's opening, offering to toss Agatha's watch into the sea: "From now on, time must mean nothing to you."[105] When Victor's illusion finally breaks, he destroys himself. In killing himself/Watteau, Victor metonymically kills *the* Watteau painting that comes to function as a record of his likeness, figuring his own erasure from the historical record.

Victor's descent from impressionism to an imitative hall of mirrors represents a larger failure to maintain touch with the real conditions of colonial life. The play politicizes impressionism as the perceptual tipping point between a socially responsible realism and an idealizing fantasy that has dangerous real-world consequences. As Tony comments, the French, through their art, not only created a "longing for the metropole in their colonials" but also "create this longing for

paradise in *their* metropole." The result of these twinned fantasies can be found in "the way [the French] fucked up Indochina, Algeria, Tahiti, Martinique, Africa, their whole empire. . . . The bastards get so cynical and disappointed about these native paradises, they turn them into hell."[106] Walcott has Tony deliver this speech in prose, marking a rough division of labor in the play between lyric passages that idealize the passing of a colonial way of life (many of Victor and Agatha's more important speeches are in verse) and the more pronounced sense of disillusionment felt by Victor's children (though the formal lines are not always clearly drawn).

Fittingly, Walcott identifies Trinidad's political independence as the moment that reveals how Victor's impressionism fails to meet life on its own terms. The festivities of Independence Day remind Victor of Manet and Monet, and yet he bitterly declares, "I am not an artist but a mortician." As he tries to paint the Independence Day celebrations, his impressionistic attempts to capture the moment in the moment are "born dead," his still lifes are still born.[107] Independence Day represents the moment the distortions of the Watteau aesthetic override his ability to capture the defining political event of his era. Indeed, the whole lineage of Watteau-esque art comes to stand for the fatal dangers of imitation, trapping the artist in an imitative sensibility and alienating him from history. Victor becomes the model of an artist whose gradual detachment from reality, under the pressure of an idealized European vision, marks the descent from impressionism to decadence, a decadence that defines the old colonial order's inability to register the changing times in its art. One might even see Victor's suicide as his own tragic contribution to the project of cultural decolonization: "No more illusions. No more Cythera!"[108] Through Victor's suicide, Walcott imaginatively purges the nineteenth-century ideal of the tragic, schizoid artist, paradoxically, by making that ideal the focus of his play's attention.[109]

Were the play to end there, Victor's decadence would seem irredeemable. But in the second act, the play introduces a new character, Brown, who, like Walcott, reviews art for the *Guardian*. Brown visits the De La Fontaine estate just as the 1970 Black Power rebellion is beginning to build steam. At first, Brown insists he is only interested in the Watteau "heritage" that informed Victor's art, "not politics." Clodia

dismisses Victor's art, but Brown expresses his admiration for Victor's persistence:

> Believe me, I can understand.
> But that's what's admirable about your father.
> That he kept at it. Me? I gave up writing stories.
> My industry only increased frustration.
> I saw no market, no future. The more I wrote,
> the more my sadness increased. So I sank
> in a slow quicksand of paper. What was the point
> of trying to write well, to write at all?
> I became afraid of art. Any piece of art.[110]

The obstacles Brown faces reflect those Walcott and other West Indian writers faced in the 1960s.[111] Brown relies on an anemic market for West Indian literature to survive, and that market ultimately fails him. By contrast, early in the play, Agatha remarks that Victor had funded an exhibition of his own paintings in London. His wealth allowed him to refuse a career contingent on the whims of the marketplace. In this way, as Pierre Bourdieu might argue, we can see Brown's pursuit of Victor's artistic heritage as an attempt to establish a system of value that transcends the quicksand of the art market. For Brown, Victor's aesthetic autonomy, indexed by his self-reflexive imitations of prior Watteau "originals," may have been the cause of his madness and death, but it was his ability to achieve distinction outside the demands of the marketplace that allowed him to pursue his art.[112]

At a certain point in the conversation, Clodia makes a pass at Brown, mockingly sticking her head in a frame and auctioning herself off as an "original, priceless De La Fontaine."[113] Clodia construes Victor's artwork as the imitation and herself as the "original." In auctioning herself off as an "original," Clodia offers Brown something his industry could never provide, a means of bypassing the artistic marketplace that crushed his writerly ambitions, but she does so in terms that recall a slave auction. Furthermore, her offer hinges on her mock status as "an original" De La Fontaine. As Victor's child, she is not merely an original model; she is also an artwork of her parents' making: "their mother's masterpieces, / not mine," Victor claims early on. "I just supplied some brush strokes."[114] The closer Brown gets to any

"original" De La Fontaine, the further he gets from any stable notion of originality.[115] Moreover, because Brown's "purchase" is purely symbolic—he does not walk away with an actual work of art or with Clodia—the scene implies that an "original" De La Fontaine still cannot be bought at any price. The symbolic auction mocks the possibility of assigning any system of value—imitation or original, worthless or priceless—other than that intrinsic to the work of art itself.[116] In this regard, the self-absorbed aestheticism that proved fatal for Victor proves seductive to a frustrated postcolonial writer who is denied access to the art world's insular and exclusive marketplace.

We see the fraught postindependence search for origins play out as well in the revolutionary politics that surround the De La Fontaines. The play's one revolutionary, Sidney Waldron, dies an unheroic death for the cause: he is shot by police while attempting to flee to the mountains.[117] During the revolution, Sidney had forged a new identity for himself by taking the nom de guerre Cuffy Africo, recalling an oft-romanticized hero of a slave revolt in Bernice in 1763.[118] This imitation of a prior revolutionary moment allows him to contest his own political circumstances, but at a price. Sidney's death seals a motif of racial exclusivity among the black militants that runs throughout the play. Earlier in the second act, Clodia remarks that a member of the Carnival crowd "in a dashiki and afro" spat on her face as the band played "Back to Africa."[119] Brown comments at one point that the revolutionaries' "rhetoric / is as imported as their revenge."[120] Brown's remark echoes those Walcott himself made in his 1970 essay "What the Twilight Says" regarding the "imitated decadence" of both the avant-gardists and the "reactionaries in dashikis" who "screamed for the pastoral vision, for a return to nature over the loudspeaker."[121]

Eventually, the revolutionaries burn the De La Fontaine estate to the ground, leaving Victor's palace of art as just another colonial ruin. In the 1992 typescript, Agatha comments that for "a country to have a history one needs ruins," to which Brown responds, "Perhaps we're tired of other people's history." After the burning of the estate, however, Agatha replies, "you have both now, a history and a ruin."[122] In *The Last Carnival*, both the West Indian artist and the West Indian revolutionary place their hopes onto an imitated vision that is essentially utopian. In their respective quests for either aesthetic purity or

a purity of cultural origins, both lose touch with reality. Both visions, that of the colonial artist and of that of the revolutionary, become trapped by a fatal cycle of imitation, leading ultimately to the same ruin, a burned down plantation marking the decayed outer edge of an empire they cannot seem to escape.

Burnett has faulted *The Last Carnival* for "its failure to show clearly enough how its yoking of the heterogeneous worlds of art and politics works as a single project. The play itself is an enactment of the thesis that art itself is a political practice, but its internal dynamic is unclear."[123] Burnett, I would suggest, is onto something about the play that does not neatly fit into her Brechtian framework: Walcott's play argues in the end that revolutionary politics has become as divorced from reality as the most detached aestheticism. The play in this sense resists the integration of art and politics by showing where both devolve into distortion and fantasy, with both ideals proving fatally seductive. As Brown comments to Clodia in the 1992 typescript,

> Look, your father's spirit informs everything
> we're trying to express in this damned island.
> And I don't care who people think I'm betraying.
> What am I supposed to write about him?
> Victor DeLaFontaine. Trinidadian painter.
> White. Post-Impressionist. Found dead in a cricket-field,
> A death more important than all our politics.[124]

The play charts the dizzying spectacle that ensues when art is cut free from the social world, leading to a cycle of imitation that superimposes its own overriding vision on external reality, with ambivalent results. The lure of a separate artistic sphere exerts a powerful pull on the black West Indian artist after independence, a pull Brown, for instance, finds difficult to resist. Figured through Clodia as seductive and feminine, this autonomous artistic realm is portrayed as the black West Indian artist's rightful domain to claim, but access to that realm is still held by the privileged classes. The "internal dynamics" of the play suggest that the frustrated West Indian artist, like Brown, must negotiate between the illusory paradise offered up both by the white gatekeepers of the artistic field and by the naïve promises of black revolutionaries. Both the artist and the revolutionary fail to embark for their illusory

paradise; they remain paralyzed like the figures in Watteau's painting, leaving a struggling writer like Brown behind. In this sense, Walcott construes the extremes of aesthetic autonomy and cultural nationalism as equally decadent. It is by successfully representing the failure to integrate art and politics that Walcott can begin to alter the premises of the artistic field itself, the field in which he must live out his own artistic ambitions.

The Last Carnival illustrates the fatal consequences of life imitating art to the point when one can no longer distinguish between art and reality, and politics itself becomes an imitative fantasy. Nevertheless, in the 1974 essay "The Caribbean: Culture or Mimicry?," Walcott defends imitation against those such as V. S. Naipaul who see the colonial condition as being defined by mimicry. For Walcott, the mimicry inherent in Caribbean artistic forms such as calypso and Carnival leads to creativity and imagination: "From the viewpoint of history, these forms originated in imitation if you want, and ended in invention."[125] The danger of imitation in a postcolonial context, however, becomes acutely visible in Walcott's many poetic references to the visual arts. As De Lima notes, Walcott's "use of European paintings . . . has been seen both as evidence of his cultured, all embracing humanism and as a sign of his alienation from the world inhabited by the mass of his West Indian compatriots, part of his residual colonized vision."[126] In Walcott's early autobiographical poem *Another Life*, for example, he depicts the hills of St. Lucia as "stippled with violet/as if they had seen Pissarro." The speaker claims to be blessed with "a virginal, unpainted world/with Adam's task of giving things their names," and yet he looks on that world and sees the "light-furred luminous world of Claude [Lorrain]," with its "ruined temples," or J. M. W. Turner's "drizzling twilights."[127] Despite Walcott's embrace of an Adamic poetics, this twilight vision of the world is hardly virginal. Rather, it is dominated by a multitude of reproductions of European art, such as those Walcott found in his youth in hefty volumes such as Thomas Craven's 1939 catalogue *A Treasury of Art Masterpieces*, which Walcott names at several points in this and other poems.

Another Life operates as a kind of poetic *Künstleroman*, in which Walcott provides a portrait of a young artist who discovers that his gifts

lie more in poetry than in painting but whose primary inspiration still lies in painting. The first section begins with an epigraph from André Malraux's *Psychology of Art:* "What makes the artist is the circumstance that in his youth he was more deeply moved by the sight of works of art than by that of the things which they portray."[128] Walcott's epigraph to the second section, a quotation from Alejo Carpentier, offers a rejoinder, admonishing the artist to forget any vision predetermined by prior works of art and instead take up "Adam's task of giving things their names."[129] This shift from a secondary vision in which art precedes reality toward a primary, Adamic vision of an unpainted and unnamed world inscribes the journey to artistic maturity as a struggle to throw off the tendency to see life as an imitation of art. The unpainted world, it turns out, is an achieved world, an ideal to strive toward, not the world with which one begins.

In commenting on Walcott's ubiquitous use of painting as a metaphor for poetry, Robert Bensen calls Walcott's poetry an "imagistic Moebius strip in which art and life imitate each other endlessly." He goes as far as to argue that *Another Life* represents an "intimate Odyssey in which he first experiences the primal facts of life and death through art," undertaking an "epic journey to the underworld, the land of the dead, which he finds in books of paintings by European masters."[130] As if to illustrate this point, in Walcott's later epic *Omeros*, the speaker encounters the ghost of his father, who, noting that his death resembled that of Hamlet's father, wryly quips, "Death imitating Art, eh?"[131] Later in *Omeros*, the speaker steps out of a museum in Boston only to discover that "Art is immortal and weighs heavily on us, // and museums leave us at a loss for words." As in "Piano Practice," the images inside the museum transform the speaker's perception of the outside world: "Outside becomes a museum: its ornate frames / square off a dome, a few trees, a brace of sparrows; // till every view is a postcard signed by great names: / that sky Canaletto's, that empty bench Van Gogh's."[132] The outside world does not just imitate art; it imitates the postcard reproductions sold in museum gift shops.

As the speaker reenters the "dead air" of the museum, he catches sight of a painting that reminds him of Achille, one of the heroes of Walcott's own Homeric epic, caught at sea on his fisherman's boat. In the painting, the figure leans on his elbow "in the light that entered

another Homer's hand, / its breeze lifting the canvas from the museum."[133] In this instance, Walcott imagines seeing a character from his own Homeric epic on a canvas by the New England painter Winslow Homer, whose 1899 painting *The Gulf Stream* depicts a lone black sailor adrift, rudderless, on tumultuous seas surrounded by open-mouthed sharks. The "canvas" of sails puns on the "canvas" of Homer's painting, while Walcott puns on "craft" to liken his own poetic art to the small "craft" on which he imagines Achille adrift. The moment threatens to betray one of the central scenes in *Omeros*, in which Achille undertakes a mythic journey across the Atlantic to meet his ancestor Afolabe in Africa, as yet another imitation of a museum masterwork. An epic journey to the underworld that connects the world of black West Indians to an ancestral home appears retrospectively as an imitation of Winslow Homer imitating ancient Greek Homeric epic. Walcott's "craft" seems adrift in a sea of imitation, of art expressing other artworks. Indeed, in an unlikely metaphor, Walcott likens the columns of the museum to circling sharks.

In the 2010 volume *White Egrets*, Walcott describes one of his own self-portraits as an echo "straight from El Greco." With chagrin, he admits, "imitation is its own aesthetic, / less theft than tribute, as they say these days." Here again, Walcott illustrates the difficulty of breaking free from the museum of remembered images that crowd out the artist's natural vision. Observing a studio lined with "failed canvases," Walcott's task as poet is to transfigure his failure as a painter into the occasion for poetry. In the last lines of the poem, Walcott observes a small "square of sunlight" moving slowly across the studio floor, claiming to "envy its patience."[134] Here, the poet as impressionist recaptures a natural eye with which to view light itself, not the inner recollection of prior artwork.

And yet, in Walcott's 2013 play *O Starry, Starry Night*, which reimagines Paul Gauguin's visit with Vincent Van Gogh in Arles, Gauguin sees a similar image, describing a "square / of sunlight moving across the studio floor." He compares it to a "sail," reminding him of the art he intends to make when he sets sail for Martinique.[135] It is an apt lyric figure, but given Walcott's tendency to pun on "canvas" as both the material from which sails are made and the material on which one paints, to see a patch of light as a canvas sail is to see light, the ele-

mental building block of impressionism, as already a work of art. The moment hints that Vincent's later drift toward madness in the play, like Victor's in *The Last Carnival*, stems from his inability to distinguish life from art, outer light from inner light. "As in art, so in life," he comments.[136] Indeed, Vincent's brother, Theo, describes the view from a train window as a succession of "frames" like an "exhibition." As Theo explains, "I thought, People will see [this country] as a Van Gogh canvas; / so often great painters sign their names on landscapes."[137] In this sense, Walcott acknowledges the visual artist's power to reshape how the "real" world is seen. This vision goes beyond typical ekphrasis. Walcott's poetry does not describe paintings so much as paintings are the world his poetry inhabits.

The idea that life in Walcott's poetry persistently imitates art is pervasive in Walcott criticism. Nevertheless, one would be hard-pressed to find any suggestion that this critical commonplace might have anything to do with the figure with whom this idea is chiefly associated, Oscar Wilde. One reason for this might be found in an oblique reference to Wilde in the third chapter of *Another Life*, a section that consists of a series of satirical, mock-Homeric character sketches (like his earlier "Type Faces") depicting ordinary life in the West Indies. In describing an assortment of local types, Walcott conjures a stereotyped image of "mincing Gaga / the town's transvestite," who, "swirling his plastic bag" while window shopping and awaiting the return of his houseboy, represents the "most Greek of all, the love that hath no name."[138] With a flippantly archaic "hath," Walcott unmistakably alludes to Lord Alfred Douglas's poem "Two Loves" with its reference to "the Love that dare not speak its name."[139] Wilde was grilled over the meaning of Douglas's poem at his trial for gross indecency, where he defended the idea of "Greek love" as the ideal of Platonic love between an older man and a youth. The mention of Greek love in Walcott's poem makes for a barely disguised reference to Wilde's homosexuality. The passage strikes an off-key note. It hints that homosexuality may mark the point at which Adam's task of naming fails. Homosexuality is the nameless, unnamable thing.

In coding homosexuality as the love that "hath no name," Walcott also recodes Wilde's aesthetic doctrine as the thing that cannot be named within an Adamic poetics. This aporia marks the central

anxiety within *Another Life* and in much of Walcott's work, that one cannot achieve an "aboriginal" vision of an unpainted world if that world is always already perceived as an imitation of prior works of art.[140] And yet one must pass through a state of seeing life as an imitation of art before one can view the world anew, to achieve that later state of invention characteristic of the New World's creolization of Old World languages and rhythms in Carnival and calypso. In a long poem that repeatedly represents the West Indian landscape as though it were imitating the great works of European art, the oblique reference to the love that dare not speak its name indicates that the critical failure to openly acknowledge the relevance of Wilde's aesthetic doctrine to Walcott's work may have something to do with discomfort over Wilde's sexuality.

Arguably, the closest Walcott comes to acknowledging Wilde in his poetry may be in a poem dedicated to a gay poet who was intimately concerned with poetry's relation to painting, Frank O'Hara. The poem, "Spring Street in '58," reflects on the time Walcott spent on a Rockefeller Fellowship in New York. In the poem, Walcott makes the fin-de-siècle doctrine behind his imitative mode of seeing more explicit. "Spring Street in '58" amounts to a pastiche of poems such as O'Hara's "A Step Away from Them." Whereas O'Hara elegizes lost painter friends such as Jackson Pollock, Walcott mourns the "peach tan" midwestern girls he misses in Manhattan's "cheap cocktail bars." As Walcott imitates O'Hara's loose, conversational lines, he comments that in New York, "one caught style from others like a cold, / and I could look at Mimi washing her soiled feet / as life imitating Lautrec."[141] Toulouse-Lautrec portrayed numerous women bathing in various states of undress. As Walcott likely would have known, the Museum of Modern Art, where O'Hara was a curator, holds dozens of Toulouse-Lautrec's depictions of Belle Époque Paris. In a poem dedicated to O'Hara, a poet closely associated with the latest modern art of his time, Walcott catches the style of a French fin-de-siècle artist according to Wilde's principle that life imitates art. While the mention of attractive midwestern girls could be read as a mildly anxious assertion of heterosexuality or as a doubling of Toulouse-Lautrec's prurient gaze, Walcott figuratively attributes the notion of catching style to an artistic lineage that runs through gay poets from Wilde to O'Hara.

There is reason to believe that the reference to Wilde submerged in the idea that "life imitates Lautrec" is more than casual. In "The Decay of Lying," Wilde challenges the assumption that the unvarnished representation of reality serves as the basis of great art: "No great artist ever sees things as they really are." Wilde supports his case by pointing to the less mimetic style of Japanese art, arguing that the "Japanese people are the deliberate self-conscious creation of certain individual artists. If you set a picture by Hokusai, or Hokkei, or any of the great native painters, beside a real Japanese gentleman or lady, you will see that there is not the slightest resemblance between them." Moreover, if you "desire to see a Japanese effect" in the real world, you will not go to Japan "like a tourist" but steep yourself in Japanese art: "and then, when you have absorbed the spirit of their style, and caught their imaginative manner of vision, you will go some afternoon and sit in the Park or stroll down Piccadilly, and if you cannot see an absolutely Japanese effect there, you will not see it anywhere."[142]

That Walcott took this passage to heart (and transposed it to New York) seems evident in "Spring Street in '58." While O'Hara's "A Step Away from Them" ends by declaring its influences—"my heart is in my pocket, it is poems by Pierre Reverdy"—Walcott's "Spring Street in '58" seems to take its cue from Wilde: "In Spring Street's dirty hermitage, where I / crouched over poems, and drawings, I / knew we'd all live as long as Hokusai."[143] Hokusai, best known for his depiction of "The Great Wave of Kanagawa," lived to be nearly ninety. In an elegy published after O'Hara's premature death, the naïve optimism expressed in the reference is touching. But the mention of Hokusai points again toward "The Decay of Lying" as the likely source of Walcott's reflection that in New York, one "caught style from others," just as Wilde suggests one "caught" the style and "imaginative manner and vision" of Japanese artists such as Hokusai by steeping oneself in their work and then projecting that vision onto the outside world.

Walcott writes elsewhere that it was during his time in New York that, by way of Bertolt Brecht, he became interested in Japanese theater and cinema. He would "look carefully at the woodcuts of Hokusai and Hiroshige" as models for his own theatrical work, copying their style in his production design and going as far as to write a play derivative of Akira Kurosawa's *Rashomon:* "This was a deliberate imitation,

but it was one of those informing imitations that gave me a direction because I could see in the linear shapes, in the geography, in the sort of myth and superstition of the Japanese, correspondences to our own forests and mythology."[144] The more abstract mannerisms of Japanese art reveal an essence critical to Walcott's own imaginative geography. "Spring Street in '58" indicates that Walcott, in reading poems and looking at drawings, does not only catch a New York effect from O'Hara, a Paris effect from Toulouse-Lautrec, or a Japanese effect from Hokusai. He has also caught the imitative doctrine of Wilde as Wilde expressed it in his commentary on Japanese art. However, as in *The Last Carnival*, Walcott has recoded any direct mention of Wilde in the poem through a French fin-de-siècle stand-in, Toulouse-Lautrec. The fin de siècle, doubly evoked here by references to Wilde and Toulouse-Lautrec, becomes the emblem not just for a historically de-fined style of artistic vision but for the principle by which one's vision of reality, even in poetry, is saturated by one's prior encounters with visual art, leading to new forms of cosmopolitan affiliation that work across various historical geographies, such that one rediscovers Carib-bean mythologies by way of Japanese woodcuts.[145]

That Walcott catches a sense of life imitating art in the metropol-itan environment of New York shows the tension between Walcott's transnational cosmopolitanism and his desire to build an independent West Indian aesthetic, employing oblique references to Wilde to signal such tensions. Walcott's metropolitan artistic vision forms a Möbius strip with his vision of the Caribbean: each continuously shapes the way the other is viewed. Given how frequently landscapes organize themselves into paintings in Walcott's poetry and how frequently this motif has been noticed by Walcott's readers, the fact that Wilde goes unmentioned in Walcott criticism is something of a mystery. In the discussion of mimicry in the Caribbean, Wilde, as a theorist of imita-tion, seems to be the name no one dare speak. However, as Walcott himself wrote in his early criticism, as discussed earlier, the "decadents continue their explorations," and when "they have found out what we are for us, we'll use it without acknowledgement."[146]

In *Tiepolo's Hound*, Walcott imagines one way to rescue Caribbean art, and his own poetry, from a seemingly ceaseless cycle of imitation, not

by returning to an unvarnished realism but by reimagining the Caribbean roots of impressionism. In the book, Walcott depicts Camille Pissarro as a restless young artist caught between two worlds, left to choose between the "clouding of ambition" on his native St. Thomas and exile in Paris, where he might have better prospects for a career.[147] For Pissarro, the son of a Creole mother and a Franco-Portuguese Jewish father, St. Thomas represents a "new world: in faith, in form, in feature, / in blaze and shadow, in tints beneath black skin," but it also represents a dead end, "the sea's blue door locked at the end of the street." As he prepares for departure, silent voices entice and accuse him. Walking up the gangplank, he hears them urging him to stay, to become "in obscure St. Thomas / our Giotto, our Jerome, our rock-hidden hermit," while the looks of others admonish him in the local vernacular: "We know you going. / We is your roots. Without us you weak." The conditions Pissarro faces anticipate those of postcolonial artists in Walcott's day, left to choose between obscurity at home and a "betrayal" of one's roots for a chance of success in the metropolitan center.[148]

From the beginning of the volume, Walcott emphasizes a complex set of parallels between Pissarro's self-imposed exile in France and the narrating speaker's own flirtations with metropolitan art. While *Tiepolo's Hound* begins with Pissarro walking the streets of Charlotte Amalie in St. Thomas, it quickly turns toward the speaker's own encounter with impressionist painting in the galleries of New York City. "On my first trip to the Modern I turned a corner, / rooted before the ridged linen of Cézanne. // A still life. I thought how clean his brushes were! / Across that distance light was my first lesson."[149] The major epiphany that drives the narrative in *Tiepolo's Hound* comes not at the Museum of Modern Art but at the Metropolitan, where the speaker encounters what he remembers as a brilliant brushstroke on the thigh of a hound in a painting by either Tiepolo or Paolo Veronese (he never finds it again). Nevertheless, that "first lesson" in light from Cézanne proves central to the story that *Tiepolo's Hound* tells about the development of modernism and its effect on the visual and literary culture of the Caribbean. Arguably, it is not until *Tiepolo's Hound* that Walcott arrives at a convincing compromise between realism and the inevitable distortions brought about by one's prior knowledge of

European art. He does so by revising the history of modernism not as a development within European art but as the distortion of an impressionism first developed in the Caribbean.

Walcott identifies the moment in 1855 when Pissarro set sail for Europe as the defining moment in this revisionary history of modernism. It was this moment that set the stage for European modernism's break from an impressionism informed by shared norms of reality toward a private vision determined by the dictates of form. Charles Altieri has described how the transition from the impressionism of Pissarro to the increasingly abstract works of his pupil Cézanne "might be characterized by the shift from 'representing' a world to 'rendering' a world, or expressing a distinctive authorial sensibility that pervades what emerges as the represented world."[150] In *Tiepolo's Hound*, Walcott likewise turns to Pissarro and Cézanne to illustrate this subtle but important shift from impression to modernist abstraction.

In Walcott's account, Pissarro saw the world with a sense of light acquired naturally in the tropics. Cézanne, however, invented a new grammar of representation less attached to immediate perception:

> The practice of modulation by a succession
> of square, progressive strokes transformed a canvas
>
> by Cézanne to a musical score. This was not Impression
> but visible syntax; a plaster cupidon, a blue vase
>
> balanced on a tilted table, a canted horizon
> and the planes of perspective challenge reason,
>
> an idiosyncratic symmetry, a private grammar
> and brutal geometry. . . . [151]

Several of Cézanne's works contain the elements catalogued here, including his portrait of Gustave Geffroy, with its oddly tilted arrangements of objects and colors. Walcott's account of Cézanne's painting style echoes that of Maurice Merleau-Ponty, who argues that Cézanne "was abandoning himself to the chaos of sensation" by disordering traditional perspective and by painting material surfaces as if they were not part of a shared atmosphere but "subtly illuminated from within."[152] In mythologizing the birth of European modernism as a consequence of Pissarro's move from the Caribbean to France and Cé-

zanne's subsequent modulation from impressionism to something more abstract, Walcott laments that an important precedent for the West Indian artist got lost along the way. Modernism abandoned a palette and mode of seeing adapted to the representation of light in the tropics and sharable among that specific community of viewers. Instead, one finds in European art and poetry a "private grammar" and "brutal geometry," an abstract sensibility that borders on solipsism. This shift from realism to abstraction destroyed the pretense of realist illusion: "Paint had, until then, // pretended it wasn't paint." Moreover, this move toward abstraction bled across the arts to music and poetry, "defying a melody like words in [Gertrude] Stein."[153] Upending conventional genealogies of modernism, Walcott recasts modernist abstraction across the arts as a late refinement on a mode of representation born in the tropics and specifically adapted to the rendering of tropical light, in the process reclaiming impressionism for use as a modernism indigenous to the Caribbean, a modernism that must, nevertheless, resist a similar drift toward what Walcott saw as the nonsense and jabberwocky of nonfigurative abstraction in both poetry and painting.[154]

The crux of the problem, as Walcott sees it, is that when later modernist modes of seeing and painting boomerang back to the West Indies, new generations of West Indian artists learn to see with Cézanne's eyes, not with Pissarro's. Modernist "orthodoxy," learned from secondhand reproductions, becomes, in turn, the gateway to a successful career, one dependent on European museum culture:

> . . . though our inheritance
> as acolytes was in the printed masterpieces
>
> of museum missals, coloured pages of Cézanne's
> gross ecstasies, his massive awkward figures, these
>
> in Phaidon's series opened the gates of an empire
> to applicants from its provinces and islands,
>
> in the old argument that the great works we admire
> civilise and colonise us, they chain our hands
>
> invisibly. Museums seen as magnetic prisons
> for the gifted exile, the self-diminished ceiling

of a baroque glory more humbling than the sun's
predictable blue, till the exile sits, reeling

with astonishment. . . . [155]

Here, the abstract grammar of modernism is a double-edged sword: it allows entry for the colonial acolyte into the deracinated realm of an abstract, "international" style, but as a mechanism of Western art's subtle enslavement, it leaves the artist's hands invisibly chained. The artist grows bored with the "predictable blue" light of the tropics and is instead drawn by the magnetism of European masterworks into something more grandiosely "baroque." These works leave the exile artist astonished, but in such a way that threatens to recolonize postcolonial art and derail any more humble effort to simply capture the blue light of the undocumented postcolonial landscape.

In reimagining Pissarro's decision to leave the New World for the Old, Walcott asks, "What would have been his future had he stayed? / He was Art's subject as much as any empire's."[156] In one sense, to ask this question is to ask what alternative modes of representation might have developed independently of European modernism had the Caribbean offered a viable future for one of its best artists at home, a question that resonates profoundly for artists of Walcott's generation. In another sense, to imagine Pissarro as a subject of Art and not of empire is to envision an artist whose allegiance to the dictates of the imagination signals a modernist longing for aesthetic autonomy. To be the subject of Art is, in James Joyce's terms, to "fly by" the "nets" of "nationality, language, religion," or any other form of social affiliation, to be "bound neither to Cause nor to State," as Yeats writes in "The Tower," a sentiment echoed in Shabine's declaration in Walcott's poem "The Schooner *Flight*": "I had no nation now but the imagination."[157] However, that declaration of aesthetic autonomy stands against Shabine's earlier acknowledgment of his own multicultural inheritance: "either I'm nobody, or I'm a nation."[158] While autonomy from any political or ethnic affiliation might be liberating for the individual artist, this becomes a Catch-22: one can only stay home as Art's subject if one achieves artistic freedom, but one can only achieve artistic freedom in exile, where one is enslaved to another way of seeing. The artist desires a cosmopolitan freedom to make his art without concern for the constraints

of national belonging, yet this desire risks triggering a series of refine-
ments that result in a mode of representation no longer suited to the en-
vironment from which it sprang. Artistic freedom and financial solvency
come at the price of an increasing detachment from the visual, material,
and social conditions of the postcolony one sought to represent in the
first place. The Joycean urge to fly by the nets of national belonging only
lands one in the net of Euro-American museum culture.[159]

Though Walcott does not explicitly characterize the drift away from
impressionism toward modernist abstraction in *Tiepolo's Hound* as a
drift toward decadence, his revisionist understanding of early mod-
ernism in *Tiepolo's Hound* is in many ways a response to the problem
of decadence as he sees it in his early critical statements. The inclu-
sion of Walcott's own impressionist works, with their representation
of conspicuously ordinary scenes (a man gathering a net on a beach,
cows in a field, the back lot of a church), seem calculated to resist col-
lapsing into the sort of subjective egoism that plagued Victor in *The
Last Carnival*. With a transatlantic shift of geography, one might say
of many of Walcott's paintings what he says of Pissarro's: "He painted
the ordinary / for what it was, not eulogies of Pontoise." In seeing
St. Thomas in Pissarro's Pontoise, and Pissarro's Pontoise in his own
impressionist renditions of the Caribbean, Walcott *"sees both sides,
both tenses."* The measure of his verse takes its tempo from the ordi-
nary, not from "Time measured in ruins, the empires of Europe, / its
smoke, its spires." Walcott's impressionist depictions of ordinary life
on the islands resist the high imperial drama and baroque grandiosity
of European art. Rather than fall into the private vision of aestheticism,
Walcott aims for "Air and light! A privacy externalised, / an open page
crossed by the letters of leaves," as though the play of light and shadow
on the page were itself sufficient as unmediated text. "There is another
book that is the shadow / of my hand on this sunlit page," Walcott
writes. Though across the Caribbean, "A broken windmill here and a
crusted cauldron / are our open museum of bondage," Walcott's impres-
sionism dismisses these vestiges of empire. Instead of the ruins of
empire, "the brushstroke's rhyme / and page and canvas know one em-
pire only: light."[160]

In *Tiepolo's Hound*, Walcott searches for a style that discovers the
epiphanic in small details (such as the brushstroke on the thigh of a

dog), and yet that style hovers at the edge of distortion, taking liber-
ties with the real. Walcott comments on his own method in telling
Pissarro's story, describing, "These little strokes whose syllables con-
firm/an altering reality for vision//on the blank page." Yet he asks
how such small departures from reality might be allowable: "What
authority granted the privilege/of blurring, dissolving, ignoring
form, outlawing//detail." In Walcott's "imagined frame," the speaker
admits, "I shift his biography as he shifted houses/in his landscapes;
not walled facts, their essence."[161] Here is the precise, subtle shift from
representing a world to rendering a world, altering its facts, its reality,
in favor of the artist's internal vision. And yet Walcott grants only such
slight shifts. This controlled avoidance of excess, this re-creation of a
natural eye that nevertheless allows for small distortions in the syl-
lables of his poetry, as in the brushstrokes of his paintings, is the com-
promise Walcott makes with a more abstract modernist vision.

For many Caribbean writers, the attempt to revise the history of
New World modernism begins with the "irruption of modernity" on
the slave plantations of the Caribbean, as Édouard Glissant puts it, and
with the subsequent creolization of European and African languages.[162]
This mixing of languages not only illustrates the hybrid roots of New
World modernity but also suggests an alternative history of modernist
form that begins not in the metropolitan capitals of Europe but with
the importation of African rhythms into Caribbean calypso and Amer-
ican jazz and blues. As Kamau Brathwaite argues, these rhythms not
only make their way into the Harlem Renaissance poetry of Langston
Hughes and Sterling Brown but also into the "Shakespeherian Rag" of
Eliot's *The Waste Land*.[163] As Walcott himself has commented, what
was carried over from the "Old World" of Europe, Asia, and Africa is
not just custom but language, "the rhythm by which we remember."[164]

Toward the end of *Tiepolo's Hound*, Walcott suggests a similar ge-
nealogy for the visual language of modernism. He writes that "Our
tribes were shaken like seeds from a sieve./Our dialects, rooted, forced
their own utterance." He goes on to suggest that Pissarro "must have
heard the noise/of loss-lamenting slaves, and if he did,//they tremble
in the poplars of Pontoise,/the trembling, elegiac tongues he painted."
Moreover, "He paints in dialect, like an islander,/in a fresh France."[165]
In Walcott's revisionist history of modernism, the dialects of an up-

rooted African diaspora force their own utterance in Caribbean impressionism, reasserting themselves in the brushstrokes of Pissarro's paintings of France, transmuting impressionism into a diasporic dialect of Afro-Caribbean modernism carried to Europe by a white Creole painter, effectively reversing the trajectory of artistic transmission imagined in *The Last Carnival*. Whereas the weight of European modernism once bore down on the young Caribbean artist, in *Tiepolo's Hound*, European art mimics the tongues that asserted themselves in Pissarro's boyhood after their then-recent emancipation. Walcott's search for an idiom with which to express Caribbean modernity, like his search for his lost image of a hound, "will lead us // where we began: to islands, not the busy / but unchanged patronage of the empire's centre."[166] This is the vision Walcott presents as "true" for the West Indies, having been born there with Pissarro, neither distorted by the rhetoric of cultural nationalism nor captured by the later distortions of European modernism. The impressionist vision that slips in "Piano Practice," *Another Life*, and *The Last Carnival* toward an imitation of metropolitan decadence stands more firmly here while retaining a degree of autonomy from strict realism. The artist who began decades earlier with decadence finds at long last an imaginative framework in which to resist it.

3

Decadence and Antirealism
in the Art of Yinka Shonibare

IN THE 1891 DIALOGUE "The Decay of Lying," Oscar Wilde turns the nineteenth-century love of realism on its head. As Vivian, one of his characters, remarks, art deals "with what is unreal and non-existent." It "is absolutely indifferent to fact, invents, imagines, dreams, and keeps between herself and reality the impenetrable barrier of beautiful style, of decorative ideal treatment." Because "Life imitates Art far more than Art imitates Life," Vivian concludes, the "final revelation is that Lying, the telling of beautiful untrue things, is the proper aim of Art."[1] If a world of "beautiful untrue things" sounds utopian, then Wilde is unabashed, for "Progress," he argues elsewhere, "is the realisation of Utopias."[2] More than a century later, the "Young British Artist" Yinka Shonibare MBE echoes Vivian's sentiments: "People have a problem distinguishing artifice from so-called reality. Artifice is not reality; they are two different things. . . . For me it is about providing people with alternative possibilities and that sometimes requires the device of the lie."[3] Like Wilde, Shonibare believes that "to be an artist," you not only "have to be a good liar"; you also "have to be utopian in your approach. You have to create visions that don't actually exist yet in the world—or that may actually someday exist as a result of life following art."[4]

Born in London of Yoruba descent, raised in Lagos, Nigeria, and educated as a young adult in Britain, Shonibare might seem like an un-

likely spokesperson for aestheticism. Yet in works such as his 2001 photographic series *Dorian Gray* and his 1998 series *Diary of a Victorian Dandy*, Shonibare casts himself in the leading role. Shonibare's work reflects both his own complex, transnational cultural affiliations and a larger institutional struggle within Britain to present a more " 'global' version of 'our island story,' " as Stuart Hall puts it.[5] Shonibare describes his childhood in Lagos as typically middle class: he spoke Yoruba at home and English in school, listened to Yoruba music, but also drank Coca-Cola and watched *Hawaii 5-0*.[6] In 2004, Shonibare was granted the title Member of the Order of the British Empire (MBE). Other commonwealth artists have refused the honor, but Shonibare has ironically incorporated the title, along with the "RA" that comes with his election to the Royal Academy of Arts, into his official artistic identity: it is "better to make an impact from within rather than from without," he argues; "It's the notion of the Trojan horse. . . . You can go in unnoticed. And then you wreak havoc."[7] Shonibare's work has been featured in such iconic British locations as Trafalgar Square, the National Gallery, the National Maritime Museum, and the Tate Gallery. His 2014 installation *The British Library* featured a colorful array of books embossed with the names of immigrant writers and artists who have made a mark on British culture, from T. S. Eliot, Kazuo Ishiguro, and Amartya Sen to George Frideric Handel and Madonna. In slyly aligning himself with the gatekeepers of British culture, however, "Shonibare infiltrates history and challenges ideas of [British] heritage" by presenting the story of Britain as "already cross-cut by new and old lateral connections and reciprocal global influences."[8]

As works such as *The British Library* demonstrate, Shonibare's themes are often highly literary. His *19th Century Kid* series of sculptures (2000) represents "giants of literature" such as Charles Dickens, Charlotte Brontë, and Mary Shelley in miniature standing on tables.[9] His *The Age of Enlightenment* series (2008) portrays Adam Smith reaching for a book and Immanuel Kant writing at this desk. In the *William Morris Family Album* series (2015), Shonibare pays tribute to a major figure of the Arts and Crafts movement known as a decorative artist, book designer, writer, and publisher. While Shonibare may not be a poet or writer like the other figures examined in this book,

Shonibare's visual work represents an ongoing critical commentary on the literary arts, including their forms, ideologies, and institutional status. At the same time, there are insights that a literary scholar might provide into his work that might not catch the notice of an art critic. While there is much at stake in Shonibare's work for literary criticism with regard to the Enlightenment and Victorian eras, no artist's work better illustrates how ideas about decadence, dandyism, and aestheticism have helped transform the politics of realism in the globally oriented art and literature of the late twentieth and early twenty-first centuries.

For Shonibare, Wilde's antirealism serves as a Trojan horse that works in two directions, infusing nineteenth-century aestheticism with the politics of twenty-first-century global migration even as it challenges what Leela Gandhi calls "the constitutively modern demand for realism in politics."[10] Aestheticism's reputation has suffered in the twentieth century for "the element of late Victorian silliness about it" as well as its "apparent political indifference," its seeming refusal to be "*for* anything—history, politics, or morality, for instance," in favor of art for art's sake. But as Angela Leighton argues, aestheticism's severest critics, Walter Benjamin among them, "[leave] out the extent to which Victorian aestheticism was almost always impure, . . . and beset by the very serious 'subject matter' it seems to avoid."[11] Moreover, as Regenia Gagnier observes, Wilde's aestheticism pushed back against the materialism of his own age: "'Art' was the magical, fetishized term dandies deployed to replace the losses of the age of mechanical reproduction."[12] For Shonibare, aestheticism's built-in impurity, despite its pose to the contrary, renders it well suited for a renewed critique of the material conditions of twenty-first-century art. In privileging beauty over verisimilitude, Shonibare gets at the heart of the political questions that drive postcolonialism—migration, diaspora, displacement, exile, globalization, cultural hybridity, and so forth—paradoxically by way of the mixed-up history of aestheticism's apparent refusal of politics. Shonibare's postcolonial decadence, however, not only entails the aestheticism expressed in his playful references to the decadent movement in Europe but also evokes the term "decadence" as it was used in Europe's former colonies, as when the playwright Wole Soyinka describes a scene at the British Residence in colonial Nigeria as

"redolent of the tawdry decadence of a far-flung but key imperial fron-
tier."[13] By fusing these "far-flung" elements of colonial and postcolonial
decadence with European aestheticism, Shonibare invites a new un-
derstanding of fin-de-siècle decadence within a broader transnational
framework, reinventing Wilde's antirealism for a globalized, postcolo-
nial world while building on the antidecadent critique developed by
earlier writers such as Achebe and Soyinka to address contemporary
global issues.

Shonibare's antirealist style reflects a pivot that began in the 1980s
away from photorealism in the representation of black experience. Ac-
cording to Stuart Hall and Mark Sealy, artistic practices based on the
photojournalism of the 1960s and 1970s, which sought to counter neg-
ative stereotypes through a "strategy of 'positive imagery,' " "now
seemed inadequate; and that in turn precipitated a critique of documen-
tary realism and a decisive move towards the 'constructed image,' "
producing "a new kind of cultural politics of representation." Hall and
Sealy argue that "the challenge to documentary notions of 'truth,' the
critique of the photographic image as a classic 'realist' text, and of es-
sentialist notions of identity and cultural nationalism, all led to a rad-
ical break with the dominant mimetic tradition in photography."[14]
This break enabled artists such as Shonibare to see identity as a "play
of positions," to take pleasure in "the artifice, the show, [and] the ex-
cess" of these new practices, and to use them to show how "in the co-
lonial drama, distinctions between 'inside' and outside'—the domestic
and the imperial—are difficult to sustain."[15] Among other artists in
this vein, Shonibare's work reminds one of the lush, highly stylized
portraiture of Kehinde Wiley, who presents realistic images against the
decorative patterning of Morris-style wallpaper, African textiles, and
stained glass. Shonibare's work also resonates with that of the Nigerian-
born artist Iké Udé, whose ironic self-fashioning as a cover model for
mock issues of *Cosmopolitan* and *GQ* suggests a dandyism "designed
to undermine forever the claim of some 'reality' to stand outside of the
'artifice' of cultural performance in such a way as to constitute a cri-
tique of it."[16]

For Shonibare, the break with documentary realism extends to his
treatment of colonial history. Like Wilde, Shonibare demonstrates that
"the one duty we owe to history is to rewrite it."[17] While Walcott sought

to revise the history of modernism by restoring impressionism to the Caribbean, thereby circumventing the imitative distortions of postcolonial vision, Shonibare is more willing to take advantage of a full break from documentary realism to reimagine history on his own terms. This extends to his subversive embrace of European museum culture, as in his sculptural installation *Colonel Tarleton and Mrs. Oswald Shooting* (2007). In that work, Shonibare created a startlingly beautiful but violent hunting scene within London's *National Gallery* to draw attention to portraits of plantation owners who acquired their wealth from slavery, revealing the colonial economy underpinning European leisure activities, from hunting to gallery going. In this sense, Shonibare's work employs a revisionary strategy similar to that of the poet Bernardine Evaristo, who takes Wilde's aphorism as the epigraph to her verse novel *The Emperor's Babe*, an anachronistic, multicultural reimagining of third-century Roman Britannia, which I examine in Chapter 4. For Shonibare, Wilde's maxim might well serve as an epigraph for his own revisions of Britain's colonial history.

When Shonibare takes on colonialism, he often does so by Africanizing the "frivolous" activities of the Victorian leisure class that reaped the spoils of empire, as in his 2000 work *Hound* or his 2001 *Leisure Lady (with Pugs)*.[18] These works display several of Shonibare's signature gestures: his use of headless mannequins to evoke the beheadings of the French Revolution, skin tones of indeterminate ethnicity, and, most strikingly, the use of Dutch wax-print fabric, a product of the European textile industry that has become a symbol of "traditional" African culture, particularly in West Africa.[19] However, as Nancy Hynes has noted, Shonibare delights in the deliberately confused authenticity of these fabrics: "For Shonibare, the cloth is an apt metaphor for the entangled relationship between Africa and Europe and how the two continents have invented each other, in ways currently overlooked or deeply buried. The basic historical joke is that while the fabric . . . looks 'African' and is of the sort often worn to indicate black pride in Brixton or Brooklyn, it is, in fact, printed fabric based on Indonesian batik, manufactured in the Netherlands, Britain, and other countries (including some in west Africa) and then exported to west Africa, where it is a popular, but foreign, commodity. The implication, then, is that nothing is as authentic as it may seem."[20]

In a further irony, the fabric's European manufacturers deliberately employ European, not African, designers. Frans van Rood, head of design for Vlisco, one of the chief distributors of these fabrics, describes their reasoning: "Most Africans appreciate innovations that come from abroad, not those that come from within. . . . We interpret what we see in the African streets, and we see what our own imagination comes up with. We mix the two, and that provides for a constant process of creation and innovation that wouldn't happen otherwise."[21] "These popular simulacra," Robert Hobbs observes, "are considered effective in providing contemporary Africans with a more compelling image of themselves than their own designers could."[22] By virtue of the material history of these fabrics, Shonibare's insistence on what Wilde calls "beautiful style" and "decorative ideal treatment" gives material form to the ironic critique embedded in his works: that the lifestyle of the Victorian elite was sustained by the colonial exploitation of Africa. Like Ali, he shows how deeply European notions of beauty, style, and form are woven into the fabric and fabrics of empire.

Rather than attempt to remove the mask of civility from the reality of empire, Shonibare prefers to reappropriate the mask itself. In his 2003 work *Scramble for Africa*, Shonibare reimagines a scene from the 1884–1885 Berlin Conference, during which the delegates "carved up the [African] continent for the European powers geometrically and with little regard for culture or ethnicity," leaving "Africans torn by artificial political lines."[23] In signing the documents of the accord, the fourteen powers effectively subordinated Africa, its peoples, and their separate histories to the history of Europe and its own inter-imperial competition. Shonibare's work makes no attempt to step outside this historical construct. Rather, he undermines what Dipesh Chakrabarty calls the "artifice of history" by creating a "real" scene that looks artificial, exposing how Europe's version of colonial history depended on a projection of Africa as unreal and inauthentic as these supposedly authentic "African" fabrics.[24] The idea is not to deny the real consequences of colonialism but to draw attention to the artifice underlying colonialism. By dressing these European diplomats in pseudotraditional African garb, Shonibare installs a highly ironized "African" presence at the scene of a conference from which it was entirely absent. He does so not by presenting a realistic counterhistory but by reconstituting

Yinka Shonibare MBE, *Leisure Lady (with Pugs)*, 2001. Life-size mannequin, three fiberglass dogs, Dutch wax-printed cotton. Woman 160×80×80 cm, dogs 40×60×20 cm each, plinth 380×180×12 cm. Collection of Jerome L. and Ellen Stern. © Yinka Shonibare MBE. All rights reserved. DACS / ARS, NY 2017.

Europe's projections of its own mastery out of the very fabric of its idealized image of Africa. In doing so, he takes Europe's attempt to redraw the map of Africa, seen inlaid on the conference table, as material to redraw the map of contemporary transnational art, "provincializing" Europe's acts of conquest within the decentered perspective

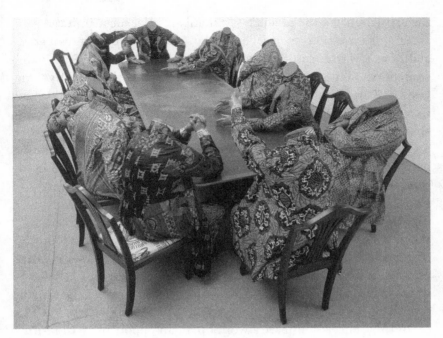

Yinka Shonibare MBE, *Scramble for Africa*, 2003. Fourteen life-size fiberglass mannequins, fourteen chairs, table, Dutch wax-printed cotton. Overall 132×488×280 cm. Pinnell Collection, Dallas. © Yinka Shonibare MBE. All rights reserved. DACS/ARS, NY 2017.

of contemporary "cosmopolitan style."[25] Shonibare deconstructs mono-cultural European accounts of colonial history by showing that the elements of "real" historical accounts are always already fakes. Provocatively, however, his work suggests that counterclaims to represent a more authentic African reality would themselves be caught up in their own illusions. In this regard, Shonibare shows a greater willingness to embrace the unabashed artificiality of decadence and dandyism to critique the same notions of African authenticity that had drawn the skepticism of earlier postcolonial figures such as Walcott.

Françoise Gaillard argues that "contrary to the *realist illusion* that takes pains to cover over all the marks of its fabrication in order to produce an effect of presence, of transparency of the real, *decadent imitation* underlines all the marks of trickery in order to accentuate

the artificiality of the product."[26] Shonibare's decadent imitations or, rather, his imitations of decadence likewise embrace their own artificiality as a way of calling out the artificiality of empire. Shonibare's contention that art must be separated from "so-called reality" suggests that "reality," too, is never more than a construction. Wilde took this idea to its logical endpoint in the cul-de-sac of self-reflexivity: since the "reality" expressed in art is no less a construction than the artwork, then "Art never expresses anything but itself."[27] But as Lawrence Danson asks, "if it were possible for art to be so thoroughly self-referential, would it have anything worthwhile to express?" In answer, Danson argues that by undoing art's mimetic relationship to nature, Wilde hoped to make visible "new forms of human creation."[28] When Shonibare speaks of the capacity of the lie to present "alternative possibilities" or "fantasies of empowerment," he aims to present new forms of human creation worthy of newly emergent global networks of human sociability.[29] For Shonibare, the lie allows the artist to give shape to reality rather than reproduce its restrictions.

In this sense, Shonibare's work offers an opportunity to rethink what Leela Gandhi, quoting Chakrabarty, calls the "straightforward identification" in certain quarters of postcolonial thought "of the realist or the factual with the political," a tendency that has produced what Gandhi calls an "anti-aestheticist fallacy." Shonibare's notion of "the lie" complicates this "disabling generic bias" not by evacuating the place of the real but by reorienting the political toward the un- or not-yet real.[30] For Stuart Hall, Shonibare represents just one case in which the turn away from realism highlights the difficulty of "finding ways of thinking about the relationship between the work and the world" without "projecting it into either a pure political space where conviction—political will—is all, or an inviolate aesthetic space, where only critics curators, dealers, and connoisseurs are permitted to play." "Fortunately," Hall remarks, with some relief, "the concepts which the diaspora arts deploy are actually *about* something—they have a content—and are not floating about in a passionless, self-referential void, entertaining only themselves."[31] And yet such passionless, contentless, self-referential voids have often been taken as the hallmark of decadence in art, or of literary exhaustion, marking the extreme separation between aestheticist doctrine and the political. Paul Gilroy,

for example, in commending music as the means by which black subjects navigate between "nationalist essentialism and a sceptical, saturnalian pluralism," cautions that black identity should be "understood neither as a fixed essence nor as a vague and utterly contingent construction to be reinvented by the will and whim of aesthetes, symbolists, and language gamers."[32] The challenge in reading an artist such as Shonibare, then, is to understand how his evocation of the self-entertaining dandy aesthete, seemingly most at home in these self-referential voids, contingent constructions, and language games, can also be about something, how his work's very connection to the world is constituted by its turn away from the real.

I do not mean to argue that such a rich and complex field as postcolonialism is biased toward or against realism in all cases. Many critics cite postcolonial literary studies' embrace of magical realism, among other stylistic innovations, as evidence of the field's broader commitment to aesthetically complex, experimental, nonrealist works.[33] Rather, I mean to emphasize the way in which Gandhi and Shonibare turn specifically to Wilde as a resource for opening up the political possibilities of aestheticism within postcolonial thought. In this regard, Shonibare follows the precedent set by earlier politically "committed" writers such as Wole Soyinka, who often bristled against the demands for social realism as they appropriated the masks of decadence and aestheticism to satirize postcolonial civil society. One of the problems Wilde's aestheticism presents in such a context, however, is the seeming "radical anti-historicism" that results from Wilde's insistence on art's self-referentiality.[34] As Gandhi argues, however, Wilde's thinking "discloses its radical provenance precisely in its defiant flight from the realm of the real."[35] Gandhi uses the term "interested autonomy" to describe how Wilde's insistence on art's difference from the real is hardly politically neutral.[36] Since, according to Wilde, nature imitates art, art that promotes "newness" and "difference" from the real holds the possibility of bringing reality along in tow. Wilde's antirealism, Gandhi argues, further reflects his cosmopolitan acceptance of the novel, the curious, and the different in general, as demonstrated by the dandy's "carefully cultivated taste for the exotic and foreign," a "xenophilia" that extends to Wilde's friendship with the young Indian poet Manmohan Ghose, for example, as well as his tastes in art.[37]

While Gandhi recovers the incipient politics of postcolonial differ-
ence in Wilde's life and work, Shonibare makes the anticolonial pos-
sibilities in Wilde's aestheticism manifest, relying on the apparent
contradiction between aestheticism and political engagement to gen-
erate surprise and interest even as he deconstructs their opposition.

At the same time, the realist paradigm to which Gandhi refers has
produced, among other things, a rich understanding of the geographic
dimensions of aesthetic objects, an understanding that is necessary for
unpacking the geographies of both fin-de-siècle decadence and its post-
colonial iterations. Edward Said argues, for example, that aesthetic
objects become "*more* interesting and *more* valuable as works of art . . .
because of their complex affiliations with their real setting," that is,
by virtue of their "*worldliness.*"[38] Importantly, the worldliness Said
describes is far from unitary. Heterogeneous histories of modernity
"derive from a discontinuous geography."[39] For this reason, the critic
must take account of "a new geographical consciousness of a decen-
tered or multiply-centered world, a world no longer sealed within
watertight compartments of art and culture or history, but mixed,
mixed up, varied, complicated by the new difficult mobility of mi-
grations, the new independent states, the newly emergent and bur-
geoning cultures."[40] By connecting artworks to their real disparate
geographies, the critic can make visible "disjunctive formations and
experiences such as women's history, popular culture, post-colonial
and subaltern material."[41] It is by tracing the disparate geographies of
Wilde's aestheticism that Shonibare makes these disjunctive forma-
tions visible in his own work, as Ali does in his references to South
Asian textiles. That is, for Shonibare, Wilde's aestheticism has its
own *worldliness*, a worldliness enhanced by its "complex affiliations"
with its "real setting" and by its subsequent postcolonial reception.[42]

Shonibare's works achieve historical depth not by conjuring history
through a realist presentation of its facts but by meticulously imag-
ining historical impossibilities that reveal hidden connections. They
"give an accurate description," as Wilde puts it, "of what has never oc-
curred."[43] Shonibare's fantastical reimaginings of Victorian England
in African garb, for example, grasp the geographic contingency of
historical formations by visually short-circuiting the colonial links
between Europe and Africa. Likewise, Shonibare routes his *Dorian*

Gray through several intervening uses of Wilde's novel. Shonibare's turn to Wilde also puts a twist on Achebe's critique of Joseph Conrad's *Heart of Darkness*, in which *The Picture of Dorian Gray* plays a pivotal role. Shonibare's return to Victorian London is further mediated by the Hollywood-produced images of London presented in Albert Lewin's 1945 film of *The Picture of Dorian Gray*, on which Shonibare's *Dorian Gray* is based. Shonibare's photographs respond as much to the political and sexual geographies of wartime London encoded in Lewin's film as they do to those encoded in Wilde's novel. That is, Shonibare's Wilde is multiple, mixed up, reflecting the disparate geographic and historical routes along which Wilde's work traveled in Europe, Africa, and America. And yet, like Wilde, Shonibare links the invention of otherness to local geographies of aesthetic experience. For this reason, Shonibare's recent work can be situated within postcolonial mappings of contemporary London, even as it reflects back on the decadence of postcolonial Nigeria, as portrayed by Achebe and Soyinka. If Shonibare locates his work in the hothouse of decadent aesthetics, that hothouse belies a worldliness that is surprisingly global in reach. At the same time, the multiple routes by which the concept of decadence enters Shonibare's work, from sources as diverse as Wilde, Baudelaire, Rococo art, Italian opera, New Wave cinema, and Soyinka's satire, demonstrate the continuing relevance of Wildean antirealism at the point where the limits of empire intersect with the limits of representation.

In the 1977 essay "An Image of Africa: Racism in Conrad's *Heart of Darkness*," Achebe explores where these limits meet in fin-de-siècle modernism, providing a foundational moment from which Shonibare departs. Achebe takes Conrad to task for portraying Europe as the location of refinement and civilization while portraying Africa as " 'the other world,' the antithesis of Europe and therefore of civilization, a place where man's vaunted intelligence and refinement are finally mocked." Achebe faults Conrad's impressionistic style for reducing African speech to an "uncouth babble of sounds" and the Congolese people to a "glimpse of rush walls, of peaked grass-roofs, a burst of yells, a whirl of black limbs." For Achebe, the problem is not just that Conrad portrays Africans as a blur of sound and image but that he does so while pretending to write in a realist mode: "When a writer while pretending

to record scenes, incidents and their impact is in reality engaged in inducing hypnotic stupor in his readers through a bombardment of emotive words and other forms of trickery much more has to be at stake than stylistic felicity." What F. R. Leavis calls Conrad's "adjectival insistence upon inexpressible and incomprehensible mystery . . . must not be dismissed lightly as a mere stylistic flaw," Achebe argues, "for it raises serious questions of artistic good faith."[44]

While Achebe's claims have been hotly debated, what concerns me here is the way Achebe reinforces the link between Conrad's stylistic excess and his bad faith by portraying Conrad as a decadent. Indeed, none of the experimental modes associated with the European fin de siècle—impressionism, symbolism, or primitivism—fare well with Achebe. For Achebe, Conrad's intensely subjective impressionism, which deepens, in Michael Levenson's words, a late-Victorian "withdrawal of subjectivity from the realm of fact," paradoxically denies the subjectivity of the non-European.[45] Likewise, by dismissing Conrad's evocation of "inexpressible and incomprehensible mystery," Achebe revives a typically high-modernist dismissal of symbolist mystification, attributing such decadent tendencies to the decline of empire. As Levenson observes, "Whereas Mallarmé had written that 'To *name* the object is to destroy three-quarters of the enjoyment of the poem . . .' Pound would bluntly remark that, 'when words cease to cling close to things, kingdoms fall, empires wane and diminish.' "[46] Throughout the essay, Achebe systematically cancels Conrad's image of Africa as bestial, primordial, backward, and barbaric. At the same time, though, he reinforces Conrad's image of Europe as overly refined, artificial, psychologically perverse, and senescent. He argues that Conrad's stylistic excess, like Gauguin's primitivism or Picasso's use of African masks, can be seen as an attempt to infuse "new life into European art, which had run completely out of strength."[47] In this, Achebe, like Walcott, sees certain developments in modernist European art as symptoms of decadence, not its repudiation. Only by reattaching words to things or, rather, to people, Achebe implies, can one successfully counter the racist consequences of an egocentric impressionism, an incomprehensible symbolism, and a last-ditch primitivism, by means of a more socially responsible realism. What matters for Achebe is the importance of being earnest, and realism is the coin by which earnestness is traded.

It is perhaps not surprising, then, that to make a point about the decadence of Conrad's fin-de-siècle English novel, Achebe turns to the leading example of British decadence, Oscar Wilde, and his novel, *The Picture of Dorian Gray:*

> For reasons which can certainly use close psychological inquiry the West seems to suffer deep anxieties about the precariousness of its civilization and to have a need for constant reassurance by comparison with Africa. If Europe, advancing in civilization, could cast a backward glance periodically at Africa trapped in primordial barbarity it could say with faith and feeling: There go I but for the grace of God. Africa is to Europe as the picture is to Dorian Gray—a carrier onto whom the master unloads his physical and moral deformities so that he may go forward, erect and immaculate. Consequently Africa is something to be avoided just as the picture has to be hidden away to safeguard the man's jeopardous integrity. Keep away from Africa, or else! Mr. Kurtz of *Heart of Darkness* should have heeded that warning and the prowling horror in his heart would have kept its place, chained to its lair. But he foolishly exposed himself to the wild irresistible allure of the jungle and lo! the darkness found him out.[48]

Achebe argues, in essence, that *Heart of Darkness* is a decadent text and that under the mask of Kurtz's colonial adventurism lies Dorian Gray's narcissistic self-delusion. Achebe uses *The Picture of Dorian Gray* to turn *Heart of Darkness* into a mirror reflecting Europe's anxiety about its own artistic, literary, psychological, and cultural decline. For Achebe, Europe's attempt to displace its own fears of degeneration onto Africa constitutes the chief symptom of a decadence well under way. While Achebe criticizes Conrad for casting Africa as a "place of negations," by invoking Wilde, Achebe casts Europe as a place of self-negation, placing Europe's illusions in a kind of self-reflexive quarantine. By detaching European modes of representation from Africa, Achebe allows another term, "reality," to appear in their absence. In doing so, he remaps the aesthetic relation between Europe and Africa as the opposition between decadent illusion and an emergent realism.

In an unexpected way, Achebe forges a strategic alliance with Wilde, an avowed foe of realism, to denounce Conrad for failing to live up to his realist pretensions. By contrast, Said argues that "Conrad's

self-consciously circular narrative forms draw attention to themselves as artificial constructions, encouraging us to sense the potential of a reality that seemed inaccessible to imperialism, just beyond its control."[49] Achebe, however, faults Conrad for a kind of representational bait and switch: Conrad offers a view into a world to which he then systematically denies access. Wilde, however, makes no claim to represent such realities, so he gets off the hook for not offering more than he can deliver. The difference between Wilde's artificiality and Conrad's, then, is distinguished only by the degree to which that artificiality is flaunted, and disagreements as to how well that artificiality advertises itself form the substance of debates over Conrad's good faith as a critic of empire. Achebe employs Wilde's flamboyant aestheticism to make this distinction visible. This leaves Wilde in a curiously Janus-faced position. Though Achebe unmasks Conrad as a decadent by reference to Dorian Gray, he positions Wilde relative to Conrad as a model of artistic good faith, the stylistic trickster who openly avows his trickery. For Achebe, Wilde's decadence cuts both ways: it becomes the signifier of Europe's cultural decadence, as manifest in Conrad's racially inflected stylistic excesses, while at the same time, because Wilde openly proclaims the distance between art and reality, Wilde provides the "words, the very tools of possible redress" that Achebe takes up to disrupt what he sees as the blind acceptance of Conrad's racism.[50] In using Wilde ironically, even satirically, to skewer Conrad, Achebe subtly shows, against the grain of his own argument, how the dandy's flamboyant aestheticism can be just as effective as an insistence on realist representation in the service of anticolonial critique.

"The Decay of Lying" illustrates how Wilde's self-conscious anti-realism may prove more congenial to Achebe's thinking, and to anti-colonial thought, than Conrad's egocentric impressionism, though Wilde's particular Orientalism presents its own problems: "No great artist ever sees things as they really are. If he did, he would cease to be an artist. . . . Now, do you really imagine that the Japanese people, as they are presented to us in art, have any existence? If you do, you have never understood Japanese art at all. The Japanese people are the deliberate self-conscious creation of certain individual artists. . . . In fact the whole of Japan is a pure invention. There is no such country, there are no such people."[51] The proposition that "there is no such country,

there are no such people" is deliberately shocking. It hangs precariously on the qualification "as they are presented to us in art." Yet Wilde's stipulation speaks to more than the referential content of Japanese painting; it speaks to the referential status of the art object itself. Said argues that for many nineteenth-century writers, "a generalization about 'the Orient' drew its power from the presumed representativeness of everything Oriental; each particle of the Orient told of its Orientalness, so much so that the attribute of being Oriental overrode any countervailing instance."[52] Wilde contravenes the (Far Eastern) Orientalism of his era by denying the "representativeness" of Japanese, or any, artwork. He insists that no generalizations are possible beyond the particular vision of the individual artist and that no particular artwork can stand in for a whole culture.

Wilde then attempts to legitimate an alternative use of foreignness in artwork to produce localized aesthetic effects. To return to a passage discussed in Chapter 2, Wilde suggests that by studying Japanese art closely, one sets about reinventing London: "if you desire to see a Japanese effect, you will not behave like a tourist and go to Tokio. On the contrary, you will stay at home, and steep yourself in the work of certain Japanese artists, and then, when you have absorbed the spirit of their style, and caught their imaginative manner of vision, you will go some afternoon and sit in the Park or stroll down Piccadilly, and if you cannot see an absolutely Japanese effect there, you will not see it anywhere."[53] Here, Wilde limits the geography of antirealist fantasy to one's local experience. The production of artistically "Japanese" effects begins at home and is realized in that most modern urban activity, flâneur-ship, strolling through a city park or around Piccadilly Circus. The flâneur fantasizes about geographically distant territory, as presented in art, only to knowingly remap those fantasies within the immediate vicinity.

For Wilde, such fantasies become essential features of the experience of urban modernity in Europe, particularly in places such as London where one might have access, as Wilde did, to Japanese art or books on the subject.[54] Indeed, *The Picture of Dorian Gray* opens with Lord Henry enjoying a "momentary Japanese effect" produced by the shadows of birds on an elegant silk curtain, which stands in contrast to "the dim roar of London" that sounds "like the bourdon note of a

distant organ."[55] It is through the decentering experience of such a "Japanese effect" that the dim roar of urban life becomes noticeable at all. That is, the modern city dweller makes and unmakes urban experience by imagining such "foreign" and "domestic" effects in tandem. The "real" London, the London indexed by its "dull roar," is no less an effect produced in the imagination of otherness than are the shadows on the curtain. A "Japanese effect" produces a "London effect."

Shonibare's *Dorian Gray* compounds and complicates such effects, reimagining twenty-first-century Britain by way of African diasporic experience. In the first scene, Lord Henry, in top hat at the right, gazes over the artist Basil Hallward at the portrait of Dorian, a likeness of Shonibare. The image preserves some sense of the division in Achebe's critique of Conrad: the white European dandy, Lord Henry, stands masterful and erect, gazing at a picture of an African that, by the logic of the novel, will wither and corrupt over time. However, if Achebe's analogy—that in Western art Africa is to Europe as the picture is to Dorian Gray—holds true, then Shonibare, by laying claim to a hybrid Afro-European identity and casting himself in the role of Dorian, doubles the terms on both sides. When Dorian later gazes on his own picture, an Afro-European will be looking back at the face of an Afro-European. If this Dorian inhabits a double geocultural identity, then by the logic of the analogy, he should exhibit a double moral identity. Rather than divvy up perfection and corruption between Europe and Africa, this culturally hybrid Dorian ought to embody both features. As Shonibare's series progresses, he does exactly that.

In both Wilde's novel and Lewin's film, Dorian notices the contrast between his perfectly preserved body and the degenerating portrait increase over time. Only when Dorian destroys the picture and himself does he come to embody the grotesque record of his immoral behavior. In a subtle departure from Wilde's narrative, Shonibare never actually shows such a temporal division between person and portrait. Rather, Shonibare's Dorian physically exhibits both Dorian's perfection and his degeneration.[56] In scene 2, we see Dorian dressed in black tie, gazing at his own image not in the portrait but in a mirror, echoing a similar scene from Lewin's film. Scene 10 depicts a living Dorian at his most grotesque, gazing into the same mirror. In this, the only scene in color, we can see the withering of Dorian's hair and skin from behind as well

Scene 1 of Yinka Shonibare MBE, *Dorian Gray*, 2001. Eleven black-and-white resin prints, one color digital Lambda print, each 122×152.5 cm unframed, 134×165 cm framed. Collection of Emily Fisher Landau, New York. © Yinka Shonibare MBE. All rights reserved. DACS/ARS, NY 2017.

as in the mirror. In Lewin's film, the only two scenes in color show the portrait once at the moment it is finished and once again for shock value at the finale. Shonibare alters this later Technicolor moment to reveal not the supernatural degradation of the painting but Dorian's embodiment of his own moral degeneracy. Shonibare depicts the Afro-European subject as both immaculately youthful and marred by corruption.

Whereas Achebe deploys Wilde's novel to expose Europe's image of Africa as a projection of Europe's own internal corruption, Shonibare indicates that the African subject exhibits these internal divisions as well. Both sides maintain images of their own mastery; both project images of their own corruption onto the other. Africa's duality mirrors

Scene 2 of Yinka Shonibare MBE, *Dorian Gray*, 2001. © Yinka Shonibare
MBE. All rights reserved. DACS / ARS, NY 2017.

that of Europe's, and the hybrid Afro-European subject claims the best
and worst of both worlds. Whereas Achebe clears a space for African
realities to emerge, Shonibare fills that space again with decadent
artifice. Realism drops out of the equation as Shonibare's work in-
sists that both Africa and Europe must work through their own illu-
sions. For Shonibare, this presents an opportunity. If the picture of
corruption returns to the African side of the equation, this allows
Shonibare to lay claim to the dandy's ability to remake his own image
just as the European dandy can. Shonibare's work suggests that this
will-to-artifice may be more desirable for the contemporary post-
colonial subject than any effort to establish stricter principles of his-
torical realism.

Shonibare confirms this position in an interview with Anthony
Downey. Downey questions whether Shonibare intends his use of the

Scene 10 of Yinka Shonibare MBE, *Dorian Gray*, 2001. © Yinka Shonibare MBE. All rights reserved. DACS/ARS, NY 2017.

figure of the black dandy in *Diary of a Victorian Dandy* to be "seen as a moment of historical revisionism—a moment of going back in time and pointing out that Victorian society was not as mono-cultural as we think it was." Shonibare resists Downey's interpretation on aestheticist grounds: "I would not necessarily go with that reading. . . . It is not about expressing something that once existed but people do not know about. The images in *Diary of a Victorian Dandy* are fakes—it is pure theatre and it is Yinka Shonibare in that picture, not some obscure historical character. It is a contemporary person doing this and it is playing with this idea of making people look twice and re-engage in what they are looking at."[57] Here, Shonibare can comfortably dismiss the reading Downey proposes because the *realist* reading that elaborates on the worldliness of the artwork has become the *expected* reading. By asking the question, Downey has done part of Shonibare's

work for him, leaving him free to deny the work's historical connections while emphasizing its aesthetic effect, "making people look twice." By evading Downey's suggestions, Shonibare brings the viewer's experience into the present moment. Just as Wilde argues that by steeping oneself in the art of a distant time and place (Japan, ancient Greece, etc.) one reshapes perceptions of one's immediate surroundings, Shonibare's work can be understood to revisit Victorian London in order to reshape perceptions of contemporary black Britain.

To better understand how this works, one must return to the 1945 film version of *The Picture of Dorian Gray* on which Shonibare's work is based. Released just two months before Germany surrendered to the Allies, the film's idealized image of prewar England stands in sharp contrast to newsreel images of London after the Blitz. As a Hollywood concoction filmed on an MGM lot by a Brooklyn-born director whose other credits include *The Moon and Sixpence*, an adaptation of the Somerset Maugham novel, Lewin's *The Picture of Dorian Gray* plays the well-preserved dandy to the picture of war-torn Europe in the newsreels. And yet the film is shot through with a desperate urge to find transcendence in the ruin. Shonibare revises and inverts the film's curious relation to its own historical moment, adding historical and geographic dimensions to his 2001 *Dorian Gray* that cannot be explained by reference to Wilde's novel alone.

Although no German bombers roar across the sky in Lewin's film, Lewin's London seems subject to an invasion of another sort, that of an encroaching Eastern spiritualism. This invasion begins in the opening credits with an epigraph from Edward FitzGerald's translation of *The Rubáiyát of Omar Khayyám* on the duality of the soul and continues throughout the film as myriad "Oriental" artworks rapidly overtake Dorian's stately English townhouse. Of course, Wilde's novel features no lack of such Oriental bric-a-brac. As Urmila Seshagiri observes, "[Dorian's] worship of cosmopolitan and racially hybrid art transforms his Grosvenor Square house into an extravagant and fully global display of ancient, medieval, and modern artistry."[58] But the novel takes its time recounting Dorian's promiscuous collecting habits, picked up partly from his reading of the "poisonous book" that Lord Henry gives him.[59] The practice demonstrates the means by which Dorian relocates "his racial consciousness from the linear ties of fa-

Frame from *The Picture of Dorian Gray*, directed by Albert Lewin, Metro-Goldwyn-Mayer (MGM), 1945.

miliar genealogy to the domain of literature," as when Dorian realizes that "one had ancestors in literature, as well as in one's own race."[60] In the film, these objects begin to appear at random, as if by their own volition. While Hurd Hatfield plays Dorian as a nearly expressionless cipher who suppresses any visible hint of his internal struggle, his home becomes a battlefield on which these mysterious spiritual forces from the East (Hindu gods, bodhisattvas, etc.) war with the sensuous materialism of Western decadence.

The charge appears to be led by a magically endowed Egyptian cat-god figurine. In a departure from Wilde's novel, the film attributes Dorian's mystical preservation to the cat's powers. Early on, Lord Henry warns Dorian that the cat is "one of the seventy-three great gods of Egypt and quite capable of granting your wish."[61] As the film progresses, the cat ominously dominates the foreground of shot after shot. In another departure from the novel, Hallward urges Buddhism on Dorian as an antidote to his spiritual ills, offering a biography of Buddha as a remedy for the influence of the notorious yellow book

Hurd Hatfield as Dorian Gray. Frame from *The Picture of Dorian Gray*, directed by Albert Lewin, Metro-Goldwyn-Mayer (MGM), 1945.

modeled on Huysmans's *À rebours*. The film's midcentury Orientalism harks back to that of Wilde's era. J. Jeffrey Franklin notes, for example, how human figures from the Orient "lurk at the margins of many Victorian texts" as "signs of a process of cultural transformation underway in Britain as an unforeseen byproduct of the counter-invasion to which empire opened the doors."[62] The same holds true here for Dorian's collectables. Read in the context of the final days of World War II, Lewin's film betrays a sense of Britain's vulnerability by recapitulating Victorian fears of reverse colonization.

At the same time, Hallward's Buddhist evangelism implies that in the wake of Europe's spiritual and moral collapse, redemption lies to the east. Broken and vulnerable, the West can only be made whole by opening itself up even further. Hallward's prodding suggests he believes that Eastern spiritualism might cure Dorian of his unhealthy, opium-laced cosmopolitanism. Hema Chari points out that it was by forcing the opium trade on India and China that the British could then demonize the East as sickly and decadent.[63] Fittingly, just as the British

displaced onto the Orient the origins of a decadence they themselves produced, in Lewin's film, it is only through Eastern religion that Dorian can restore an English sense of vigor. As Lord Henry tells Dorian, "Nothing can cure the soul but the senses, just as nothing can cure the senses but the soul."[64] That is, only by indulging in one cosmopolitanism can Dorian cure himself of the effects of another. This leaves Englishness itself a continually displaced phenomenon, always an object placed out of reach by competing cosmopolitanisms.

Jessica Feldman highlights how attempts to account for the advent of dandyism often begin in such geographic displacements: "For the French, dandyism is an English phenomenon, an import. For stylish Londoners, 'la mode,' Parisian style, must set the standard. This international proliferation of dandyism suggests the very displacement crucial to 'placing' dandyism: it exists in its purest form always at the periphery of one's vision, often in a foreign language or a text requiring decipherment."[65] In Monica L. Miller's account, the long tradition of black dandyism to which Shonibare belongs begins with the displacements of the slave trade and indexes a "cosmopolitanism that African subjects did not choose but from which they necessarily reimagined themselves."[66] Shonibare's use of African fabrics likewise trades on an African identity glimpsed through the eyes of European designers. For this reason, it is all the more surprising that Shonibare strips his re-created *Dorian Gray* of any of the visual references to the Orient that proliferate throughout Lewin's film. Rather, Shonibare seems to select his scenes for their quintessential Englishness: a pub, a day in the park, two scenes in the London fog, a hunting scene, and so on. His interiors are devoid of any Oriental statuary that might break up the monocultural homogeneity of the setting. By removing the East Asian, South Asian, and Egyptian iconography from Lewin's film, Shonibare heightens the contrast between his own presence as black dandy and the background image of white, Victorian London. In swapping the threat of reverse colonization from one corner of the empire for that from another, Shonibare enacts not one but two substitutions: the black dandy substitutes for the white, and an oppressive Englishness substitutes for an oppressive Orientalism. Shonibare's work indicates that whether or not Victorian London was a historically multicultural cosmopolis, this work of art known as *The Picture*

of Dorian Gray, in each of its iterations by Wilde, Lewin, and Shonibare, has always been a (differently) multicultural invention, a work best glimpsed through its ever-changing visions of the imperial periphery.

Shonibare identifies with the figure of the dandy as "an outsider," he says, "whose only way in is through his wit and his style." The dandy's "frivolous lifestyle is a political gesture of sorts, containing within it a form of social mobility. Needless to say, Oscar Wilde is a good example of the dandy and he played that role well; he used his wit and his style to progress within English society and was brutally penalised in the end for his apparent frivolity." Speaking as "a black man living in the U.K.," Shonibare observes of Wilde, "His apparent lack of seriousness of course belied an absolute seriousness and that attracts me to the dandy as a figure of mobility who upsets the social order of things."[67] Wilde, of course, was convicted not of frivolity but of "gross indecency." How, then, does Wilde's status as a queer Irishman relate to Shonibare's depiction of Dorian as a racial and cultural outsider, a figure of global and transnational, not just gender and sexual, mobility?

Miller remarks that Shonibare curiously evades the subject of homosexuality: "Nowhere is the sexuality depicted in *Diary of a Victorian Dandy*, in Wilde's story, and in Lewin's film in evidence in this series; it is empty of any scenes of charged assignations between Dorian and Sybil or of homoerotic banter between Lord Henry, Basil, or Dorian. Shonibare empties out the queer content of one of the English language's most prototypically queer texts."[68] Although this may appear to be the case at first glance, it is important to remember how careful Wilde's publishers were to avoid making the novel's allusions to homosexuality too explicit.[69] Likewise, Lewin's film was promoted as a heterosexual, bodice-ripping potboiler (the tagline in one promotional image reads, "Why did women talk about Dorian Gray in whispers?"), with the homoerotic undertones pushed to the background. (In the same image, James Vane is seen pressing a knife to Dorian's chest under a streetlamp.) This promotional image is then enticingly underlined with the salacious warning, "suitable only for adults." To my eye, the sexuality in Shonibare's *Dorian Gray* has not been evacuated so much as it has been rather deeply encoded, just as it is in Lewin's film and Wilde's novel.

Promotional poster for *The Picture of Dorian Gray*,
Metro-Goldwyn-Mayer (MGM), 1945.

Scenes 6 and 7, for example, depict an episode in which Dorian pretends not to recognize Hallward on the street through the fog. The images echo the visual vocabulary of gay male street cruising in an era of legal repression: the risky exchanges of glances and casual conversation, chance encounters that could lead variously to a sexual tryst, misunderstandings and violence, or arrest by decoy police officers. Quentin Crisp's humorous memoir of midcentury gay life in London, *The Naked Civil Servant* (1968), renders many such scenes and their widely varying outcomes. Crisp's account of the war years, particularly relevant in the context of Lewin's film, describes various sexual dangers and opportunities brought out by the Blitz. During the blackouts, when the lights were dimmed to avoid making easy targets for German bombers, anything could happen: "For most of 1940 London by night was like one of those dimly lit parties that their hosts hope are slightly wicked. . . . As soon as the bombs started to fall, the city became like a paved double bed. Voices whispered suggestively to you as you walked along; hands reached out if you stood still and in dimly lit trains people carried on as they had once behaved only in taxis."[70] The ambiguity of the encounter in Shonibare's pair of images, the absent context and content of the conversation and Hallward's subsequent backward glance, could easily signify two ships passing in the night or a prelude to an erotic encounter.[71] Indeed, in the next scene, Dorian is placed immediately behind Hallward in a distinctly homoerotic position, on the verge of penetrating him from behind with a knife. The following scene shows Dorian markedly distanced from his British peers, allegorizing Wilde's own ostracism from British society after the exposure of his sexual conduct. Miller, I would suggest, mistakes ambiguity for absence, missing the diminished visibility and plausible deniability that were often the condition of homosexual encounters after Wilde's trial and well into the war years, when Lewin's film was released.

Tellingly, in Wilde's typescript for the 1890 version of the novel, Dorian can similarly be found wandering "dimly-lit streets." He even gets cruised: "A man with curious eyes had suddenly peered into his face, and then dogged him with stealthy footsteps, passing and repassing him many times."[72] Wilde's editor at Lippincott canceled this last sentence along with numerous other suggestions of homosexual activity in Wilde's typescript.[73] As such cancellations remind us, di-

Scene 6 of Yinka Shonibare MBE, *Dorian Gray*, 2001. © Yinka Shonibare MBE. DACS/ARS, NY 2017.

minished visibility and plausible deniability were the preconditions for *The Picture of Dorian Gray*'s publication.

If Shonibare is imprecise about the cause of Wilde's punishment, attributing it to Wilde's "frivolity," his imprecision demonstrates an open-ended identification in his work between various outsider positions: queer, Irish, Eastern, African, imprisoned, exiled, black, diasporic. To sum up all these precarious and potentially subversive positions as "frivolous" is to show how the dandy's expertise at self-invention enables multiple remappings of British identity by Britain's internal "outsiders."[74] If the metropolitan dandy is best glimpsed at the periphery of one's vision, Shonibare suggests that the European metropolis itself can only be caught in glimpses of its imperial and sexual peripheries, that to "place" London is to be caught up in the same series of geographic and gender displacements that define the spirit of dandyism. Shonibare's use of the dandy reveals that, like the "dull roar" that Lord Henry

Scene 8 of Yinka Shonibare MBE, *Dorian Gray*, 2001. © Yinka Shonibare
MBE. All rights reserved. DACS / ARS, NY 2017.

catches only after glimpsing a "Japanese effect," London itself is an ef-
fect of one's "peripheral" vision, in all senses of the term.

In this manner, Shonibare's *Dorian Gray* calls up the discontinuous
colonial and sexual geographies that give shape to Wilde's story in each
of its iterations in 1890, 1945, and 2001. In Lewin's film, however, the
colonial presence remains physically peripheral to the central protag-
onist, always more a matter of decor. Otherness belongs more to the
film's objects than its subjects. Shonibare, by casting himself in the
role of Dorian, inverts this relationship between center and periphery,
casting the colonial subject at the heart of the metropolis as the cen-
tral protagonist in Britain's drama of self-definition. Like Hatfield's
Dorian, Shonibare's Dorian is a blank slate. Yet Shonibare's Dorian is
set upon not by Oriental mysticism but by the invading forces of En-
glishness all around him, pressing in on him like the London fog. To

survive, the African subject, like Dorian's Irish author, becomes the quintessential Englishman, a dandy more English than the English.[75]

In Wilde's novel, Lord Henry observes that by becoming an artist, one becomes foreign: "Even those that are born in England become foreigners after a time, don't they? It is clever of them, and such a compliment to art. Makes it quite cosmopolitan, doesn't it?"[76] As Seshagiri observes, "Lord Henry's witticisms describe an aesthetic-racial cycle that powerfully shapes the originality of Dorian's life: artistic expression transfigures the racial character of artists, who then, from their newfound roles as 'foreigners,' make art itself 'quite cosmopolitan.' "[77] Shonibare's work demonstrates that the process of becoming English, even for an artist born in London such as himself, is itself a process of becoming foreign.

Shonibare's *Dorian Gray* thus reflects the experience of migrant artists from across the globe as they come to terms with their sense of Britain's foreignness. It is Britain's sense of foreignness to itself, however, that Shonibare captures in his most prominent public work, his re-creation of Admiral Nelson's HMS *Victory* as a ship in a bottle. Unveiled in May 2010 as part of a series of "fourth plinth" exhibits, this oxymoronically huge "miniature" poked fun at the monumentality of Nelson's pillar from a corner of Trafalgar Square. The work now sits on permanent display at the National Maritime Museum in Greenwich, not far from the very meridian that marked London as the center of a world empire. Sporting sails of Dutch wax-print fabric, Shonibare's HMS *Victory* not only draws attention to the multiculturalism of contemporary London and the colonial relation between Europe and Africa but also draws Britain's celebrated projection of naval dominance inward. His ship in a bottle evokes the decadent trope of the hothouse flower, a figure of decadent subjectivity capable of surviving only under a bell jar. The work also evokes Dorian's practice of collecting exotic specimens from colonial territory, setting off a symbol of British conquest as one among any number of curios in some decadent's collection. The work literally seals itself within one of those "watertight compartments of art" that Said warns about, and yet it shows the "mixed up" mobility of postcolonial London within the airtight space of the antirealist artwork. Even as it draws ironic attention to Britain's dominion overseas, in reshaping Trafalgar Square or the National

Yinka Shonibare MBE, *Nelson's Ship in a Bottle*, 2009. Fiberglass, steel, brass, resin, UV ink on printed cotton textile, linen rigging, acrylic, and wood. 250×250×500 cm. Fourth Plinth Commission at Trafalgar Square, London. Courtesy of the artist and Stephen Friedman Gallery, London, and James Cohan Gallery, New York. © Yinka Shonibare MBE. All rights reserved. DACS/ARS, NY 2017.

Maritime Museum as multiculturally conscious public spaces, it recalls that vessel in Wallace Stevens's "Anecdote of the Jar," which "took dominion everywhere."[78] This ship in a bottle thus provides an apt figure for Gandhi's notion of interested autonomy, sealed off from reality yet able to reshape the reality all around it.

While glimpses of the colonial periphery are central constituents of even the most decadently self-reflexive aestheticism, Shonibare's work helps make visible the ways in which decadence floats at the periphery of postcolonialism in its displacement of aestheticism from the colony to the imperial center. In doing so, Shonibare inverts the relationship between insider and outsider, demonstrating how aesthet-

icism, even in its most decadent forms, may become central to postco-
lonial imaginings of the "real."

If, as I have argued, Shonibare's use of decadent artifice allows him to
claim the best and worst of both worlds, Dorian Gray's sense of mastery
as well as his moral and physical corruption, how might these internal
divisions map back onto an image of Africa? As Hall remarks, Shoni-
bare's work employs artifice and excess to blur distinctions between
"the domestic and the imperial."[79] If so, how might that blurring of
distinctions allows us (paradoxically) to see more clearly the internal
divisions between realist and antirealist modes of critique among
Nigerian artists during the era of decolonization? Achebe's critique of
Conrad looks more complicated, for example, when we look back on
the way Achebe hurled accusations of decadence and degeneracy at
Nigeria's postcolonial regimes. While Achebe's ironic use of Wilde
demonstrates how the idea of decadence might be employed to reveal
Europe's internal corruption, it was Achebe's contemporary Wole Soy-
inka who took the ironic use of decadence to its most satirical ends in
his critique of Nigeria's postindependence oil-boom years. In doing so,
he developed a satirical style that helps us reconceive Shonibare's
work as a mirror that reflects back on Africa as much as it does on
Europe.

Like Achebe, Soyinka lived through the Biafran civil war and its
aftermath, though he was imprisoned for nearly two years during the
war for his political activities. Also like Achebe, he later became a
fierce critic of the corruption and waste that plagued Nigeria during
the postwar oil boom. While Shonibare uses Dutch wax-print fabric to
appropriate the artifice of empire while giving Africa a seat at the table
in works such as *Scramble for Africa*, Soyinka addresses his writing
to a period when dictatorial postcolonial regimes were carving up the
continent for themselves and taking the spoils. Considered in such
light, *Scramble for Africa* might be understood to show both how a Eu-
ropean elite blindly exploited the continent's resources and people
and how an African elite in European tailoring (but brandishing em-
blems of African authenticity) committed many of the same sins de-
cades later. That is, the geographic lens of Shonibare's critique is easily

reversible. This can be illustrated by considering Shonibare's 2004 film *Un Ballo in Maschera* in relation to Soyinka's satirical critiques of colonial and postcolonial decadence in his plays *Death and the King's Horseman* and *Opera Wonyosi.*

Shonibare's *Un Ballo in Maschera* takes its title from Verdi's 1859 opera of the same name, which was inspired by the assassination of King Gustav III of Sweden in 1792. Gustav was an "actor" and a "dandy," as Shonibare remarks, and a patron of the arts who modeled his court on that of France.[80] His autocratic tendencies, however, sowed discontent by elevating the monarchy over the Swedish parliament and by playing the lower classes against the nobility.[81] After a bad harvest, Gustav quelled unrest by launching an unprovoked war against Russia, stirring up nationalist sentiment in the process. As Shonibare comments, Gustav's "costly and divisive" wars served to distract his subjects from their poverty and the extravagance of the court. For Shonibare, Gustav's "frivolity" represents "a metaphor for the kind of imperialist figure who, like [Nero] in Rome before, is 'fiddling' whilst the seat of empire is burning."[82] Gustav's imperial ambitions won him enemies among the Swedish nobles, who conspired to have him assassinated at a masked ball at the Stockholm Opera House. Shot by a captain in his own court, Gustav died some days later of his injuries.

While Verdi's opera originally stuck closely to historical events, the Naples censors "forbade regicide on the opera stage," prompting Verdi to transpose the scenario to colonial-era Boston.[83] This transposition to the United States is fitting for Shonibare, who claims that his own *Un Ballo in Maschera* was inspired by "the current global situation, particularly the war in Iraq." Gustav's war against Russia provides a ready historical parallel to the war launched by the George W. Bush administration, which was accused, like Gustav, of stirring up nationalist sentiment to further its own imperialist agenda and to distract from problems at home. However, Shonibare sees such imperialist parallels in terms of a longer history: "From the Roman to the Ottoman Empire, we have this repetition of power that always returns to the same point—the ambition to expand imperially is not very different from what's going on now."[84] Shonibare's work suggests that this is a repetition to which no culture, European, Asian, American, or African, is immune.

This repetition is built into the very structure of Shonibare's *Un Ballo in Maschera*, seeming to take on a life of its own. The film takes place at the Stockholm Opera house, where Gustav and his court are gathered for an elaborately choreographed masquerade ball dressed in eighteenth-century costumes tailored from Shonibare's signature Dutch wax-print fabric. Gustav himself is played by a female actor, and the staged rivalries and little court dramas of the dance culminate in Gustav's being shot by a female courtier, further adding to the free-wheeling play of cultural and gender signifiers. Though Gustav collapses to the ground, he magically springs up again as though the film were rolled backward, and the dancers reenact the entirety of the dance, with subtle differences, a second time. The looping effect intentionally mimics the repetition of art films displayed on loops in museums. That is, instead of reversing and repeating sequences of the film mechanically, Shonibare's actors incorporate the mechanical reversibility and reproducibility made possible by the medium into the performance itself. (Think of Charlie Chaplin's penchant for filming comically balletic sequences in reverse.)[85] In having the actors imitate the reversibility and reproducibility of the medium by performing the loop live, Shonibare foregrounds a moment of life on film imitating art, doubling a filmic moment that is then forever redoubled in the eternal loop of the museum exhibit. "It was a way of looking at formal repetition and also the way history repeats," Shonibare comments.[86] The effect is eerie, as first-time viewers are not sure whether they are watching a film on repeat, a repetitious film, or both. In performing the same sequence twice, the film is not merely selectively self-referential; it is self-referential in its entirety. The film eschews documentary realism. There are no scenes of airstrikes by coalition forces or explosions of improvised explosive devices evoking a direct connection to the Iraq War. There is violence, but the violence appears completely reversible. Played on a loop in a museum, the film's apparent attention to itself and consequent detachment from any military and political context would seem almost complete.

This would appear to be the point. Understood in the context of the Iraq War, the film would seem to condemn an out-of-touch elite for fiddling while Baghdad burns. However, the effect of the film is somewhat more ambiguous. Shonibare insists that the artist present

Frame from Yinka Shonibare MBE, *Un Ballo in Maschera* (A Masked Ball), VII. 2004–2005. © Yinka Shonibare MBE. All rights reserved. DACS / ARS, NY 2017.

multiple sides of the argument, recognizing the relativity of any moral position. There "are people who believe that the war in Iraq is absolutely right, as there are people who believe that it is absolutely wrong," he comments. The film allows "the opportunity to rethink these things, but you don't necessarily have to." Indeed, Shonibare presents Gustav's sudden resurrection in the film as a potential opportunity for redemption. Moreover, as in many of Shonibare's works, the sheer beauty of the performance draws the viewer in not with a sense of moral outrage but with astonishment at the visual imagery: "The film gives you the opportunity to engage with the various tensions. In the dance and the theatricality as well as the breathtaking visuals, you're part of that excess and you indulge in it, but then it's not that simple because there's a dark side to this beauty. It's not just a lavish banquet; there's always this 'terrible beauty.' "[87] Drawn in by the film's rich imagery, it becomes difficult to separate one's complicity in the decadence of the scene from one's sheer enjoyment of the spectacle.

(I, for one, found the film mesmerizing, strange, and obscure.) The film's appeal to beauty, then, forces an oblique and ambiguous approach to political critique.

The "disturbing quality" of the film, as Shonibare puts it, derives less from a Yeatsian sense of ambivalence (a "terrible beauty") than it does from the film's uncanny attention to its own formal qualities. There is no dialogue or music, for example. Rather, one is presented with a kind of dumb show in which the rhythmic sound of the dancers' feet, the rustling of costumes, the actors' breathing and vocal ejaculations ("huh!") constantly remind the audience, in Brechtian fashion, that what they are watching is an elaborate performance, as though one had sneaked onto the set of a silent film. "According to Brecht," Shonibare comments, "the audience completes the work of art, and that is a notion I very much subscribe to." In his use of imitation, repetition, gender ambiguity, and nonlinear narrative, Shonibare cites the influence of the French New Wave, including films such as Jean-Luc Godard's *Weekend* and Alain Resnais's lavish *Last Year at Marienbad*.[88] As a haunting image of an aristocracy in its late days implicitly threatened by popular revolution, *Un Ballo in Maschera* also brings to mind Aleksandr Sokurov's 2002 film *Russian Ark*, which depicts a grand ball at the Hermitage palace in prerevolutionary Russia. There are also parallels with Walcott's *The Last Carnival*, with its depiction of a fading French Creole plantocracy in the West Indies. In each of these cases, the detached and self-referential performance of power is taken as the chief index of a regime in decline; each presents an insular and self-reflexive aestheticism as a marker of historical decadence.

The influences Shonibare cites are European, and the target of his critique appears to be the imperialist tendency that led to Sweden's war against Russia, either Bush's war against Iraq or, as in *Scramble for Africa*, Europe's imperial conquest of Africa. Nevertheless, if the two wars the United States fought in the Persian Gulf were arguably intended to secure the U.S.'s interest in the region's oil, then Shonibare's portrayal of Gustav's aristocratic decadence might also be understood through the lens of oil. That is, Gustav's extravagance could just as easily reflect the extravagance of Nigeria's military rulers during the 1970s oil boom, suggesting an imperial continuity in the neocolonial corruption of rentier states through the exploitation of fossil fuels.

Indeed, it was oil that catalyzed the transition from colonial to post-colonial decadence in Nigeria, as demonstrated by the shift of satirical targets from Soyinka's *Death and the King's Horseman* (1975) to his *Opera Wonyosi* (1977). These plays offer important precedents for *Un Ballo in Maschera*'s political ambiguity, irony, repetitive temporality, and departure from realism through their exploration of decadence as a symptom, first, of Nigeria's misrule by Britain and, second, of its corrupt oil economy.

Both *Death and the King's Horseman* and *Opera Wonyosi* stage scenes of aristocratic extravagance, imperialist ambition, and political corruption, first by the British and then by Africa's most notoriously autocratic postcolonial regimes. Both plays condemn what Soyinka describes explicitly as the decadence of Nigerian authorities and society at large. At the time of their production, both also incited demands by Marxist-influenced Nigerian critics for more responsible social realism and explicit class analysis, demands Soyinka rejected in the name of his art. Though both plays draw attention to the artifice of authority and prestige, they also indulge, even revel in that artifice for satirical purposes, drawing attention to the ostentatious use of costume and expensive fabrics in the performance of power. As Biodun Jeyifo remarks of *Opera Wonyosi*, "The operative principle seems to be [to] use the very seductive, almost completely disarming 'oeuvre' of gaiety and rollicking fun to present decadence and stupidity, and a complicity in all this, which spares virtually nobody, ruler and ruled alike. It is very like being served a mixture of poison and excrement on a platter of gold." Furthermore, Jeyifo argues, "*this* kind of engaged art poses grave questions about the *political* responsibility of the artist." In appealing to the audience with the frivolity of a satirized decadence, you "lure" the audience "into your lap, seduce them into the charmed circle of your artistry and then cut them to size, reveal to them the mediocrity of their existence." Such an approach in Soyinka's work, Jeyifo argues, lacks "a solid class perspective."[89] Yet it is precisely this seductive mix of gaiety, decadence, and complicity that gained currency in Shonibare's work a generation later. Shonibare's highly theatrical, hybrid depiction of European decadence in African drag can be viewed as continuous with an earlier, satirical strain in Nigerian theater as it confronts the same debates over the social responsibility of black artists.

In Soyinka's *Death and the King's Horseman*, which is based on a historical incident in Oyo in 1946, a British officer interferes with local custom by interrupting the ritual suicide of the king's horseman, Elesin, who, according to Yoruba tradition, is required to prepare the way into the afterlife for his deceased king. Soyinka sets the play during World War II, heightening the pressure on the district officer, Pilkings, to stop what the colonists view as a barbaric ritual and to avoid an embarrassing incident during an official visit from the Prince of Wales. Despite the obvious tension between indigenous ritual and colonial authority, Soyinka describes *Death and the King's Horseman* as a "metaphysical" tragedy in which the "Colonial Factor" is merely a "catalytic incident." The play represents the "confrontation" between "the human vehicle which is Elesin and the universe of the Yoruba mind."[90] While the tragedy of the play begins with Elesin's failure to take his own life and ends with Elesin's British-educated son Olunde's decision to sacrifice his own life in his father's stead, I wish to draw attention to scene 4, which takes place at a masquerade ball at the Colonial Residence, thrown in honor of the visiting Prince. The scene enacts a satirical departure from the play's otherwise-tragic events and illustrates the odd temporality and geography of colonial decadence, setting the stage for Soyinka's later critique of Nigeria's postcolonial decadence.

In the stage directions for the scene, Soyinka paints a tableau "redolent of the tawdry decadence of a far-flung but key imperial frontier," in which the Prince and his retinue arrive "dressed in seventeenth-century European costume" while a black military band, led by a white conductor, "plays 'Rule Britannia,' badly."[91] The fact that the ball, according to Soyinka, is "redolent" of a "tawdry" and "far-flung" scene of colonial decadence marks this instance as a faded repetition of some prior scene of grandeur, distant from its European original in both time and space but easily recognizable as a scene repeated again and again throughout the colonized world. That is, the decadence of this colonial outpost becomes as much a function of empire's geography, its distensions and repetitions, as it is a function of empire's diminishment over time.[92] The image of a band of locals playing "Rule Britannia" badly might also be read as a representation of colonial mimicry. There is a slyly subversive quality to the poor performance

that undercuts the Prince's attempt to project the majesty of his office abroad.[93]

While the masquerade documents the ritual quality of colonial power and the elaborate trappings of royal prestige, the scene is also clearly a travesty of a prestige in tatters. While the Prince and his company's costumes are a deliberate throwback to the masked balls of earlier eras of European royalty fiddling while their nations burned (as in the courts of Louis XVI, Gustav III, and the Romanovs), in the midst of a world war that was to lead directly to the breakup of the British Empire, the ball could be seen as the empire's last dance, lending the scene a sense of historical irony. When Pilkings's wife, Jane, accuses the Yoruba of feudalism and barbarism for insisting on Elesin's suicide, Olunde responds, gesturing toward the Prince and his retinue, "And this? Even in the midst of a devastating war, look at that. What name would you give to that?" Jane calls it "therapy, British style. The preservation of sanity in the midst of chaos," to which Olunde replies, "Others would call it decadence."[94] From the colonizer's perspective, "sanity" can be preserved only by the continuing, desperate imposition of British civility. While the play's tragic arc bends inexorably toward Olunde's death, the masked ball marks the empire's attempt to project its strength through the creation of a kind of timeless and deracinated space where imperial power is held frozen in its most aristocratic guise across the centuries and despite local difficulties. Nevertheless, the attempt to impose imperial civility appears to the colonized as an increasingly tawdry spectacle. In this sense, the key mode of anticolonial critique shifts momentarily in the play from one of metaphysical tragedy bound by the Yoruba world to decadent travesty in the exposure of empire's exhausted and exhausting iterations. The masked ball is a pale imitation of the original, betraying the original display of power as a display of power in decline.

The masquerade is interrupted when Pilkings and his wife arrive at the ball wearing the traditional Yoruba ancestral masks and costumes of the *egungun*, which, as a note explains, are "considered to be the reincarnated spirits of ancestors; their dress grass robe and a wooden mask representing the face or head of an animal."[95] In what seems like a parody of European modernism's encounter with African masks,

their startling appearance fascinates and impresses the Prince.[96] Nevertheless, the arrival of these pseudo-*egungun* openly smacks of sacrilege to Olunde. While the *egungun* masquerades are traditionally meant to completely conceal the wearer, bringing forth the actual presence of the ancestors, Pilkings and his wife show off the inner workings of the costume, making fun of the steps and sounds of the *egungun* masquerade to the applause of the assembled participants at the ball.[97] The moment has been read as an illustration of the profound ignorance of colonial rule, but in unmasking the *egungun*, the colonizers also unmask and deconstruct their own rituals of power.[98] Indeed, the Yoruba have been known to use the *egungun* masks to parody the appearance of white colonials, suggesting how quickly the tables on this scene might be turned. In a daring production at the National Theatre in London in 2009, director Rufus Norris went as far as to have the British roles performed by black actors in white face, further exposing the masquerade quality of Britain's rule while ingeniously enacting a carnivalesque inversion of that rule. In the end, it appears that there is no authentic colonial power; all projections of power are tawdry imitations, parodies and travesties of an absent and imagined original.

Soyinka's later play *Opera Wonyosi* takes its satirical treatment of decadence much further, except that *Opera Wonyosi* takes as its targets those postcolonial African regimes that mimic the sort of extravagance portrayed in scene 4 of *Death and the King's Horseman. Opera Wonyosi* is Soyinka's postcolonial revision of Brecht's 1928, Weimar-era *Three Penny Opera*, which was itself based on John Gay's 1728 satire *The Beggar's Opera*. Soyinka retains much of the structure and plot of the earlier plays and many of the same characters, including the gangster Mack the Knife (Macheath). The performance is accompanied by an eclectic mix of music borrowed from Kurt Weill, contemporary jazz, and traditional Yoruba song. Soyinka explicitly characterizes the social and political corruption of postcolonial Africa in terms of "decadence." "The Nigerian society which is *portrayed*," Soyinka comments, "without one redeeming feature, is that oil-boom society of the seventies which every child knows only too well."[99] As he explains in his note to the original play script,

> *Opera Wonyosi* has been written at a high period of Nigeria's social
> decadence the like of which will probably never again be experienced.
> The post Civil-War years . . . has witnessed Nigeria's self-engorgement
> at the banquet of highway robberies, public executions, public flog-
> gings and other institutionalised sadisms, arsons, individual and
> mass megalomania, racketeering, hoarding epidemic, road abuse
> and reckless slaughter exhibitionism—state and individual, callous
> and contemptuous ostentation, casual cruelties, wanton destruc-
> tion, slummification, Nairamania and its attendant atavism (ritual
> murder for wealth), an orgy of physical filth, champagne, usury,
> gadgetry, blood . . . the near-total collapse of human communication.
> There are sounds however of slithering brakes at the very edge of
> the precipice.[100]

In decrying the corruption of postcolonial Nigeria, Soyinka mimics the
excesses of the state in the excessiveness of his own litany of abuses.
Even the brakes applied to this runaway condition of social decline are
"slithering" with corruption.

A number of *Opera Wonyosi*'s main characters are expatriate Nige-
rians living in Central African Republic, allowing Soyinka to criticize
corruption at home in Nigeria from a remove. His targets, however, in-
clude not only the military regimes of post-civil-war Nigeria but also
various dictators then plaguing several African nations, including
Idi Amin of Uganda, Mobutu Sese Seko of Zaire, Francisco Macías
Nguema of Equatorial Guinea, and, most importantly for the play,
Jean-Bédel Bokassa of Central African Republic, who "got his 'parlia-
ment' to pass a bill proclaiming him as emperor-for-life, the corona-
tion ceremony of which was to cost his country almost the entire budget
for that year."[101] He is known in the play simply as Boky.

The corruption that Soyinka portrays extends from the highest
levels of government down to the pettiest of thieves. When, for example,
Mack's gang prepares a wedding party for Mack and his fiancée, Polly,
they unload piles of stolen luxury goods, including televisions, clocks,
tables, caviar, salmon, and champagne. While the gangsters show off
their expensive tastes, it turns out that the items they boosted were
intended for Boky's coronation banquet, a fact to which the corrupt
government official, Brown, turns a blind eye, more interested in
trading favors with his gangster friend than in reporting criminal ac-

tivity. The gang's extravagance not only mimics but is also part and parcel of the decadence at the top of the regime. Soyinka caustically ridicules "emperor" Boky as a self-aggrandizing Francophile (like Shonibare's Gustav) and a self-styled "black Napoleon" whose actions prove him to be a brutally violent psychopath. Boky himself recounts how, with his self-attributed "cultured tastes," he condescends to design the school uniforms for the nation's students, profiting himself from their manufacture, only to have the students gunned down when they protest, an incident Soyinka draws from real life. This grandiose imitation "emperor," then, who refers to Charles de Gaulle as "Daddy," is no less a thief and a murderer than Mack is.[102]

The ubiquitous corruption seen in Soyinka's play reflects that of Nigeria's oil-boom years, in which even the most satirical representation of society approached too closely to reality.[103] Andrew Apter recounts how, as the "expanding petro-state" exploited the nation's resources for its own enrichment, "public resources flowed back into private hands" through kickbacks, inflated contracts, graft, nepotism, inflated payrolls, and other forms of waste, including "legendary spending on lavish parties and mansions that secured social status within a highly volatile prestige economy." With the conspicuous consumption it produced, "Nigeria's oil bonanza was literally sensational," reflecting "the dizzy excitement of new wealth and opportunity." Apter further argues that in "the magical realism of Nigerian modernity, the signs of development were equated with its substance." The symbolic conversion of oil into currency, and currency into prestige, produced "a national dramaturgy of appearances and representations that beckoned toward modernity and brought it into being."[104] Nigerian society, then, took on the artifice of the theater and dramatized its modernity by its spectacular decadence. As in Fanon, Achebe, and Walcott, a sudden collapse into decadence came to be understood as the chief consequence of the postcolonial nation's leap into modernity; decadence represented the leading edge of postcolonial modernity.

In *Opera Wonyosi*, Soyinka incorporates one of the more ostentatious emblems of Nigeria's sudden leap into an illusory economic prosperity into the title of the play itself, which amounts to a cross-linguistic pun. The Yoruba phrase *Òpèrá Wónyòsi* translates roughly into English as "the dupe buys Wonyosi cloth."[105] Wonyosi was one variety of

the "lace" fabrics that became all the rage in 1970s Nigeria: "Taken up
as fashionable dress by an urban, educated elite, these cloths are worn
at traditional ceremonies as an expression of nationalistic-Africanist
sentiments."[106] Alternatively known as "Swiss lace," "Austrian lace,"
or "African lace," these fabrics share a similar history with that of
the Dutch wax-print fabric that Shonibare employs. They are, in fact,
not traditional lace at all but richly embroidered cloths originally de-
signed and produced in Austria and Switzerland and marketed in West
Africa in the 1960s. "Like the well known wax prints . . . that are
today regarded as the African fabrics par excellence, the embroidery
fabrics originating from the Austrian province of Vorarlberg are an
expression of global intertwining and question conventional percep-
tions of tradition and authenticity."[107]

As the oil boom fanned Nigeria's prestige economy, the fabrics
themselves became increasingly elaborate in both design and manu-
facture, incorporating "prestige items such as high-heeled shoes,
watches, logos of expensive car brands" into their patterns, while the
most expensive varieties were studded with hundreds of Swarovski
crystals.[108] In the popular press, "Wonyosi became a symbol and
epitome of the wastefulness of a segment of the society that had be-
come affluent as a result of the oil boom" and symbolized "the harsh
realities of the decadence of post-civil-war Nigeria."[109] As Nigeria failed
to make good on the promise of its newfound oil wealth, the govern-
ment shifted blame for its wastefulness by undertaking the "Nigeri-
anization" of industry and banning the import of luxury goods such
as Wonyosi, champagne, wine, and luxury cars, as though the nation's
decadence, like its fabric, were manufactured in the West, which, to a
certain extent, it was.[110] Such bans, however, did little to improve con-
ditions at home and only increased smuggling through Benin and other
illegal routes, compounding wastefulness with further illegal activity.

In *Opera Wonyosi*, the cloth comes to play a starring role as the vis-
ible sign of a prosperity that is rotten to the core. Indeed, the fabric
becomes a kind of currency in the symbolic economy of corruption.
Mack's wife, Polly, for instance, outfits the entire gang in "the famous
Wonyosi" that fetches "five hundred dollars a yard." Decked out in lace,
the gang hopes to convince outside partners of their legitimacy and

prestige, as though the gangsters were members of a corporate board.[111] When Mack winds up in prison, he attempts to trade his lace outfit to his guard for his freedom, arguing that since "the stuff has been banned," it will cost "twice as much."[112] The spectacle of conspicuous consumption is thus one target of the satire, but so, too, is the nationalist cynicism that led to the ban on luxury items and the subsequent exploitation of that ban for personal gain. The song that Mack then sings, "The Song of 'The Ruling Passion,'" crystallizes the link between the love of such finery and the corruption of authority:

> Don't pledge yourself to ration.
> Is it lace that brings you elation?
> Was it on your account they banned champagne?
> Tell the truth and we'll counter-campaign
> Man should indulge in what he pleases
> Who cares who calls them social diseases
> Don't sit on the fence
> You'll go all tense
> Tell me your ruling passion.[113]

As George L. Dillon notes, Neo-Classical critics employed the idea of a "ruling passion" as a means of defining character in the criticism of history and literature. It was through such ideas that John Dryden, Alexander Pope, and others came to understand the ruling passion of a character as a driver of tragedy.[114] In Soyinka's play, to let such individual passions rule is to let political self-rule fall into indolence. While satirizing conspicuous consumption on the part of the people, the "The Song of 'The Ruling Passion'" also exposes the indolence of "ruling" authorities, those who fail to address such "social diseases" because they suffer from them themselves. Soyinka's play thus underscores the degree to which the conspicuous consumption of luxury goods was symptomatic of the tragic "ruling" indolence of a state apparatus propped up by the oil boom.

Polly's father, Anikura, a corrupt philanthropist, insists at the end of the play that the trappings of prestige matter little compared to the actual enjoyment of power itself. One must ask

Who really accumulates and exercises
Power over others. The currency of that power
though it forms the bone of contention
Soon proves secondary. I tell you—
Power is delicious *(turns sharply)* Heel![115]

While luxury cars, color televisions, and Wonyosi may be the currency
of prestige in a corrupt society, that currency is secondary, a mere token
of the enjoyment of power for its own sake.

Although the practice of conspicuous consumption among the
common people mimics the ostentation of the authorities in the play,
Soyinka is quick to remind the audience that real power promotes the
illusion of equality through consumption to further its own aims. As
Boky declares, "Listen you fools. I am a revolutionary. You know the
motto of my mother country . . . —France. *Liberte. Egalite. Fraternite*
[*sic*]. If I were not an egalitarian I would not be among you dregs, you
scum, you *residue de bidet!* But I'm an egalitarian. I have the common
touch. I am a commoner. But I am not common."[116] Though Soyinka
satirizes dictators who mouth the language of egalitarianism while
holding the reins of authoritarianism, his barbs are not limited to the
condemnation of such grandiose dictators. Just as Achebe imagines
the way in which an undertow of corruption undermines political revo-
lution from the start in *Anthills of the Savannah*, Soyinka skewers the
way in which the rhetoric of revolution slides easily toward dictator-
ship. As Yemi Ogunbiyi comments, "Soyinka appears to have written
a work demanding a social revolution while in another respect it latently
attacks the revolution."[117] As with Achebe and Walcott, the language
of decadence offers a vehicle for skepticism toward the revolutionary
rhetoric of cultural and political nationalism.

Brian Crow notes in a 1987 essay that despite Soyinka's well-
regarded political activism, after his return from exile to Nigeria, his
leftist admirers in the academy took him to task for failing to embrace
a serious class critique: "Increasingly, a younger generation of Nigerian
critics has portrayed Soyinka as a brilliant but ultimately reactionary
romantic, and his plays have been unfavourably compared with the
'committed' art of Senegal's Sembène Ousmane, Kenya's Ngũgĩ wa
Thiong'o and younger Nigerian dramatists such as Femi Osofisan and

Kole Omotoso."[118] In this regard, the all's-well-that-ends-well resolution of *Opera Wonyosi* did little to impress Soyinka's critics. After a series of ludicrous plot points and betrayals, Mack is eventually condemned to death for his crimes. At the very last moment, however, he is granted a pardon as part of a general amnesty for nonpolitical criminals on Boky's coronation day. The play thus magically reaches a resolution that leaves all the corrupt sectors of society intact while eliminating political resistance. As Anikura asks, "Well, does that surprise you? It shouldn't. We men of influence—of power if you like—respect one another. We speak the same language, so we usually work things out."[119] Ogunbiyi notes that "Macheath's last minute save (as he is saved in Gay and Brecht) . . . may be a parody of the sentimental attachment to villainous heroes" or a cynical commentary on a society that routinely lauds its criminals in popular music and applauds when they get away "scot-free." Such an approach, however, is "fraught with dangers," for the play's "persistent rollicking hilarity . . . can sometimes miss its objective, when truth is set spinning around its axis so persistently, it tends to vanish amidst the laughter." Without such "truth," he argues, the play cannot credibly further a revolutionary agenda.[120] I would argue, however, that the play's all-too-pat resolution can be seen not just as a mockery of its audience's love of charming villains or as a satire of the way society's leading figures protect each other. Rather, the play's ending exposes the paradoxical temporality of Soyinka's conception of postcolonial decadence: while society appears to follow a narrative of decline, it in fact resists arriving at any sort of final judgment or revolutionary upheaval. It simply begins the cycle of corruption anew.

In the "Song of Jenny Leveller," Jenny, a prostitute whom Mack visits, sings of her expectation of judgment for her rich patrons:

Sodom and Gomorrah
Will seem quite paradisal
When this whorehouse comes to trial
On that soon-to-be tomorrow
You in your golden villa
Will know this life for real
In that cup of no denial
As I shout Hip-hip-Hurrah!

Indeed, the song takes on a revolutionary fervor as Jenny insists that
judgment will come not from divine intervention but from a social up-
rising (a great leveling of the playing field, as per her name):

> But the hand that passes sentence
> Will not descend from heaven
> There's a girl who cleans the linen
> Smeared in spunk of moneyed wantons
> It's the girl you tip the tuppence
> Who scrubs from nine to seven
> She'll watch you slowly riven
> On that rack named DECADENCE

Here, the *ABBA* rhyme scheme links "sentence," "wantons," "tuppence,"
and "DECADENCE," implying that the decadence and wantonness of
the oil boom will inevitably reach its logical, almost grammatical
conclusion in the sentencing of its worst offenders. Jenny goes on to
declare that the proletarian mob, a "crowd you've driven frantic," will
come at last to "end the picnic" for her high-class customers as she
and the crowd shout "Hip-hip-Hurrah!"[121] And yet the revolutionary
promise of the song is undercut not only by the play's resolution but
also by the notion that decadence is, in a sense, its own punishment.
To watch as society is slowly riven on the rack of decadence is to put
off any final score keeping to that "soon-to-be" yet never-arriving
"tomorrow." That Soyinka puts the play's most revolutionary anthem
to the meter of a drinking song as sung by a prostitute would suggest
a certain lack of faith in any revolutionary uprising. While Soyinka
clearly skewers the brothel's corrupt patrons, Jenny herself sells out
Mack to the police in a fit of jealousy. Instead of a hand that passes
sentence, one is left with the impression that the real temporal quality
of decadence is not that it drives toward some final apocalypse, such
as that of Sodom and Gomorrah, but that it continually avoids and puts
off any such final judgment.

 In a 1910 critique of "aesthetic culture," György Lukács argues that
from the aesthete's point of view, "Permanent tragedy . . . is the greatest
frivolity. While waiting for the impending reckoning (which never
comes), everything is permitted; at the Last Judgment everybody will
be found light—and what is the difference between light and heavy in

the real matters of life anyway? Since the whole of life and art is tragic, it does not matter how heavy or serious each detail is. . . . The feeling of eternal tragedy offers absolution for every frivolity."[122] In Soyinka's satire, decadence is a parody of judgment; the sentence is never carried out. Sodom and Gomorrah go on as per usual, and the presence of eternal tragedy rationalizes every frivolity. This manifestation of postcolonial decadence defies narrative closure of the type found in tragedy by never reaching a full stop. It is in this sense that permanent frivolity represents the true tragedy. As in Shonibare's *Un Ballo in Maschera*, this endless frivolity loops back on itself again and again, and fallen hero-villains spring magically back to life, escaping final judgment. Whereas Lukács intended his comments to deride the aesthete's art for adopting the guise of the tragic to lend substance to an otherwise-shallow attention to form and emotion, Soyinka and Shonibare ironically stage such frivolity to put history's endlessly repeating patterns of violence and corruption on full display.

When Boky calls for the promotion of folk dancing as part of the nationalist project, Soyinka further appears to mock the way revolutionary Marxism's rhetoric of cultural nationalism and social realism can be hijacked in service of a corrupt regime: "So understand this— in this empire . . . em, nation, culture is on our priority list. . . . Now a revolutionary dance must possess what we Marxists call social reality. So we are going to adapt this dance to the social reality of our progressive Centrafrique Social Experiment. Boots!"[123] In the forced gaiety that follows, Soyinka mocks both Boky's dictatorship and the Marxist insistence that art explicate social reality, showing how easily doctrinal realism can be bent to the will of autocracy. Soyinka's critic Ogunbiyi responds by attacking Soyinka's use of irony and ambiguity: "Soyinka puts in the mouth of questionable characters, sometimes in the same speech, certain incisive commentaries about society which are partly accurate, but only partly so, and therefore misleading, misleading and dangerous because they distort reality and consequently our knowledge of the obstacles that need to be mastered and even overcome within the framework of the world-view purveyed by the play. For, after all, *Wonyosi* like any effective satire exposes in the hope that it can bring about change. In a text that is packed with irony it becomes difficult to see who or what is being ironised, or to relate

the character to the prototypes they are meant to satirise."[124] While Ogunbiyi acknowledges Soyinka's Brechtian strategy of alienation, "presenting issues in a most roundabout way and so forcing us to see them in their real forms," he doubts the social utility of such irony and ambiguity as literary strategies to begin with, judging the play "in terms of its practical relevance to the struggle for a more democratic form of existence."[125]

Because "a committed work of art . . . must lay bare unambiguously, the causal historical and socio-economic network of society" in order to "transform it," Ogunbiyi proclaims that *Opera Wonyosi* must be judged a "flawed" work. "A considerable weakness of the play hinges on the fact that its irony moves in both directions."[126] Biodun Jeyifo further faults the play for focusing only on the darkest elements of society: "Art can and should reflect with the dominant temper of the age, those vital, positive points which even in the darkest times are never totally absent."[127] By insisting that the play lay bare the "truth" of the social reality it portrays, however, critics such as Ogunbiyi and Jeyifo seem to ignore that one of the "truths" Soyinka, for all his "commitment," seeks to expose is the inherent limitations and distortions of the Marxist orthodoxy of realist representation as a catalyst for social revolution. His critics of this period view his work only from within that framework, not as a critique from outside it, so they see the work as a dangerous distortion of reality. Indeed, the play's "irony moves in both directions," putting Marxist interpretative practices on the spot even as it condemns the corruption and inequality brought about by the oil boom.

In Soyinka's foreword to the published version of the play, he makes his distaste for the "malformation of the critical intellect of African neo-Marxists" abundantly clear.[128] But Soyinka agrees with Jeyifo that art should reflect the temper of the age: "Equally is it necessary that art should expose, reflect, indeed magnify the decadent, rotted underbelly of a society that has lost its direction[,] jettisoned all sense of values and is careering down a precipice as fast as the latest artificial boom can take it."[129] Soyinka further responds by insisting on art's relative separation from purely political domains of thought and action, showing an "uncompromising concern for the social values of literature," while recognizing its "limitations and its potential" and

asserting the "writer's rôle as being merely complementary to that of the politician, sociologist, technocrat, worker, ideologue, priest, student, teacher etc., not one which can usurp one or all of these roles in entirety without forfeiting its own claim to a distinctive vocation." Art can and should respond to politics, but it must do so on its own terms and with respect to the genres in which it operates: "A play, a novel, a poem, a painting or any other creative composition is *not a thesis on the ultimate condition of man.*"[130] Rather, "*Opera Wonyosi* is an exposition of levels of power in practice—by a satirist's pen. To ask for a 'solid class perspective' in such a work curtails creative and critical options and tries to dodge labour which properly belongs to the sociopolitical analyst."[131] Soyinka's response to his critics on the left is to maintain a separation of imaginative and sociopolitical disciplines in order to do justice to both approaches, maintaining art's separate but "interested" sense of autonomy.

There is something exceptional, then, to the problem of decadence that disrupts the overly rigid Marxist methods of analysis applied by Soyinka's critics. In exposing the exaggerated and unbalanced tendencies of society, Soyinka's satire must be exaggerated and unbalanced. In decrying excess and extravagance, it risks indulging the appeal of such excess and extravagance. In ironically satirizing decadence and corruption, Soyinka's art refuses to be reduced to the mere political condemnation of decadence and corruption. Decadence, which always seems to collapse into self-parody on its own, instead casts its satirical net back on the viewer. To look at Shonibare's *Un Ballo in Maschera* from the perspective of *Opera Wonyosi*, then, is to remark on the extraordinary degree to which Shonibare embraces an irony that "moves in both directions." Indeed, Shonibare's many ambiguous depictions of the Victorian leisure class, headless, with ethnically indeterminate skin tones, seem to hark back to earlier critiques of Nigeria's Wonyosi era, when fabric manufactured in Europe and sold in West Africa became the currency of an extravagance built on the back of Nigeria's oil boom. That is, Shonibare's work can be seen as satirizing the neo-Victorian extravagance of postcolonial Nigerian society as much as it draws attention to the exploitive practices of Victorian Britain's leisure class. That Shonibare can embrace dandyism and aestheticism to cast his critique so globally demonstrates the success of first-generation

postcolonial artists such as Soyinka, Achebe, Walcott, and Faiz in parrying the strictly ideological left-wing criticism of their day to open the pathway for a more imaginative relation to the fictive "truths" of postcolonial politics. And they did so through an antidecadent critique that deliberately risked replicating the very decadence they decried. By drawing on the multiplicity of decadent literature's cross-cultural ironies, they demonstrate the capacity of decadent modes of representation to condemn both the colonizer and the corrupt regimes of the formerly colonized, wherever the cycle of corruption repeats all over again.

4

Bernardine Evaristo's Silver Age Poetics

IN *À REBOURS* (1884), Huysmans's protagonist, Des Esseintes, comments with disgust on the great Latin writers of the Golden Age. He calls Virgil "one of the most appalling pedants" and "deadly bores that Antiquity ever produced." The "indescribable fatuity of this rag-bag of vapid verses," with its Homeric plagiarism, its obeisance to a "dry, pedantic prosody," its "tinny hexameters . . . stuffed full of useless words and phrases," its "poverty-stricken vocabulary," and "dull, dreary colours" causes Des Esseintes "unspeakable torment." Likewise, Ovid's "limpid effusions" generate little enthusiasm, Horace is full of "vulgar twaddle," and Caesar, Cicero, Livy, and Seneca all fail to inspire. Lucan manages to win some praise, but the "author he really loved" was Petronius. Unlike Virgil, the Silver Age author of the *Satyricon* was "a shrewd observer, a delicate analyst, a marvelous painter." He records "the manner and morals of his time," setting forth "the day-to-day existence of the common people, with all its minor events, it bestial incidents, its obscene antics." Petronius's licentious romp, full of tawdry escapades and upper-class extravagance, was to Des Esseintes a "realistic novel," a "slice cut from Roman life in the raw."[1]

According to Des Esseintes, it is in the work of this second-century satirist that Latin finally reaches its "supreme maturity," as demonstrated by Petronius's mix of linguistic registers and lexicons: "All this is told with extraordinary vigour and precise colouring, in a style that

makes free of every dialect, that borrows expressions from all the languages imported into Rome, that extends the frontiers and breaks the fetters of the so-called Golden Age, that makes every man talk in his own idiom—uneducated freedmen in vulgar Latin, the language of the streets; foreigners in their barbaric lingo, shot with words and phrases from African, Syrian and Greek; and stupid pedants . . . in a rhetorical jargon of invented words."[2] Rather than merely replicating the stiff perfection of Golden Age Latin, Petronius's writing offers a "linguistically hybrid" mélange that "bind[s] together different languages, literary traditions, historical periods, and regional dialects," as Matthew Potolsky observes.[3] Against the opinion of earlier critics of the Latin Decadence, such as Désiré Nisard, Des Esseintes relishes writers from the period after Petronius, such as Apuleius, Tertullian, Saint Cyprian, and Claudian, who wrote as Latin began to decompose, as Huysmans puts it, "like venison, dropping to pieces at the same time as the civilization of the Ancient World [was] falling apart while the Empire succumbed to the barbarian onslaught and the accumulated pus of ages."[4] For Des Esseintes, Rome's decline, defined by its failure to defend either its geographic or linguistic borders, affords an opportunity for literary innovation.

As Potolsky argues, while many nineteenth-century writers sought to buttress the idea of a national culture by clinging to monolingual literary traditions, Des Esseintes's favorite writers "bear textual witness to the fragmentation of the empire and its language" and to the consequent "rise" of local "vernaculars" that "complete" the process of decline. The "books and objects that Des Esseintes praises depict the collapse of national unity, not its consolidation," evincing the Decadents' general suspicion of jingoistic and chauvinistic nationalism.[5] For Des Esseintes, poets writing during the decline of the Roman Empire extend the frontiers and break the fetters of the dominant language by suffusing stuffy Latin with the barbaric lingo of the invaders and by enlivening dried-out prosody with the rhythm of the streets. It was in the fragmented, hybrid language of imperial decline that writers of the Decadent movement sought alternative models to what they saw as the stifling linguistic and literary norms of their own day.

It is toward similar ends—to extend the frontiers and break the fetters of the dominant norms of twenty-first-century British literature—that the poet Bernardine Evaristo situates her 2001 verse novel *The Emperor's Babe* in third-century Roman Londinium. The choice of this cosmopolitan, linguistically hybrid scene registers both the linguistic and political fragmentation of the British Empire over the course of the twentieth century and the consequent linguistic and ethnic diversity of twenty-first-century London by recalling an earlier era when Britain stood at the periphery of another empire in decline. Evaristo explores the roots of early British society not as a defensive, nativist return to an earlier, more cohesive sense of national culture, as Jed Esty has documented in the works of modernists such as T. S. Eliot, Virginia Woolf, and E. M. Forster.[6] Rather, Evaristo's work demonstrates how British culture has for millennia been the product of a dynamic interplay of native communities, migrant outsiders, and inter-imperial legacies.

Like Victorian decadents such as Oscar Wilde, Walter Pater, and George Moore, Evaristo's stance toward late-imperial Rome is ambivalent. Empire is represented in her text as the author of great violence, chauvinism, political corruption, pedantic moralism, sexual cruelty, and racial oppression and as an incubator for sexual, cultural, and linguistic diversity. As Norman Vance observes, in *The Picture of Dorian Gray*, Wilde can remark on the cruelty of Nero while celebrating Petronius as Nero's official arbiter of taste.[7] Evaristo likewise evokes the cruelty and violence that accompanied Rome's conquest of Britain—its repeated campaigns against the native Caledonians and the gladiatorial spectacle of the amphitheater, for example—while celebrating the freewheeling underground life of empire, its queer life in particular. In introducing her postimperial reimagining of Roman Britannia, Evaristo takes her epigraph—"The one duty we owe to history is to rewrite it"—from Oscar Wilde.[8] In setting her novel at what was arguably the pivot point of Rome's decline, Evaristo recalls a queer model of historical revisionism first pioneered by Victorians such as Wilde and Symonds to rewrite the language and genres in which Britain tells the national story of its contemporary multiculture. In this sense, Evaristo, like Ali, Walcott, and Shonibare, employs

Wilde's antirealist approach to history to reimagine contemporary literature and art's relation to the rise and fall of varying imperial formations.

The Emperor's Babe tells the story of Zuleika, a young Nubian girl born in the "wild west" colony of Roman Londinium at the beginning of the third century to refugee parents from the Kingdom of Kush (present-day Sudan).[9] In the Britannia of 211 C.E., barbarian Picts (ancient Scots) are taken by the Romans as slaves, the border with Caledonia is guarded by a troop of Ethiopian moors, the official standard language imposed on the colony is Latin (English did not yet exist), and the emperor, Septimius Severus, is a Libyan-born general who takes the reins after decisively defeating his European rivals. The historical irony of a world where Britain serves under a colonial master from Africa, and its native white inhabitants are taken into slavery, works to undo any essentialist notions of who counts as civilized or savage, master or slave, across the "deep time" of literary representation.[10] Over the course of the novel, Zuleika finds herself married off to a Roman nobleman, has an affair with the emperor, fosters her ambition to become a poet, and struggles to form some sense of herself as a woman caught between her immigrant family's roots and her new life among the Roman elite. Unlike Shonibare's dandy figures, who, like Wilde, successfully deploy their wit and style to infiltrate the upper levels of British society, Zuleika only begins to master the social codes of Londinium's Roman hierarchy before that hierarchy destroys her, making her a quintessential decadent type: youth forced to maturity too soon and wasted before its time.[11]

Zuleika's development takes place against the backdrop of an outwardly prosperous empire plagued by inequality and inner corruption.[12] While Severus controls a vast territory stretching from the Middle East to the border of what is now Scotland, he also has to contend with the great and good of the established Roman nobility, such as Zuleika's husband, Felix, a Roman senator who travels throughout the empire on business, and his sister, Antistia, a "Grand Matron/of Rome-cum-Orgy Queen."[13] The extravagances of this mostly Italian-born oligarchy—which has been satirized by the likes of Juvenal, Horace, and Petronius and condemned by Pliny the Younger and Seneca—make the rough-and-ready emperor appear something of an outsider in his own state.

According to Edward Gibbon's *History of the Decline and Fall of the Roman Empire*, after a successful and active rule, the historical Severus commanded his sons to accompany him on his campaign through Britain with the hope that, in addition to subduing the unruly Caledonians, the martial exercise might toughen his heirs against the decadent ways of the imperial center.[14] Though Severus was successful in his military campaign, his effort to reform his children failed, and he died at York leaving the empire split between rival and unready siblings, setting off the tumultuous years of the Severan dynasty and, in Gibbon's estimation, the eventual decline of the empire.[15]

In Juvenal's "Sixth Satire," an important source for Evaristo, who has some background in Latin, Juvenal writes of a general laxity among the Roman elite, who had grown soft by prosperity: "We are now suffering the calamities of long peace. Luxury, more deadly than any foe, has laid her hand upon us, and avenges a conquered world. . . . Filthy lucre first brought in amongst us foreign ways; wealth enervated and corrupted the ages with foul indulgences."[16] In Juvenal's eyes, the rewards of imperial conquest bring with them the seeds of the empire's undoing: crime, lust, foreign customs, enervation, and corruption. That these sins should avenge a "conquered world" suggests that ultimately the decadence of the imperial elite opens the gate to the barbarians.[17] As Norman Vance points out, whereas concerned parties in nineteenth-century Britain often moralized about examples of Roman excess to guard their own imperial culture against foreign contamination, Evaristo takes a different tack.[18] For Evaristo, the Roman Empire's porous condition invites a newly productive pluralism. By way of historical parallel, the scene of Britain's postwar decline affords those who are excluded by the British Empire's narcissistic self-regard an opportunity to fundamentally alter Britain's monocultural self-understanding. The weakening of imperial hegemony by its own excesses thus unleashes a pluralism that undermines the dictates of imperial history and loosens the generic boundaries in which such history is often told, be it in novels, epics, or lyrics.

As Zuleika makes her way up through the social strata of Roman society from the back-alley shops of her childhood to the fancy villas, governor's balls, and orgies she witnesses in her married life, to the imperial processions and gladiatorial spectacles she attends during

her affair with Severus, Londinium becomes, as Soyinka described late-colonial Nigeria, increasingly "redolent of the tawdry decadence of a far-flung but key imperial frontier."[19] Indeed, the city of Londinium, which was founded as a Roman settlement only 170 years earlier, already exhibits all the signs of premature decline. That is, the city itself becomes a figure of youth grown decadent before its time. At the governor's ball, for example, Zuleika observes servants "sponging vomit off the floor" as the nobles stick "perfumed feathers / down their gullets, or, in the words of Juvenal, // *the guests soused the floor / with the washings of their insides.*"[20] On one of her dates with Severus, Zuleika serves up a feast worthy of Petronius's Trimalchio, who famously serves a roasted sow stuffed with live thrushes. Zuleika and Severus dine on "Songbird Surprise," among a host of other Roman culinary delicacies, including "milk-fed snails," "fried jellyfish, bear cutlets, // sliced flamingo tongue," and "par- / cooked // courgettes, boiled / whole," with "sautéed peacock // brains." Evaristo's delightful, off-kilter rhymes, such as that between "par- / cooked" and "peacock," capture the succulence of the meal in pared-down verse that serves to heighten attention to the menu of exotic ingredients. Zuleika and Severus even consume an array of exotic bird tongues (some spiced in "Gaul garlic"), as if every Roman feast made a point of symbolically consuming the exotic languages (*lingua*) found at the outer reaches of the empire.[21] Such dishes are straight out of the late Roman cookbooks attributed to Apicius, a legendary gourmand of the ancient world who reportedly inspired the culinary habits of some of Rome's most notorious emperors, such as Elagabalus, a later member of the Severan dynasty whose excesses in turn inspired the extravagant feasts (and other proclivities) of fictional fin-de-siècle decadents such Dorian Gray and Des Esseintes.[22]

While the outrages of Elagabalus, an emperor in the vein of Nero, took place decades after Septimius Severus's death, Evaristo portrays the Severan dynasty as clearly tilting in that direction. Severus describes his sons as alcoholics who "despise each other, // abuse boys, embezzle funds, beat women, / hobnob with strippers and charioteers // and spend all day at the races." The elder son, Caracalla, "prances around // in blond wigs and Germania-style cloaks."[23] Softened up by the luxury of the imperial center, Severus's sons become prone to the supposed effeminacy and barbarian (i.e., Germanic) customs to which Rome, in the eyes

of contemporaneous satirists and later historians, was eventually to suc-
cumb. Evaristo's portrait of Caracalla as a prancing, effeminate Ger-
manophile also echoes the Nazi-era figures of Luchino Visconti's film
The Damned (1969) or the 1930s decadence of Christopher Isherwood's
Berlin, as depicted in Bob Fosse's 1972 film *Cabaret*, making the Roman
empire of Evaristo's novel anachronistically reminiscent of the Weimar
era, complete with a drag bar and cabaret run by Zuleika's transgender
pal and mentor, Venus.[24] Such moments highlight the perceived threat
that queerness, transvestitism, pederasty, and effeminacy have often
represented to the masculinist order of states organized around martial
ideals, be it republican Greece, imperial Rome and Britain, or the
Deutsches Reich. Such masculinist ideals have also thoroughly infused
modern historiography on Rome's decline. In *The Emperor's Babe*, refer-
ences to queer and effeminate figures are inextricable from the text's
depiction of third-century Roman Londinium as a burgeoning metrop-
olis rife with perversion and corruption. And yet such references are
also inextricable from the text's embrace of queerness as a positive mode
of identity for twenty-first-century Britain.

As historians note, Severus derived his strength as emperor from
his firm command of the military. Or, as Evaristo's Severus succinctly
remarks, *"Give army pay rise and sod everyone else."*[25] But as Gibbon
argues, though the historical Severus's pampering of his soldiers won
him their loyalty, it turned them into virtual princelings too accus-
tomed to luxury to perform on the field. Severus's lax discipline toward
his two sons and his Lear-esque division of the empire between them,
moreover, produced a messy and murderous succession, setting the
stage for decline. As Gibbon writes, "The contemporaries of Severus
in the enjoyment of the peace and glory of his reign, forgave the cruelties
by which it had been introduced. Posterity, who experienced the fatal
effects of his maxims and example, justly considered him as the prin-
cipal author of the decline of the Roman empire."[26] Though the drift
of this narrative of decline serves as background to the central story of
The Emperor's Babe, it nonetheless looms over the historical horizon
of the text, suggesting a cultural milieu ripe for the sort of critique of
imperial values favored by decadent writers such as Huysmans.

In the process of adapting to life among the elite, the young Zuleika,
like Des Esseintes, rebels against the literary and linguistic norms of

her day. When her husband, Felix, fixes her up with a Latin tutor, Zuleika bristles at the expectation that she should merely learn to imitate the canonical greats. She calls Homer's *Iliad* (read in Latin translation) "bloody tedious" and "old fashioned," and she complains of having to learn Virgil's *Aeneid* by heart. When her tutor claims it "will still be a classic text // in two millennia from now," she responds, *"As if."* She likewise expresses her frustration with having to learn her "hendecasyllables," telling her tutor she finds "the lot of it B-O-R-I-N-G," even as her tutor browbeats her by asking her questions: "Did I know what asclepiad meant? Or trochee? // Or spondee? Or dactyl? Or cretic? No? / Oh, surprise, surprise! Well when I did, then // I could give him backchat."[27]

Zuleika's adolescent impatience with her tutor is hardly out of place given her age, and Evaristo ironically acknowledges the endurance of the classics. Nevertheless, Zuleika's objections strikingly echo the first extant pages of the *Satyricon*, which blame teachers of rhetoric, with their "tripping, empty tones," for causing "the ruin of true eloquence," a sentiment reprised in the anticanonical tone of the fin-de-siècle decadents.[28] According to the historian Jérôme Carcopino, by the second century, the typical syllabus employed by the Roman *grammaticus* had become backward looking and rigid: "The school of grammar at Rome always fixed its eyes on the past . . . and the Latin there taught was never at any time a living language in the full sense of the term, but, like the Greek from which it was inseparable, a language which 'the classics' had employed and which had become fixed in the moulds they had poured it into once and for all."[29] When Zuleika searches for less stultifying models than Homer or Virgil for her own poetry, her tastes run in the same direction as Des Esseintes's, toward a Petronian image of "Roman life in the raw" with all its "obscene antics."[30] As she explains to her father,

> But you see, Dad, what I really want to read
> and hear is stuff about us, about now,
>
> about Nubians in Londinium, about men
> who dress up as women, about extramarital
>
> peccadilloes, about girls getting married
> to older men. . . .

And though her tutor tells her she "should write for readers/five centuries hence," she declares, "I ain't writing for posterity—//....I'm a thoroughly modern miss/and who knows what life will be like then,//the Caledonians could rule the world for all we know."[31] Again, the historical irony is obvious, but in a linguistic context dominated by the sclerotic teachings of the grammarian, the minor rebellions of speaking improperly ("ain't") and representing everyday life and all its tawdry little dramas constitute something of a literary revolution.[32] Like many other examples in the book, such moments represent what Gilles Deleuze and Félix Guattari call a "minor utilization" of the dominant language of the empire, an attempt to reground the dead, deterritorialized language of the empire's official language in the here and now of the vernacular.[33] Put more plainly, Zuleika prefers the flexibility of her own Silver Age to the rigidity of the official Golden Age Latin preferred by her tutor.

But though Zuleika rejects the dead, classical language of Homeric and Virgilian epic, the text also lampoons the cliché identity politics of the contemporary poetry scene. To showcase Zuleika's budding talent as a hip, young, Nubian poet, she and her friends Alba and Venus throw a poetry orgy ("Verbosa Orgia," or wordy orgy) at Felix's villa. This extended bit of parody begins with an epigraph from Pliny the Younger: "Scarce a day has passed wherein we have not been entertained with the recital of some poems."[34] Taken out of context, this might seem like a good thing, but the full text of Pliny's letter criticizes the indifference of Roman audiences toward poetry, a criticism Evaristo renders no less relevant in the twenty-first century.[35] For her own reading, Zuleika adopts "the literary sophisticate look," sporting a "black cape and three rings, . . . the least expected of all good poets."[36] The first poet called to the stage, however, appears dressed like a cross between a Rastafarian and Mel Gibson in *Braveheart*, with "ginger dreadlocks" and a "face dyed blue with woad." Hrrathaghervood, the "real Authentic Pict," wows the audience with the "exotic charm of his Pictish patois" and "how brilliantly he *did* Anger."[37] In the mock-anticolonial rant that follows, delivered in a thick Scottish accent, Evaristo evokes the long history of English colonialism in Scotland even as she affectionately parodies the "Inglan is a bitch" sentiments of poets such as Linton Kwesi Johnson, whose rebellious

poetry has been absorbed into the mainstream of the British culture industry.[38] The more immediate target of the parody, however, is the way certain habits of dress and speech have become conventionalized as markers of ethnopoetic authenticity (a subject Johnson also addresses). It is later revealed, after Hrrathaghervood has hooked up with Venus, that he was born south of the Antonine Wall and is not much of an oppressed Pict at all. His adoption of overtly ethnic codes and his hypermasculine performance of anger are no less constructed than Zuleika's "literary sophisticate" look.[39]

The passage runs through a catalogue of caricatures drawn from the contemporary poetry scene, from the elite, academic poetry of "Pomponious Tarquin, / winner of the Governor's Award for poetry," to the pastoralism of the " 'mud, plough and sow' poet" Calpurnius Tiro, to the Black Power stylings of "Manumittio X."[40] Following suit, Zuleika's contribution to the reading becomes a parody of postcolonial ambivalence and identity politics titled "Identity Crisis: Who is she?":

> Am I the original Nubian princess
> From Mother Africa?
> Does the Nile run through my blood
> In this materfutuo urban jungle
> Called Londinium?
>
> Am I a Londinio or a Nubian?
> Will my children be Roman or Nubinettes?
> Were my parents vassals or pharaohs?
> And who gives a damn![41]

This is intentionally adolescent stuff, an immature version of Derek Walcott's "A Far Cry from Africa": "I who am poisoned with the blood of both, / Where shall I turn, divided to the vein?"[42] Unsurprisingly, the audience yawns and ignores Zuleika. Wanting a little less verbosa and a little more orgia, the sexual shenanigans take over, drowning out Zuleika's overly earnest performance. Evaristo comments that Zuleika's "Identity Crisis" serves to satirize "the kinds of clichéd poems prevalent in some performance poetry communities today—it's not making a deeper statement about Zuleika."[43] Nevertheless, Zuleika's

failed performance suggests that the earnest, ambivalent, postcolonial poetics pioneered by Walcott's generation no longer proves adequate. Rather, the identity politics of the first wave of postcolonial poetry appears to have collapsed in the twenty-first century into a certain disillusionment and ennui: "who gives a damn!"

Evaristo comments on her own resistance to being pinned down categorically as a writer, telling Alastair Niven, "I would like to be thought of as a writer full stop. But the reality is that I am pigeon-holed as a black female writer," even though such labels, she suggests, are coming to mean less as "black British writers" enter the mainstream.[44] Some of that mainstreaming of black British writing occurred as a result of Zadie Smith's 2000 best seller *White Teeth*, and Evaristo's work has been read alongside that of other black British writers such as Hanif Kureishi, whose *The Buddha of Suburbia* (1990) holds generic similarities as a postcolonial Bildungsroman, and the Scottish-Nigerian poet-novelist Jackie Kay, who explores her complex family history in verse in the *Adoption Papers* (1991), much as Evaristo does in her first verse novel, *Lara* (1997). While Evaristo cites Derek Walcott for his interest in classical epic, *The Emperor's Babe* also anticipates more recent retellings of British classics such as Patience Agbabi's *Telling Tales* (2014), which "remixes" Chaucer's *Canterbury Tales*.[45] Wary of pigeonholing Evaristo solely as a black British writer, John McLeod emphasizes the "transnationality of black writing in Britain." Commenting on *Lara*, an imaginative retelling of Evaristo's family origins in Nigeria, Brazil, and Britain, McLeod argues that in "seeming keen to position Evaristo as part of a black British canon, there is always the danger of committing violence to the historical sensibility and transnational fertility of her work."[46]

Evaristo employs scenes such as her *verbosa orgia* to skewer the cliché categories employed by the literary market. For Evaristo, as with Wilde or Shonibare, the best way to master the codes of the establishment is to satirize them. As a virtuoso performance in verse, *The Emperor's Babe* enacts the sort of achievement and garners the sort of recognition that continually eludes its protagonist. As Zuleika wonders in the book, "Poems were meant to fulfil me instead, / but I failed to create pictures // with words—or did I?"[47] That is, whereas Shonibare

ironically challenges British heritage and the artistic establishment through the artfully constructed visual surface of his work, it is at the level of words on the page, in the *verbosa orgia* of poetic language, that Evaristo undertakes this same task.

Huysmans's description of the *Satyricon* as a novel that "makes free of every dialect," whether "vulgar Latin" or "barbaric lingo," might well be mistaken for a review of *The Emperor's Babe*. As Evaristo herself describes the novel, "There are many parallels to be made between Londinium and contemporary Britain/London. . . . The language that Zuleika uses is very now, very hip. The novel is peppered with Latin, Italian, Cockney-rhyming slang, patois, American slang, pidgin Scots-Latin, and in the case of Severus, broken English. . . . No, the Romans didn't speak all of these vernaculars or languages, but it enriches the story for me to do so. And we mustn't forget that the English language itself is a hybrid of several other languages, so I'm just continuing the tradition."[48] Among the many dialects and linguistic registers represented directly or described in the novel, what Mikhail Bakhtin would call its polyglossia and heteroglossia, Zuleika is described as speaking a "second-generation plebby creole"; her father gets by with "pidgin-Latin"; and her mother hates her "adopted language," spitting out such words as *"Khu-kh-umba! Cabb-age!/Haspara-gush!"*[49] Zuleika's Caledonian slaves speak a "vulgar babble" and a "strange pidgin"; Zuleika's friend Venus enunciates with an "affected mockney accent"; and the emperor is "ridiculed" for "his thick African accent."[50] At Londinium's amphitheater, the "lower ranks" drop their consonants—*"Why are we wai'ing!"*—while the gladiators are said to be "air-heads,/wot 'adn't mastered the lingua Latin proper,//wot didn't know their Horace/from their hors d'oeuvres," mixing cockney, Latin, and French.[51] When Zuleika doubts her own potential as a poet, she checks herself with a mix of West Indian Creole and mockney borrowed from Venus: "for all your pathetic poetic pretensions," she remarks to herself, "you're jus' a likkle housewife," and *"you'll not never be nuffink else."*[52]

Because the Romans did not speak these particular vernaculars, such gestures toward demotic speech can be taken less as an attempt at linguistic verisimilitude and more as an example of what Matthew Hart calls a "synthetic vernacular." Such synthetic vernaculars at-

tempt to negotiate between "ethnonational languages" and the more "macaronic linguistic constructions" typical of "cosmopolitan modernism." They represent what Hart calls poetry's "attempt to sublate the tension between local languages" and a "new inclusiveness" typical of "modernism's late imperial engagement with the non-occidental world."[53] A similar tension exists in the twenty-first century English(es) of Evaristo's verse, though it is represented by way of a parallel with the tension between the diverse, ethnically particular languages heard on Londinium's streets and the more macaronic and cosmopolitan varieties of late-imperial Latin.

When one places Huysmans's and Evaristo's texts side by side, one can see how Evaristo's polyglot linguistic play occupies an analogous imaginative position in relation to standard British English as Huymans imagined the *Satyricon* did to classical Latin. That is, Des Esseintes might smile approvingly on *The Emperor's Babe* as a fulfillment of the English language's full maturity. The language of Evaristo's text, like the poetry of the Latin Decadence, bears witness to the breakup of the empire and its linguistic aftermath. Evaristo's verse novel, with its persistent Petronian and Juvenalian gestures toward excess among the Roman elite and its knowing winks toward post-Severan imperial decay, invites us to imagine its own twenty-first-century English as the overripe fruit of the late British Empire. Just as Petronius, Apuleius, and the other writers of the Latin Decadence inhabit the increasingly tarnished (and therefore all the more lively) Silver Age of Latin, Evaristo positions her own work as occupying the Silver Age of postcolonial poetry, an age after the epic ambitions of Walcott's *Omeros* that fosters its cross-cultural identifications and borrowings not in the creolized poetics of the former colonies but in the decaying but fertile ground of a hybrid, metropolitan English.

According to Linda Dowling, it was the "general habit" of Victorians to refer to " 'the declension' of Rome, as if the territorial disintegration of the Roman Empire and the loss of Latin grammatical inflections or declensions were the result of the same inward collapse." Latin was thus "portrayed as having 'died' while 'giving birth' to the vernacular tongues that succeeded it." Because of the Roman example, imperial English was "haunted by the spectre of an eventual disintegration, a collapse out of which would emerge, at the end of the century, such

movements as literary Decadence."[54] Such fears were reprised during
the postwar era of immigration and reverse colonization in Britain, a
moment that generated anxiety among cultural conservatives over the
fate of standard English. The Tory parliamentarian Enoch Powell con-
jured a bogeyman invasion of "wide-grinning piccaninnies" who "cannot
speak English" in his infamous 1968 "Rivers of Blood" speech. Powell
looked back to the Romans for an example of imperial decline that
anticipated the condition of modern Britain: "As I look ahead, I am
filled with foreboding; like the Roman, I seem to see 'the River Tiber
foaming with much blood.' "[55] Powell, like the Victorians before him,
suspected that the decadence of British national culture could be de-
tected in the foreign influences overtaking official English. Such para-
noid warnings against British national decline left postwar black
British writers to contend with a xenophobic political discourse that
imagined Victorian fears of a crumbling empire as having been realized
in fact. The fact that the title of the prologue to *The Emperor's Babe*
("Amo Amas Amat") takes the form of a Latin declension, but is swiftly
given more colloquial expression as a question in the first line of the
novel ("Who do you love?"), demonstrates how Evaristo embraces such
linguist tumult. The book's opening focuses attention on the exact
moment when newly diversified vernaculars displace the official lan-
guage of empire. Evaristo establishes the displacement of the lingua
franca of late empire by the local vernacular as the very condition
from which Zuleika emerges as a new voice for British poetry.

On the first page of *The Emperor's Babe*, the eleven-year-old Zuleika re-
counts the story of her family's migration down the Nile from the
Kingdom of Kush, then in a state of collapse, across the sea to Britannia:

> [My] parents sailed out of Khartoum on a barge,
>
> no burnished throne, no poop of beaten gold,
> but packed with vomiting brats
>
> and cows releasing warm turds
> on to their bare feet. Thus perfumed,
>
> they made it to Londinium on a donkey,
> with only a thin purse and a fat dream.[56]

Evaristo's allusions to a "burnished throne" and a "poop of beaten gold" recall Shakespeare's description of Cleopatra's more opulent journey down the Nile in act 2, scene 2, of *Antony and Cleopatra:*

> The barge she sat in, like a burnished throne,
> Burnt on the water. The poop was beaten gold,
> Purple the sails, and so perfumed that
> the winds were love-sick with them. . . . [57]

Evaristo picks up on Shakespeare's imagery as a contrast to her own characters' less glamorous voyage while echoing Shakespeare's carefully constructed alliteration and consonance. Whereas the dense sonic echoes of "barge," "burnished," "burnt," and "beaten" and "poop," "purple," and "perfumed" emphasize the heavily artificial character of the pharaonic spectacle in Shakespeare's play, in Evaristo's verse, the imagery is deflated by its echoes with "brats" and "bare feet," while "*perfume*" (assonant with "t*u*rds," compounded by the implicit pun on "poop") seems ostentatious when one carries a "thin p*u*rse."[58] In this fashion, the passage also recalls the already-diminished appearance of the same allusion in Eliot's *The Waste Land*, where the "burnished throne" reflected in the marble of the feminine boudoir is decadently scented with "strange synthetic perfumes."[59] From Cleopatra's perfumed sails to Eliot's synthetic perfumes to the perfume of warm cow dung, this family's arrival in Britannia coincides with a figurative decline in the literary canon from history play to modernist parody to postcolonial travesty, as if to confirm, with an ironic wink, the xenophobe's worst fears of literary degeneration by reverse colonization.

The scene also recapitulates the postwar "moment of arrival" depicted in numerous texts of the "*Windrush* generation," a generation typified by writers such as Samuel Selvon, Wilson Harris, and George Lamming who arrived in Britain around the time the *Empire Windrush* set sail from Jamaica carrying hundreds of West Indians to Britain in 1948. Mike Phillips notes how the "moment of arrival" constitutes a crucial element in the formation of diasporic identity in black British literature written in the first few decades after 1948.[60] By gesturing in *The Emperor's Babe* toward a moment of arrival nearly two thousand years in the past and implicitly toward the innumerable arrivals that have occurred since, Evaristo fundamentally recasts 1948 as just one

moment, albeit a significant one, in a much-longer history of transna-
tional migration that connects Africa to Britain and the rest of the globe.

The idea to rewrite this particular bit of British history occurred to
Evaristo while she was poet in residence at the Museum of London,
where she happened upon galleries depicting daily life in Roman
Britain.[61] Though Londinium was an active trading center with connec-
tions all over the world, the galleries had little to say about its demo-
graphic makeup, so Evaristo embarked on her own imaginative recre-
ation, drawing on historical descriptions of the city of Rome as a model
for her depiction of a multicultural, if provincial, Londinium. As she
describes it, "I worked with the premise that the Roman Empire
stretched over 9,000 kilometers into Africa and Asia; there were lots of
good roads and travelling across the Empire, so I thought why not make
London something of the multi-racial melting pot that was Rome?"[62]
Evaristo's thinking was also spurred by a countertradition among black
historians that traces the once little-known history of Africans in early
Europe. Peter Fryer's *Staying Power*, for example, begins with the ar-
resting declaration that "there were Africans in Britain before the En-
glish came here."[63] As Evaristo comments, "Growing up as I did in the
1960s and 1970s we were led to believe that black people came to England
post-1948. And I think that is what people are still led to believe in this
country. Fryer touches very briefly on the Roman period and talks about
Septimius Severus—who is in my book—and the legion of Moors sta-
tioned at Hadrian's Wall. . . . That was a real revelation for me. It is
important because it is an aspect of British history that hasn't been fully
recognised and that is still invisible to most people."[64] In depicting
third-century Londinium as a bustling outpost with mixed cultural,
ethnic, and linguistic influences, Evaristo, like Shonibare, questions
monocultural notions of British heritage and essentialist notions of ra-
cial or cultural authenticity. As she comments, "I wanted to disrupt the
notion that Britain was only populated by white people until recently, so
this novel is a direct challenge to Britain's misguided sense of its own
history and identity."[65] When Zuleika attempts to reconcile her inability
to fit in with the Roman nobility with her identity as a citizen of empire,
she thinks, "Yet I was Roman too./Civis Romana sum. It was all I
had."[66] In doing so, she echoes the effort by commonwealth immigrants
to make good their claim to full citizenship after the Nationality Act of

1948, while underscoring the two-thousand-year history of migration to Britain that makes such claims central to Britain's national story.

Stuart Hall observes that such " 'hidden histories' have played a critical role in the emergence of many of the most important social movements of our time—feminist, anti-colonial and anti-racist."[67] Paul Gilroy further observes how the attempt to foreground the "great shock" of empire's demise can produce "some unorthodox historiographic sensibilities."[68] For Evaristo to take the epigraph to *The Emperor's Babe* from Oscar Wilde's essay "The Critic as Artist" is, almost by definition, to pursue an "unorthodox" view of historiography to register the shock of imperial decline. When Evaristo was asked by an interviewer whether her epigraph from Wilde—"The one duty we owe to history is to rewrite it"—is not simply a clever aphorism, she affirmed that she is "creating" history, not just retelling it: "For me it was also about having a lot of fun with history and being quite satirical about aspects of contemporary British society."[69] As David Gunning observes, "Wilde's aphorism takes the form of a pun that plays on two meanings of 'history' used most commonly. History as the objective past, 'the way it really was' that has the causal and emotional power to direct both our present and futures, is undermined by the recognition of the constructed nature of history and the interventions of the recorder in creating the physical historical archive."[70] Evaristo's use of Wilde's words for her epigraph, then, indicates an underlying historiographical tension in *The Emperor's Babe* between, on one hand, a documentary or "forensic approach to multi-culture's metropolitan genealogies," as Gilroy puts it, and, on the other hand, a more Wildean or Shonibarean departure from historical realism, in which to rewrite history is to acknowledge the inventive aspect of all historiography.[71]

I would go further and argue that Evaristo's imaginative recovery of an African presence in British antiquity is as much indebted to the sort of historical revisionism undertaken by late-nineteenth-century apologists for homosexuality, such as Wilde or Symonds, as it is to the historical revisionism of black scholars in the late twentieth century. That is, the sort of fin-de-siècle neoclassicism that brought the concept of "Greek love" and queer icons such as Antinous and Sappho to the forefront of the Victorian imagination provides an important precedent for Evaristo's attempt to recover and reimagine the hidden

histories of people of color in British antiquity. My claim is not that Evaristo steeped herself in works such as Symonds's *A Problem in Greek Ethics* as part of her research for *The Emperor's Babe*. Rather, I would suggest that the underlying politics of such queer revisionism have been successful enough to have become nearly invisible in contemporary reimaginings of classical antiquity. Or, rather, as in the case of *The Emperor's Babe*, they are hiding in plain sight, easily overlooked unless one takes the text's queer elements as integral to the work's exploration of racial identity.[72] To make the queer politics of the text visible, one must view Evaristo's image of Londinium under Severus through the lens of Victorian decadence, a move Evaristo invites us to make with her epigraph from Wilde.

Zuleika's main frustration in her relationships with both Felix and Severus is her lack of visibility, a frustration that reflects the text's larger project of making visible the historical presence of Africans in Britain. Hidden away in her villa by Felix, Zuleika longs for public recognition and greater access to the upper reaches of Roman society. At home, she is merely an adornment to Felix's social climbing, ignored by the "wives of the Great and Good." She knows she is little more than a "knock-out objet d'art" for her husband and his lascivious guests, who would gladly "strip her naked and fling her/on the floor."[73] She even complains to Severus that Felix wants her to be merely "decorative," a "little birdie/in a gilded cage, waiting for her master//to come home—and sing for him," like the gold-enameled bird in Yeats's "Sailing to Byzantium" that sings to entertain the "lords and ladies" and to "keep a drowsy Emperor awake."[74]

When Severus takes Zuleika to see the gladiators, things are not much better. He relegates her to a remote position in his entourage, prompting her to refer to herself as "Mistress Invisibilis."[75] She then fantasizes her own spectacular solution to her invisibility, daydreaming of mounting Severus in front of the legions of onlookers at the amphitheater:

> . . . I would lift his skirts (and mine),
>
> straddle him, send the masses into a frenzy
> as I flashed my shiny, black, shimmering arse.

I'd sho nuff go down in history den,
sprawled all over the *Daily Looking Glass:*

ZULEIKA—THE WOMAN WHO SHOCKED A NATION.
It wasn't fair. We hadn't spoken all day.

I wanted recognition, I wanted commitment.
A tantrum stirred in my feet, but I checked myself.

It had only been one month, after all.
Ave Imperator! Morituri te salutant.[76]

Zuleika's fantasy of tabloid infamy (with a play on the *Daily Mirror*)
becomes an inverse measure of the degree to which her desire for "rec-
ognition" and "commitment" has been suppressed. Indeed, she appears
to aspire to exactly the sort of hypervisibility achieved by the titular
character of Max Beerbohm's satirical 1911 novel *Zuleika Dobson*. It
is not clear whether Evaristo's use of the name Zuleika constitutes an
intentional allusion to Beerbohm's novel, but the comparison between
the two characters is instructive. In Beerbohm's novel, a fatally alluring
young woman arrives in Oxford (under the watchful eyes of a set of
busts of Roman emperors), sending masses of young Oxford men into
such a frenzy of desire that they all commit suicide in her honor. "She
was a moving reflector and refractor of all the rays of all the eyes that
mankind had turned on her," writes Beerbohm of his Zuleika.[77] With
the slant rhyme and transfer of epithets from "shimmer*ing arse*" to
"look*ing* Gl*ass*" (arses shimmy, glass shimmers), Evaristo similarly
presents Zuleika in her fantasy as a shimmering reflection of the mass
culture that surrounds her. Zuleika also imaginatively claims a scan-
dalous place in the history of Britain using stereotyped African Amer-
ican vernacular ("sho nuff . . . den"), employing black vernacular as a
language of protest against the invisibility that comes with being a
young black woman among Britannia's elite. When Zuleika Dobson's
dandyish suitor, the Duke of Dorset, manages to please her, it is the
words of the gladiator's salute, "Moriturus te saluto," that form on his
lips.[78] Beerbohm's Zuleika becomes, in effect, the Duke's empress, and
all eyes are on her. This is exactly the scenario to which Evaristo's
Zuleika can only aspire.

While Zuleika's description of herself as "Mistress Invisibilis" captures the invisibility of women of color in the larger story of British culture, the seeds of Zuleika's fantasy of visibility can be found in a prior conversation she has with her friend Venus. Venus (born Rufus) is the proprietor of Mount Venus, a club where men of all social strata, including famous lawyers and "butch" centurions, "disappeared / into the back room for anonymous antics," only to emerge "in a wig, torn gown and smudged lipstick."[79] Amid the anonymous sex play, Venus longs for her own measure of recognition and visibility. Indeed, Zuleika's tabloid fantasy of public sex with Severus pales in comparison with the tale Venus tells of the emperor Hadrian and his lover Antinous, an example well known in Roman times and resuscitated by later nineteenth-century apologists for homosexuality. Venus, lamenting her longtime affair with a married, closeted man, informs Zuleika of this particular bit of queer history:

> You know about the Emperor Hadrian, right?
> Nearly a hundred years ago he cavorted
>
> around the world with his pretty boy Antinous.
> When said lad died prematurely, Hadrian
>
> named a city in Africa after him, erected
> over five hundred statues depicting
>
> Cute Lips as various gods;
> deified said lad, built a temple for his worship
>
> (still going on today I might add) and so on
> and so forthly and so rightly and what have you.[80]

Hadrian's devotion to Antinous marks a high point in the history of posthumous adoration, on par with the building of the Taj Mahal. Venus mocks such grandeur with her faux rhetorical flourish, "and so forthly." The passage illustrates another of Evaristo's clever historical ironies. While a number of contemporary African societies criminalize homosexuality on the basis of laws imposed by the British during the colonial era, and Britain today allows same-sex marriage, in Hadrian's day, the emperor built a wall against northern barbarians and devoted a city in Africa to his male lover. A minor character in Evaristo's 2014 novel *Mr. Loverman*, a PhD student at Brunel University (where Eva-

risto herself teaches), notes that it was *"homophobia,* not homo-
sexuality, that was imported to Africa," countering the masculinist
rhetoric of decolonizing movements while unmasking the "civilized"
West's supposedly more tolerant values.[81]

Though Venus employs the Antinous legend to persuade her boy-
friend to come out of the closet, she also provides Zuleika a means to
measures her own lack of visibility as the current emperor's lover by
contrast with the open devotion Hadrian paid to Antinous. Insofar as
Zuleika wishes that she and Severus can come out of the closet, it is a
specifically queer model of public recognition to which she aspires.
However, the way in which the tale of Hadrian's love for a beautiful
male youth came to be received and reconceived in the late nineteenth
century holds significance for Evaristo's larger project of claiming rec-
ognition for Africans in Britain as another group marginalized and ig-
nored in the annals of history, art, and literature.

What historians write of the Antinous story matches Venus's
account. Hadrian, who ruled the empire from 117 to 138 C.E., met An-
tinous on the coast of the Black Sea in Bithynia, made him his favorite,
and took him around the world. As Bryan E. Burns recounts, "The
sexual nature of their relationship is described only obliquely in an-
cient texts, but Hadrian's devotion to the younger man took manifest
form after the latter's death by drowning in the Nile in the year 130."[82]
In his grief, Hadrian named a city and a star after Antinous, anointed
him a god, created a cult around him, and "commissioned or inspired
the manufacture of the vast number of statues, friezes, and coins by
which Antinous's form has become familiar to the modern world."[83]
Though the cult of Antinous swelled in popularity in the century after
his death, the ascendency of Christianity, with its condemnation of
homosexuality, drove the cult underground. Antinous's legacy, how-
ever, was preserved in numerous artistic and literary works as a model
of classical beauty that rivaled depictions of Adonis, Ganymede, and
Narcissus.

The ubiquity of Antinous art and its queer subject matter made An-
tinous a ripe figure for recovery among nineteenth-century scholars,
offering a rallying point for the emerging movement to gain acceptance
for same-sex relations in the decades before the term "homosexuality"
came into popular use.[84] Sarah Waters notes that to scratch beyond the

surface of the legend of Antinous and Hadrian at that time was to invite censure. Nevertheless, "a largely homosexual group of amateur and expert art historians and aesthetes" emerged, centered on John Addington Symonds, whose researches "delv[ed] into and beyond the established histories to construct their own version of Hadrian's favorite and secure it scholarly authority."[85] Symonds himself warned another scholar that it was "dangerous in England to allude to such a subject."[86] After a concerted effort to recover and revise the Antinous legend, Antinous came to be recognized as an important homosexual presence in art and literary history. But he also serves as a meta-figure in fin-de-siècle literature for the process of queer historical revisionism itself. That is, he was not just the subject of such historical revisionism but something like its patron saint.

For Symonds, Antinous was the saint of a "decadent paganism," a figure recognizable, in Percy Bysshe Shelley's words, for his "eager and impassioned tenderness" and "effeminate sullenness."[87] Symonds's writings on Antinous are remarkable for their attempt to discern a flesh-and-blood portrait of the youth from the various myths surrounding his death.[88] As he writes, "We have before us no figment of the artistic imagination, but a real youth of incomparable beauty . . . with the almost imperceptible imperfections that render choice reality more permanently charming than the ideal."[89] In sorting through the legends surrounding Antinous's death, Symonds notes how each attempts to "relieve Antinous from [the] moral stigma" of his relationship with the emperor.[90] Symonds himself, in contrast, is careful to affirm Antinous's status as Hadrian's "friend" and "favourite," one who had "passed into the closest relationship with his imperial master" and whom Hadrian had loved "with Greek passion."[91] As Jonathan Ned Katz notes, for "nineteenth-century men of the upper classes" such as Symonds, "the ancient world's 'Greek Love' between an adult man and a male youth served as the most prominent legitimating ideal."[92] The subject of pederasty was one Symonds addressed in his essay *A Problem in Greek Ethics* (1873).[93] Nevertheless, Symonds recounts how, after Antinous's death, his cult "subsisted as an echo, a reflection," and his image became "an aesthetic rather than a religious product." Despite Symonds's best scholarly effort, he insists that there remains "a cloud of darkness and impenetrable doubt" over Antinous:

"To pierce that cloud is now impossible." In the end, the "sincere critic . . . will confess that he has only cast a plummet into the unfathomable sea of ignorance. What remains, immortal, indestructible, victorious, is Antinous in art."[94]

Symonds paints a portrait of Antinous as a figure who is simultaneously knowable and unknowable. This is a paradox that speaks to the difficulties of historical revisionism. Antinous is at once a "real youth" and a mere "echo" or "reflection," a "choice reality" and an "aesthetic" ideal. His figure is lost in darkness yet triumphant in art. To know him, one must both recover and invent his history. It is Antinous's fixed image in the many sculptures that bear his visage that continues to drive the quest to uncover the warm-blooded youth beneath the cool marble, yet "when we question those wonderful mute features and beg them for their secret, they return no answer."[95] With an echo of Keats's "Ode on a Grecian Urn," what is left for Symonds is a kind of reverence for the imaginative effort of scholarship itself, which brings the sphinx-like Antinous back to life only as long as the effort runs its course.

It was the fixed, aesthetic dimension of the Antinous legend that most fascinated other fin-de-siècle writers such as Oscar Wilde. In stories such as "The Young King" and "The Portrait of Mr. W. H.," Wilde's allusions to Antinous offer hints of homosexual desire. In *The Picture of Dorian Gray*, however, Antinous comes to represent an entire theory of artistic innovation. As Dorian's portraitist, Basil Hallward, explains to Lord Henry, "I sometimes think, Harry, that there are only two eras of any importance in the world's history. The first is the appearance of a new medium for art, and the second is the appearance of a new personality for art also. What the invention of oil-painting was to the Venetians, the face of Antinous was to late Greek sculpture, and the face of Dorian Gray will some day be to me. . . . [His] personality has suggested to me an entirely new manner in art, an entirely new mode of style. I see things differently, I think of them differently. I can now recreate life in a way that was hidden from me before."[96] For Hallward, Dorian Gray is both the source of innovation and a repetition of a prior model. Through a process of imitation and resignification, Dorian introduces the new by becoming a new Antinous, a figure of young male beauty, as much a statue in his never-changing

visage as the replicas of Antinous commissioned by Hadrian.[97] In be-
coming a new Antinous, Dorian reveals an artistic and sexual poten-
tial that previously lay hidden in classical culture. In replicating the
Antinous legend in *Dorian Gray*, Wilde renders Antinous himself a
paradoxical figure for both historical recovery and modern innova-
tion, a paradox resolvable through the lens of revisionism, a looking-
again at the same antique thing to understand it anew: "I see things
differently, I think of them differently."

If the one duty we owe to history is to rewrite it, then Antinous
has more than done his share, heralding a queer renaissance in late-
Victorian literature. In *The Emperor's Babe*, Venus makes clear that
the retelling of such legends is part of the difficult process of achieving
recognition: "Now I've told Tel this little bit of history / a mille times.
Precedent set many moons ago // my man. Let's go public."[98] However,
the Hadrian and Antinous example matters both for its public promi-
nence and for its centrality to the functioning of the Roman state. That
is, the example offers an alternative basis for same-sex relations not
on the threatening grounds of effeminacy but within the martial order
of empire, being a relationship between a military-minded emperor and
a colonial youth. When the youth dies, Hadrian transforms his affec-
tion for the youth into a spiritual ideal around which he organizes his
own political power. As Dowling argues, it was on such grounds that
writers such as Symonds employed examples from ancient Greece and
Rome to make homosexuality more palatable to the Victorian public,
casting same-sex affection as integral to the martial and spiritual
values of the state and not outside them. For Venus to claim a desire
for a "sparring partner, / a Mr and Mrs scenario," is to make a claim
for acceptance on grounds pioneered by revisionist classicists such as
Symonds.[99]

Evaristo's queer characters, then, fall along several lines: effeminate
heralds of social ruin, such as Caracalla; pederastic pairings seen
as integral to the healthy functioning of the state, such as Hadrian
and Antinous; and aspirants to middle-class respectability, such as
Venus. That is, the text encodes queerness both as a marker of the sort
of social and political dissidence perceived as decadent and as an alter-
native social foundation for the modern state on the basis of an even-
older, uncorrupted antiquity. The multifaceted queerness of the text

exposes the dissonant historiographical models at work in its depiction of Rome's late-imperial moment. On one hand, the text describes the narrated world of the text within a cyclical model of history in which civilization is imagined to move through stages of "virtue, luxury, corruption, and ruin," and effeminacy and sexual dissidence are understood as markers of decline. On the other hand, the text, in its openly accepting stance toward its queer characters, seems to evoke a more progressive and linear model of history marked by increasing tolerance, in which history amounts to a "single, cumulative ascent from barbarism to enlightenment."[100] And yet any sense of progress in the text is undermined by the text's acknowledgment of history's many reversals.

As Elizabeth Freeman has observed, because modern homosexual identity emerged at a specific historical moment in the late nineteenth century, "gay men, lesbians, and other 'perverts' have also served as figures *for* history, for either civilization's decline or a sublimely futuristic release from nature, or both." The emergence of such sexual dissidence in the late nineteenth century produced, Freeman argues, a particular temporality, experienced as a sort of "double-time." Its "signature was interruptive archaisms: flickering signs of other historical moments and possibilities."[101] The many anachronisms of *The Emperor's Babe* might also be read as a sort of "interruptive archaism." Dissident characters serve both as figures for historical decline and as figures for future possibilities. Such double-time can be heard in the text's very language, in which ancient Latin interrupts the flow of modern English. It can be understood too as a matter of genre, such that ancient genres such as the epic and lyric inform and sometimes interrupt a narrative that often resembles a modern Bildungsroman.[102]

In *Cruising Utopia*, José Esteban Muñoz describes his method of exploring queer futurity as a "backward glance that enacts a future vision."[103] Like Evaristo, he takes an aphorism from Wilde—"a map of the world that does not include Utopia is not worth even glancing at"— as the epigraph to his work.[104] Wilde's statement, Muñoz remarks, "makes explicit the connection between queerness, utopia, and world making."[105] With Wilde's utopian mapping as inspiration and recurring motif, Muñoz refigures "cruising" not just as a sexual practice but as a more imaginative way of mapping queer potentialities, as demonstrated

by the vision of queer artists as they anticipate new, as-yet-unrealized modes of relation. In this regard, "the past is used in service of the future, a place of possibility and transformation" amid a heteronormative culture that "makes queers think that both the past and future do not belong to them. All we are allowed to imagine is barely surviving the present."[106]

In Evaristo's text, Venus undertakes a similarly queer practice of world making. After getting kicked out of her house in her youth for dating a "local shepherd boy," she feels "brutally // severed from her past, blanking / it all out to survive." After coming to London at age fourteen, she works as a rent boy, cruising "Spitalfields Cemetery after hours" for work.[107] In effect, her cruising becomes an attempt to survive her separation from her familial past by charting a new relation to the world. After reestablishing a chosen connection to a queer past in the legend of Hadrian and Antinous, she arrives at a vision of the future that is both concretely domestic and utopian in its imagining of a queer afterworld unmarked on any map but still reachable from the space-time of the present moment: "I believe in for ever. I believe in dreams. / I believe in finding my soul partner, // a life of domestic bliss, then sailing / off to Tranny Hades together."[108] The text deliberately queers a cliché of domestic bliss and marital happiness here. In doing so, it disrupts a heteronormative temporality based on marriage and family. Venus, severed from the immediate past of her biological family, invents her future in "Tranny Hades" through an affiliative reimagining of queer antiquity (the reign of Hadrian). She imaginatively extends her present-day life in Londinium's queer underground into the afterlife of a future (yet classical) queer underworld. The double-time of Evaristo's queer and trans figures can thus be seen in their reinvention of past and future. This double-time is integral to the flickering temporality of Evaristo's text as a whole, in which interruptive archaisms are the rule and not the exception. As the text shuttles between disparate historical moments, it also oscillates between seemingly incompatible historiographic paradigms, both decadent and utopian, cyclical and progressive. In this manner, the text's queerness is in many respects a function of its conflicting temporalities, and vice versa.

While the example of Antinous and Hadrian is now well acknowledged, the figure of Antinous would not have been available for

Evaristo's text on the same terms without the intervention of nineteenth-century aesthetes and decadents. The nineteenth-century thread of Antinous literature provided a queer counterdiscourse to the then-reigning art-historical establishment that ignored or denied representations of homosexuality. The artists and scholars involved in this revisionist project made ready a model for the recovery and reinvention of other historically marginalized subjects. It is in this sense that Evaristo's own project of revisionism—to imagine a precedent for a black presence in Britain that goes back two thousand years—can be said to be underwritten by a queer practice of historical revisionism that took the recovery of classical Roman and Greek models of same-sex desire as a strategic entrée to wider social acceptance and a utopian future. Zuleika is, in effect, Evaristo's Antinous, a figure who brings new possibilities to life but whose historical roots remain clouded by both legend and bias. As with Shonibare's use of Wilde's dandyism, the notion of black visibility in Evaristo's text relies in part on queer countertraditions of the nineteenth century to make its own claims on the present-day literary establishment.

There is a darker side to the Antinous legend, however. In many decadent reimaginings of the legend, Antinous becomes "a kind of reverse Galatea."[109] Unlike the statue that Pygmalion brings to life, Antinous begins as a warm-blooded person but is then fatally turned into a piece of art, such as the myriad statues commissioned by Hadrian. Such is the case in both *The Picture of Dorian Gray* and Rachilde's decadent novella *Monsieur Venus*, in which Rachilde's aristocratic, gender-bending protagonist, Mlle. Raoule de Vénérande, plucks her pretty boy toy, Jacques Silvert, from his lowly flower shop, calling him the "Antinoüs of the boulevard Montparnasse."[110] She then installs him in her studio and reduces him to an object of sexual slavery, dressing him in women's clothes, subjecting him to a variety of perverse scenarios, and, after his untimely death, transforming his corpse into a functional automaton with rubber skin and a spring-loaded tongue. Even Symonds, in his more sober treatment of the Antinous legend, remarks that the way in which Antinous was often depicted in the guise of other classical figures reminds one of how "a wealthy lover may amuse himself by dressing his mistress after the similitude of famous beauties."[111] In his poem "The Lotos-Garland of Antinous,"

he intimates that Antinous chose suicide because he saw for himself a "wanton's doom" when his "blossom withered" and the emperor would no longer desire him.[112]

Having been plucked by Felix from the streets, Zuleika is also at risk of being turned into a decorative automaton in Roman *matrona* drag for the sexual and aesthetic pleasure of her husband. In selecting the eleven-year-old Zuleika as his wife, Felix opts for a "simplex, quiet, fidelis girl" who exhibits none of the strong will or sexual license found among the grand dames of the Roman elite.[113] In terms that echo Juvenal's "Sixth Satire," Felix complains of the "hedonistic breed // of aristocratic matronae, determined to compete / with the husband in all spheres, // ever boastful of their sexual shenanigans." Things have "got quite out of hand in the fatherland," Felix remarks.[114] The figure who best illustrates the licentiousness of women at the imperial center is Felix's sister, the "Divine Antistia," a rich widow who sits atop Roman society's "A list." When Antistia visits Londinium, Felix locks Zuleika in her room so she will not fall prey to Antistia's sexual advances. Evaristo casts Antistia as a sadistic "dominatrix" whose welcome orgy at Felix's villa involves whips, chains, and the sexual torture of children. Bejeweled "in dazzling turquoise silks" with "a face fashionably white with lead / and pouting ochre-red lips," this "Divine" noblewoman sounds less like a Roman matron and more like something out of a John Waters movie, signaling the book's volatile mixture of modern camp, ancient satire, and sadism in its critique of the sexual exploits of the upper classes.[115]

In warning "Little Miss *Noobia*" that Felix will never take her to Rome because he has his "career to think of," Antistia claims, "A real Roman is born and bred . . . // and that goes for the emperor too, / jumped-up *Leeebyan*."[116] However, in tallying Antistia's layers of makeup, costume, and S&M gear, Evaristo suggests that Roman nobility is less an inborn quality than something a of a drag performance.[117] After Felix chooses an unspoiled colonial for his bride, he makes Zuleika over as a tamer, secondhand version of the familiar Roman house matron, seeing to her "educatio" and providing "lessons in elegantia."[118] On her wedding night, Zuleika is "pampered by maids," her face is painted white with chalk, and her lips and cheeks are tinted with "lees of red wine."[119] After getting the full Pygmalion treatment,

Zuleika imagines herself as the "It Girl of Londinium," but her trans-
formation stands as a striking example of colonial mimicry, with Felix
going as far as to put a black girl in white face, simultaneously dis-
tancing himself from and replicating (in more manageable form) the
sexual and social mores of the imperial capital.[120] When Felix consum-
mates his marriage, he also replicates Antistia's sexual violence. Zuleika
screams and passes out on being penetrated and has to be repeatedly
sewn up by her doctors after intercourse.[121] In this sense, the racial mas-
querade to which Felix subjects Zuleika by turning her into an artifi-
cially pale imitation of a Roman matron is inseparable from her sexual
subjugation. If Zuleika undergoes a Galatea-like physical and linguistic
transformation from street urchin to Roman matron at the hands of
her Pygmalion-like husband, she also undergoes the same reversal of
the Pygmalion myth to which Antinous was often subjected in de-
cadent retellings, metamorphosed from a flesh-and-blood being into
a beautiful but lifeless object of art.

While the Antinous legend helps account for the dialectic in Evaris-
to's text between the aspiration for black visibility and the dangers asso-
ciated with the aestheticization of black bodies, it is to classical figures
such as Virgil and Sappho that the text turns to navigate questions of
genre. That is, the text steers between a classically male, epic poetics and
a lyric poetics that is marked as female and queer. For example, as Zu-
leika's education in classical poetry proceeds, she finds herself stuck
between the epics of Homer and Virgil and the works of "some butch
dyke who lived with a bunch/of lipstick lesbias on an island in Greece."
Moreover, her tutor, Theodorus, tells her that "all the notable poets were
men," except for Sappho, "but she was really a minor poet," her butch-
ness only seeming to gain her partial recognition.[122] Having dismissed
the lyric poetry of Sappho, Theodorus informs Zuleika that she could
never become an epic poet either. As Zuleika sums it up, "I'd never write
good poetry because what did//I know about war, death, the gods,/and
the founding of countries?"[123] Likewise, when Zuleika wonders what to
do about her budding relationship with Severus, her friends tease her not
to "create an epic poem" out of her troubles.[124]

Katherine Burkitt argues that *The Emperor's Babe*, like Walcott's
Omeros, "ambivalently" locates itself on the cusp of several genres, in-
cluding the poem, the novel, and the epic. Like *Omeros, The Emperor's*

Babe can be read as "a contemporary manifestation of epic," or as "post-epic."[125] Despite the imperial setting that gestures toward epic and the novelistic narrative of development that shares many features with other postcolonial Bildungsromans, it is in the short, lyric model of the "minor poet" Sappho that *The Emperor's Babe* finds its most intimate and disruptive path into the domain of the male-dominated world of classical epic poetry. If epic is the primary genre concerned with the developmental tale of nations and empires, then Evaristo's Sapphic alteration to the postcolonial "post-epic" constitutes another queer revision to literary tradition undertaken in the service of a new, pluralistic poetics.[126]

Take, for instance, the contrast between a scene describing Severus and Zuleika's lovemaking and the lyric that immediately follows. While Severus woos Zuleika with flowers and notes containing lyrics from Sappho, Zuleika casts sex with Severus in distinctly mock-epic terms. Asking, *"Are you ready for war?"* Zuleika fondles Severus's armor and muscular flesh and finds herself "dying" of his "dulcet conquest" as she invites him to "besiege" her and "batter-ram" her "forted gateway," crying, "futuo me, my actor-emperor." Punningly scrambling Julius Caesar's famous declaration, she proclaims, "Vidi, Vici, Veni": I saw, I conquered, I came.[127] Though the passage is clearly over the top, it is also the moment in the text that most directly appropriates and satirizes the language of epic as Zuleika learns to have her way with the conquering emperor.

The passage that follows, however, titled "Post-Coital Consciousness," moves distinctly away from mock epic toward earnest lyricism:

> suspended
> on feathers we were
> borne on wind windows framed azure sky far off silver
> wicks flickering
> embroidered silk throws
> thrown to the ground were crushed indigo and crimson
> anemones we did not stir soaked
>
> anonymous limbs sprawled
> a brutish arm sweetly
>
> limp on my shoulder[128]

The shift from the unrhymed couplets that dominate the narrative portions of the text toward more free-form, free-verse lyric is immediately recognizable, produced with an array of devices, including dense internal echoes ("wind windows" / "wicks flickering"), unexpected rhyme pairs ("anonymous" and "anemones"), syntactic indeterminacy and enjambment, a lack of punctuation, and a right-justified text block, all of which announce to the eye and ear that the mock-epic tone of the previous few pages has indeed been "suspended" in both time and form, literally reversing the scheme of text and margin in favor of the more marginal and minor lyric voice.

In one of the fuller extant fragments attributed to Sappho, the ancient Greek poet declares that while some lovers prefer soldiers and horsemen, she would rather look on her lover Anaktoria's face than "all the war chariots in Lydia / and soldiers battling in arms."[129] Such statements might also be read to make a claim for the emotional intensity of the lyric form and its more intimate subject matter over the more expansive scaffolding and typically martial preoccupations of the epic. Similarly, it is through lyric passages that *The Emperor's Babe* most engages the epic tradition by bursting its structures wide open, allowing the minor, Sapphic moment of diffuse lyric consciousness to emerge out from under the "brutish arm" of soldierly epic.

This generic tension between epic and lyric runs high in the short burst of grief-stricken lyrics that follow Severus's death. In an earlier scene, Severus recalls how, as a young boy, he dreamed of becoming emperor after reading Virgil's line *They can because they think they can.*[130] After his death, the devastation Zuleika experiences is conveyed not with epic grandeur but in the bare bones of stunned lyric brevity:

<div align="center">

you

have

murdered me

you bastard

you have

died

at

York[131]

</div>

Though Severus's campaign to subdue Caledonia may have been epic
in its ambition, the effect of his death ricochets in the most personal,
lyric terms for Zuleika. In reducing the hexameters and pentameters
of Greek and English epic to as little as one beat per line, the verse
marks both the death of a warrior-hero who was epic in stature and the
diminishment of the Virgilian epic mode in which Severus saw him-
self. Were these two stanzas to be written out as two lines, they would
scan as half of a ballad stanza of the type often employed by Emily
Dickinson. The first stanza could be read as a single line of trochaic
tetrameter with a "feminine" ending while the second amounts to a
single line of trochaic trimeter with a "masculine" ending:

> / / / /
> you have murdered me you bastard
> / / /
> you have died at York

Compare this, for example, to Dickinson's "If the foolish, call them
'flowers'—/Need the wiser, tell?"[132] However, Evaristo, in breaking up
the lines as she does, works against their natural rhythm, emphasizing
the stilted anger in Zuleika's grief. In such moments, the work's frag-
mentary Sapphic inheritance overtakes the classical epic model it
writes against. The work of the minor poet, in its very smallness, like
a cog turning a great wheel, overturns the dominance of the imperial
epic tradition.

 This burst of lyric energy toward the end of novel, which one critic
has read as a collapse in narrative momentum, indeed amounts to a
kind of dying fall.[133] With the death of Severus, the verse must con-
front the abrupt end of the epic progress of the empire and its immi-
nent pivot toward decline. That is, the individual lyric, focused as it is
on the pain of the individual subject, crystallizes events more proper
to epic's attempt to narrate the greater story of the nation or empire,
which suddenly stutters to a halt. As bells ring in the street with the
news of the emperor's death, Zuleika hurries out to hear the cacophony
of a nation in shock: "hordes/were swaying towards the Forum, poured
out//of alleys, swept into the swell of excited voices./I tried to deci-
pher the babble, no one would stop."[134] As history comes to a halt with
the death of the emperor, the voice of the nation itself disintegrates into

"babble." The verse must somehow reconcile the grief of the nation with Zuleika's personal grief at a moment when the story of the nation, like Zuleika's personal story, is stripped of meaning, becoming unintelligible. In this sense, Evaristo's formal puzzle is much like that of the fin-de-siècle lyric, which, as Helen Vendler argues, seeks to "reconcil[e] the epic subject of history with the lyric moment," gathering the end-of-an-epoch feeling into the "short-breathed" expression of the individual lyric subject.[135] Verlaine's "Langueur," for example, with its declaration, "Je suis l'empire à le fin de la décadence," collapses France's story of national humiliation at the end of the Franco-Prussian War with the speaker's own personal decadence and dissolution.[136] Similarly, Evaristo captures the end of Severus's reign by attenuating the expansive measure of the epic line into a subjective moment of lyric shock. The result is a poetics of diminishment more typical of the fin-de-siècle lyric than classical epic, rendering such lyric modulations an important facet of the "post-ness" of postcolonial "post-epic." It is at exactly such moments that the cohesive force of the dominant imperial language breaks down, allowing a cacophony of postimperial voices to emerge into the forum, if only, at first, as babble.

While it is true, as Evaristo notes, that the ancient Romans and ancient Britons did not speak the same mix of languages represented in *The Emperor's Babe*, their linguistic environment, which predates the rise of English by three centuries, had its own complexities. In the third century, the majority of the island's inhabitants would have been native Britons, likely of Celtic descent (though the origins of the Celts are disputed), and their primary language likely would have been one of the old Brittonic languages that later developed into Cumbric, Welsh, Breton, and Cornish, or one of the other Celtic languages that developed into modern Irish, Scottish Gaelic, and Manx.[137] While Cumbric, Cornish, and Manx have gone extinct, Welsh, Irish, Scottish Gaelic, and Breton are still taught in schools as second languages, though the number of "native" speakers of these Celtic tongues has dwindled.[138] The Picts spoke a language so little attested that linguists have debated whether Pictish represents a variety of Celtic or whether it evolved out of another language branch entirely.[139] Evaristo's synthetic mix of modern creoles, pidgins, and dialects, then, implicitly evokes a now-alien world of languages that can only be speculatively reconstructed.

The closest Evaristo's text comes to evoking these lost or nearly lost languages is in its occasional gestures to the ghostly "hypnotic Celtic beats" from the orchestra at the amphitheater, or in the "caterwauling vocals" of a green-haired punk singer who "emit[s] glass-shattering vibratos / over a fusion of military marching horns, // the drum rolls of a mysterious Celtic cult / and the discordant twang of the harem harp."[140] In approaching the condition of punk music, such primal Celtic rhythms are figured as virtually unrepresentable.[141] In other words, the linguistic world of *The Emperor's Babe* is haunted by the disappearance of native British languages, which leave their traces in the primal rhythms of Celtic music and in the unconscious rhythms, lilts, and regional grammatical legacies embedded in modern English speech patterns.[142]

The text makes clear that linguistic losses are the cost of empire building. Zuleika remarks on the Roman Londoners' hope that Severus would come to Britainnia, "defeat the fucking Scots, Pict and Saxon / bastards, . . . // spear every last man, . . . / colonize their terra firma, [and] make them speak // our lingo."[143] The historian Peter Salway understates the violence that accompanied the colonial imposition of Latin when he observes that "the spreading of the Latin tongue carried with it a subtle means for the absorbing of subject populations into the Roman system. [Latin] education was, in short, an essential step in establishing the civil mechanism of a Roman province."[144] The force with which the English imposed their own language on Wales, Scotland, and Ireland, as well as on much of the colonial world, remains the source of much discontent in postcolonial cultures today, including those of the British Isles. As one contemporary native speaker of Welsh complains, "The English are congenitally incapable of understanding that there is another indigenous language and culture in Britain which is not Anglo-Saxon. This imperial vocation dies hard."[145]

The loss of native languages represents a significant, if only implied, formal challenge for Evaristo's imaginative re-creation of third-century Londinium. Because Evaristo does not have the privilege Petronius had of reporting from the scene, she must recode Britain's lost dialects in modern analogs with their own markers of social and ethnic difference. When Zuleika's Caledonian slaves speak to her in

pidgin, for example, they are represented as speaking in heavily accented modern Scottish English, not in Scottish Gaelic or Pictish:

> we'd sit cross-legged in a big raing,
> an eat breid an stew out of wuiden bowlies.

> Efterward de Druids would tell stories
> aboot de goads, oor granfaither

> was chief Druid, he could confabble wi thaim.[146]

In such passages, we must implicitly take the deviation of modern regional dialects from Received Pronunciation as a figure for the deviation of Pictish- or Gaelic-Latin pidgin from the Standard Roman Latin that was then the lingua franca of the empire.

Likewise, it is easy to gloss over the fact that the text's chatty, anachronistic, conversational English presumes a continuous translation of whatever never-quite-identified vernacular Zuleika must have spoken with her friends, which differs from the formal language she speaks with the Roman nobility, the creole she speaks with her parents, or the classical literary Latin that influences her poetry. When Zuleika upbraids her Caledonian servants for getting uppity, the text emphasizes how much her upper-class Latin is an acquired speech, a result of Received Pronunciation classes of the "how now brown cow" or, rather, the *"How nunc brown vacca"* variety.[147] Evaristo makes a point of having her characters overpronounce and spell out proper Latin to show a conscious shift in register from the vernacular. As Zuleika says of Alba, she occasionally "puts on a very received pronunciation accent: // 'I have of late added to my list of amores.' "[148] Likewise, Zuleika tells her servants, "In case you have forgotten, / you are S-E-R-V-A-E. Whadoesthatspell?"[149] Moreover, lines from *The Aeneid* are quoted in their original and then translated into English, suggesting that Zuleika and her friends usually speak in something more demotic.[150] By the same token, the text largely reserves its use of "vulgar" Italian for sexual subject matter: "Men and women, women and women, / men and men, multiples of all sorts // groaning in pain. Absolutely fascinatio!"; "he sucked my *toes*, / called me *mea delicia*, opened my legs"; "When you go make bambino?"[151]

These examples stress the way in which Latin was under pressure from cross-linguistic contact with native populations. In the third century, the separation between spoken Latin and classical written Latin was already under way. The Latin that Roman officials spoke to each other, even in Rome, would have varied significantly from the variety of Latin found in *The Aeneid*. The British Latin spoken by those upper-class Britons assimilated into the empire would have differed even more so. Evaristo may not have made a study of such linguistic changes, but they provide the historico-linguistic matrix on which her text is built, and the way such changes have been understood historically affects how ancient languages and their modern analogs have come to be represented in texts such as *The Emperor's Babe*.

As Dowling notes, it was through the study of Latin's transformation into myriad vernaculars that philologists in the nineteenth century, such as Max Müller, began to think of language as an organic thing that can grow, decay, and die: "After having been established as the language of legislation, religion, literature, and general civilisation, the classical Latin dialect became stationary and stagnant. It could not grow because it was not allowed to change or to deviate from its classical correctness. It was haunted by its own ghost. Literary dialects, or what are commonly called classical language, pay for their temporary greatness by inevitable decay." In Müller's view, literary languages become frozen until, at certain moments of crisis, "the vulgar dialects which had formed a kind of under current, rise beneath the crystal surface of the literary language, and sweep away, like the waters in spring, the cumbrous formation of a bygone age."[152] To those Victorians who hoped their empire would expand on the strength of English's literary superiority, this was a frightening prospect. For the decadents, such ideas offered an opportunity for experimentation and innovation.

Dowling argues that "within the new linguistic order, then, literary language, be it the Latin of Horace or the English of Shakespeare, was viewed as dead or decaying just as it succeeded in preserving itself from the ceaseless change and variation of approximate, impermanent human speech."[153] Furthermore, "the only monuments of dead language were works of literature embalmed as books on the shelves of libraries."[154] The conclusions of modern philology led some Victorian writers, as Dowling argues, to write modern languages as though they

were dead, as Pater was said by Max Beerbohm to write English: "I was angry that he should treat English as a dead language, bored by that sedulous ritual wherewith he laid out every sentence as in a shroud—hanging, like a widower, long over its marmoreal beauty or ever he could lay it at length in his book, its sepulchre," Beerbohm remarks.[155] Others, such as Baudelaire and Huysmans, chose to revel in the multiple barbarisms and solecisms that broke up the monotony of classical language.

While Evaristo may not have been familiar with nineteenth-century views on the decay of Latin, Dowling's arguments can help us understand the contrasts in *The Emperor's Babe* between the vibrant vernacular of the street and the frozen, half-dead version of Latin spoken by Londinium's Roman nobility. That is, these contrasts can be read in the imagined context of imperial decline. When Zuleika is confronted with the seemingly natural privilege of the Roman nobility claimed by Antistia, she contrasts the woodenness of her own speech with that of the elite:

> My tongue became wood.
> I could never speak in her presence
>
> or to Felix's cronies, who spoke
> as if they owned the world. Well,
>
> I guess they did. My words revealed me,
> their ornate diction was a mask.[156]

While Zuleika's silence has an organic, wooden quality, her attempts at upper-class Latin betray her origins as if she were some Eliza Doolittle only halfway through her training with Professor Higgins. The "their" of "their ornate diction" is somewhat ambiguous. If it refers to Zuleika's own "words," then the line could be read to suggest that the cracks in her attempts to mouth such ornate diction reveal her words to be a mask, not a product of natural facility. If one reads "their ornate diction" to refer to the diction of Felix and his cronies, then it is "their" upper-class Latin that functions as a mask, while Zuleika's words are more raw and revealing. Either way, official Latin is figured as having an opaque, artificial quality, one that must be learned in a certain social environment. Naturalness in the official language of the

state must, paradoxically, be acquired—it is hardly "born and bred,"
as Antistia would have it—and those who take the mask of official
Latin as second nature remain hostile to any baser elements that might
be detected in the speech of others.[157]

Evaristo employs the relationship between Zuleika and her Cale-
donian slaves to dramatize the tensions between the ornate mask that
Zuleika dons as a nouveau-riche house matron and the rough remain-
ders of her vernacular speech, registering the estranging, composite
quality of her own language:[158]

> 'Madam is waiting,' I said, intoning
>
> just like the late, gladly departed Antistia,
> in fact sounding like every magniloqua
>
> matrona I'd ever had the misfortune to meet,
> with a little bit of Venus camposity
>
> and the pompousness of Pops thrown in too.
> What had I become? But a composite.[159]

In this passage, the sound effects of the verse itself are constructed from
the multiple facets of Zuleika's linguistic mask. The bracket rhyme be-
tween "magniloqua" and "matrona" links linguistic performance and
gender performance, while the echo of the portmanteau "camposity"
("camp" and "pomposity") in the word "pompousness" renders Zulei-
ka's speech a tense "composite" of matronly Latin eloquence and the
equally affected, subversive camp style employed by Venus. The dif-
ference between matronly eloquence and its parodic, camp Other be-
comes difficult to distinguish, making Latin, for Zuleika, in every
sense a drag.

While Zuleika's linguistic drag act might appear camp at moments,
it also betrays the violence underlying the tension between native and
dominant languages. In a section titled "A Quiet Bedtime Voice," Zu-
leika sits in front of a mirror as her slaves, Valeria and Aemilia, help
her remove her makeup and hair dressing. This section begins abruptly
in the third person as Zuleika regards her own alienated image in
the mirror. As Valeria and Aemilia wipe the "white / chalk" off her
face, "she" sees her "wide cheekbones" and "jet / nostrils": "I am the
deepest // of them all," she thinks at last. The third-person pronouns

"her" and "she" afford a rare outside perspective on the novel's protag-
onist, bringing us closer to a perspective shared by Zuleika's slaves.
As they massage her, Amelia whispers softly, *"Madam is sae
blue,*/sotto voce" in Zuleika's ear. At first, this seemingly sympathetic
acknowledgment that madam is "so blue" is soothing, but Zuleika
soon clutches the dressing table to steady herself as her servants pre-
sumably begin to pleasure her: "I am too often alone,//these wretched
girls will play me/like a lyre," she thinks. The "quiet bedroom voice"
of her Caledonian slaves subtly reveals an undercurrent of hostility in
the slaves' sexual manipulation of their mistress.[160] This manipulation
becomes a figure for the way their "quiet" vernacular subtly under-
mines the dominance of official Latin. Later in the novel, Valeria and
Aemilia betray Zuleika by spilling news of her affair with Severus,
leading Felix to have her poisoned to death.

To characterize the slaves' soft speech with the Italian phrase "sotto
voce" is ironic because the vernacular voice of these enslaved Scots
represents nothing less than a lethal threat to the Roman hierarchy.
Like the undercurrent of "vulgar dialects" that Müller imagines
sweeping away "the cumbrous formation of a bygone age," theirs is a
quiet voice of native resistance that threatens to sweep away the
nobility. If *The Emperor's Babe* is haunted by the ghost of lost Celtic
languages that it cannot quite represent, here we encounter a represen-
tation of such voices biding their time, waiting for a chance to over-
throw their mistress. The linguistic decadence of the masters opens the
gates to the barbarians, who will play both sides of the linguistic divide
"like a lyre," that is, in the subversive lyric forms of their poetry.

Giorgio Agamben notes that for Dante, vernacular language repre-
sented the "primordial and immediate experience of speech" as we first
passively acquire it in the home. By contrast, Latin represented a per-
fect grammar that must be learned. However, Dante did not see Latin
as a dead language. Rather, he viewed the vernacular as "perishable"
because it was always changing, while Latin was "perpetual and in-
corruptible," putting "an end to the mortality of languages."[161] As
Agamben notes, this attitude toward language underwent an almost
complete reversal among later humanists.[162] Somewhere in between,
one finds bizarre texts such as the *Hypnerotomachia Poliphili* (1499), a
baffling hodgepodge of Latin words stuffed into a seemingly vernacular,

Italian grammar.[163] The *Hypnerotomachia Poliphili* seems to illus-
trate either the case of a living language written as though it were
dead or the case of a dead language written as though it were alive or
both. Agamben's point, however, is that each state of the language,
living or dead, implicitly expresses the other state. For Agamben, what
one finds in the *Hypnerotomachia Poliphili* is a text "in which one
language—Latin—is reflected in another—the vernacular—in recip-
rocal deformation."[164] In this sense, the mutable Italian vernacular
always contains within itself the unconscious expression of fixed clas-
sical Latin.[165] In Evaristo's text, we also find a "dead" Latin lexicon
stuffed into modern English syntax through a process of reciprocal de-
formation. The modern vernacular contains a reflection of its "dead"
literary predecessors, and vice versa. Like the *Hypnerotomachia, The
Emperor's Babe* demonstrates how English vernacular might revive a
dead classical language and how a classical literary language might
give life to perishable vernaculars.

A figure for this entanglement between dead and living languages
can be found in the statue of Medusa that presides over Felix's villa,
where it guards against the barbarians at the gate. As Zuleika describes
it, in the atrium of the villa, which is designed in an open-air Mediter-
ranean style ill-suited to Londinium's cold winters, one finds "a statue
of a snarling Medusa" intended to frighten off "low-class intruders."

> Water poured out of her open mouth,
> and her flying dreadlocks, which normally
>
> produced fine sprays,
> had grown icicle extensions.
>
> I snapped one off and sucked.[166]

If language flows from the mouth like water, in the harsh Britannic
winters, Medusa's classical head literally freezes over. While the image
of Medusa is meant to scare off the plebes, for Zuleika, it is Antistia
who serves as a kind of linguistic Medusa, turning Zuleika's vulgar
tongue to wood, if not stone. And yet, when Zuleika plucks the icicles
from Medussa's classical head (or capital), they melt in her mouth. If the
socially imposing aspect of a dead classical language threatens to turn
Zuleika's second-generation plebby creole to stone, through a process of

mutual deformation, Zuleika warms up and revives a language frozen
by geographic displacement. (The Jamaican-style dreadlocks of this Me-
dusa's hair further evoke the creolization of language and culture by the
African diaspora.) In Deleuze and Guattari's terms, we might say that
Evaristo imaginatively reterritorializes a deterritorialized, official, "ve-
hicular" Latin, grounding it in the here and now of London/Londinium.
By the same token, the text reterritorializes the vernacular in the mythic,
symbolic realm once occupied by classical Latin poetry. However, clas-
sical languages are not necessarily always happy to be so creolized.
When Zuleika consoles herself for the failure of her poetry reading, she
finds herself sitting by the fountain, "where Medusa," she says, "spat on
my neck," seeming to express her disapproval.[167]

 At the end of the novel, as Zuleika is slowly poisoned with arsenic
on Felix's orders, she says her good-byes to her friend Alba and resigns
herself to having never created the "magna opera of words" she so de-
sired to leave behind.[168] She instead offers her last attempt at verse—
"There are drops of clarity/Poison does that to you"—and laments that
she "wanted to be a great poet or mosaicist/or something," sending
Alba home with instructions for her epitaph and burial.[169] Thereafter
follows a metaleptic epilogue, presumably in the voice of the poet, Eva-
risto, lyrically bidding farewell to her poetic creation. She does so
under the statue of Medusa:

> It is you I have found to wear, Zuleika,
> lying in a panel of summer,
> your golden couch moved into the atrium
> to feed your skin, for the last time.
>
> I enter quietly from Watling Court,
> the pounding bass and horns of the City's
> square mile, suspended. Between
> two columns, your couch faces a pool
>
> fed by the aching stone mouth of Medusa.[170]

Though Zuleika dies, the final scene takes place in summer, and water
flows easily from Medusa's mouth.[171] At the moment of death, however,
Zuleika herself appears as if turned to stone, becoming "obsidian/with
light and sweat." At that moment, the voice of the poet enters: "I

slip/into your skin, our chest stills, drains/to charcoal. You have expired, Zuleika,/and I will know you, from the inside."[172] While Beerbohm criticized Pater for laying out every sentence as if in a shroud or sepulcher, in the final moment of *The Emperor's Babe*, Zuleika becomes her own obsidian sepulcher. During her life, Zuleika's warm, flowing mix of vernaculars was stilted by the frozen language of her Roman betters. Yet here, as she herself turns stone-like, water flows freely from Medusa's mouth as if to signal that Zuleika's memory would be carried henceforth in the literary language of the classics. Zuleika's living vernacular dies with her, but her memory lives on, as Dante would have it, in the "eternal" language of literature.

In Medusa's "aching stone mouth," we have a figure not of low-class intruders turned to stone but of a woman, like Zuleika, fixed in stone, aching to speak. Zuleika herself becomes the very embodiment of language in its half-dead, half-living state, a "composite" in her own words. In this way, Evaristo takes the half-dead language of the past and gives it new life, while fixing the mortal, ephemeral vernaculars of her own time in the unchanging language of the written word. The very contemporary quality of the text's language is what will fix it forever in its early twenty-first-century moment. What remains behind of any language are those words that have been put into writing as though chiseled on an epitaph, such as the many stone epitaphs that, along with the occasional bit of antique graffiti, offer some of the best evidence of the social composition of the ancient world. Or, as Zuleika jokes early in the novel about her own legacy, "I will vaporize, a puff of steam, // and my lengthy epitaphium,/listing my great achievements: //*Zuleika Woz 'Ere.*"[173] It is a vernacular of the type often expressed in graffiti, etched into a more durable stone epitaph, that offers the best evidence of a life otherwise lost to history. That is, the living vernacular survives, but on a tombstone.

As a vernacular epitaph for empire, *The Emperor's Babe* dramatizes the still-uncertain status of postimperial English vernaculars and their claim on the high language of poetry. In *The Emperor's Babe*, Evaristo, like the decadents, takes both sides, writing a dead language as though it were alive and a living language as though it were dead. The result is no less artificial than Paterian English, but it is also capacious and flexible, open to Petronian code switching and postmodern anachro-

nism. Its mode is one of interruptive archaism, embedding its competing historiographic paradigms in its competing linguistic registers. Zuleika is not just a cultural composite but also a composite of linguistic history. As such, she is a figure for an emergent vernacular consciousness in perennial danger of being choked by the heavy weight of attempts to preserve a standardized, classical, literary language. Evaristo claims this full, ripe moment in the history of Roman Britannia to capture the perennial tension in twenty-first-century, postimperial Britain between the language of the canonical classics and the language of the streets. The linguistic world Evaristo conjures is still an imaginary one, a synthesis in which classical Latin, the ghosts of dead languages, and living, if mortal, vernaculars jostle side by side. But, as we can never fully know or synthesize our own linguistic cosmos in its present moment, it is a world we can only capture at the moment of its death, as the breath slips out of it (and into print) and we know it for the first time.

5

Decadence and the Archive
in Derek Mahon's *The Yellow Book*

IN THE 1888 short story "The Aspern Papers," Henry James offers an ironic parable about what can go wrong when an ambitious literary critic sticks his nose where it does not belong, namely, among the private papers and correspondence of a great poet. The story paints a biting portrait of its duplicitous narrator, an English literary scholar who rents a room in Venice under false pretenses in order to ingratiate himself to the house's residents, the Misses Bordereau, the elder of whom the narrator suspects of being the former lover of a long-dead American poet by the name of Jeffrey Aspern. The narrator undertakes this ruse with the aim of securing what he imagines to be a treasure trove of Aspern's literary remains—love letters, unpublished poems, and the like—documents he hopes will bring to light important details about the poet's life and work and enhance his own reputation as the steward of Aspern's legacy. Without giving too much away, one can say that the story ends badly. When the narrator's intentions are finally revealed, he discovers that there is a personal price he is simply not willing to pay for the object he seeks, the sought-after papers are destroyed, and lives are ruined or ended in the process.[1]

Given the unhappy ending of James's parable, one can imagine the mixture of alarm and excitement I felt when I sat down in the reading room of the Manuscript, Archives, and Rare Book Library at Emory

University (MARBL, now the Stuart A. Rose Library), cracked open Derek Mahon's scrapbook of notes for *The Yellow Book*, his 1997 homage to 1890s aestheticism, and discovered the following rather cryptic note: "The Aspern Papers: the Emory archive?"[2] I found similar remarks repeated in several other documents. Barely a day into my research, I found myself in the uncanny position of having already been inscribed by Mahon into a Jamesian universe in which the archive itself anticipates my presence, knows the value I stake on it, holds forth the promise of a lost world of documentary evidence, and threatens to pull the figure in the carpet out from under me.

I had gone to Emory, which is just outside Atlanta, Georgia, because I had read Hugh Haughton's comment that the scrapbook Mahon compiled for *The Yellow Book* was unusual among his papers, containing not drafts but "notes, quotes, names, and ideas," offering a hodgepodge of jottings and fragments, "many of which, in filtered form, contribute to the eventual text."[3] Noting that Mahon "preferred Auden's 'sets of notes' to his lectures, finding them 'singular, mischievous, erudite and aphoristic,'" Haughton observes that Mahon's equally singular notebook "is unique in his compositional history, [suggesting] something about the peculiar 'materials scholarship' of the sequence."[4] The scrapbook, which opens with a sort of title page on which Mahon has written the words "The Yellow Book; or Decadence," seems as though it functions not as a draft for the published volume but as a discrete work composed (to an extent) specifically for readers of Mahon's papers.[5] The care taken in its assembly and the collage style it develops (one Mahon had been developing for some time) indicate that Mahon meant for this scrapbook to be preserved as a kind of work in its own right, not just as a step toward some other finished product.

Many of the tidbits Haughton highlights make sense within a poetic sequence that takes "the revival of Wildean decadence" at the most recent fin de siècle as a means to examine some of the changes in Irish culture wrought by the economic boom of the Celtic Tiger years of the early 1990s, which exposed Ireland in newly visible ways to the forces of globalization and Americanization, seemingly producing a new decadence of pop culture, corporate branding, and postmodern art, a cultural regime Mahon appears to refuse by embracing the oppositional stance of the Decadent movement. As Haughton argues, the scrapbook

also demonstrates the way in which *The Yellow Book* builds on themes distilled from Mahon's journalistic writing over the years.[6] Mahon's *The Yellow Book* takes its title from the 1890s journal that became known as a leading vehicle of the Decadent movement in Britain, much to the chagrin of Henry James, whose story "The Death of the Lion" became the first story printed in the first issue (but more on that later).[7] With bright-yellow covers and striking illustrations by Aubrey Beardsley, the journal advertised itself both as a home for experimental writing that eschewed the tastes of the mass market and as a luxury commodity in and of itself.[8] The typographic design of both the Gallery Press and Wake Forest editions of Mahon's *Yellow Book* likewise gestures toward the Beardsley era, signaling that Mahon's resistance to, and potential complicity with, the commercial deluge of 1990s Dublin would be a matter both of style and materials.

In addition to figures such as Wilde, Baudelaire, Huysmans, and Pater, Mahon's highly allusive volume takes its heroes from what Mahon calls the "old boys of Yeats's 'tragic' (pathetic) generation," figures such as Ernest Dowson, Lionel Johnson, Arthur Symons, and Richard Le Gallienne who suffered like Mahon through their own *mal du siècle*.[9] The volume also includes figures of personal significance to Mahon, such as the Anglo-Irish writers Elizabeth Bowen and J. G. Farrell. Mahon's notes, however, wander among themes and motifs that go well beyond his fellow Anglo-Irish writers or the usual 1890s suspects. Drafts for *The Yellow Book* repeatedly allude to a "postcolonial theme" with evocations of "colonial fatigue," "the death of the nation state," "slave narratives," "Haiti," "The West Indies," Faulkner's *Absalom, Absalom!*, and Margaret Mitchell's *Gone with the Wind*, none of which bear obvious relation to the original *Yellow Book* journal or to Mahon's repeatedly revised published versions of the text.[10] One recurring cluster in the drafts—"Defoe? Césaire. Baldwin. Achebe. Kincaid. Crusoe/Tempest"—seems to rehearse the efforts by postcolonial, African American, and black diasporic authors to "write back" to earlier works in the English canon, such as *Robinson Crusoe* and Shakespeare's *The Tempest*, or to modernist works by Conrad and Yeats.[11] Such references point beyond the world of metropolitan aestheticism, suggesting that Mahon recognizes how the idea of decadence came to characterize colonial languor and imperial after-

math in texts from Africa, the Americas, and Asia and was given new meaning in the rhetoric of anticolonial thinkers.[12]

This can be seen in the 1999 poem "Roman Script," which was published two years after *The Yellow Book* but which encapsulates several of its important themes. In the poem, Mahon describes Rome as a palimpsest of imperial ruins and statues: "Here they are, Nero, Julia, Poppaea, Diocletian." But according to Mahon, "even the wretched of the earth are here."[13] In placing references to Rome's most notorious rulers alongside an allusion to Frantz Fanon's *The Wretched of the Earth*, Mahon renders Rome's imperial decline as the symbolic backdrop for the birth of decolonizing movements. Indeed, Fanon delivered an important speech at the Second Congress of Black Writers and Artists in Rome in March 1959 and met Jean-Paul Sartre and Simone de Beauvoir there in 1961.[14] However, just as Fanon worried that the youthful energies of revolutionary nationalism would be reabsorbed into a secondary decadence of bourgeois individualism, Mahon suggests that those who might take up the cause have been absorbed into the touristic simulacra of a "cinema city" where "everything is scripted for our delight." Mahon writes that Rome is "as good a place as any / to watch the end of the world," but "in the refuse of the world a new world is born."[15] Translating this last line from the Italian filmmaker Pier Paolo Pasolini, Mahon sees a possibility for rebirth in the detritus of empire and also, perhaps, in the act of refusal. In a notebook that dates between the publication of *The Yellow Book* and "Roman Script," Mahon has pasted a picture of Oscar Wilde in Rome in 1900, situating Wilde in his postincarceration exile as himself being among the wretched of the earth.[16] Such references align Wilde, an exiled dandy at the heart of an empire long past its decline, with the anti-imperial critique of later decolonizing movements.

Mahon's *Yellow Book* also locates Ireland's place within the changing landscape of the global literary market. Mahon's scrapbook for *The Yellow Book* is very much a product of Mahon's interaction with that literary market at the time of its composition. As it turns out, Mahon was invited to speak at Emory University in January 1996 at precisely the time when he was gathering ideas for *The Yellow Book*, and the particular scrapbook in question contains, among other things, a record of his visit.[17] During his time in Atlanta, Mahon showed great

interest in sites related to Mitchell's 1936 novel *Gone with the Wind*, including Mitchell's house, which is now a small museum in downtown Atlanta, and the nearby town of Jonesboro, the imagined site of "Tara," Scarlett O'Hara's ill-fated, fictional plantation house. Mahon's notebook contains driving directions to Jonesboro, and a separate folder holds a map highlighting the proximity of Emory University and the Margaret Mitchell House, as well as a ticket stub for the museum and a bag from the gift shop.[18] Mitchell herself was no stranger to Yeats's tragic generation. She took the title for her novel from a line in Ernest Dowson's poem "Non Sum Qualis Eram Bonae sub Regno Cynarae"—"I have forgot much, Cynara! gone with the wind"—an intertextual link to the fin de siècle that Mahon apparently could not resist. In Dowson's poem, the speaker notoriously declares his faithfulness, in a fashion, to an old flame, despite all the while lying in the arms of a prostitute, calling "for madder music and for stronger wine."[19] In evoking the language of metropolitan decadence to describe the faded glory of the southern slave plantation, Mitchell provides Mahon with a useful pivot from the insular poetic concerns of Rhymers' Club poetry to broader changes in the economic and political foundations of modernity.

It is also clear from correspondence and photos in Mahon's papers that during his 1996 visit to Emory, Mahon met with the curators of the Manuscript, Archives, and Rare Book Library and consulted with them on improving their bibliographic database of his papers. These papers constitute a large and expanding collection of material, the seed of which was purchased from a private collector but the bulk of which continues to be acquired directly from the poet under an agreement signed in 1991.[20] Several photos in the archive show Mahon examining some papers in the tenth-floor reading room as a librarian looks on.[21] Just two months after Mahon's visit, one of the librarians wrote to find out if he would be willing to grant them permission to digitize two manuscript drafts and mount them on their website. The librarian also asked whether Mahon would be willing to have a recording of himself reading one of his poems posted to the library website.[22] A later letter confirms that this was done, while other letters indicate that Mahon offered advice regarding Emory's holdings of works by other Irish poets.[23] Mahon was also asked for information regarding his acquaintance and correspondence with Samuel Beckett.[24]

This is all to say that during the period when Mahon was com-
posing the *Yellow Book*, the archivization of his work, the digitiza-
tion of his voice, and the collection of work by other Irish writers were
all very much on his mind, as were the changing bibliographic and dig-
ital technologies employed by Emory. Moreover, the accident of this
particular archive's proximity to the locations of New World slavery,
real and imagined, became, for Mahon, an opportunity to reimagine
the economic politics of the archive from a transatlantic perspective.
That is, his exposure to the new technologies of archivization occurred
simultaneously with his poetic exploration of the archive's relation to
the southern slave plantation and the southern slave plantation's rela-
tion to the language of decadence. While I began this project with the
assumption that the Emory archive would reveal the record of how
Mahon composed *The Yellow Book*, it quickly became clear that the
volume of poems called *The Yellow Book* contains, in part, the record
of Mahon's encounter with the archive and an ironic commentary on
his participation in the ongoing process of archivization.

In this sense, I follow a line of thought from Jacques Derrida's 1995
work *Archive Fever*, in which Derrida argues that "the archive, as
printing, writing, prosthesis, or hypomnesic technique in general is not
only the place for stocking and for conserving an archivable content
of the past which would exist in any case." Rather, "the technical
structure of the *archiving* archive also determines the structure of
the *archivable* content even in its very coming into existence and in
its relationship to the future. The archivization produces as much as
it records the event."[25] To put this another way, Derrida presents us with
a case of the tail wagging the dog. He suggests that the technologies of
the archive, whether they consist of technologies of memory, transcrip-
tion, audio recording, or digitization, give form to the materials that
become archivable in the very moment of their creation. Following
this logic, the archive is not so much a final destination or repository
for, say, drafts of poems as it is a determining factor in the very creation
of a literary work. Following Derrida, one must ask, in what sense do
the technologies and structures of the archive at Emory give form to
Derek Mahon's poetry at the moment of its creation? What difference
does the specific location of the archive at an institution in Atlanta,
Georgia, make for our reading of the transnational dimensions and

economic politics of contemporary Irish poetry? And how has Mahon adapted strategies developed by his Decadent predecessors to address both these issues?

As Derrida also points out, the concept of the archive has its classical Greek roots in the repository of documents held at the home or domicile of the *archon*, or law giver, making the archive central to the imposition of civil order. "The archons are first of all the documents' guardians. They do not only ensure the physical security of what is deposited and of the substrate. They are also accorded the hermeneutic right and competence. They have the power to interpret the archives. Entrusted to such archons, these documents in effect speak the law." For this reason, there "is no political power without control of the archive."[26] One can see this profound link between the archive and political power in the founding of national archives, in the extensive record keeping of government agencies and colonial authorities, and in the ways in which institutional archives of all sorts, including literary archives, wrestle over who best should preserve documents and artifacts considered to be part of the national, ethnic, or linguistic heritage of whichever country claims them.[27] By reading Freudian psychoanalysis, with its interest in prosthetic forms of memory such as writing and the phonograph, as a theory of the archive, Derrida further suggests how a certain analog to the death drive, the desire to forget, might lead to a kind of political anarchism, suggesting the "possibility of putting to death the very thing, whatever its name, which *carries the law in its tradition:* the archon of the archive."[28] In this sense, the desire to erase, to forget, whether conscious or unconscious, attacks the very archival root of authority and, by extension, the state. Thus, *archivalism*, the institutionalized desire to remember, includes within it an *anarchival* impulse, an instinct bent on destroying archival memory even as it induces the desire to conserve memory against such destructive impulses: "anarchiving destruction belongs to the process of archivization and produces the very thing it reduces, on occasion to ashes, and beyond."[29] It is this internal contradiction that Derrida refers to as "le mal archive," or "archive fever."

We can see this contradiction at work in Mahon's translation of Jorge Guillén's poem "La Musa Retirada" ("The Muse in Retirement"),

an homage to James's "The Aspern Papers." Guillén's original poem imagines Jeffrey Aspern's former lover, the elder Miss Bordereau, alone with her memories of the past beside the waters of Venice, perfectly preserved with her stash of papers: "Los poemas, las cartas y en reino/La mujer para siempre ya reinante." Or as Cola Franzen straight-forwardly translates, "The poems, the letters, and the woman/in her realm now reigning there forever."[30] Ignoring the violent end that en-gulfs both Miss Bordereau and her trove of papers in James's story, Guillén paints a picture of documentary fixity, lasting authority, and contemplative lyric stasis. Mahon's translation, however, simply titled "The Aspern Papers," alters the poem to offer a warning more fitting to James's tale: "Not/everything has to be spoken;/not everything has to be known."[31] The gap between Guillén's original and Mahon's trans-lation becomes the very point of internal division between archivalism and anarchivalism, between the desire to preserve Aspern's papers in defiance of the knowledge of their ultimate destruction and the desire to never speak of them, not simply to destroy them but to erase all memory of their having been something to be destroyed.

It is in this sense that one can trace an *anarchival* strain in Ma-hon's work that allows him to recover the political anarchism of 1890s aestheticism, an anarchism that finds its most forceful expression in the political writings of Oscar Wilde, which Mahon simultaneously preserves and erases in *The Yellow Book*. Mahon's active engagement with the archive also opens up larger questions about the archive's role in what James English calls the new global "geography of cultural pres-tige," especially with regard to the specific politics surrounding the acquisition of work by Irish and Northern Irish authors by American academic institutions.[32] With regard to my own method, my aim is to move from a purely "extractive" model of archival research toward an examination of how the process of archivization itself, its forms and contexts, shapes a particular set of tropes and formal devices in Mahon's poetry, and, vice versa, how the poetry seeks to alter, reshape, hack, or otherwise transgress the seemingly given function of the archive as mere repository or resting place for moribund literary docu-ments.[33] Rather, the archive offers a position from which the poet can, through a more mischievous and specifically decadent anarchivalism,

craft a different relation to the future of Irish poetry. As with Walcott, Shonibare, and Evaristo's historical revisionism, Mahon rewrites the history of the archive in order to craft a new relationship to the archive's future.

Decadence in this sense might also be understood as an archival methodology. If every document of culture is, as Walter Benjamin writes, a document of barbarism, then the archive itself, when viewed under the shadow of literary decadence, has a reversionary, atavistic quality, one that bites back at modernity.[34] The decadence of the archive can be found in the archive's propensity to unsettle received understandings of literary inheritance as old documents rise up from their dusty coffers to accuse the living of complicity in modernity's barbarism. Mahon's work demonstrates how the literature of decadence exposes the vampiric and reversionary tendencies of the archival record. It shows the archive's ability to draw its readers in by their own prurient and perverse desires. Mahon's work also provokes us to question the underlying faith in the marriage of technological advancement and civilizational progress underpinning the archival methodologies of the twenty-first-century digital humanities.

Most readings of *The Yellow Book* size up the volume as a critique of the changes that have come to Ireland since the 1990s as a result of globalization, the tourist trade, and modern technology. For instance, in the last lines of Mahon's poem "Axel's Castle" (the title of which alludes to Villiers's play and Edmund Wilson's literary criticism), the echo of the "fountain's flute" in Yeats's "Coole demesne," a figure of romantic inspiration, is supplanted by the dehumanized echolalia of a brave new world in which "computer talks to computer, machine to answering machine."[35] As Mahon reconciles himself with the new technologies of archival memory that emerge in this new media environment, allowing his own voice and manuscripts to be posted online, it is nevertheless still the archive that preserves the relics of the old print regime. In "Remembering the '90s," later retitled "Hangover Square," Mahon, like Dorian Gray or Des Esseintes, embraces an antiquarian interest in the material book as rare object while posing the library as the chief site of resistance to the cheapening effects of modern culture.

> . . . in the known future,
> new books will be rarities in techno-culture,
> a forest of intertextuality like this,
> each one a rare book and what few we have
> written for prize-money and not for love,
> while the *real* books like vintage wine survive
> among the antiquities, each yellowing page
> known only to astrologer and mage
> where blind librarians study as on a keyboard
> gnomic encryptions, secrets of the word,
> a lost knowledge; all the rest is lit(t)erature.[36]

In setting up a series of oppositions between antiquarianism and post-modern techno-futurism, "Remembering the '90s" also notes important structural changes in the field of cultural production and their effects on the literary forms by which Mahon's own 1990s will be remembered.[37] When the traditional means of supporting print media collapse, any new, physical books will be treated like rare antiquities. Whereas Baudelaire in his "Correspondances" imagines his poetry as a "forêt de symboles" connecting sense and soul, Mahon's "forest of intertextuality" reflects a field where books are written for a narrow insider audience of other producers (who sit on prize committees) and not for consumers, merely recycling references to themselves and to each other.[38] Ironically, Mahon poses this textual condition as a symptom of literary decadence that he embraces as a formal strategy in constructing his own poetry.[39]

While Mahon suggests that *"real* books" survive only among antiquities, they are nevertheless looked over by "blind librarians" tapping away at their keyboards and employing the "gnomic" codes of digital technology. The "yellowing" of the page, then, associates "decadence" as a literary movement (with its many "yellow books") with the physical decay and yellowing of paper, which becomes a badge of pride marking the distance of antique print media from the new computerized regimes to which they become subject in the modern library. The archive is thus romanticized as a refuge for print culture, a sort of "rag and bone shop" of old media, even as its modes of interface are increasingly structured by the new arcana of the computerized database, ambivalently rendering the archive as a visible site of both

"historical change and the defiance of historical change."[40] If there is
any doubt as to whether Mahon is referring to present-day archives
such as the one at Emory, a draft for "Remembering the '90s" locates
these antique, yellowing books "on the Special Collections Floor."[41]

In *New Collected Poems*, however, Mahon replaces the last six
lines I quoted earlier, those describing the preservation of "real" books
by "blind librarians," with the following four:

> No doubt I should invest in a computer
> but I'm sticking with my old electric typewriter,
> its thick click, black ink on the white pages,
> one letter at a time, fuzz round the edges.[42]

The new ending emphasizes the materiality of the typewritten page
both as a comforting aid to composition and as a figure (sonically ma-
terialized in the consonant click-clacking of the lines) for the artisanal
value staked on the production of a literary typescript on an actual
sheet of paper, not on a screen.[43] As Darren Wershler-Henry observes,
the concrete materiality of the typewritten page has come to evoke a
"mythical time when words had unequivocal meanings" and sub-
stance, a time perceived as "the antithesis of the present, a world of
information flows and endless cheap digitized text."[44] Ironically in
Mahon's case, the fact that such a typescript is considered to have such
an artisanal value is due largely to the trade in literary papers under-
taken by private collectors and institutional archives, a fact that Mahon
repeatedly alludes to in his drafts for *The Yellow Book* but that he re-
peatedly obscures in his revisions.

While *The Yellow Book* poses its hyperlinked "forest of intertextu-
ality" as a symptom of the new media environment, in Wilde and
Huysmans, such obsessive intertextual borrowings often mimic the
descriptive lists found in museum and library catalogues. It is no sur-
prise then that among the boxes containing Mahon's *Yellow Book* pa-
pers, one finds reams of dot-matrix printouts from the Trinity College
Library catalogue. These printouts record hundreds of bibliographic
hits for search terms such as "yellow," "gold," and "saffron" among
the thousands of titles in the Trinity catalogue. A number of the more
resonant titles have been highlighted by hand.[45] While these may well

have been part of Mahon's initial search for themes and motifs, they
come to play a significant role in the poem "At the Chelsea Arts
Club," where one finds a seemingly random list of "hits" on the theme
of yellow: "so let me write / in praise of yellow while its still bright, / of
crocus and freesia, primrose and daffodil, / the novels of Huxley,
Rimbaud's missing vowel, / yahoos, yippies, yuppies, yoga, yoghurt,
Yale / . . . *I Ching*, golf, Roman fever, bubonic plague," and so on.[46]
This goes on for nearly twenty lines.[47] The rhyme and alliteration that
Mahon discovers among these hits draw attention to the serendipi-
tous connections between search results for individual keywords in
the key of "yellow."[48] The poem works on its surface as a cranky satire
of the "trash aesthetics" seen in art galleries of the Saatchi *Sensation*
exhibition era, expressing a preference for Whistler's impressionism
over the postmodern dispensation in which, somewhat askance of Pater,
"everything aspires to the condition of rock music."[49] In giving the
ending of "At the Chelsea Arts Club" the form of bibliographic search
results, however, Mahon turns to the library catalogue not simply as a
haven *from* postmodern trash aesthetics but as one of the sites where
the arbitrary, rubbish quality of the digital world is most on display.[50]
Nevertheless, through careful prosodic crafting, such search results
are shown, despite their arbitrariness, to aspire to become the music
of the archive.

The Yellow Book also indicates how the public reception of Irish
literary modernism becomes subject to widespread changes in popular
media and the technologies of memory. In " 'shiver in your tenement,' "
Mahon recalls the Dublin of the 1960s, "where a broadsheet or a broad-
cast might still count." Those were days when one lived "the life of
the mind," when even the "black Quartier hats" that Mahon's cohort
sported were "suggestive of first editions and dusty attics." However,

> Those were the days before tourism and economic growth,
> before deconstruction and the death of the author,
> when pubs had as yet no pictures of Yeats and Joyce
> since people could still recall their faces, their voices.[51]

The poem casts this more bohemian Dublin as a time when the au-
ratic qualities of broadcast and broadsheet were felt to offer some

more direct connection to the voice and hand of the author. The days when one could still remember the real presence of Irish modernists such as Yeats and Joyce (artfully rhymed with "faces" and "voices") were, in effect, the last days of the print and radio era. Irish literary modernism is viewed from a point beyond the eclipse of its primary media outlets. Mahon romanticizes the print and radio era as an idyllic time before globalization and tourism turned Yeats and Joyce into little more than mere branding devices to lure tourists into the pub.[52] Mahon further demonstrates his skepticism toward the notion that the rising economic tide lifts all boats, even for poets: "Oh, poets can eat now, painters can buy paint / but have we nobler poetry, happier painting[?]" Asking if art benefits "from the new dispensation," the poem seems to side with the bohemian notion that artistic poverty (construed as insulation from the bourgeois economy) produces better art. Notably, Mahon aligns this romanticized view of artistic poverty with the virtues of "first editions and dusty attics," imagining a time when archival memory took more private, less institutional forms. "Those were the days," Mahon writes with a touch of nostalgia: "we nod to you from the pastiche paradise of the post-modern."[53]

Among the canceled drafts of poems for *The Yellow Book*, one finds evidence that Mahon came to consider the sale of his papers to Emory in light of these broader changes in the Irish economy. One tantalizing page of notes for "The Gold Rush," a poem that never quite made it into *The Yellow Book*, juxtaposes decadent collectables such as "old paintings, rare manuscripts, first editions, jades, bronzes, [and] crystals" against "the invisible transnational kingdom of capital," a pairing sealed by the rhyme of "crystals" and "capital."[54] Similarly, in the published version of the poem "America Deserta," the speaker worries that in the "post–Cold War, global warming age / of corporate rule, McPeace and Mickey Mao," the Irish are losing their reputation for "witty independence," shirking their "noble birthright as the glitch / in the internet," that is, their stalwart and subversive resistance to modernization.[55] A draft version of "America Deserta" is more self-critical, evoking "The Aspern Papers" as an of emblem of Mahon's own self-reflexive thinking on archivization.

> Now our own artistic value is measured by export,
> We frown on the sale at auction of Keats's love letters
> yet gladly sell our own stuff to collectors.
> 'Culture follows money'; ~~(and) you can be sure~~ knowledge is power
> & the Aspern papers are kept at the right temperature.[56]

In this canceled passage, Mahon ties the technical conditions of the archive, which promises to keep papers in perpetuity "at the right temperature," to the notion that "culture follows money," a phrase Mahon borrows from a letter F. Scott Fitzgerald wrote to his friend, critic Edmund Wilson, the author of *Axel's Castle*. Fitzgerald's 1921 letter to Wilson reflects on the degradation of European culture after the First World War, positing a cyclical historical model of national progress and decay in which art and literature follow the money through periods of decadence to new centers of cultural capital. As Fitzgerald wrote to Wilson from London, "You may have spoken in jest about New York as the capital of culture but in 25 years it will be just as London is now. Culture follows money and all the refinements of aestheticism can't stave off its change of seat (Christ! what a metaphor). We [Americans] will be the Romans in the next generations as the English are now."[57] Though Mahon cancels the lines in which this allusion appears, Fitzgerald's letter poses one of the central questions of *The Yellow Book*: whether "the refinements of aestheticism" can indeed halt or reverse the flight of high culture out of one society in decline to another, whether from Europe to the United States or from the United States to whichever empire comes next.

The canceled lines also question whether the archive functions as a bastion of literary autonomy, that is, as a refuge for "real books," or as an agent of the transnational flow of deracinated cultural capital, one that exploits the decadent phases of older cultures to vacuum up their cultural artifacts. Mahon's drafts address what James English calls the "denationalization" and "deterritorialization of prestige . . . from particular cities, nations, even clearly defined regions."[58] When Mahon comments, for instance, "We frown on the sale at auction of Keats's love letters," he recalls Wilde's sonnet "On the Sale by Auction of Keats' Love Letters," which Wilde wrote after Keats's letters to

Fanny Brawne were sold by Sotheby's on March 2, 1885, for a sum of
£543, 17s.[59] As Wilde wrote,

> These are the letters which Endymion wrote
> To one he loved in secret, and apart.
> And now the brawlers of the auction mart
> Bargain and bid for each poor blotted note,
> Ay! for each separate pulse of passion quote
> The merchant's price. I think they love not art
> Who break the crystal of a poet's heart
> That small and sickly eyes may glare and gloat.[60]

For Wilde to remark on the price that a merchant quotes for "each sep-
arate pulse of passion" is to liken the auctioneer of literary papers to a
pimp. It is better to keep one's loves secret and apart, that is, off the
market and in the closet, it seems. Despite the poem's further denun-
ciation of the market's brutal invasion of the artist's privacy, Wilde
went on to purchase one of Keats's letters for himself for £18.[61]

Mahon's drafts indicate that the poet was all too aware of the irony
of having sold his own "stuff" to collectors, both private and institu-
tional. However, Mahon's critique extends beyond what may be his
own self-doubt. In the drafts of "America Deserta," the passage re-
garding the sale of papers was inserted after lines describing New
York as a city plagued by "corruption and fatigue" and defined by a
culture of "merger acquisitions, leveraged buy-outs, corporate raiding."[62]
Fitzgerald wrote that New Yorkers "will be the Romans in the next
generation as the English are now." Mahon raises the same vision in
the published version of "America Deserta":

> Not long from barbarism to decadence, not far
> from liberal republic to defoliant empire
> and thence to entropy; not long before
> the pharaonic scam begins its long decline
> to pot-holed roads and unfinished construction sites,
> as in the 'dark' ages a few scattered lights—[63]

In addition to echoing Fitzgerald, these lines on New York's decrepi-
tude echo Baudelaire's assertion in his "Further Notes on Edgar Poe"
that the United States was a nation born between the decadence of the

Old World and the barbarism of the New. In a typescript draft for "America Deserta," Mahon writes, "America was already decadent years ago (Poe):/exceptionalism, dandyism, self-love, bodily project."[64] In Mahon's view, the United States, like Europe's other ex-colonies, has been prone to a premature decline, even if it falls from more imposing heights. Both its longevity and its geographic reach contract in Mahon's mournful repetitions: "not long . . . not far . . . not long." Under such circumstances, it may seem inevitable that Mahon's papers, like Keats's, would follow the money elsewhere.

In the published version of "America Deserta," however, the lines I quoted earlier regarding Keats and "The Aspern Papers" have been cut. However, Mahon figures the same concerns more obliquely in the surviving text. For instance, Mahon describes the United States' voluble business culture as "a nation singing its heart out in the business pages" (later revised to "yellow pages"), recalling Whitman's line "I hear America singing" as revised by Lawrence Ferlinghetti: "I hear America singing/in the Yellow Pages."[65] If we take one of Whitman's reigning tropes from *Leaves of Grass* to be that "leaves" also represent the "leaves" of paper that make up a book, then a "defoliant empire," as Mahon calls the United States, is an empire stripped of the paper substrate of its literature.[66] All that remains are the "unfinished construction sites" that evoke the ubiquitous mid-1990s web page error message: "this site under construction." The business of the archive that Mahon points to in the drafts (the selling of Keats's papers, Aspern's, and his own) has been figuratively displaced by the archive of business in the yellow pages of the phone book. In the battle between aestheticism and the market, between Wilson's *Axel's Castle* and Fitzgerald's *The Great Gatsby*, Gatsby wins.

Mahon's various versions of "America Deserta" suggest that as archives follow the money toward new centers of cultural capital, like Benjamin's angel of history, they look back on the trail of ruined civilizations they leave in their wake. Just as Dorian Gray collects native instruments from among the tombs of cultures destroyed by contact with Western civilization, and Des Esseintes collects and rebinds late Roman texts, the archive both conserves the remnants of dead cultures and registers, as with the Dacca gauzes, the destructive workings of empire. Just as monks preserved and illuminated late Latin manuscripts through the "dark" ages of post-Roman Europe, the archive would appear

to preserve and illuminate a "few scattered lights" through the dark age of an increasingly decadent American century. And yet, as with the Victorian market for fine textiles, one of the qualities the literary market values the most is rarity, a fact Mahon well understood during the time his papers were being sought by Emory.

In a 1991 interview, Mahon jokes about his own place in the literary market, admitting his terror at the demand for frequent publication: "I think there's something a little exceptional and distinguished about being silent for ten years and then bringing out a thin pamphlet which is hard to come by. The next best thing to being a bestseller like Seamus [Heaney] is being a much-sought-after rarity."[67] When asked whether there is "any point in all this literary business besides the 'business,'" Mahon replies, quoting Yeats, "I believe in the lonely impulse of delight. I hate the 'business.'"[68] In "Schopenhauer's Day," Mahon writes,

> The only solution lies in *art for its own sake*,
> redemption through the aesthetic, as birds in spring
> sing for their own delight, even if they also sing
> from physical need; it comes to the same thing.[69]

While "art for its own sake" might represent an imaginary exemption from the more distasteful demands of the marketplace (the need to sing for one's supper), Mahon's bookend rhymes on "sing" impose a perhaps too easy reconciliation of the artistic impulse with the satisfaction of physical need. Nevertheless, in comparing the sale of his own papers to the sale of the Keats's love letters or to the unsettling bargain offered in "The Aspern Papers," the speaker expresses his chagrin at commodifying his own literary remains, while positing the archive as a kind of alternative marketplace, a place to cultivate one's "much-sought-after rarity." In this sense, the "solution" lies not in a wholesale version of "art for its own sake" but in a more limited model of relative artistic autonomy, one that shields the poet from the demands of frequent publication for a mass market while permitting the poet to continue to sing, relatively unhindered, for a limited market of collectors, whether or not they represent the sort of brawlers and pimps of the auction mart that Wilde imagines them to be.[70]

It appears that Mahon takes advantage of this alternative market on a rolling basis, contributing several boxes worth of material to his papers

at Emory in any given year, with occasional gaps, as soon as he is done with those materials. For example, a December 1996 letter from a librarian at Emory asks whether Mahon had received payment for a new batch of papers, indicating that Mahon was composing the *Yellow Book* even as he was turning over what may have been fairly current material.[71] Moreover, notes in his scrapbook for *The Yellow Book* led to the development of poems that were not published until many years later, as in the case of "Tara Boulevard," which I discuss below. If you happen to be a librarian behind the scenes, or a scholar with a keen eye for new material, you stand a chance of reading material for a new volume of Mahon's poetry before the book itself has been released, a privilege hitherto held largely by editors. What we have, then, is what appears to be an extraordinary situation in which archivization quite literally precedes publication. However, what this scenario reveals is the economic logic now governing certain sectors of the market for contemporary poetry: the creation of a structure of patronage and speculation that encourages the production of material specifically for the archive. In a world where poetry is increasingly written on a word processor, the trade in drafts and letters on paper comes to function like an advance on royalties. This is a logic that precedes and determines aspects of the poetry's composition and that is now fundamental to the relationship between archivization and the event of publication. In the world of big-name novelists and celebrity authors, big advances are often made public as part of the publicity for a book. In the upper echelons of the contemporary literary marketplace for poetry, however, where prestige often matters more than visible sales (except for a few rare best sellers), archivable material may well be valued more highly than, and may be contractually acquired prior to, material more widely available to the public through traditional consumer outlets, while announcements and events surrounding the acquisition of such papers pay dividends to the institution and the author in other more-or-less-convertible forms of symbolic capital.

Mahon's papers do not represent a unique case in this regard, even if *The Yellow Book* takes this problem as one of its themes, recoding it through the antiquarian concerns of fin-de-siècle decadent literature. In a 2006 interview, the Belfast-born poet Michael Longley, whose papers, like those of Seamus Heaney, Paul Muldoon, Ciaran Carson, Medbh McGuckian, Seamus Deane, and Joan McBreen, are also held at Emory, was

asked how he felt about the Emory archive and "what it means for the study of Irish poetry." He answers in personal terms, describing the offer as "a lifesaver not just financially but spiritually," freeing him to pursue his own work knowing someone out there was interested. At the same time, he expresses the need to develop a strategy to mitigate the new self-consciousness brought about by the prospect of having every scrap of his papers preserved: "now I just keep a grocery box next to my desk and put papers into it the way I would put things into a waste-paper basket. I don't think twice about it." Nevertheless, Longley maps out a cascade of small changes that begins with the process of composition—which becomes, simultaneously, a process of collection—and alters every aspect of how he composes, first on paper, then on machine: "Composition has changed. I begin poems in handwriting. I then move on to the word processor as quickly as possible because I find I get some kind of inspiration from it; some sense of shape emerges from the machine. I know some American poets who print every time they change something. That would kill a poem for me—if I was that self-conscious."[72] Longley's comments illustrate how structural changes in the system of literary patronage create a demand for archivable material that runs contra to the poet's natural inclination to compose on a digital platform, on which important steps in the process of revision would be lost. He makes sure instead to create at least one paper record of a poem's early drafts. Longley also notes the death of literary correspondence in an era of email, remarking that Mahon, however, still sends postcards.

Mahon's case, like those of other contemporary authors collected by Emory and similar institutions, highlights some of the ways in which modernist institutions of literary patronage and speculation, such as those that Lawrence Rainey has examined in the cases of Eliot, Pound, Joyce, and H.D., have migrated to the academy as the collections it controls and the prizes it offers have grown in importance in the past half century as poetry has largely lost its footing with a wider reading public.[73] Rainey sees the modernists' turn to the deluxe limited edition, for example, as an attempt to "concretize the literary" and adopt "market structures typical of the visual arts, a realm in which patronage and collecting can thrive because its artisanal mode of production is compatible with a limited submarket for luxury goods." This is the sort of move one sees, too, in the artisanal quality of the original *Yellow Book* journal.

"Literary modernism," Rainey argues, thus "constitutes a strange and perhaps unprecedented withdrawal from the public sphere of cultural production and debate, a retreat into a divided world of patronage, investment, and collecting."[74] With the increasing dominance of (frequently U.S.) academic institutions and MFA programs in the determination of poetry's economic and literary value, one might supplement the modernist concept of the deluxe limited edition with the idea of an open-ended "archival edition," a seemingly unique set of objects by a living author that is simultaneously "published" into a limited version of the public sphere when made available as part of a library's accessible collection but that, in practice and despite increasing efforts at scanning and digitization, remains restricted to an audience of elite scholarly readers with the time, travel funds, and credentials to examine these objects (I include myself among these lucky readers).[75] The academy in this sense reproduces elements of modernism's compromise with the marketplace through its own instruments of patronage and collection.

As Mahon was reflecting on his own relation to the archive, he was also taking into account decisions made by other Irish writers. Among the papers included in a folder of drafts for "Remembering the '90s," one finds another note referring to James—"(real presence / esoteric knowledge) Aspern Papers; Emory"—alongside a clip from a review of Brian Friel's play *Give Me Your Answer, Do!*, which premiered at the Abbey Theatre in Dublin on Wednesday, March 12, 1997.[76] Friel's play tells the story of a financially strained Irish novelist who hopes to sell his papers to a special collections library at a Texas university, a library clearly modeled on the Harry Ransom Center. While the novelist and his wife, Tom and Daisy, await the verdict of the university's acquisitions agent, they consider the reasons to sell, "the most persuasive reason of all" being confirmation that "the work has value." Ultimately, however, Daisy (unlike Longley) insists that the comfort afforded by the tangible establishment of literary value would come at the price of the "necessary uncertainty" that drives the creation of art.[77] To sell, to arrive at a verdict, would, Daisy argues, amount to a kind of literary death, a relief from the sort of negative capability necessary for the literary imagination.

Friel wrote the play after a period in which he had been courted by several institutions and ultimately declined an offer from the Harry

Ransom Center, choosing instead to deposit his papers in the National Library of Ireland.[78] Friel's ultimate decision to place his works in a national institution in Ireland rather than sell them to the highest bidder in the United States highlights a choice heavily weighted with political significance at a moment when some Irish feared the loss of the nation's cultural heritage in the face of globalization and Americanization. The decision bucks what James English cites as the increasing trend among producers of culture in a globalized economy to bypass traditional national and local gatekeepers in the consecration of cultural value.[79] Friel's decision also echoes concerns by British writers such as Philip Larkin decades earlier. As Larkin points out in a 1979 speech, for a long time, British librarians dismissed the idea of purchasing the papers of living British authors because their reputations had not yet been determined; the matter was too much one of speculation. Leaping into the gap, American universities, less afraid to place a few bets on various writers' long-term reputations, swept up these uncontested assets (culture follows money), removing important collections from their nations of origin. Larkin argues that "a country's writers are one of its most precious assets, and . . . if British librarians resign the collection and care of their manuscripts to the librarians of other countries they are letting one of their most rewarding responsibilities slide irretrievably away."[80] Larkin's efforts led to Britain's establishment of the National Manuscripts Collection of Contemporary Poets in 1963 and the ensuing preservation in Britain of the work of more than fifty contemporary British poets. Larkin led the charge despite a promise to burn whichever portions of his own papers he did not "want anyone to see." As Helen Taylor notes, there "is celebration . . . when valuable resources are preserved for the nation" and British literary papers, such as Ted Hughes's or Thomas Hardy's, are "safely ensconced" closer to home.[81] For a nation that continues to hold onto the Elgin marbles, the irony is palpable. Nevertheless, this is a process that would, as Friel's play demonstrates, play out among Irish writers as well, producing another set of colonial ironies.[82]

Mahon wryly demonstrates his awareness of these issues when he clips a review of Friel's play and pastes it directly into a draft for "Remembering the '90s." As the clip states, "The questions [the play] raises are broadly political, evoking the cultural politics of post-colonialism. Literary merit is conferred through financial acquisition, and novels

become the property of whichever foreign institution pays the most. The Irish literary canon can be bought, collected, owned and contained. The emigration and exile of the early plays has been replaced by the export of culture, by which, as [one of the characters] says, 'its real worth is established.' Or is it?"[83] As Mahon's canceled quatrain on literary export value, Keats, and "The Aspern Papers" shows, he was by no means unaware of the irony of raising these questions explicitly in notes already bound by contract for a well-to-do private university in the United States. This irony is all the more compounded by the fact that it was Richard Ellmann, the famed biographer of Wilde, Joyce, and Yeats, who, having been enticed himself to take a late-career position at Emory, first convinced Emory to aggressively pursue the acquisition of British and Irish literary papers.[84] It appears from the correspondence Mahon received from Ronald Schuchard, dated October 12, 1990, that Mahon was enticed to sell to Emory partly because the university had already acquired a portion of his work from a private collector.[85] According to Stephen Enniss, one of Emory's librarians at the time, the purchase of Mahon's papers had been made in response to a letter from Mahon seeking financial assistance at a moment when personal difficulties had put his teaching career in New York in jeopardy. However, it appears that before agreeing to Emory's offer, Mahon offered Trinity College in Dublin the chance at first refusal, a nod of loyalty to his alma mater, perhaps, but also a gesture of recognition toward the argument for keeping his papers closer to "home."[86] Mahon seems to have made that very point implicitly to Emory University at the time he was composing *The Yellow Book*. A letter from Enniss to Mahon dated February 14, 1997, indicates that Mahon had suggested that Enniss make time on his trip to Dublin to see a performance of Friel's *Give Me Your Answer, Do!*[87] When Enniss, who moved on to a job at the Harry Ransom Center, remarked on Emory's purchase of Mahon's papers in his 2014 biography of Mahon, he framed the purchase in terms that echo Friel's play: "The acquisition was an important validation of his work, and in the coming years this subsidy would prove a reliable and steady source of income."[88]

It is in this context that Mahon's references to *Gone with the Wind* and the city of Atlanta become important. In the *Yellow Book* scrapbook, Mahon refers to the corporatization of this genteel southern

capital by companies such as Delta, Coca-Cola, and CNN, noting that Daimler-Benz even sponsored the restoration of the Margaret Mitchell House Museum.[89] The transformation of Atlanta by global corporations, and the preservation of the Mitchell House by a German luxury-car company, parallels the transformation of Celtic Tiger–era Dublin into what Mahon describes in the poem "Night Thoughts" in *The Yellow Book* as a "Georgian theme-park," alluding to the architecture of his neighborhood in Fitzwilliam Square.[90]

If one looks at Mahon's later poem "Tara Boulevard," one discovers that the labeling of Dublin as a "Georgian theme-park" involves more than an unconscious pun, linking the visible corporatization of Dublin to the same process in Atlanta. Though "Tara Boulevard" was not published until 2008, early notes for the poem, originally titled "Gone with the Wind," can be found in Mahon's 1996 scrapbook for *The Yellow Book*. The version of "Tara Boulevard" in the 2011 *New Collected Poems* contrasts modern Atlanta's corporate skyline with the imagined antebellum days of the Old South in nearby Jonesboro, the location of Scarlett O'Hara's fictional plantation:

> Amazed by the shining towers were she alive,
> she wouldn't know the downtown skyline now
> —Coke, Delta Airlines, CNN, King Drive—
> but ten miles south, in many a back yard,
> it's going to be another day tomorrow
> on an imaginary plantation where
> the Ibo sat once to their hominy grits;
> in Jonesboro, 'O'Hara Gas' and 'Body Parts'
> light up at dusk on Tara Boulevard,
> red neon scribbling to the thundery air.[91]

The poem suggests that Margaret Mitchell's nostalgic image of the antebellum plantation not only romanticizes an economy that relied on the labor of West African slaves but also masks a present-day economy dominated by corporate interests. Curiously, this set of images is predicated on the particular physical environment of Emory's MARBL. As any visitor to the archive knows, one of the best places to view the Atlanta skyline is from the tenth floor of the Robert W. Woodruff Library, the location of MARBL's reading room. A photo among his pa-

pers shows Mahon gazing across the room in the light of these tenth-floor windows.[92] The drafts of "Tara Boulevard" demonstrate that this fact is more than coincidental.

Though the poem underwent significant revision, the composition begins in the MARBL reading room:

> (The) ~~harp that once~~ drafts lives (on) at a constant temperature
> upstairs in the ~~excellent~~ Emory ~~u~~University library
> amid the gold books, the Coke literature
> and files devoted to the finer arts.
> Atlanta sunlight glazes desk and chair;
> On Tara Road 'O'Hara Gas and Body Parts'
> Light up at sundown in old Jonesboro,
> ~~The darkening slave huts kept with loving care~~
> ~~A light breeze whispering to the~~
> Late breezes dying in the fields out there.[93]

Here, the speaker views the changes that have taken place between those imagined antebellum days of *Gone with the Wind* and present-day Georgia, quite literally, from the archive window. Mahon carries over similar language to that used in drafts of *The Yellow Book* to describe the Aspern papers ("kept at the right temperature") to describe Mitchell's drafts for *Gone with the Wind*, which are also housed at Emory "at a constant temperature." The poem envisions Atlanta sunlight on the tenth floor of a library named after none other than a onetime president of the Atlanta-based Coca-Cola Company, Robert W. Woodruff, whose papers are also kept at MARBL.[94] That is, the same money that helped transform both Atlanta and Dublin into "Georgian theme-parks" also established the very library that purchased both Mahon's and Mitchell's papers, where they are presumably kept somewhere near those of Coca-Cola. Moreover, as Emory's own historians have acknowledged, the university was founded by slave owners with the benefit of unpaid slave labor, such as that of the Ibo in "Tara Boulevard," much as many other U.S. universities (including my own PhD institution) were.[95] In this sense, Mahon's drafts for both "Tara Boulevard" and *The Yellow Book* highlight the archive's unavoidable entanglement with a system of patronage historically funded in part by the southern slave plantation and in part by the same multinational corporations whose increasing dominance drives Irish culture overseas, a

Photo of Derek Mahon with Ronald Schuchard at the Manuscript, Archives, and Rare Book Library, Emory University, 1996. Derek Mahon Papers (Manuscript Collection No. 689), Stuart A. Rose Manuscript, Archives, and Rare Book Library, Emory University. Photoduplication: Emory University Library.

cultural pattern that Mahon nonetheless skewers throughout *The Yellow Book.*

Mahon also picks up on the link between the mythological Tara, hall of the Irish kings, and Mitchell's use of "Tara" as a name for the O'Hara plantation, alluding in the canceled portion of the draft to the first line of Thomas Moore's ballad "The Harp That Once in Tara's Halls."[96] In replacing a reference to Ireland's national emblem, the harp, with a reference to "the drafts," Mahon suggests a parallel between the migration of the Irish diaspora, figured by the relocation of Tara from Ireland to rural Georgia, and the migration of Irish literary papers in the transatlantic literary marketplace. That is, the diasporic trajectory of Mahon's archival material follows the émigré path of Scarlett O'Hara's displaced Irish planter father, who was driven out of Ireland by the colonial imposition of a plantation economy in Ulster only to rise again, ironically, on a plantation in the American South.[97] The tra-

ditional symbols of Ireland's pride—the harp, the land, its literature—
live on in a Georgia archive, where tomorrow is another day. For the
Irish poet, Tara Boulevard leads as much to Emory's MARBL as it does
to the O'Hara plantation.

Though the initial scribbled drafts of "Tara Boulevard" begin with
an exploration of the physical location of the archive and the climate-
controlled conditions under which its collections are preserved (at a
"constant temperature"), the poem ends in its most recent version with
a more oblique figure of red-neon business signs "scribbling to the
thundery air."[98] The neon script of "O'Hara Gas and Body Parts" in
Jonesboro serves as a reminder of the Orphean *disjecta membra* kept
as drafts in the library. The business of the archive is displaced by the
archive of business writ large and small across the Georgia skyline. To
the degree that *The Yellow Book* romanticizes the retreat of print cul-
ture from the public sphere to the archive, Mahon's revision also figu-
ratively enacts the displacement of print by corporatized media. Neon
scribblings supplant scribblings in ink. The drafts make visible the
reach of "the invisible transnational kingdom of capital" into the world
of "rare manuscripts" and "first editions," even if the self-ironizing
image of the stalwart technophobe clacking away at his keyboard in
the most recent revisions of *The Yellow Book* (retitled simply *De-
cadence* in the *New Collected Poems*) displaces figures for the book's
initial imbrication with the economic conditions of the archive for
which those very typescripts are contractually destined.

It is in this sense that Mahon's archivalism betrays its anar-
chivalism. On one hand, the genetic link between *The Yellow Book*
and "Tara Boulevard" demonstrates how the transatlantic market in
literary papers structures the transnational dimensions of Mahon's po-
etry, revealing the common economic foundation underpinning the
establishment of plantations in Ulster and Georgia, the diasporic tra-
jectory of Irish literature, and the parallel effects of globalization on
Ireland and the American South. On the other hand, if one follows the
development of Mahon's *Yellow Book* from its initial drafts to its suc-
cessively published versions, traces of Mahon's personal entanglement
with the manuscript trade, found in references to "The Aspern Papers,"
Emory, and the sale of Keats's letters, are displaced by more general ref-
erences to the custodial function of the library archive. These figures

are then again displaced by figures for the production of archivable ma-
terial in the moment of its creation (with fuzzy black letters on the
page). In the course of this series of revisions, the poet's stake in the
sale of his manuscripts is masked by the more benign image of their
preservation, which is then rolled back to the artisanal moment of pro-
duction. That is, figures for artisanal production come to displace fig-
ures laying bare the market economics of archivization. The effort to
preserve Mahon's drafts in the archive engenders an almost-systematic
attempt on the poet's part to mask any initial disclosures of that ef-
fort in his poetry through the process of revision.

 This is not to accuse Mahon of anything sinister. I for one am glad
he has found a means to support his art, and he is free to revise all he
wants. It is rather to outline the ways in which the poetry, in its con-
tradictory archival and anarchival impulses, reflects the internal divi-
sions of the literary archive itself, which both preserves and masks its
own activities while simultaneously consolidating and diffusing na-
tional claims on literary heritage. However, as Derrida suggests, insofar
as one can imagine the erasure of the archive (as an institution of
national consolidation that conserves both the law and a common
cultural heritage), one can imagine a world without nations themselves.
It is in this sense that the intertextual method that Mahon develops
in *The Yellow Book* and its drafts, with their various traces and era-
sures, gives rise to a distinctly anarchical strain in the poetry, as
voiced through the idiosyncratic and anarchistic political philosophy
of Oscar Wilde.

 The chief expression of this anarchical strain in *The Yellow Book*
can be found in "The World of J. G. Farrell," a poem written as Britain
was preparing to hand Hong Kong back to China in 1997, "leaving to
the Chinese, if they so desire, / the investment banks and polo fields of
Hong Kong, / the Coke and Marlboro ads; they're going home."[99] The
titular figure of "The World of J. G. Farrell," the novelist James Gordon
Farrell, to whom Mahon also dedicated his most famous poem, "A Dis-
used Shed in Co. Wexford," was born in Liverpool in 1935 of mixed
Irish and English parentage, allowing him to write about "the decline of
the British Empire," as he put it, "from both sides—from that of the
colonist and the colonised."[100] Mahon describes Farrell's "empire
trilogy," which includes *Troubles* (1970), *The Siege of Krishnapur* (1973),

and *The Singapore Grip* (1978), as "a belated swan-song for the British Empire, whose still-visible remains Jim Farrell contemplated with qualified affection."[101]

Mahon writes that Farrell's central theme was "decline," with a particular eye for the way civilization "surrenders itself bit by bit to the encroachments of the natural world."[102] "The World of J. G. Farrell" thus opens by building a waste-land aesthetic out of the empire's ruins, with its "vegetable encroachments," "exhausted pipes," and "a creeper twining around a naked light." In the aftermath of empire's withdrawal, nature reclaims and devours the detritus of colonial rule, figured by a heap of broken images that Mahon lifts from Farrell's novels:

> hill stations deserted (*Siege*), impenetrable foliage,
> long bars empty (*Grip*) in tropical heat,
> their pools afloat with matchboxes and driftwood,
> fly-blown verandahs, ceiling fans at rest,
> carnivorous plants entangling gates and fences,
> the coercive empire an empire of the senses,
> of rustling organisms and whispering rain-forest,
> a dripping silence after torrential rain,
> the fluttering butterfly that starts the hurricane.[103]

Here, the "whispering rain-forest" of intertextual imagery (with all its sonic rustling, dripping, and fluttering) becomes the unconscious twin of Baudelaire's "forêt de symboles" or Mahon's "forest of intertextuality." Mahon identifies his tangled skein of intertexts with the encroaching forces of nature, an "empire of the senses" that mocks the "coercive empire" of colonial order by overgrowing it. Like encroaching nature, Mahon's whispering forest of intertexts works within and against the *arche* of sovereignty imposed by colonial rule.

The 1997 version of Mahon's poem lingers at the moment when the last imperial bugle has blown but no new postcolonial nation state has yet been established:

> Everyone's going home now, those with homes to go to;
> the bugles blow and the Union Jack comes down
> in the West Indies and the Antarctic soon,
> Bermuda, Antigua, South Georgia and Pitcairn
> and even, who knows, Gibraltar and Ulster too.[104]

As Jahan Ramazani observes, such lists of imperial toponyms, some marking places where the imperial flag has come down and some marking territories such as Gibraltar and Northern Ireland where the flag still doggedly flies, are typical of the poetry of decolonization. Poets such as Derek Walcott, Lorna Goodison, and Kamau Brathwaite deploy such "decolonizing lists" in order to "transvalue names that Europeans once invoked to demonstrate the boundless reach and might of empires on which the sun would never set," thereby "unleashing [the] cultural and national multiplicity once squelched by the homogenizing force of empire."[105] Mahon's list, however, pauses at the very moment between the lowering of one flag and the raising of another, sustaining a sort of geopolitical caesura before such place names have been reclaimed and transvalued by their postcolonial inheritors. That is, Mahon freezes the poem at the moment before imagined postcolonial communities are transformed into political, national realities.

If the Union Jack comes down, what flag, if any, then, should rise in its place? Remarkably, the poem's final passage appears to sidestep the problem by turning to the twenty-five-hundred-year-old teachings of the Chinese Taoist philosopher Chuang Tzu (Zhuang Zhou): "do nothing and everything will be done."[106] This seeming dodge, however, takes advantage of the prolonged transitional moment between the departure of British rule in Hong Kong and the arrival of Chinese rule to propose an alternative. While appearing to transcend the moment of decolonization (or imminent recolonization in Hong Kong's case), through a complex series of imitations and transformations, the text offers in the lines that follow a vision of what culture might look like without imperialist notions of what it means to be "civilized."

The final passage of "The World of J. G. Farrell" reads at first like a lyric pastiche of Chuang Tzu's Taoist maxims:

> Better a quiet life, the moon in a bucket of water
> with nobody there to hear though the stars do
> and a bedside book like the teachings of Chuang Tzu—
> type of the unselfconscious thinker who,
> never a slave to objective reality, knew
> the identity of contraries, traced us from the germ
> and saw our vital unity with the rest of nature;

disdained, of course, utilitarian system;
like Echo, answered only when called upon
in bamboo cage or palace of white jade.
We have lost our equilibrium, he said;
gaze at the world but leave the world alone.
Do nothing; do nothing and everything will be done.[107]

Haughton partially explains Chuang Tzu's presence in the poem by suggesting that Mahon "presents [Chuang Tzu] as an equivalent of the figures in Yeats's 'Lapis Lazuli,' an Eastern thinker who is the antithesis of the colonial will to control."[108] That is, Chuang Tzu's opposition to the Confucian bureaucracy of his own day offers Mahon an apt beacon of resistance to excessive governmental authority, cutting against both colonial British rule and Chinese authoritarianism. The textual game that Mahon is playing here, however, is far more interesting. Mahon does not, in fact, take the words that make up these thirteen lines directly from Chuang Tzu. Rather, as his drafts and notebooks reveal, he has pasted together a collage of phrases lifted from "The Chinese Sage," a review that Oscar Wilde wrote of Herbert Giles's 1890 translation of Chuang Tzu.[109] Looking at Wilde's review and Mahon's poetic reconstruction of it side by side, one can see how Mahon has transformed Wilde's text by clipping or slightly altering select phrases and splicing them together, disguising Wilde's hypotext, to borrow a term from Gérard Genette, as a collage-style pastiche of Taoist philosophy.[110] That is, Mahon uses Chuang Tzu like a ventriloquist's dummy to give covert voice to Wilde, placing Wilde at the heart of the dilemma over what to do about Hong Kong.

Just as the decadents in fin-de-siècle writing establish literary genealogies through the poisonous texts they pass one to another, ventriloquism serves as a means of establishing one's decadent credentials. For example, in "A Chinese Sage," Wilde describes a dialogue in Chuang Tzu's text between "The Spirit of the Clouds" and the "Vital Principle" as "not unlike the dialogue between the Sphynx and the Chimæra in Gustave Flaubert's curious drama" *The Temptation of Saint Anthony*.[111] As Wilde knew, Flaubert's dialogue became a showcase piece in Huysmans's *À rebours*, in which Des Esseintes persuades his ventriloquist lover to throw the voices of Flaubert's dialogue onto two miniature statues of a Sphinx and a Chimera that he keeps in his

bedroom. Wilde himself was an avid proponent of just this sort of eroticized ventriloquism, using it to create a set of intertextual relations in his poem "The Sphinx,"[112] for example, or, more famously, to defend flights of critical fancy such as Walter Pater's notorious description of the *Mona Lisa*, which Wilde's Gilbert claims in "The Critic as Artist" to mutter any time he stood before the portrait, in effect, allowing himself to become Pater's dummy.[113] In this sense, Wilde retrospectively introduces Chung Tzu into the decadent canon by splicing him into a chain of decadent predecessors.

For both Wilde and Mahon, ventriloquism offers a way of thinking reflectively across historical periods and national borders by speaking through other persons and objects, opening a space for a kind of "critical cosmopolitanism."[114] Indeed, Wilde writes that Chuang Tzu, "like Plato, adopts the dialogue as his mode of expression, 'putting words into other people's mouths,' he tells us, 'in order to gain breadth of view.' "[115] But, of course, Chuang Tzu never exactly said this. Wilde takes these words from Herbert Giles's commentary and puts them in Chuang Tzu's mouth.[116] But if Mahon means to speak Wilde through Chuang Tzu in order to gain "breadth of view," what might one discover within this broader cosmopolitan perspective? What kind of critique would such a move offer?

The image of Chuang Tzu that emerges in Wilde's review is decidedly contrarian and anarchistic, anticipating the radical views Wilde presents in "The Soul of Man under Socialism."[117] According to Wilde, Chuang Tzu "sought to destroy society, as we know it, as the middle classes know it."[118] He was a critic of the bureaucratic decadence of his time and of the altruistic spirit that lead people to meddle "in other people's business."[119] It was in part from Chuang Tzu that Wilde derived the paradoxical belief that government induces anarchy: "In an evil moment the Philanthropist made his appearance, and brought with him the mischievous idea of Government. 'There is such a thing,' says Chuang Tzu, 'as leaving mankind alone: there has never been such a thing as governing mankind.' All modes of government are wrong."[120] Wilde later reframed this objection in "The Soul of Man under Socialism" from the perspective of the individual artist: *The form of government that is most suitable to the artist is no government at*

all. . . . There is no necessity to separate the monarch from the mob; all authority is equally bad."[121]

This same notion leads Wilde in his review to present an image of the ideal community, loosely derived from Chuang Tzu, harking back to a Golden Age in which people "lived simple and peaceful lives, and were contented with such food and raiment as they could get. Neighbouring districts were in sight, and 'the cocks and dogs of one could be heard in the other,' yet the people grew old and died without ever interchanging visits. There was no chattering about clever men, and no laudation of good men. The intolerable sense of obligation was unknown. The deeds of humanity left no trace, and their affairs were not made a burden for posterity by foolish historians."[122] Chuang Tzu could not have lamented in his day the Victorian education system, the established Anglican Church, humanitarian societies, or the Victorian lecture hall, as Wilde does in his review. But in the spirit of Chuang Tzu's anti-Confucianism, Wilde imaginatively absolves the artist from the forced sense of "duty" that such institutions impose. Wilde also rails against the print media in which his fellow Victorians took to advertising their good deeds, media that, as Benedict Anderson argues, enabled geographically distant individuals to forge a shared sense of community.[123] Moreover, individuals in Wilde's utopia would find themselves free from the national narratives woven by "foolish historians." That is, their deeds would go unrecorded in the archives. In this sense, Wilde's anarchism is distinctly anarchival, suggesting that the absence of governmental authority would remove the necessity of record keeping and, vice versa, that in declining to abet foolish historians, a community would relieve itself of governmental authority. As an alternative, Wilde imagines communities living without reference to the abstract image of a nation enabled by print media or inscribed in the archive, allowing for no community larger than the distance at which a dog's bark or a cock's crow could be heard, with about as much mark on posterity as either.

In imagining the social conditions under which the individual artist can flourish beyond the walls of the metropolitan *civitas*, Wilde suggests that individual cultural refinement need not be predicated on the progress of civilization. In effect, he undermines the Enlightenment-era

ideological premise of the civilizing mission of empire, that all cultural progress unfolds by virtue of the spread of civic order and that no history or artistic progress happens outside it.[124] Instead, he imagines cultured individuals, dandy barbarians, living beyond and without the structures, organizations, and abstract ideals associated with imperial Britain's notion of civility. Farrell picks up on this idea from Wilde in his novel *The Siege of Krishnapur*, in which he stages an argument between a colonial administrator in India, Mr. Hopkins, who insists that British civilization is "irresistible" because of its advances in "science and morality," and a visiting would-be aesthete, George Fleury, who declares, "It's wrong to talk of a 'superior civilization' because there isn't such a thing. *All* civilization is bad. It mars the noble and natural instincts of the heart. Civilization is decadence!"[125] While the dialogue comes off as frivolous at first against the backdrop of the 1857 Sepoy Rebellion, the biting, antiutopian irony of Farrell's novel is that after witnessing the bloody failures of colonialism in India, both Hopkins and Fleury completely reverse their views on art and civilization. Hopkins, having witnessed the revolt against colonial rule, becomes a disillusioned skeptic of empire, having lost his faith in the empire's moral and cultural superiority. Fleury, however, abandons his romantic ideals and becomes an advocate for imperial order.

Either way, by covertly giving voice to Wilde in the undefined moment between the fall of one imperial regime and the transfer of territory to an authoritarian one, Mahon positions Wilde not just as a critic of empire but as political thinker whose ideas present a radical alternative to the ongoing cycle of imperial dominance, whether by Britain, China, or the United States. In decoupling artistic refinement from the progress of large-scale imperial civilizations, Wilde's artistic "decadence" manifests itself as a break from the cycles of historical "decadence." When Mahon ends his poem by ventriloquizing Wilde through both Chuang Tzu and Farrell, he offers an alternative model of political community oriented toward small communities of artisans.[126] In this model, small groups of like-minded artists undermine notions of national belonging by finding a place for themselves beyond the rise and fall of empires, whatever flags might be lifted in their place and whatever archives historians might gather to preserve their notion of national identity for posterity. This is, nevertheless, a model that ac-

knowledges the naiveté of its own utopianism. In one of the finest moments of the review, Wilde remarks that the publication of Chuang Tzu's radical thought in English "two thousand years after his death is obviously premature."[127] Thank goodness, then, for foolish historians. In Mahon's review of Ellmann's biography of Wilde, he similarly writes, "It's a measure of Wilde's complexity and originality that we should have had to wait a hundred years to understand, to be *allowed* to understand, exactly what he was about." For Mahon, Wilde is "a subversive, indeed a revolutionary figure," his "feminism and socialism, . . . his sexual self-definition and elegant republicanism, his use of style as a weapon, have . . . a proleptic higher punkdom about them . . . which will make him an apt *maître-à-penser* for our own '90s."[128]

Mahon elsewhere writes of Wilde that a "certain kind of Anglo-Irishman . . . has always been intrigued by those who live on the edge of things, those beyond the pale."[129] "Pale" has a particularly charged relevance here, having once referred to the "area of Ireland under English jurisdiction" between "the late 12th and 16th centuries, . . . including parts of modern Dublin, Louth, Meath, and Kildare."[130] One can read Mahon's act of cosmopolitan ventriloquism as a way of allowing an Anglo-Irishman once silenced by British authority to re-emerge in a space beyond the jurisdiction of the colonial state or, indeed, the usual boundary markers of ethnic, national, or historical identity. "The World of J. G. Farrell," a world caught in the brief, unformed moment after empire and before the imposition of a new authority, is Wilde's world. Wilde becomes a kind of partial presence, everywhere and nowhere at once, uncontained by the walls of any single civilization yet containing the cultivation and breadth of view that makes art possible. Paradoxically, Wilde's anarchival anarchism is preserved through a collage aesthetic developed out of the Mahon's personal intertextual archive. A queer voice that had become silent, daring not to speak its name because it had become "unspeakable," is heard again as a web of quotations from the archive.[131]

However, if we look to the latest version of "The World of J. G. Farrell" in *New Collected Poems*, the twenty lines detailing the flight of "the last ship out of the opium wars" have been cut from the poem, as have been the lines depicting the lowering of the Union Jack. Mahon's

revision skips over any explicit mention of the decolonizing moment of the Hong Kong handover, leaving a less cluttered, more minimally Taoist poem but one with fewer traces of the "postcolonial theme" that spurred Mahon's initial explorations. If one takes the most recent published versions of the poet's work as definitive, then one might be tempted to criticize Mahon for covering the tracks of an archival path that takes us from Coca-Cola's dominance in postimperial Hong Kong back to, among other things, Coke's sponsorship of the Woodruff Library in Atlanta. However, Mahon's own comments on the process of revision suggest another reading.

In 1991, when Mahon was putting together a volume of selected poems and coming to terms with Emory, he told an interviewer, "The new *Selected Poems* is a tombstone—a handsome enough tombstone, but a tombstone none the less. Buy it, by all means, and complain about the finicky revisions and re-revisions, but don't imagine that that is the whole story. Valéry said that a poem is never finished, only abandoned; and there is more where that came from."[132] In September 1999, just two years after publishing *The Yellow Book*, Mahon comments in a subsequent journal on his latest project, "Proof-reading *Collected Poems*—a terrible moment, since this is the way it's going to be now for the future, not an apotheosis but an amputation."[133] Mahon's resistance to the fixity connoted by a definitive edition of his work is also demonstrated in the phantasmal open-endedness he expresses in the journal entry at the top of the same notebook page, in which Mahon writes that behind "every event stands the ghosts of its alternatives, the way it might have been, equally valid & invalid, now lost forever; the mere fact of occurrence can claim only fortuitous precedence, and this also applies to the printed page."[134] While one might think of the archive as the repository of dead letters, and the published page as live material engaged in an open-ended world of readerly possibility, Mahon's dismissal of the "mere occurrence" and "precedence" of the event, which in the case of the printed page would indicate publication, suggests the very opposite. It is the published record that marks a kind of tomb, while the archive of lost alternatives, however ghostly, remains open to a world of (canceled) possibility.[135] Though the traces of the postcolonial caesura in Hong Kong, or of Mahon's self-criticism with regard to the sale of manuscripts, have been canceled from the

most recent versions of his poems, those ghostly alternatives live on in the archive. Every amputation creates a new archival record.

As I have discussed, in Wilde's dialogue "The Decay of Lying," Gilbert asserts that the "one duty we owe to history is to rewrite it" and that "the proper occupation of the historian" is to "give an accurate description of what has never occurred."[136] In "The Portrait of Mr. W. H.," Wilde toys at length with the idea of forging and falsifying the documentary record in order to reveal some more important contemporary "truth." In this sense, Mahon's reflections on Henry James and the Emory archive take on a new resonance. In the preface to "The Aspern Papers," James defends himself against a critic who accuses him of creating characters who, because of their extreme artistic temperament, could not realistically emerge from the times and places in which their stories are set. In reply, James writes,

> What does your contention of non-existent conscious *exposures*, in the midst of all the stupidity and vulgarity and hypocrisy, imply but that we have been, nationally, so to speak, graced with no instance of recorded sensibility fine enough to react against these things?—an admission too distressing. What one would according fain do is to baffle any such calamity, to *create* the record, in default of any other enjoyment of it; to imagine, in a word, the honourable, the producible case. What better example than this of the high and helpful public and, as it were, civic use of the imagination? . . . How can one consent to make a picture of the preponderant futilities and vulgarities and miseries of life without the impulse to exhibit as well from time to time, in its place, some fine example of the reaction, the opposition, or the escape?[137]

In other words, James argues, in distinctly Wildean fashion, that if you cannot find examples of a fine artistic temperament in the real world because that world is too vulgar to produce such characters or would kill them off were they to be exposed, then it is the artist's civic duty to create, that is, to forge the record of their existence. Such is the case with the character James creates in "The Death of the Lion," the very first story in the first issue of the *Yellow Book* journal, a fact that bears some relevance for Mahon's own *Yellow Book*.

In "The Death of the Lion," an obscure novelist by the name of Neil Paraday takes ill and dies of his sudden exposure to global celebrity,

becoming a victim of the voracious appetite of modern journalism, which plays on the public's demand for the "immediate exposure of everything."[138] Such exposure is cast unmistakably as the result of the "wider latitude" of newly globalized print media, with regard to both its license to print whatever it wants and its wider geographic range. Indeed, the journal that exposes Paraday is called *The Empire*, while Paraday casts himself in colonial terms as a lone, undiscovered isle on whom a news editor bears down like a monstrous steam ship.[139] When Paraday dies, he leaves behind the manuscript of an unfinished work that he initially read aloud only once to the unnamed narrator but that then circulates privately through a network of aristocrats, patrons, literary celebrities, and servants, only to fall through their hands when left accidentally on a train.[140] As the manuscript takes its own trip through a mechanically interconnected world, the manuscript's loss ironically secures its permanent value as the most rare and most obscure commodity of all, a lost masterpiece, transmitted only once orally and therefore placed forever out of the public's reach. The loss of the manuscript simultaneously seals Paraday's posthumous reputation as a first-rate artist and wins the sly narrator some personal cachet as the only auditor of Paraday's final work. No one else, it turns out, had bothered to read the manuscript. As the single audience for the work, the narrator remains the last medium for Paraday's masterpiece, the protector and bearer of its singular obscurity through the modern web of print media. He becomes the sole proprietor of a lost archive. Indeed, he becomes an archive. For Paraday, to become a rare commodity is, at least as far as his reputation goes, the next best thing to becoming a best seller.

Despite James's satirical presentation, this is the logic that prefaces the central concerns of "The Aspern Papers," that in those lost documents, one might find the record of an artistic sensibility that opposes the conditions of modernity, even if such a sensibility is too fragile to survive those conditions. Mahon, in imagining himself as "a decadent who lived to tell the story," creates within the archive (in his notes and drafts) the record of the reaction, opposition, and escape from the vulgarity of his time, so that the archive may in turn give shape to some new artistic event that will craft an alternative future.[141] It is in this sense that the decadence of Mahon's *Yellow Book* can be read not just

in its many allusions to the 1890s but in its archival methodology, its use of the archive as a site of opposition to modernity that is nevertheless the product of a compromise with modernity. Regardless of what form the latest version of *The Yellow Book* or *Decadence* takes, each cut alters the archive, enlarging the record of its engagement with the changing conditions of a postmodern, postcolonial, postprint modernity, just as the knowledge of the changing conditions of the archive itself continues to provide a ladder up and out of the rag-and-bone images that accumulate in its many boxes and folders.

In tracing the roots of modern archival theory, Paul Saint-Amour notes that the First World War, which saw an enormous increase in the volume of war-related documents, raised the prospect of another catastrophic war in which such documents could be destroyed. It was partly in response to this nightmare scenario that the seminal British archive theorist Hilary Jenkinson fleshed out a new ethics for archival practice, arguing that an archive should be compiled without prejudice to the archive's future use. Two of the pillars of this theory were impartiality and authenticity.[142] To maintain impartiality, the archive should not be instrumentalized by its creators for "their own present-tense needs" but instead accumulated with *"indifference* to posterity." To guarantee the authenticity of such an archive, an unbroken line of custody would be necessary to ensure that it had been "shaped only by its creators and custodians, not disfigured through forgery." As Saint-Amour sums it up, "If we living researchers are to attempt to see the faces of the dead for our own purposes, we must feel certain that the dead did not alter their expressions in a prospective attempt to meet our gaze."[143]

It seems precisely the nature of the decadent collection to violate these principles. Decadent collections are accumulated for the needs and pleasures of their collectors. Dorian Gray collects the "strangest instruments" from "the tombs of dead nations" and "loved to touch and try them."[144] He collects rare objects of lost civilizations, but for his own personal pleasure. Des Esseintes rebinds editions of his favorite books in rare, luxurious materials, creating a unique edition of Baudelaire, for example, in "velvety China-ink" and "flesh-coloured pigskin" not primarily for the purposes of preservation but for his own sensuous

enjoyment.[145] Wilde's "The Portrait of Mr. W. H." is premised on the notion that "to censure an artist for a forgery was to confuse an ethical with an aesthetical problem."[146] Wilde would appear to free the archive of literary history from any such ethical considerations, construing it instead as a work of art, a fiction, even if the attempt to provide evidence for a literary theory that is otherwise lacking (a portrait of the supposed dedicatee of Shakespeare's sonnets) ultimately proves fatal to those who find the forged version of history more alluring than one based on authenticatable evidence.

Moreover, decadent literature's various figures for the archive demonstrate the intent of the dead to meet the gaze of the living, to draw the living into the archive's sometimes fatal workings. If the face of Dorian Gray shows no trace of his corruption, his portrait certainly records each transgression in excruciating detail. Dorian's perverse fascination within his own portrait, a kind of moral archivalism, paradoxically frees him to act in any manner he chooses. Ultimately, his archivalism gives way to his anarchivalism, his need to destroy the record of his crimes. Dorian's destruction of his portrait results, again paradoxically, in the record of his corruption being made public, restored to face value on his withered visage. If, as Saint-Amour argues, Jenkinsonian archive theory claimed a new ethics of impartiality and authenticity, the decadent literature that predates the war imagines the archive as riven with anarchival tensions, open on aesthetic grounds to alteration, and likely to seduce its readers with its perverse, corrupting, and potentially falsified or fatal vision. It makes a spectacle of the very partial and inauthentic nature of collecting that modern archive theory after Jenkinson sought to suppress or disguise.

In examining Mahon's drafts and revisions, I have been locating the decadence of Mahon's *Yellow Book* not just in its allusions to the Decadent movement but also in its archival methodology, in the willingness of Mahon's archive to meet the gaze of the living while covering the tracks of the poet's participation in the business of archivization. Stepping back from *The Yellow Book*, one might ask two broader questions. First, how does Mahon's ambivalent stance toward the archive alter his relation to the constellation of his fellow Northern Irish poets? Second, how do the archival methods of literary decadence square with current methodologies in online digital humanities projects as twenty-

first-century scholars digitize literature of the 1890s? To answer these questions, one might consider two recent works of archival scholarship, Heather Clark's *The Ulster Renaissance: Poetry in Belfast, 1962–1972* and *The Yellow Nineties Online*, a digital archive focused on periodicals such as the *Yellow Book* and the *Evergreen*. In examining these projects, one can see how Mahon's stance toward the archive challenges the assumed origins and trajectories of his fellow Northern Irish poets. Moreover, references in Mahon's drafts to Roger Casement and to Bram Stoker's *Dracula* suggest the role archives play in unearthing histories of crime and brutality that run counter to the assumed progress of modernity, calling out the reader's complicity in exploitation, consumerism, and genocide. It is this atavistic strain in the decadent literary imagination that runs counter to the progressive ethos underlying current digital approaches to the archive of Decadent literature.

Clark's *The Ulster Renaissance* examines the relationship among Northern Irish poets who came of age in the 1960s and 1970s, including Mahon, Longley, Heaney, and James Simmons, among others. The idea of an Ulster Movement or Belfast Group stems from Heaney, Longley, and Simmons's participation in a workshop founded in 1962 at Queens University by the English poet and critic Philip Hobsbaum. Mahon attended the workshop only once, but the idea of an organized movement of young Belfast poets became a critical commonplace, so much so that various members of the group have at times strenuously denied the workshop's importance or their participation in any sort of coherent movement. "I was not a member of Philip Hobsbaum's fucking Belfast Group," Mahon insisted in one interview.[147] Nevertheless, Clark demonstrates how the intense friendships and rivalries that developed among these poets drove them to varying degrees of achievement. Their identification with a group provided one means for these poets "to overcome anxieties of influence" even if they sometimes worked against their identity as a group.[148]

Although Clark's account is too detailed to rehearse here, toward the end, the book broadly follows a familiar narrative structure, one in which a tightknit group, bound by common origins and interests, eventually disperses as each member goes his or her own way. Heaney lands a job at Harvard and strikes it big with a Nobel Prize; Muldoon dazzles "the literati from his post at Princeton"; Mahon, Longley,

Simmons, and John Montague "give readings at home and abroad"; and Ciaran Carson and Medbh McGuckian find a "receptive audience" at home in Belfast.[149] All's well that ends well, it seems. Of course, there's much more at stake in Clark's account. Nevertheless, Clark's narrative is largely centrifugal; each poetic career flies off in its own direction. If one looks at the archival materials underlying this account, however, one finds that a large swath of it comes from these various poets' papers at Emory.[150] Despite a critical narrative in which the band breaks up, the leader goes solo, and everyone disperses with a mix of admiration, resentment, and nostalgia, all reunite again, for the most part, in a single archive. Clark's account would not be possible on the same terms if the Belfast Group's origin story did not to some extent determine the group's archival destination, a fact that Clark's persuasive and well-researched account does not pause to consider.

Such a literary history might benefit from focusing on the role the archive plays in consolidating and reinforcing the notion of a poetic "school." The desire to acquire such an archive of Northern Irish poets in the first place was no doubt a response both to the reputation of the supposed movement and to the reality of the poets' having maintained an active correspondence within their network. Still, the consolidation of a large portion of their materials at a single institution in the United States renders their consideration as a group somewhat inevitable, and it is worth incorporating the story of their material collections into the larger story of "the Ulster Renaissance," especially as any one poet's awareness of the group's archival destiny enters into the interpretation of the origin story itself.

So where would such an awareness make a difference in how we tell that story? Mahon offers a striking example through his alterations to "In Carrowdore Churchyard," his elegy for Louis MacNeice (retitled "Carrowdore" in *New Collected Poems*). As Clark notes, Mahon, Longley, Heaney, and other Ulster poets sought to reclaim MacNeice from Auden's shadow and reinvent him as a poet of Belfast. Through their collective efforts, they sought "to give recognition to MacNeice as literary benefactor and, in turn, to be recognized as his heirs." In claiming MacNeice as a progenitor for a Northern Irish voice, Mahon's generation helped solidify "a regional literary tradition distinct from

that of Dublin or London."[151] In this light, Clark reads "In Carrowdore Churchyard," which Mahon wrote after visiting MacNeice's gravesite with Heaney and Longley, as both "a stunning tribute" and "a subliminal act of disinheritance, for it presents the reader with a passive and inactive version" of MacNeice, as seen in the "repeated trope of stasis in phrases such as 'Your ashes will not stir,' 'Your ashes will not fly,' and 'You lie/Past tension now.'" These lines have "the curious effect of undermining MacNeice's immortality while at the same time assuring it."[152] Ultimately, Clark argues, it is MacNeice who "lies past tension," while Mahon "lies in the future tense," consecrating himself as the poet who, in appropriating MacNeice's legacy, brings "the all-clear to the empty holes of spring."[153] If, as Harold Bloom argues, "strong poets" have a habit of "returning from the dead," then Mahon seems bent on tamping down MacNeice's grave so his own flower may bloom.[154]

Mahon's revisions to these lines, however, tell a different story. In the version published in the chapbook *Twelve Poems* (1967), Mahon wrote,

> Your ashes will not fly, however rough winds burst
> Through the wild brambles and the reverend trees.
> All we may ask of you we have. The rest
> Is not for publication, will not be heard.[155]

Here, MacNeice's ashes resist the stirrings of contemporary winds. His body, his thoughts, and his unpublished poems are held back from public hearing. In *Poems, 1962–1978*, Mahon revised "reverend trees" to read "reticent trees." Even the trees beside his grave in that version will not reveal MacNeice's secrets.[156] In *New Collected Poems* (2011), Mahon takes a different view:

> Your ashes will not fly, however the winds roar
> Through elm and bramble. Soon the biographies
> And buried poems will begin to appear,
> But we pause here to remember the lost life.[157]

In this version, Mahon gestures toward a new unearthing of MacNeice's corpus. The trees are no longer reticent, the biographers will do their digging, and "buried poems will begin to appear."[158] Mahon

revises these lines as if to say, in Eliotic fashion, "O keep the biographer far hence, that's friend to men, or with his nails he'll dig it up again!" The corpse Mahon planted with "In Carrowdore Churchyard" sprouts in a revision keenly attuned to the potential of the archive to disrupt a seemingly settled legacy. That is, Mahon's revision figures the archive as an unquiet grave, and it is the unquietude of the archive that drives the revisionary process.

Mahon's revision may have had something to do with the fact that biographers would soon come digging through his own buried papers. Indeed, Stephen Enniss, formerly a librarian at Emory's MARBL, published a biography of Mahon in 2014. Enniss reports in the biography that Mahon expressed misgivings about the book's discussion of certain details of his private life.[159] Mahon's discontent with the biography gives added resonance to his translation of Guillén in "The Aspern Papers": "Not/everything has to be spoken;/not everything has to be known."[160] Curiously, in his notebook for *The Yellow Book*, one notation reads, "The Aspern Papers: Hedli and Letty," a likely reference to Hedli MacNeice (née Anderson), Louis MacNeice's second wife and the recipient of some of his more important correspondence.[161] It seems Mahon was already toying with the idea of MacNeice's legacy being stirred up again in Aspern-like fashion as he was writing *The Yellow Book*.

More importantly, Mahon's revision to "In Carrowdore Churchyard" betrays the tendency of archival material to sprout again from its grave, upending long-settled matters of literary inheritance and group affiliation. If MacNeice's poetic grave is so unsettled, so too is the collective vision of those Belfast poets who anointed MacNeice their common father figure. While Clark's narrative of an Ulster Renaissance begins with a sense of common origin and ends with the poets going their separate ways, Mahon's revised poem, with its suggestion of MacNeice's archival afterlife, reverses Clark's narrative: the Belfast poets end in a common archival destination, a literary grave, but the stirrings of that grave disrupt the very originating impulse of poetic youth, the search for a poetic patron that bound these poets together at the outset. If one of the major principles of modern European archive theory is the *respect des fonds*, or "principle of origin," the idea that no "scheme of arrangement can be fixed until the whole group of

documents has been examined and its original relations understood,"
Mahon suggests a scenario in which the archive is the very thing that
unsettles that sense of the original relation among poets whose work
shares a common archival fate.[162] If the archive has a decadent quality
as Mahon imagines it, it is in part this: that the temporality of the ar-
chive runs counter to the forward motion of literary inheritance.
Younger poets create their benefactors retrospectively by anxiously
burying them, but the dead refuse to remain buried, working to un-
settle and expose to scandal (as biographers do) the originary impulses
of youth.

Such latent stirrings of the archive also haunt Mahon's notes for
The Yellow Book in repeated references to Roger Casement's "black dia-
ries." In this case, the archive serves to indict the colonial brutality
that drove the Irish independence movement and led to the persecu-
tion of an Irish nationalist hero for sexual dissidence. Casement, an
Anglo-Irish Protestant who worked for the British consular service in
Africa, rose to fame as the author of a 1904 report that exposed atroci-
ties in the Belgian Congo.[163] The British awarded him a knighthood
for his efforts, and Casement went on to expose the brutal treatment
of Amerindians in the mines of the Amazon. Having witnessed the
violence of colonialism firsthand, Casement became a fervent sup-
porter of Irish independence. Before the Easter 1916 uprising, Case-
ment hatched a scheme to smuggle arms to Ireland and recruit Irish
prisoners of war from German camps to take part in the revolt. The
British discovered the plot, and Casement was captured, tried for
treason, and executed. Yeats, appalled, praised Casement as a sixteenth
martyr of the Easter Rising. Joseph Conrad, who had been Casement's
friend during the Congo years, disavowed him. James Joyce mentions
Casement's Congo report in the "Cyclops" episode of *Ulysses*, refer-
ring obliquely to Casement's 1916 execution. Hugh Haughton cites
Mahon's mention of saints and heroes not "Landing at night from
conspiring seas" in the poem "Glengormley" as being in part an allu-
sion to Casement's failed venture.[164]

The ongoing controversy over Casement surrounds not just his role
in the rebellion but also the discovery of journals in which he appears
to have recorded numerous sexual encounters with various men during
his travels. British officials privately circulated selected transcripts of

salacious entries to discourage any chance of Casement's winning a reprieve from execution. His case gained subsequent comparisons to Wilde's trials and to the adultery scandal that brought down Charles Stewart Parnell. Casement's defenders accused the British of forging the diaries to discredit Casement. To this day, despite forensic studies supporting the journals' authenticity, the controversy (tinged with homophobia) is regularly reignited in the Irish press, as it was in 1994, when the British government finally released Casement's "black diaries" to the public.

It is likely because that event was in the news around the time that Mahon was first contemplating *The Yellow Book* that a dozen references to Casement crop up in Mahon's journals and drafts. One scrap of notebook paper contains the words "Casement Poem/Dorian Gray."[165] A page of notes for "Remembering the '90s" mentions the "black diaries."[166] A note in the *Yellow Book* scrapbook reads, "Irish Heroes?—Tone/Casement," while another note links Casement more explicitly with Conrad: *"Heart of Darkness:* Marlow goes 'into the yellow' (Congo Map)/(Casement)," a reference to the moment when Marlow identifies the Congo as a yellow patch on the map of Africa.[167] Mahon lists "the Congo" in the catalogue of yellow items at the end of "At the Chelsea Arts Club."[168] Another note refers to Brian Inglis's 1973 biography of Casement, quoting a letter Casement wrote during his incarceration: "Let them not leave one in this dreadful place!"[169] A draft for "The World of J. G. Farrell" quotes a letter from Conrad: "Conrad met Casement, 1890; 'Best wishes on yr. Crusade.'"[170]

Gazing at these scattered notes linking Casement, Wilde, Conrad, and Anglo-Irish nationalist heroes such as Wolfe Tone and Parnell, one cannot help but think that even though Casement makes no identifiable appearance in the published versions of *The Yellow Book*, as Yeats furiously intoned, "the ghost of Roger Casement/is beating on the door."[171] This ghostly possibility hints at an anticolonial critique that begins with the archival remains of Casement's black diaries, a record of transgressive activity that, like *The Portrait of Dorian Gray*, results in the author's persecution and eventual death. As with Wilde's novel, the diaries' allusions to homosexuality were exploited by the British legal system to suppress a rebellious Irishman. But the intimacies recorded in those diaries were inseparable from Casement's identification

with those wretched of the earth in the Congo and South America. In Mahon's own journey "into the Yellow," he aligns Casement's anticolonial critique, which begins with the evident corruption at empire's farthest reaches, with the sexual dissidence of Wilde. The true decadence, it is implied, is not Casement's sexual history, or Wilde's, but the exploitation and hypocrisy of colonial rule that Casement exposed and the overbearing governmental authority that Wilde resisted in the name of art and on behalf of the love that dare not speak its name. That Casement failed in his bid to aid the Easter Rising is no matter, for as Mahon writes of Wilde in a line cut from the end of a draft of "Rue des Beaux-Arts," "You were probably thinking of Parnell when you said: / 'The greatest men fail, or seem to have failed.' "[172] An ethos of ennobling failure is one thing, Mahon suggests, that literary decadence shares with Ireland's independence movement.

Nevertheless, the atrocities that Casement sought to expose undergo a gradual process of displacement in succeeding versions of *The Yellow Book*. A draft for "America Deserta" links the colonial exploitation of ivory to the modern-day exploitation of uranium mining, seizing on Conrad's absurd image of a French ship firing randomly into the bush and evoking the racist imagery that Achebe critiques in his essay on *Heart of Darkness*:

> Heart of Darkness: into the yellow.
> The land seemed to glisten & drip with steam
> A frigate 'firing into a continent'; pace Achebe.
> Clinking chain-gangs; ivory (bones); uranium.
> Bundles of acute angles; piano teeth grimaces[173]

The version of "America Deserta" published in *The Yellow Book* suggests that the immediacy of Conrad's and Casement's accounts of such exploitation is lost on the modern television viewer:

> Back home, I surf the bright box for world news
> and watch with sanctimonious European eyes
> the continuing slave narrative, people in chains,
> the limp ship firing into the vegetation.[174]

As the revisions continue, new media displace the original print-era eyewitness record. In *New Collected Poems*, the foregoing passage is rewritten as the following:

> Back home now with my 20th-century blues
> I surf the radiant icon for world news
> and watch with sanctimonious European eyes
> Get Real, Global Impact, Born to Kill.[175]

In searching for news of the world, the speaker finds only the usual mediocre fare of sitcoms, wrestling shows, and old movies. The "continuing slave narrative" detailed by Casement has been pushed aside by a process of revision that seems to mimic the cultural change it laments.

It is the archive's ability to return from the dead and accuse the living, however, that asserts itself against such erasures. This can be seen in a nearly complete poem that Mahon cut from *The Yellow Book*. The draft poem, titled "Bad Girls," begins with an epigraph from Bram Dijkstra's *Idols of Perversity: Fantasies of Feminine Evil in Fin-de-Siècle Culture*. In that book, Dijkstra observes the persistence of the female vampire in fin-de-siècle literature as a figure for the "inherently regressive, degenerate susceptibilities of woman."[176] As the quotation Mahon uses for his epigraph notes, "these fashionable daughters of Dracula" would recur in the film era "as Hollywood 'vamps.' "[177] In Mahon's poem, the enduring popularity of such figures spurs the perennial curiosity of tourists in Transylvania. Speaking as a vampire, Mahon writes, "You come in your hordes each spring now to Romania / hoping to catch a glimpse from coach or train / of roaring gorges, morose forests, . . . bat-swirling fortifications," and other gothic scenery.[178]

Dijkstra observes that in *Dracula*, to "travel eastward is to travel into the past."[179] Mahon likewise portrays the tourists' journey as a trip into the primeval Romanian wood. Nevertheless, the vampire story itself continues to advance into modernity through successive new media:

> You who first entered these mountains an hour ago,
> your cameras at the ready, how can you know
> while you watch on videotape Lugosi, Schreck
> or Kinski going down on each white neck
> that we whom you thought subdued by the crucifix
> and spiked, with severed head, in our earth-box
> for ever, are born anew in every generation.
> Glamorous in decadent periods, never out of fashion,

[we] cross with insolent ease frontier and ocean
sucking your brains out in anticipation.
. .
[we were in Asia for a thousand years, our crimes,
go back even beyond ~~Byzantine~~ Phoenician times.][180]

The vampires, buried in each telling of the tale, emerge again un-
daunted on film and video. In emerging perennially from the East,
they atavistically haunt Western modernity.

Vincent Sherry has argued that in Stoker's *Dracula*, the degenerative
character of the vampire serves as the Other to Western modernity's
faith in progress. This progressive ethos is registered through advances
in the technologies of writing employed by Stoker's characters to track
information about Dracula, from handwritten letters and diaries to
the typewriter and phonograph.[181] Mahon's vampiric speaker simi-
larly evokes the horror of ancient crime reborn across borders, from one
fallen empire to the next, from one recording technology to the next,
belying the modern faith that technological advancement proves the
larger progress of civilization.

The vampire's atavistic crimes, in Mahon's telling, are both biolog-
ical and ecological, signifying an "~~addiction~~ ambition to possess and
liquidate / the substance of the earth." The vampires' ambition evokes
the insatiability of the fossil-fuel economy with its violently extrac-
tive and exploitive practices. These practices recall those of the rubber
and ivory trade in Casement's Congo. In a reference to Casement's 1904
report in *Ulysses*, Joyce mentions that native women were flogged "to
squeeze all the red rubber they can out of them," as though rubber were
blood sucked from the very bodies of the Congolese.[182] Given Mahon's
evident interest in Casement around this time, the context of colonial
exploitation is ready to hand in his figuration of the vampiric quality
of modern extractive technologies and the liquidation of natural
resources.

In *The Waste Land*, Eliot alludes to Stoker's vampire in the image
of "bats with baby faces" that "crawled head downward down a black-
ened wall," just as Dracula crawls down his own castle wall. In a mar-
ginal note to "Bad Girls," Mahon refers to "baby bats," directly evoking
Eliot's imagery.[183] Though Eliot envisions a Western modernity overrun
by Asiatic barbarians, those "hooded hordes swarming / Over endless

plains," Mahon reverses this atavistic trajectory. It is now "hordes" of Western tourists who go east to catch a glimpse of the "wicked source" over "dark fields of original sin."[184] What the tourists find, however, are the prescripted images of the Transylvanian wood they have already glimpsed in Hollywood films, a simulacrum, not an original source. Mahon evokes Eliot at his most decadent, but for Mahon, it is the Western tourists, heads full of Hollywood imagery, who overrun the East, not the degenerate Easterners who beset Western Europe.

Just as the vampire falsifies faith in the progress of modernity through its perennial revelations of ancient crime, for Mahon, the archive too has the power to expose the potential for barbarism within modernity. Speaking in the voice of the damned, the poem asks, "What do you know about the incurable ache / of the still living past—corrupt, archaic"—or "of famine, pestilence, phrenology, the Third Reich's / ~~Research programme~~ experiments."[185] For Romania in the 1990s, the "still living past" was that of the genocidal atrocities committed by the dictator Nicolae Ceauşescu, who was deposed and executed in 1989 after decades of brutal rule. In reprising the atrocities of the Nazis, the "still living past" proves as corrupt, archaic, and difficult to bury as the vampire.

In "Bad Girls," the undead speaker goes on to accuse the *hypocrite lecteur* of the same atrocities, eroding the moral distinction between tourist-consumer and bloodthirsty demon:

> . . . we do not fade
> in the sunrise of recovery but bubble
> in your own veins, alive in your own times;
> for you also are coded for genocide
> and our bitter thirst is your consumerism
> pumping its body with our glistening gism;
> You have known, like us, the secrets of the grave,
> ~~but we~~ you too are human ~~too~~ and we need your love.
> It's all coming out now, child abuse, war crimes;
> racists and serial killers sign up for psycho-babble.[186]

As I note earlier, because Freud took writing, the phonograph, and film as metaphors for living memory, Derrida takes psychoanalysis as a theory of the archive, which becomes subject to the same internal ten-

sions, revealing the same past traumas. Mahon shows the traumas of history bubbling to the surface in both the documentary and psycho-analytic record. "It's all coming out now." The repressed trauma of humanity's inhumanity is unearthed in the language of "psycho-babble," that is, through the talking cure and its jargon. As with the return of repressed trauma from the depths of the psyche, the unearthing of past trauma from the archive demonstrates the past's propensity to reach out and accuse its unsuspecting readers of also being "coded for geno-cide." The capacity for atrocity is written into human DNA, bubbling atavistically in our veins, giving the lie to the progress of civilization. The cancellation and revision of "~~but we~~ you too are human" signals the confusion of we / you, the undead and the living. Both show their capacity for inhumanity, but both deserve human sympathy. Just as the night "needs our love" in Auden's elegy for Freud, so too do Mahon's creatures of the night.[187]

Notably, Mahon also refers to the passage Wilde so loved from *The Renaissance* in which Pater describes the *Mona Lisa* as a vampire: "She is older than the rocks among which she sits; like the vampire, she has been dead many times, and learned the secrets of the grave."[188] As I have discussed, these words, like the revenant they describe, haunt the lips of Gilbert in Wilde's "The Critic as Artist," who claims to mutter them each time he passes Leonardo's masterpiece in the Louvre. In Ma-hon's poem, you, the reader, like us, the vampires, know the secrets of the grave. In that grave lies the archival code of decadence, the secret of its mode of transmission from one decadent writer to the next. What the literature of decadence transmits to each passing generation are the secrets of those crimes in which the sanctimonious reader is complicit. Like the Dracula-hunting tourist, readers delight in the perversity of their own imaginative attraction to and capacity for criminality. It was Baudelaire's insight into his readers' hypocritical enjoyment of the perverse subject matter of his verse that reasserts itself across the literature of decadence, from Poe to Huysmans, Wilde, Eliot, and Mahon. One finds it in the prurient interests of the archive's readership, among the "small and sickly eyes" of scholars, to use Wilde's phrase. The self-replicating archive of decadence, with its perennial resuscitation of its many vampires, betrays the decadence of the archive, the alluring and

perverse attractions of its many secrets that perennially draw new generations of readers. What one finds in its record is not the barbarism of the past, but oneself.

How does such an atavistic vision of the archive square with the progressive vision of digital humanities scholarship? Frederick D. King argues that the Aesthetic movement's response to the new media culture of the 1890s can serve as a guide to understanding new initiatives such as *The Yellow Nineties Online*, a digital archive edited by Dennis Denisoff and Lorraine Janzen Kooistra. Looking at periodicals such as the *Yellow Book* and the *Savoy*, King identifies the hallmarks of literary decadence as an archival method, including self-reflexivity, transnational eclecticism, irony, the rejection of linear history, the rejection of use value, and the indictment of the reader's complicity in modern culture.[189] Indeed, these represent many of the same qualities I have been tracing in Mahon's archive. Nonetheless, when one looks at the principles underlying *The Yellow Nineties Online*, one wonders if the editors and contributors, in doing such an excellent job of making their archive transparent, accessible, and useful, have not taken some of the bite out of decadence. That is, while I agree that we can read decadence as a self-conscious and ironic archival method that calls out the complicity of its readers, those are not necessarily the main principles underlying the compilation of digital archives.

Like King, the editors of *The Yellow Nineties Online* emphasize that "the aesthetic periodicals of the long 1890s anticipate key conceptual and methodological concerns of electronic scholarship," citing this idea as their reason for including a series of self-reflexive essays on their own "critical processes." As a justification for the project, the editors note that the site "gives immediate open access to historical documents, while preserving, in a regularly updated virtual form, periodicals in danger of disintegration due to their crumbling, pulp-based and chemical-bleached paper."[190] Nevertheless, Kooistra and Constance Crompton acknowledge that while "the periodical may decay through frequent handling," the site itself will degrade if the design and code are not constantly updated to keep pace with changing technologies.[191] In other words, while paper may yellow and decay over time, technological advancements and the planned obsolescence of both hardware

and software may render such online archives far more ephemeral than the materials they are meant to preserve.

In one of the commentaries on the site, Constance Crompton considers the objections of readers who are more accustomed to using print sources. In reflecting on the advantages and disadvantages of the digital medium, Crompton reveals how the ambitious dreams of the coding team met with real-world limitations. They began by tagging "place names, geographic regions, dates, each character's fictional status, quotation marks, and foreign words." They "envisioned [their] efforts meeting the needs of as many of the scholarly users [as they] could imagine for *The Yellow Book*'s text and images." Due to the constraints of time and labor, however, the team "adopted a simpler tag set, one that does not attempt to imagine all the inquiries users might make of the text."[192] Such decisions hint at the problems of labor underlying the digitization of Victorian periodicals (and the attractions of overseas outsourcing, not employed in this case, but common elsewhere).[193] More importantly for this discussion, the underlying ambition to imagine all the inquiries that future users might have (a departure from Jenkinsonian indifference to posterity) reveals the project's underlying faith in technological progress. In encoding, interpreting, and tagging these texts for future use, the project anticipates a future in which more technologically advanced users will have the ability to resuscitate dormant portions of the code and constellate new relations among various textual elements. This is the archive as a vision of technological promise, and yet that promise hints at the atavistic return of encoded latency.

Nevertheless, the stated ethos here runs contrary to the Decadent movement's provocative rejection of utility and accessibility in the arts, their preference for rare materials, and their objections to the cheapening effects of new media, even if the Decadents' own publications sometimes compromised those values. Crompton acknowledges such concerns only to put them aside. There is "a fear that digital humanities is a threat to the printed word," she writes, but she suggests that the actual threat is coming from elsewhere, from the digital publishing practices that have already disrupted the revenue models of traditional print media. Digital archives, however, offer "resources and tools" that "are more than just replicas of books online." They provide

"expedited" access to previously "scarce" texts and contextual materials. The overriding ethos is one of utility: "*The 1890s Online* team's challenge for the future is to maintain a site that is useful to digital humanities experts as well as novices (who may prefer books), to provide collaborative learning and teaching opportunities to humanities scholars, and to offer access to analytical tools and material that give us new insights into 1890s periodicals and their publishing and cultural contexts."[194] As a user of this online archive, I can only concur and applaud. But is this how we are to understand decadence as an archival method? The ethos here is clearly one that embraces and normalizes new media rather than resisting them. The goal is utility, to provide tools for collaboration, to offer instruction to digital novices (assuming they want it). Is this the spirit expressed by Des Esseintes when he rebinds his favorite books in luxurious materials for his own private use? If we are to find the ethos of decadence in *The Yellow Nineties Online*, it is not necessarily in the hopes or practices of the editors, coders, and contributors but in the oppositional stance of its contents toward the changing literary landscape and in decadent literature's perverse refusal of utility, the market, and public taste.

This spirit may be best expressed by one of *The Yellow Book's* first critics. In *The Yellow Nineties Online's* (really quite useful) collection of contextual materials, one can find a review of the first volume of the *Yellow Book* that originally appeared in the *Critic* in 1894 under the headline "A Yellow Impertinence." The anonymous reviewer calls the *Yellow Book* "the Oscar Wilde of periodicals" and does not mean it as a compliment. The reviewer opines that the periodical attracts attention by "clever," if "mountebank methods," that the attitude expressed by the editors, Henry Harland and Aubrey Beardsley, is "that of one who sticks his tongue in his cheek at the public—and who has a great deal of cheek to stick it in." The reviewer goes on to call Max Beerbohm's contribution, the satirical "A Defense of Cosmetics," a "vulgar and impertinent article that has no place in a self-respecting periodical." He cites several other impertinences, calling Arthur Symons's "Stella Maris," for example, a "poem of the gutter." While the reviewer appreciates Beardsley's "deliciously funny" illustrations, he ultimately declares that if the *Yellow Book* "is the embodiment of the modern spirit," then "give us the good old-fashioned spirit of

Harper's, The Century and *Scribner's,* whose aim is to please intelligent people, and not to attract attention by 'tripping the cockawhoop' in public." This last phrase is Beerbohm's.[195]

If decadence is to be understood as an archival method, we must, I think, restore its impertinence, its willful rejection of the public taste, and its suspicion that technological advancement is no guarantor of social progress. Rather, decadence, as a literary mode, continues to rely on the aura of private perversity surrounding artifacts in the print archive in ways that are not easily encoded or made accessible by TEI or XML. How, then, might we read decadence against the grain of the utilitarianism of online digital archives? One might take as a test case Beardsley's 1896 drawing "The Lacedaemonian Ambassadors," an illustration for Aristophones's bawdy satire *Lysistrata.*

Because Beardsley's illustrations for *Salomé* had inextricably linked him to Wilde in the public mind, after Wilde's trial, the *Yellow Book*'s publisher, John Lane, gave in to pressure to drop Beardsley as art editor.[196] Not long after, Beardsley collaborated with Leonard Smithers, seller of erotic books, to found the *Savoy* as a rival journal that would continue in the spirit of the original *Yellow Book*. Smithers supported Beardsley financially as Beardsley's health grew worse, paying him a salary for new work in exchange for the rights to that work.[197] It was Smithers who commissioned Beardsley to provide illustrations for a new translation of *Lysistrata,* a play in which the women of Greece conspire to withhold sex from their men as a ploy to stop the Peloponnesian war, leading to an epidemic of priapism. Beardsley's drawings for *Lysistrata* drew on the sort of European pornographic work that Smithers traded in as well as the exaggerated representations of genitalia in Japanese erotic prints, or *shunga,* which Beardsley collected.[198] However, as Linda Zatlin points out, Beardsley's humorous images for *Lysistrata* do more to mock the sexual frustration of their subjects than they do to exploit it for pornographic purposes.[199]

Beardsley's drawings for *Lysistrata* demonstrate his willingness to court public disapproval even after Wilde's public humiliation. Nevertheless, for decades, these images were only circulated privately. Smithers printed a limited edition of one hundred copies of *Lysistrata,* which could be acquired only by private subscription and became, like many of Beardsley's works, a collector's item. The volume illustrates

Aubrey Beardsley, "The Lacedaemonian Ambassadors," 1896, illustration to
The Lysistrata of Aristophanes, published by Leonard Smithers, London,
1896 (facing page 50). Pen and ink over pencil on paper. Prints, Drawings,
and Paintings Collection (Museum No. E.301-1972). Purchased with the
assistance of The Art Fund. © Victoria and Albert Museum, London.

how a coterie audience for decadent (and later modernist) literature continued to overlap with the underground trade in work considered to be obscene or pornographic. Smithers not only sold the original drawings but also secretly commissioned numerous forgeries of Beardsley's work, even while Beardsley was still alive, selling the forgeries off to private collectors. A cottage industry developed around the forgery and imitation of Beardsley drawings, which became all the more desirable because of their illicit content.[200] On his deathbed, Beardsley, who had converted to Catholicism, pleaded with Smithers to destroy his drawings for *Lysistrata:* "Dear Friend, I implore you to destroy *all* copies of Lysistrata and bad drawing. . . . By all that is holy *all* obscene drawings."[201] Smithers declined to do so, selling them instead to Jerome Pollitt. Mabel Beardsley, the artist's sister, later attempted to purchase the drawings from Pollitt with the intent to destroy them, but Pollitt refused to sell.[202]

Although expurgated versions of these images were published in 1901, Beardsley's *Lysistrata* drawings did not fully resurface until the 1960s. As Matthew Sturgis recounts, "The swinging decade of post-war liberation found an echo in his flouting of Victorian convention. A major Beardsley exhibition attracted crowds at the Victoria & Albert Museum in London. Although the *Lysistrata* drawings were on view at the museum, reproductions offered for sale in London and Edinburgh were seized by the police as indecent. The resulting furore stimulated interest, and all the offending drawings were reproduced, the following year, in [Brian] Reade's magisterial illustrated collection, *Beardsley*."[203] Ironically, the effort to suppress these artworks only stimulated Beardsley's cultural revival seven decades after his death.

It is perhaps no surprise then that "The Lacedaemonian Ambassadors" makes a cameo appearance among Mahon's papers as part of a joke mock-up book cover for *The Yellow Book* sent to Mahon by his American publisher, Wake Forest University Press. The mock-up consists of a cut-and-paste collage composed of Beardsley's drawing for *Lysistrata*, a cover for an issue of the original *Yellow Book*, and a humorously placed cutout of Mahon's author photo.[204] The piece serves as a delightfully impertinent and bawdy response to Mahon's own impertinent volume. The mock-up also constitutes a well-calculated send-up of the literary market for poetry; the joke depends on the idea

that a cover featuring "The Lacedaemonian Ambassadors" could obviously never be published. Indeed, it seems unlikely such archival material could ever be reproduced or digitized, given the difficulty of securing permission to reproduce materials of a sensitive nature.[205] So for now, this artifact lies in wait, hidden from public view yet accessible to any scholar granted access to the collection, placing the scholar, like Smithers's customers, among the consumers of illicit material. It is all the more ironic that an image that Beardsley created as a deliberate affront to Victorian morality and that he later wished destroyed should haunt the archive of materials for a book of poetry whose genesis lies in the author's understandably ambivalent stance toward the archivization of his own work.

To encounter Beardsley's drawings under such circumstances is to experience firsthand the print archive's continuing capacity both to delight and surprise the researcher and to frustrate and skewer the utilitarian values of the contemporary digital archive. Such privately circulated, occasionally forged, sometimes suppressed materials evoke the irreverence of a decadent coterie resistant to the demands of the contemporary mass marketplace and the prurient interests of scholarship. That a wittily repurposed image of "The Lacedaemonian Ambassadors" might lurk in the archive waiting to leap out at the unsuspecting researcher with its still barely printable, priapic provocation to public taste is just one illustration of what a decadent archival ethos might look like. It reaches back to the very point when decadence, in part because of its association with Wilde, became unspeakable, unprintable, even criminal. It alters the original arrangement of materials for the artist's own private purposes, sticks its cockawhoop, as it were, in the face of our politely utilitarian scholarly methodologies, and calls on us scholars, like the narrator of "The Aspern Papers," to question our own prurient interests.

CONCLUSION

Dandies at the Gate

IN A 1989 REVIEW of the work of the Australian poet Les Murray, wittily titled "Crocodile Dandy," Derek Walcott paints a tongue-in-cheek portrait of a metropolitan literary establishment shaken by the arrival of colonial outsiders: "The barbarians approaching the capital bring with them not only the baggage of a cow-horned, shaggy army but also the vandalization of the imperial language."[1] The barbarian bards, looking like something out of a Mad Max movie, shock the imperial elites with the "cacophony" of their "dented provincial vocabulary" and with their unsettling ability to "recite long passages of the imperial literature as if it were their own." Flummoxed and "fascinated" by these outsiders, the elites "invite the bards to dinner" and drape their "hairy shoulders with the sashes of the Academy." Giving the lie to imperial myths of inarticulate and uncivilized savages outside the walls, these provincial bards not only astound by their manners and "scholarship" but also demonstrate their capacity to "elevate the dialect of the tribe" by the disruptive force of their rough-edged vernaculars.[2]

Walcott's review offers a parable for many of the themes and ideas I have been tracing throughout this book. With mocking irony, Walcott demonstrates the pride of the colonial upstart who, like Wilde or

283

Shonibare, arrives at the capital better versed in the language and literature of the colonizer than the colonizers themselves are. Rather than reject imperial literature, he boasts his mastery over it. Slyly recalling the sack of Rome by Germanic Vandals in 455 CE, Walcott, like Evaristo, employs the example of Rome to revel in the creative destruction that colonial vernaculars wreak on the standard language of the imperial capital. Like Mahon in "The World of J. G. Farrell," Walcott decouples artistic refinement from notions of imperial civility. Moreover, Walcott employs the anticolonial rhetoric of imperial decline to distance the barbarians from the effete mannerisms of the metropolitan center. He even needles the British for the silliness of their social "formality," attributing their loss of the American colonies during the Revolutionary War to their habit of "advancing politely in squares" as if mimicking the phalanxes of Greece and Rome before them, a formalism that applies as much to verse as it does to armies.[3] Rather than rejecting such rigid formalism outright, however, Walcott, like Ali, embraces the poet's desire to elevate language through poetic form, just as Eliot sought to "purify the dialect of the tribe" in *Four Quartets*, but Walcott challenges Western notions of civilization in the process.[4] Ultimately, Walcott turns the metropole's polite disdain back on itself, insisting that the barbarians have no intention of staying among their astonished hosts.

If Walcott sets out to mock the decadence of the imperial center, claiming solidarity with another poet of the colonial periphery, he nevertheless does so using tropes familiar from the literature of decadence. For a Caribbean poet such as Walcott to claim to "elevate the dialect of the tribe," for example, is to ironize Eliot's monocultural ambition to "purify the dialect of the tribe." In doing so, Walcott writes himself into a cross-linguistic genealogy of decadent writing that includes Eliot, Mallarmé, Baudelaire, and Poe. Eliot, after all, derives his phrase from Mallarmé's poem "Le tombeau d'Edgar Poe," in which Mallarmé credits Poe, the godfather of French decadence by way of Baudelaire, with giving a "sens plus pur aux mots de la tribu."[5] Moreover, Walcott positions himself much as Baudelaire positioned Poe, as a poet caught between the decadence of the Old World and the cacophonous volubility of the New World. Baudelaire himself wondered whether "those tribes which we call 'savage' may not in fact be the

disjecta membra of great extinct civilizations," preserving a dandyism that is "the last spark of heroism amid decadence."[6]

Walcott's spoof of imperial manners likewise recalls the "barbarians at the gate" topos familiar from C. P. Cavafy's poem "Waiting for the Barbarians" (and J. M. Coetzee's novel of that title), as well as Paul Verlaine's 1883 poem "Langueur," which casts the aesthete's cold eye on the arrival of "blond barbarians" in Paris during the Franco-Prussian War, declaring, "Je suis l'Empire à la fin de la décadence."[7] Walcott, by imagining himself and Murray as the party crashers of empire, inverts this typically fin-de-siècle perspective to undercut the metropole's exclusive claims as the gatekeeper of literary tradition. In the process, he claims the haughty sophistication of the dandy on behalf of the supposed savage, while celebrating, as decadents such as Huysmans did, the linguistic tumult that takes place across newly permeable borders. In other words, Walcott, like many of the authors discussed throughout this book, employs the tropes of the Decadent movement ironically to stake his own claims for recognition from a literary establishment he simultaneously mocks for its late-imperial decline.

Doubling down on such ironies, Walcott further alludes to the work of Max Beerbohm, himself an essayist on dandyism, whose many well-known caricatures of Wilde, Beardsley, Dante Gabriel Rossetti, and other fin-de-siècle luminaries kept the image of 1890s aestheticism alive in the twentieth-century cultural imagination.[8] In describing Murray's place in the Australian poetry scene, Walcott conjures "Beerbohm's famous cartoon of Whitman inviting the American eagle to soar in front of a dour and sceptical Queen Victoria."[9] Remarkably, Walcott has conflated two different images by Beerbohm. The first shows Whitman energetically inciting an uninterested eagle to flight as an American flag flutters in the background. The second shows Tennyson seated opposite Queen Victoria, gesticulating as he reads "In Memoriam." For Walcott to imagine the barbarically yawping Whitman in Tennyson's place is, consciously or not, to depose Britain's laureate in favor of an upstart American, imaginatively paving the way for a later colonial upstart such as himself. To draw on Beerbohm so directly in this context is also to skewer Britain's still-Victorian literary establishment using a visual vocabulary borrowed explicitly from one of the fin-de-siècle's leading satirists, in effect identifying with Beerbohm's

Walt Whitman, inciting the bird of freedom to soar.

Max Beerbohm, "Walt Whitman Inciting the Bird of Freedom
to Soar," *The Poet's Corner* (London: William Heinemann
Ltd., 1904). © Estate of Max Beerbohm. Berlin Associates,
2017. Photoduplication: University of Delaware Special
Collections Library.

Max Beerbohm, "Mr. Tennyson Reading 'In Memoriam' to His Sovereign," *The Poet's Corner* (London: William Heinemann Ltd., 1904). © Estate of Max Beerbohm. Berlin Associates, 2017. Photoduplication: University of Delaware Special Collections Library.

ability to critique the mores and values of empire from within. Whereas Walcott once mocked those West Indian émigrés who went abroad and adopted the mannerisms of the *Yellow Book* era, including the "wit of Beerbohm" and "the delicate wickedness of Wilde," Walcott himself strikes the pose of a dandy in his review, exhibiting "the importance of being un-earnest."[10] Three years after writing this review, Walcott won the Nobel Prize in Literature. As Shonibare commented regarding his own dandyish ability to win sashes from the Academy, "it's the notion of the Trojan horse. . . . You can go in unnoticed. And then you wreak havoc."[11]

Walcott's "Crocodile Dandy" aptly illustrates the way in which a number of postcolonial writers tapped fin-de-siècle tropes, strategies, and images to position their art in relation to the end of the imperial era and the rise of new postcolonial literatures, sometimes earnestly, sometimes ironically, almost always ambivalently. While the use of "decadent" as an epithet in anticolonial thought initially signaled a

desire to break away from the artistic establishments of Europe and the United States, it just as easily came to express a desire to break into existing artistic establishments and reshape them from within. For the writers and artists discussed in this book, decadence and aestheticism become tools with which both to shock the metropolitan literary and artistic establishment and to reclaim beauty, form, and the imagination on behalf of postcolonial artists against the realist orthodoxies of cultural and ethnic nationalisms. Rejecting doctrinaire realism and embracing the idea of form, these writers and artists came to see aestheticism not as a retreat from the world but as one (often ironic, sometimes utopian) means to express art's opposition to real-world conditions, to reclaim forms disavowed for their decadence or perversity, to provincialize the dominance of Euro-American modernism, and to revise monocultural imperial historiographies. Despite the disinterested pose associated with aestheticism or dandyism, to evoke the idea of decadence in the late twentieth century and after is inevitably to engage with the material, political, and institutional conditions that give rise to art and literature after empire.

One might argue that from a historical standpoint, insofar as the idea of "decadence" evokes imperial decline and the emergence of postimperial plurality, it also provides a formative *ur*-concept for postcolonial thought more broadly. It is the very condition from which postcolonial societies imagined themselves emerging and into which they often found themselves too soon collapsing. Decadence comes to suggest the dawn of diverse new national cultures, a pluralization of history, and the retrieval of traditions eclipsed by colonialism just as much as it defines the decline of empires and nations from within. Insofar as the label "decadent," from Désiré Nisard onward, came to characterize certain features of an artistic sensibility associated with empires in their waning days, a sensibility one either embraced or disavowed depending on one's political stance toward nation and empire, it provided early postcolonial thought with an indispensable means of linking aesthetics and politics, if initially only negatively.

Because the fin-de-siècle period in European art has been so thoroughly mythologized for its association with aestheticism, symbolism, art for art's sake, and the Decadent movement, references to that period in postcolonial thought, even when vague, cliché, or coded, serve heu-

ristically to draw attention to debates over the social function of art. For this reason, attitudes toward decadence, aestheticism, and the fin-de-siècle period in art have shifted in ways that closely track the ideological questions and practical realities confronting postcolonial artists. For early postcolonial writers such as Achebe, Walcott, Faiz, and Soyinka, the language and tropes associated with decadent literature and art provided the means with which to critique the corrupt political, social, and artistic conditions of emerging national cultures, leading them to revise the idea of decadence in the process. In doing so, they prepared the ground for later uses of the concept to imaginatively connect the extravagance and corruption of the metropolitan center with colonial exploitation across a disjointed and distended imaginative geography. The use of decadence as a concept that crosses the divide between empires and their former colonies can be seen in the transnational poetics practiced in Ali's reading of *Dorian Gray* in Kashmir, in Walcott's reimagining of the Caribbean roots of French impressionism, in Shonibare's use of "African" textiles to critique the Victorian leisure class, in Evaristo's revisionist history of an African presence in Roman Londinium, and in Mahon's revisionary stance toward the transnational trajectory of the Irish literary archive. These writers and artists invite us to reimagine the origins and trajectories of "decadence" not simply as a name for a transitional phase between the Victorian and modernist periods defined within a narrow European geography but as a recurring foil in debates over the politics and ethics of art, and the social responsibilities of artists, across a more globally extensive geography from the colonial era to the present.

In many respects, Walcott's idea of the "crocodile dandy," a sort of dandy barbarian, captures the insider-outsider status of many postcolonial artists, just as fin-de-siècle dandies, in claiming to practice art for its own sake, gained purchase within the establishment by skewering its basic presuppositions about the use and function of art. Throughout much of this discussion, Oscar Wilde, the consummate insider-outsider, has served as a figure whose presence in postcolonial art brings various tensions over the politics of form, realism, history, aestheticism, sexuality, and colonial authority to the surface. Throughout this book, I have illustrated how Wilde's departure from conventional realism enabled later artists to reimagine and reinvent their own

histories. This should come as no surprise. As Joseph Bristow comments, "Everywhere we look in Wilde's writings . . . we can detect the fin-de-siècle origins of post-1900 fascination with dissident sexuality, critiques of the patriarchal family, the creative spirit of criticism, and the callous mindlessness of the British prison system. Over time, Wilde has become a figure upheld for his distinctly oppositional qualities— as an Irishman who at times felt decidedly at odds with an English literary culture to which he never fully belonged, as a man martyred for his sexual intimacy with other men, and as a maverick who refined his unrivaled wit through epigrams that turn received wisdom on its head."[12] While Wilde's enduring legacy has often been discussed in relation to European and American writing, Hollywood cinema, celebrity culture, the gay rights movement, and queer theory, the ubiquity of Wilde and his ideas in postcolonial literature and criticism argues for the fact that, as Auden said of Freud, "If often he was wrong and, at times, absurd, / To us he is no more a person / Now but a whole climate of opinion."[13]

The fact that Wilde's legacy extends so deeply into postcolonial thought, even when refuted or disguised, suggests that his work remains an ongoing provocation, asserting its relevance at those tension points where art's social function comes most into question. In closing, then, I want to offer two examples of how Wilde's life and ideas and, more specifically, his image call into question art's relation to society in the work of two poets who share little of Wilde's style or mannerisms, the Northern Irish poet Medbh McGuckian and the American poet Robin Coste Lewis. McGuckian's poem "The Palace of Today" depicts Wilde doing hard labor in prison after his conviction for gross indecency. Lewis's poem "The Wilde Woman of Aiken" is an ekphrastic poem based on an 1882 photograph intended to mock Wilde's aesthetic ideals during his lecture tour of America. Both poems respond in one way or another to the famous photographs that were taken by Napoleon Sarony at the beginning of Wilde's American tour and that continue to serve as the images by which Wilde, and arguably the figure of the dandy itself, is best known today. By triangulating McGuckian and Lewis's poetry with Sarony's images of Wilde, I hope to sketch what may prove fertile ground for the future of Wilde scholarship, namely, Wilde's relevance to fundamental questions about the way aes-

thetic values are intertwined with the punitive authority of the state
and with systemic racism in the institutions of the art world.

McGuckian's 2002 poem "The Palace of Today," which is dedicated
to Wilde, begins with what appears to be a kind of ars poetica cast
in gnomic terms that recall the ending of Yeats's "Among School
Children."[14]

> The meaning is very much
> a rhythmical one, the same law
> in blossom on the shoulder-high
> fork of a shrub-like tree,
> just streaming out presence
> and expecting nothing.

Though McGuckian's syntax obscures this riddle-like statement, the
poem would appear to suggest that the same law governing the blos-
soming expressions of nature governs the rhythms of verse. For poetry
to stream presence in this fashion while expecting nothing in return
obliquely suggests the nonutilitarian function of beauty. But as the
poem moves on, it becomes clear that rhythm takes on another
meaning, the rhythm of Wilde's steps on the treadmill, the Victorian
instrument of prison labor employed for no other purpose than that of
punishment. Noting the "slowness of his tread," McGuckian writes
that the "treads are set so / very far apart, he has to stretch / his limbs to
their utmost." The "slowness of the movement / is enough to make his
head spin / and strain the muscles of his stomach." Worse yet, "Some-
times he loses consciousness / and falls from the top of the wheel."[15]
The rhythm here is the rhythm of slow torture. Wilde's "meaning" lies
not in his verse, his epigrams, or his stylish self-presentation but in
the slow tread of his suffering. It is his bodily presence, not his style,
that conveys his meaning.

Wilde would have undergone such punishment during his incarcer-
ation at Pentonville. As Richard Ellmann notes, a typical day for a
prisoner in good health would involve six hours on the treadmill.[16]
Other punishments included picking oakum and turning a crank.
Though Wilde reportedly avoided speaking of the physical aspect of his
imprisonment, in *De Profundis*, his letter from prison to Alfred
Douglas, he did speak of his new awareness of the rhythms of suffering.

He comments that he came to view his friendship with Douglas as a "prelude" to the daily anguish of his prison existence. It "had all the while been a real Symphony of Sorrow, passing through its rhythmically-linked movements to its certain resolution, with that inevitableness that in Art characterises the treatment of every great theme."[17] In Wilde's reflection, it is as if his personal suffering does not belong to him but to the rhythms of some larger pattern, of which he is but an instrument. Like the clockwork marionettes of his poem "The Harlot's House," which go through their nightly dance like "wire-pulled automatons," Wilde goes through the automatic routine of his punishment as though pulled by unseen strings.[18] Wilde goes on to describe suffering in contrast to nature as "one long moment" that cannot be divided into "seasons." Rather, it turns on its axis like the treadmill: "It revolves. It seems to circle round one centre of pain. The paralysing immobility of a life, every circumstance of which is regulated after an unchangeable pattern . . . according to the inflexible laws of an iron formula."[19] To Wilde, who saw art as the realization of personality and the perfection of the individual, in prison, one's movements and routines are not one's own but are instead subject to an unchangeable pattern that revolves on a wheel going nowhere.

McGuckian's image of Wilde captures this sense of Wilde's revolving immobility, of his life having lost any self-willed direction. Because the steps of the treadmill are so far apart, "one of his legs is always/in mid-air, and takes the whole/of his weight when it lands./During this his body remains/completely motionless."[20] In "Among School Children," Yeats asks how we can "know the dancer from the dance."[21] In doing so, he captures the difficulty of separating body from movement, content from form, subject from pattern. McGuckian's poem approaches much the same question, suggesting the recurring difficulty of separating Wilde's art from his life. And yet, in his suffering, the rhythms, forms, and motions of his body do not belong to himself but to an artwork whose pattern he cannot fully see. On the treadmill, he is a dancer caught up in a dance not of his own making.

This image of Wilde stands in sharp contrast to that of the elegantly turned-out dandy visible in the many photographs and portraits done of Wilde during his lifetime. The records that exist of Wilde's appearance at the time of his incarceration come chiefly through the letters

of friends who visited him in prison or in the reminiscences of his jailers. When McGuckian shifts toward the first person toward the end of her poem, she takes a perspective that could be that of a prison warden: "I watched men and children // as they came off, and not one / had the slightest trace of sweat, / on the contrary, all appeared / to be cold, all pale, almost blue."[22] The account given here could apply to nearly any prisoner. From this perspective, Wilde's sufferings are not individual to himself. Rather, they are shared by the anonymous prison population, among whom Wilde was known by his prisoner number, C.3.3.

In 1896, during Wilde's first year in prison, Max Beerbohm wrote that "the dandy presents himself to the nation whenever he sallies from his front door. Princes and peasants alike may gaze upon his master-pieces." However, the "young dandy will find certain laws to which he must conform. If he outrage them he will be hooted by the urchins of the street, not unjustly, for he will have outraged the slowly con-structed laws of artists who have preceded him."[23] Wilde recalled that his greatest humiliation was being recognized on a station platform in his prison garb as he was being transferred from Pentonville to Reading Gaol.[24] This was not how he meant for the public to see him. In "Palace of Today," McGuckian commemorates Wilde's imprison-ment by starkly contrasting Wilde's appearance as a prisoner to our received understanding of his spectacular self-presentation as a dandy. Wilde as we know him is hardly visible as an individual in this poem. Prison life would seem to represent the antithesis of dandyism, a complete loss of the ability to control one's public ap-pearance, poses, gestures, and movements.

Curiously, however, the idea that the rhythms, motions, and ges-tures we associate with Wilde's persona are not his own came to de-fine the controversy over the famous photographs of Wilde taken by Napoleon Sarony in his studio in New York in 1882 at the beginning of Wilde's tour of America. As many scholars have noted, Wilde's lecture tour was a remarkable publicity stunt. It was arranged by pro-moters to provide a live example of the sort of dandyism and aestheti-cism lampooned by Gilbert and Sullivan's comic opera *Patience*. Wilde and the play in effect served to advertise each other. At the time, Wilde was famous mostly for being famous. He had made a name for himself

BEGINNING AT THE END

as a conversationalist who billed himself as an expert on aesthetics, despite having not yet published any of his major works. His celebrity was based as much on his outrageous appearance, with long hair, velvet waistcoat, fur-lined coat, and knee breeches, as it was on his ideas. This was the image of Wilde that Sarony helped to construct in his studio, putting Wilde through a series of poses, sometimes against a decorative backdrop. The striking images caught on, and advertisers started pirating Sarony's iconic images of Wilde for lithographs promoting everything from cigars to freckle ointment. As Michael North notes, "Wilde was famous because he was widely pictured and not vice versa."[25]

As Daniel A. Novak recounts, Sarony saw himself not as a photographic technician (he did not snap or develop the photos produced in his studio) but as an expert at posing and arranging his subjects. In Sarony's view, subjects appeared most natural when they abandoned themselves to the will of the photographer: "For Sarony, the only way to produce a proper photographic likeness, the only way to produce an authentic photographic subject was, paradoxically, for the sitter to surrender any identity, subjectivity, or consciousness that might make itself visible."[26] Thus, when advertisers started pirating Sarony's images of Wilde, Sarony sued, arguing that the poses themselves were his property; they were his work of art. As Michael North points out, the idea that Wilde might have some claim to the dissemination of his own image seems to have been legally beside the point. Sarony's case went to the U.S. Supreme Court, and he won based on the idea that he arranged the posture and appearance of Wilde's body and thus had the exclusive right to reproduce and sell images of those very poses we have come to identify specifically with Wilde.

Both Novak and North point out the degree to which Wilde's gestures, poses, and disarticulated bodily features came to be abstracted from his person, becoming both endlessly reproducible and subject to ethnographic and homophobic typing. Aspects of his person were taken in a criminological sense as typical of the dandy, degenerate, or homosexual. In Lord Queensberry's crude terms, he was taken to be "posing" as a sodomite. North links Wilde's arguments in his lectures, which centered on "the necessity of aestheticizing every area of ordinary life," to the power of the camera to likewise aes-

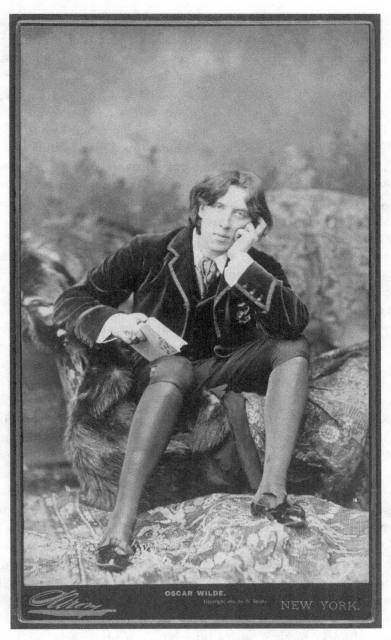

Napoleon Sarony, portrait of Oscar Wilde. Albumen silver print.
30.5 × 18.4 cm. Metropolitan Museum of Art, New York. Gilman
Collection, Purchase, Ann Tenenbaum and Thomas H. Lee Gift, 2005
(Accession Number: 2005.100.120). Creative Commons (CC0 1.0).

theticize and abstract a vast array of ordinary objects. The camera and other recording devices held the capacity to stabilize, fix, and alienate "personal appearance, expression, movement, [and] disposition" such that "these are no longer fleeting emanations private to self but products, transferable in time and space." The photograph, North argues, "aestheticizes a world of things never before thought of as art."[27] In this sense, McGuckian not only presents an image of Wilde in prison as the antithesis of the self-possessed dandy known to the public through Sarony's photographs but also stresses the way in which the regulatory regime of prison life similarly dispossesses incarcerated subjects from their own movements, gestures, and body parts, abstracting the rhythms of a prisoner's existence and rendering them reproducible, be it for prisoner C.3.3 or C.4.8. The prison becomes a kind of camera, and the prisoner shares with the photograph that mechanical reproducibility that Benjamin defined as the condition of modern art and that alienates the subject represented in art from his or her own bodily disposition.

Wilde's image lent itself to another variety of mechanical reproducibility, the racist typing of the dandy-as-Negro and Negro-as-dandy promulgated in satirical cartoons intended both to lampoon Wilde and to dismiss the possibility of taking black subjects seriously as the objects of aesthetic appreciation, such that not even the camera could credibly aestheticize them. As Ellen Crowell notes, wherever Wilde went on his tour, descriptions of his physical appearance conflated the racial stereotypes of the Irish as savage with gender stereotypes of the dandy as effeminate. Wilde's "gorilla-like frame," long hair, "large lips," and "prominent nose" were taken as "evidence of racial, as well as sexual, difference." As Crowell comments, "Wherever Wilde aligned himself in terms of culture, nationality, and breeding, observers insisted on aligning him both with the 'native' Irish (and by extension the African 'savage') and the effeminate 'queer.'" This racial and sexual othering of Wilde took virulently racist form, as when a group of students in Rochester, New York, interrupted Wilde's performance by, according to one report, marching "an old Negro in a swallow tailed coat and knee-breeches, with a huge bunch of sunflowers in his buttonhole" down the aisle of the lecture hall to the pleasure of a jeering

crowd, mocking "aestheticism through race" and leaving Wilde silently angry at the podium.[28] Similar racial caricatures featured in a variety of cartoons and advertisements, some depicting effeminate black male subjects dressed similarly in suits and knee breaches with exaggerated features carrying sunflowers. In the United States, the gestures and poses by which the dandy advertised his own sensational presence were abstracted, racialized, and weaponized to denigrate both the dandy and the "Negro."

In the poem "The Wilde Woman of Aiken," Robin Coste Lewis seizes on one instance of such racialized mockery in an 1882 photograph taken by J. A. Palmer. A note accompanying the poem provides the relevant context:

> In 1882, Oscar Wilde toured the United States. Many American critics chastised him for his theories on beauty, including comic strip artists and photographers. One photographer, J. A. Palmer from Aiken, South Carolina, seeking to disprove Wilde's aesthetic—that anything could be beautiful—staged what he believed to be a satirical photo shoot, choosing objects he found to be inherently repugnant: a black woman, highly patterned fabrics, an ornately upholstered chair, a sunflower, and a face jug, placed prominently on a table. The sunflower was a reference to Wilde, as were the patterned fabrics. As for the vessel, Aiken had a small population of slaves who worked as potters. Many art historians believe face jugs from South Carolina were made by these slaves, and hence, Palmer's probable reasoning for including it in the photo.[29]

Palmer not only mocked Wilde's ideas on the aesthetic value of ordinary things but also mocked the possibility that black women, or the artworks they crafted, could in any sense be considered beautiful. Palmer had also taken a similarly staged photo of a young boy with a face jug, sunflower, horseshoe, book, and calla lily, titled "An Aesthetic Darkey," which was inspired by a caricature by W. H. Beard of "An Aesthetic Monkey." That image was printed on the cover of the Saturday, January 28, 1882, issue of *Harper's Weekly* to coincide with Wilde's tour of America. Palmer substitutes an African American boy for a monkey in an "overtly racist gesture."[30] That is, Palmer's photographs were not some private joke but played

on a widely circulated image that already doubly mocked aestheti-
cism as savage and savagery as unaesthetic, relying on already highly
conventionalized and racialized representations of aesthetic poses,
gestures, and symbols to do so.

Palmer's mockery can be seen in the way he has posed his various
"objects." While the face jug stares directly at the camera, the human
sitter is posed looking forlornly beyond the frame, hands posed together
at her head in a deliberately "aesthetic" gesture. To convey his satire,
Palmer must disembody the pose of the dandy and render it another
decorative object, like a jug, sunflower, or floral print, rendering the
black subject of his photograph likewise into a posed object, fixed by
the artist and in no sense in possession of her own bodily disposition.
She must, as Novak says of Wilde, "surrender any identity, subjectivity,
or consciousness that might make itself visible." Her pose becomes her
photographer's property, rendering the sitter subject to the racial logic
of slavery. What appears to be a chain hanging off her arm leads to a
horseshoe in her lap, playing on nineteenth-century portraiture con-
ventions but also suggesting the woman's status as property or work-
horse. By mocking the supposed excesses of aestheticism, the image
lays bare the way racist ideologies have governed aesthetic values, ren-
dering its subject abject in the process. The artist Pope.L, whose iconic,
public "crawl" works create powerful and complex images of abjection
and racial inequality, recently incorporated Palmer's photo as a kind
of found object in his 2015 work *Container*, in which the photograph
has been blown up to the size of a doorway and displayed in the gal-
lery behind a curtain, as if the image itself marked a blocked aesthetic
passageway.[31] Commenting on the larger exhibition, titled *Forest*,
Emily Anne Kuriyama remarks that the "inscrutable forest" that
Pope.L makes visible with such works "is the racist ideological struc-
ture in between and all around us," calling on the audience to see the
forest, not just the trees.[32]

In "The Wilde Woman of Aiken," Lewis restores a sense of the sit-
ter's individual subjectivity by ventriloquizing her voice, imagining her
determination to outlast the moment of her exposure on film and her
unwillingness to have the narrative of her life determined by the lim-
iting aperture of the camera:

Pope.L, *Container*, 2015. Vinyl. 96" H×48" W (243.84 cm
H×121.92 cm W). Edition of 5, 1 AP. Courtesy of the Artist and
Susanne Vielmetter Los Angeles Projects. Copyright Pope.L.
Photo: Robert Wedemeyer. (This work incorporates the same
1882 photograph by J. A. Palmer referred to in Robin Coste
Lewis's "The Wilde Woman of Aiken.")

I am not supposed to be
beautiful. I am not
supposed to sit

before the observant eye
of a sunflower. I am incapable
of having a voice

like a robin's singing
of springtime's newborn impatiens.[33]

The subject goes on to suggest, "If I were a name,//it would be
Wall/paper," evoking her status to the photographer as mere decorative
object. Punning on her own name, "Robin" Coste Lewis lends her
singing voice to that of a woman robbed of hers. The speaker thinks of
the gulf between her and the photographer beneath the "dark/velvet" of
his blackout cloth "waiting for the light//to reach" him. She conflates
the photographer's control over the aperture of the camera with the
mouth that imposes his narrative on her body, "whenever your
mouth/opens and is then closed./The story has not even begun." As the
poem goes on, the woman affirms her own beauty, like that of her "satin
sash the color of sun//warmed eggplant/still fetching/on the vine,"
while also perhaps darkly evoking the "strange fruit" of a lynching. At
the end, the speaker fiercely rejects the photographer's attempt to fix her
story in place: "You/cannot/prevent me."[34] The poem openly rejects
the racial logic by which Wilde's aesthetic theories were supposed to
have been refuted. In doing so, it also rejects the process by which this
sitter becomes subject to the dehumanizing separation of self and pose,
body and image. For both Lewis and McGuckian, then, Wilde's self-
possessed posing, his bodily artifice, his endless play of masks, comes to
figure the dispossession of the subject's body on the grounds of racial
and sexual difference. Their poetry, through indirect and direct ekph-
rasis, grants a degree of imaginative restitution for that separation.

For Lewis, "The Wilde Woman of Aiken" is but one piece of the
larger project in her volume *Voyage of the Sable Venus*. The long title
poem of that volume might be described as part found poem, part meta-
ekphrasis. Lewis describes it as "a narrative poem comprised solely
and entirely of the titles, catalog entries, or exhibit descriptions of

Western art objects in which a black female figure is present, dating from 38,000 BCE to the present."[35] The poem represents an epic voyage from prehistory through the middle passage and slavery up to the present in "catalogs" of verse that cut and paste together hundreds of descriptions of objects and artworks from museums and institutions around the world. What becomes quickly clear through Lewis's brutal repetition of stock phrases is the dehumanizing nature of the institutional language of museum description. Although I cannot do justice to the full poem here, I observe how Lewis's poem draws attention to the generic and repetitive language used to describe the bodily positions of black female subjects represented in any number of artworks. Such language is reproduced almost mechanically in exhibit text after exhibit text, from gallery to gallery:

> Standing
>
> Female Figure with Child Kneeling
> Female Figure with Child Standing
> Female Figure Head
> Rest Supported by Seated
> Female Figure with Bowl Standing
> Female Figure with Bowl and Child Standing[36]

The enjambment here even separates pose from figure across each line. Other passages emphasize the repeated depiction of black female figures in bondage, suggesting that the conventional language in which they are described is itself a form of discursive bondage:

> Back
>
> View Head of an African Prisoner
> Statue of Prisoner Kneeling Arms
>
> Bound at the Elbows
> Left Arm Missing
>
> Bust of a Nubian Prisoner
> with Fragmentary Arms
>
> Bound Behind Funerary Mask
> of a Negro with Inlaid Glass Eyes[37]

In these and numerous other examples, the women represented in these works of art do not own their own poses so much as these poses become the discursive property of the exhibit text. When these descriptions are taken individually, one might not notice the dehumanizing quality of such institutional language, but woven together into the larger narrative of Lewis's poem, they accumulate the force of a truth hiding in plain sight, not in the "intellectual propaganda we call 'history,' " as Lewis writes elsewhere, but "simply in what the image is called." In the "invisible archeology" of exhibit text, Lewis discovers, "Black female bodies ornamenting the tripods, the base of a table, sleeping inside the frame, selling, offering, tending in the background of innumerable paintings. Bending, standing, waiting. Our whole artistic history crawling with the decorative bodies of black women. Every continent, every country, every time period, every museum, every exhibit, every gallery, every library, every archive, every repository, every court."[38]

As Lewis notes, she sometimes changed the label "African American" back to the "historically specific markers—such as *slave, colored*, and *Negro*"—that she suggests have been erased by recent curators and cataloguers. In doing so, she describes her decision to "allow that original horror to stand." She states her "intent was to explore and record not only the history of human thought, but also how normative and complicit artists, curators, and art institutions have been in participating in—if not creating—this history."[39] In a poem such as "The Wilde Woman of Aiken," Lewis places Wilde within that larger project to interrogate the art world's institutional complicity in both normalizing and obscuring racial violence and aesthetic and discursive subjugation within its own presentation of history. The process by which Wilde's poses, gestures, and spectacular mode of self-presentation were abstracted and alienated from his person and became, instead, conventionalized markers of racial and sexual difference belongs to this larger history. By the same token, the larger project Lewis undertakes to expose and defamiliarize the conventions by which race and gender are marked in art-historical texts, and thus participate in other systematic forms of racism and misogyny, can just as well be applied to Wilde studies and studies of decadence and aestheticism more broadly.

Wilde's own complicity in this regard is certainly up for question, given his flirtation with the likes of Jefferson Davis and his expressed sympathy for the Confederacy during his tour of the United States. But if Wilde's image is part of this larger story, Wilde played his own part in exposing the accepted conventions of art history by epigrammatically dissecting the aesthetic norms and conventions of his own day. In referring to Wilde in *Voyage of the Sable Venus*, Lewis joins Achebe, Walcott, Thelwell, Shonibare, and Evaristo in employing references to Wilde's aestheticism to challenge the standards of beauty foisted on black subjects by conventional narratives of art history. Like all the other figures examined in *Beginning at the End*, Lewis plays on Wilde's role in destabilizing conventional understandings of realist representation, such as that assumed of photography, to challenge dominant exclusionary histories of art.

In 2016, Reading Gaol, where Wilde wrote *De Profundis* and conceived of "The Ballad of Reading Gaol," commemorated his incarceration there by turning the prison into an art museum, exhibiting dozens of works by contemporary artists inspired by Wilde. Famous performers such as Ralph Feines, Ben Wishaw, and Patti Smith were recruited for public readings of *De Profundis*. The organizers invited artists such as Ai Weiwei to write and record "letters of separation" inspired by Wilde's letter to Douglas, in which the artists wrote letters to loved ones from whom they had been separated by "state enforcement."[40] The exhibition demonstrates Wilde's ongoing role in imaginative acts of restitution for past injustices and his evolution in the public mind from pariah to political prisoner, an example for other artists interned or exiled for their art. Nevertheless, to turn a prison into an art gallery is also to imagine the manner in which the art gallery imprisons its subjects, just as Walcott suggests in *Tiepolo's Hound* or Lewis makes vivid in *Voyage of the Sable Venus*. Startlingly, in the 2017 exhibition *Queer British Art 1861–1967* at the Tate Gallery in London, the curators hung what is believed to be the actual prison door to Wilde's cell alongside Robert Pennington's full-length portrait of Wilde and a famous 1893 photograph of Wilde and Lord Alfred Douglas, framing the door itself, this artifact of Wilde's life at its lowest point, as itself a work of art.[41] In Wilde's defense of *Dorian Gray*, he wrote that it is "the spectator, and not life, that art really mirrors," that "each man sees his own sin in

Dorian Gray," and that it is an "unpardonable crime" to "confuse the artist with his subject-matter."[42] And yet it was by problematizing the distinction between art and life, style and subject matter, that Wilde himself has become a mirror for succeeding generations of readers and artists as they grapple with the relation between art and injustice. In this respect, Wilde's legacy, and the legacy of the fin de siècle period in art generally, opens up to a wide area of human experience. It has become part of the fabric of how the politics of art are imagined in relation to social justice movements and to the dominant institutions of art and state. Wilde is only one prominent figure in these debates, but his own intertextual journey through the literature and art of the late twentieth and early twenty-first centuries suggests the continuing need to expand the range of materials considered in relation to concepts such as decadence and aestheticism. Toward that end, this book is but a beginning.

Notes

INTRODUCTION

1. Charles Baudelaire, "Further Notes on Edgar Poe," in *The Painter of Modern Life and Other Essays*, trans. and ed. Jonathan Mayne (London: Phaidon, 1995), 94.

2. Frantz Fanon, *The Wretched of the Earth*, trans. Constance Farrington (Bungay, UK: Penguin Books, 1970), 123, 179. The passage from which I take my title reads as follows in the original French: "Elle suit la bourgeoisie occidentale dans son côté négatif et décadent sans avoir franchi les premières étapes d'exploration et d'invention qui sont en tout état de cause un acquis de cette bourgeoisie occidentale.... Il ne faut pas croire qu'elle brûle les étapes. En fait elle commence par la fin. Elle est déjà sénescente alors qu'elle n'a connu ni la pétulance, ni l'intrépidité, ni le volontarisme de la jeunesse et de l'adolescene." Frantz Fanon, *Les damnés de la terre* (Paris: Éditions La Découverte and Syros, 2002), 149.

3. Ibid., 179, 190, 182.

4. Derek Walcott, "A Dilemma Faces W. I. Artists," in *The Journeyman Years: Occasional Prose, 1957–1974*, vol. 1, *Culture, Society, Literature, and Art*, ed. Gordon Collier (Amsterdam: Rodopi, 2013), 69.

5. Derek Walcott, "Reflections on the November Exhibition," in *Journeyman*, vol. 1, 397.

6. Chinua Achebe, *There Was a Country* (New York: Penguin Books, 2012), 243.

7. See Joseph Bristow, *The Fin-de-Siècle Poem: English Literary Culture and the 1890s* (Athens: Ohio University Press, 2005), ix. Bristow notes that the heterogeneity and diversity within Anglophone European poetry of the late nineteenth century has "seldom been well served by the trio of critical terms—'aestheticism,' 'Decadence,' and '*fin-de-siècle*'—that have for the

most part cast such leading figures as Ernest Dowson, Arthur Symons, Lionel Johnson, and Oscar Wilde in unfavorable critical light." Likewise, the accounts of Max Beerbohm, W. B. Yeats, and Max Nordau and the criticism of modernists such as Ezra Pound and T. S. Eliot are also responsible for misconstruing or oversimplifying the poetic achievements of the era.

8. Arthur Symons, "The Decadent Movement in Literature," *Harper's New Monthly Magazine*, November 1893, 858–859.
9. Ibid., 866, 859.
10. Ibid., 863, 864, 867.
11. Ibid., 858.
12. Aimé Césaire, *Discourse on Colonialism*, trans. Joan Pinkham (New York: MR, 1972), 31, 39.
13. Jean-Paul Sartre, introduction to Fanon, *Wretched of the Earth*, 23.
14. Dipesh Chakrabarty, *Provincializing Europe: Postcolonial Thought and Historical Difference* (Princeton, NJ: Princeton University Press, 2000), 45–46.
15. Léopold Sédar Senghor, "The General Nature of African Art," in *Prose and Poetry*, trans. John Reed and Clive Wake (London: Heinemann Educational, 1976), 81–82.
16. J. O. J. Nwachukwu-Agbada, "An Interview with Chinua Achebe," in *Conversations with Chinua Achebe*, ed. Bernth Lindfors (Jackson: University Press of Mississippi, 1997), 130.
17. Mulk Raj Anand et al., "Manifesto of the Indian Progressive Writers' Association, London," *New Left Review*, February 1936.
18. Césaire, *Discourse on Colonialism*, 64.
19. See Matei Calinescu, *Five Faces of Modernity* (Durham, NC: Duke University Press, 1987), 200–203.
20. György Lukács, "Aesthetic Culture," trans. Rita Keresztesi-Treat, *Yale Journal of Criticism* 11, no. 2 (1998): 373–374.
21. Walter Benjamin, "The Paris of the Second Empire in Baudelaire," in *Selected Writings*, vol. 4, *1938–1940*, trans. Edmund Jephcott et al., ed. Michael W. Jennings and Howard Eiland (Cambridge, MA: Harvard University Press, 2003), 64–65.
22. See Calinescu, *Five Faces*, 196. Calinescu points out that despite the work of more "sophisticated" Marxist thinkers such as Lukács, Christopher Caudwell, Benjamin, and Theodor Adorno, it "was not until the mid-1960s that the crisis of conscience brought about by de-Stalinization prompted certain Western Marxists associated with the communist movement to reexamine the Soviet dogma of decadence and its implications." Ibid., 203.
23. Chinua Achebe, "Thoughts on the African Novel," in *Morning Yet on Creation Day: Essays* (Garden City, NY: Anchor, 1975), 88.
24. Achebe, "Africa and Her Writers," in *Morning Yet on Creation Day*, 31.
25. Nwachukwu-Agbada, "Interview with Chinua Achebe," 130.
26. Achebe, "Africa and Her Writers," 30.
27. Ibid., 36–37.
28. As Laura Doyle argues, an "inter-imperial" framework allows one to explore texts as the product of "influences of both non-European and European empires, of both successive and surrounding empires, and of the political identities sedimented over long-historical time," with an eye on the "cofor-

mations of culture, state, and economy" that shape postcolonial texts and identities. See Doyle, "Inter-imperiality and Literary Studies in the Longer Durée," *PMLA* 130, no. 2 (2015): 342–343.

29. Jawaharlal Nehru, *The Discovery of India* (New York: John Day, 1946), 216–220.

30. Ibid., 562.

31. Ibid., 567.

32. Partha Chatterjee, "The Constitution of Indian Nationalist Discourse" (1987), in *Empire and Nation: Selected Essays* (New York: Columbia University Press, 2010), 53.

33. On Nehru's interest in Spengler and Gibbon, see Sabyasachi Bhattacharya, *Talking Back: The Idea of Civilization in the India Nationalist Discourse* (Oxford: Oxford University Press, 2011), 86–87, 91. On the backward historical motion of modernity, see Vincent Sherry, *Modernism and the Reinvention of Decadence* (Cambridge: Cambridge University Press, 2015), 98–109. See also Oswald Spengler, *The Decline of the West*, vols. 1–2, trans. Charles Francis Atkinson (New York: Knopf, 1926–1928); Edward Gibbon, *The History of the Decline and Fall of the Roman Empire*, vols. 1–12 (London: A. Strahan and T. Cadell, 1788–1790).

34. Chatterjee, "The Constitution of Indian Nationalist Discourse," 53.

35. Justin Quinn, *Between Two Fires: Transnationalism and Cold War Poetry* (Oxford: Oxford University Press, 2015), 3.

36. Derek Walcott, "The Caribbean: Culture or Mimicry?," in *Critical Perspectives on Derek Walcott*, ed. Robert D. Hamner (Boulder, CO: Lynne Rienner, 1993), 51–52.

37. Quinn, *Between Two Fires*, 176.

38. Derek Mahon, *The Yellow Book* (Winston-Salem, NC: Wake University Press, 1998), 48.

39. Bernardine Evaristo, *The Emperor's Babe* (New York: Penguin Books, 2001), 4.

40. Leela Gandhi, *Affective Communities: Anti-colonial Thought, Fin-de-Siècle Radicalism, and the Politics of Friendship* (Durham, NC: Duke University Press, 2006), 151, 161.

41. Edward W. Said, *Culture and Imperialism* (New York: Vintage Books, 1994), 13.

42. See Jahan Ramazani, *A Transnational Poetics* (Chicago: University of Chicago Press, 2009), 95–115.

43. I owe a comment by Vincent Sherry for this insight.

44. See Kristin Mahoney, *Literature and the Politics of Post-Victorian Decadence* (Cambridge: Cambridge University Press, 2015), 3–4.

45. Joseph Bristow, introduction to *Oscar Wilde and Modern Culture*, ed. Joseph Bristow (Athens: Ohio University Press, 2008), xxii.

46. Achebe, *There Was a Country*, 59, 56.

47. Achebe, "Africa and Her Writers," 39.

48. Ibid., 29.

49. Achebe, "Colonialist Criticism," in *Morning Yet on Creation Day*, 21–22.

50. Oscar Wilde, "The Critic as Artist," in *The Artist as Critic: Critical Writings of Oscar Wilde*, ed. Richard Ellmann (Chicago: University of Chicago Press, 1969), 359.

51. See Richard Gilman, *Decadence: The Strange Life of an Epithet* (New York: Farrar, Straus and Giroux, 1979).

52. Charles Bernheimer, *Decadent Subjects: The Idea of Decadence in Art, Literature, Philosophy, and Culture of the Fin de Siècle*, ed. T. Jefferson Kline and Naomi Schor (Baltimore: Johns Hopkins University Press, 2002), 8, 3, 162, 5.

53. See Matthew Potolsky, *The Decadent Republic of Letters: Taste, Politics, and Cosmopolitan Community from Baudelaire to Beardsley* (Philadelphia: University of Pennsylvania Press, 2013), 1–19.

54. Leela Gandhi, preface to *Collected Poems*, by Nissim Ezekiel, 2nd ed. (New Delhi: Oxford University Press, 2005), xiv–xv.

55. Chinweizu, Onwuchekwa Jemie, and Ihechukwu Madubuike, *Toward the Decolonization of African Literature: African Fiction and Poetry and Their Critics* (London: KPI, 1985), 174.

56. Ibid.,183.

57. Ibid., 209.

58. Ibid., 170, 215–216.

59. Ibid., 188.

60. Michael Thelwell, "Modernist Fallacies and the Responsibility of the Black Writer," in *Duties, Pleasures, and Conflicts: Essays in Struggle* (Amherst: University of Massachusetts Press, 1987), 219–224.

61. Ibid., 223.

62. Ibid., 225.

63. Ibid., 229.

64. Ibid., 219.

65. Oscar Wilde, *The Picture of Dorian Gray* (1891), ed. Joseph Bristow (Oxford: Oxford University Press, 2008), 3.

66. Thelwell, "Modernist Fallacies," 218. The first epigraph, from 1 Corinthians, suggests a certain populist urgency combined with writerly humility. The second, from a 1979 *New York Times* interview with James Baldwin, recognizes the interrelatedness of black literature in the United States with that of Africa and the diaspora, as well as the need to break free from the "arbitrary convention called Europe" as a "frame of reference" for black experience. Thelwell does not provide a source for the quotation from Walcott.

67. Patricia Ismond, "Walcott versus Brathwaite," *Caribbean Quarterly* 17, nos. 3–4 (1971): 54–71. Paul Breslin comments that Walcott's "early poems often affect the language of the alienated poet, which is a legacy of metropolitan avant gardes engaged in critique of middle-class values." Walcott's "adopted idiom" was therefore "incommensurate with the circumstances." Breslin, *Nobody's Nation: Reading Derek Walcott* (Chicago: University of Chicago Press, 2001), 56. As Natalie Melas observes, for some critics, Walcott's "insistence on traditional European forms and on the autonomy of the aesthetic in the very midst of militant critiques of Eurocentrism in the late 1960s and 1970s made him appear as a pre-postcolonial, an assimilationist Ariel figure, an Afro-Saxon seeking salvation on Prospero's terms or from within Prospero's order, rather than in the refusal of an oppositional Caliban." Melas, *All the Difference in the World: Postcoloniality and the Ends of Comparison* (Stanford, CA: Stanford University Press, 2007), 115.

68. In recent decades, the critical tide has turned considerably but not fully. Ato Quayson, for example, argues that if "Achebe, along with other African writers, made gestures towards Modernism, it was not in the form of a mimicry of western forms, but because those forms revealed a sense of things that the African writer felt could be appropriated and cross-mapped onto the African structures of feeling undergoing transformation via the inescapable cultural exchanges with the west." Quayson, "Modernism and Postmodernism in African Literature," in *The Cambridge History of African and Caribbean Literature*, ed. F. Abiola Irele and Simon Gikandi (Cambridge: Cambridge University Press, 2004), 824–825. F. Abiola Irele likewise argues that the "dynamic imparted by Western texts" to African literature represents an "important factor in the historical circumstances of their emergence." What Irele calls "Euro-African intertextuality" and what Homi K. Bhabha and Jahan Ramazani describe as a postcolonial hybridity marked by ambivalence, identification, and resistance can be understood "not as a validating norm but rather an enabling principle in the development of modern African literature." Irele, *The African Imagination* (Oxford: Oxford University Press, 2001), xiv–xv. As Ramazani notes, "Members of a small educated elite, anglophone poets of the Third World are perhaps especially hybridized by their intensive exposure to Western ideas and values through higher education, travel, even expatriation." Ramazani, *The Hybrid Muse: Postcolonial Poetry in English* (Chicago: University of Chicago Press, 2001), 7. Bhabha's elucidation of migrant experience as being "caught in-between a 'nativist,' even nationalist, atavism and a postcolonial metropolitan assimilation," which he discusses in the context of Salman Rushdie's diasporic writing, also helps illuminate the in-between position of these educated poets of the Third World. Bhabha, *The Location of Culture* (London: Routledge, 1994), 321.

69. Agha Shahid Ali, introduction to *The Rebel's Silhouette: Selected Poems*, by Faiz Ahmed Faiz, trans. Agha Shahid Ali (Amherst: University of Massachusetts Press, 1991), xiv.

70. Sherry, *Modernism*, 4.

71. Norman Vance, "Decadence from Belfast to Byzantium," *New Literary History* 35 (2005): 563. Alex Murray, in recovering a tradition of Decadent landscape writing, also notes that "one of the most important factors in the critical neglect of place and location in the study of Decadence is the seeming centrality of temporality to the term, and to its deployment at the fin de siècle." Murray, *Landscapes of Decadence*, 7.

72. Richard Ellmann, "The Uses of Decadence: Wilde, Yeats, Joyce," in *The Ordering Mirror: Readers and Contexts*, ed. Phillip Lopate (New York: Fordham University Press, 1993), 115.

73. Sherry, *Modernism*, 248.

74. Derek Walcott, *White Egrets* (New York: Farrar, Straus and Giroux, 2010), 36; Wole Soyinka, *Death and the King's Horseman*, ed. Simon Gikandi (New York: Norton, 2003), 37.

75. Potolsky, *Decadent Republic*, 1.

76. Liz Constable, Matthew Potolsky, and Dennis Denisoff, introduction to *Perennial Decay: On the Aesthetics and Politics of Decadence*, ed. Liz

Constable, Matthew Potolsky, and Dennis Denisoff (Philadelphia: University of Pennsylvania Press, 1999), 11.

77. George C. Schoolfield, *A Baedeker of Decadence: Charting a Literary Fashion, 1884–1927* (New Haven, CT: Yale University Press, 2003), xiii.

78. Schoolfield's *Baedeker* includes separate chapters on France, Ireland, Italy, Sweden, England, Holland, Norway, Belgium, Poland/Prussia, Finland, Ireland, Austria, Wales, Spain, Germany, Denmark, Australia, the United States, and Iceland.

79. Titles in the series include *The Dedalus Book of English Decadence, The Dedalus Book of Russian Decadence, The Dedalus Book of German Decadence,* and so forth. See also the exclusively French focus of Asti Hustvedt, ed., *The Decadent Reader* (New York: Zone Books, 1998). While Daniel Pick notes in passing that "it would be possible to argue that degeneration must primarily be understood as one intellectual current within a far-wider language of nineteenth-century racist imperialism," his *Faces of Degeneration* considers the intimately linked ideas of decadence and degeneration exclusively within three "national contexts of debate" in separate discussions of France, Italy, and England. Pick, *Faces of Degeneration: A European Disorder, c. 1848–c. 1918* (Cambridge: Cambridge University Press, 1989), 37, 7. David Weir argues that decadence declined in the early part of the twentieth century or was absorbed into the mainstream through Hollywood films. Though Weir acknowledges that postmodernity and multiculturalism may carry some of the decadent movement's anticanonical thrust, his examples stick to Europe and America, with the brief exception of Latin American *Modernismo.* Weir, *Decadence and the Making of Modernism* (Amherst: University of Massachusetts Press, 1995). Important exceptions to this tendency can be found in Potolsky, *Decadent Republic*; Shu-mei Shih, *The Lure of the Modern: Writing Modernism in Semicolonial China, 1917–1937* (Berkeley: University of California Press, 2001); Urmila Seshagiri, *Race and the Modernist Imagination* (Ithaca, NY: Cornell University Press, 2010); and various essays in Constable, Potolsky, and Denisoff, *Perennial Decay*, including Sylvia Malloy, "The Politics of Posing: Translating Decadence in Fin-de-Siècle Latin America," and Hema Chari, "Imperial Dependency, Addiction, and the Decadent Body."

80. Regenia Gagnier, *Individualism, Decadence and Globalization: On the Relationship of Part to Whole, 1859–1920* (New York: Palgrave Macmillan, 2010).

81. Jason David Hall and Alex Murray, *Decadent Poetics: Literature and Form at the British Fin de Siècle* (New York: Palgrave Macmillan, 2013).

82. David Weir, *Decadent Culture in the United States: Art and Literature against the American Grain, 1890–1926* (Albany: State University of New York Press, 2008), xii, xvi.

83. Alex Murray, *Landscapes of Decadence: Literature and Place at the Fin de Siècle* (Cambridge: Cambridge University Press, 2016), 158.

84. As Jahan Ramazani observes, "although creolization, hybridization, and the like are often regarded as exotic or multicultural sideshows to literary histories of formal advancement or the growth of discrete national poetries, these cross-cultural dynamics are arguably among the engines of modern and

contemporary poetic development and innovation." Ramazani, *Transnational Poetics*, 3.

85. Shih, *Lure of the Modern*, 116.

86. Mahoney, *Literature*, 161.

87. See Potolsky, *Decadent Republic*, 1.

88. Susan Stanford Friedman, "Periodizing Modernism: Postcolonial Modernities and the Space/Time Borders of Modernist Studies," *Modernism/Modernity* 13, no. 3 (2006): 425–443.

89. Édouard Glissant, *Poetics of Relation* (1990), trans. Betsy Wing (Ann Arbor: University of Michigan Press, 1997), 24–29.

90. Jessica Feldman, *Victorian Modernism* (Cambridge: Cambridge University Press, 2009); Cassandra Laity, *H.D. and the Victorian Fin de Siècle* (Cambridge: Cambridge University Press, 1996); Sherry, *Modernism*; Weir, *Decadence and the Making of Modernism*; Ronald Bush, "In Pursuit of Wilde Possum: Reflections on Eliot, Modernism, and the Nineties," *Modernism/Modernity* 11, no. 3 (2004): 469–485; Heather K. Love, "Forced Exile: Walter Pater's Queer Modernism," in *Bad Modernisms*, ed. Douglas Mao and Rebecca L. Walkowitz (Durham, NC: Duke University Press, 2006); Benedicte Coste, Catherine Delyfer, and Christine Reynier, eds. *Reconnecting Aestheticism and Modernism: Continuities, Revisions, Speculations* (New York: Routledge, 2016).

91. Eric Keenaghan, "Newly Discrepant Engagements: A Review of Three Recent Works in Modernist Postcolonial Studies," *Journal of Modern Literature* 29, no. 3 (2006): 176–190. See also Ramazani, *Hybrid Muse*; Ramazani, *Transnational Poetics*; Michael Malouf, *Transatlantic Solidarities: Irish Nationalism and Caribbean Poetics* (Charlottesville: University of Virginia Press, 2009); Charles W. Pollard, *New World Modernisms: T. S. Eliot, Derek Walcott, and Kamau Brathwaite* (Charlottesville: University of Virginia Press, 2004); Simon Gikandi, *Writing in Limbo: Modernism and Caribbean Literature* (Ithaca, NY: Cornell University Press, 1992); Peter J. Kalliney, *Commonwealth of Letters: British Literary Culture and the Emergence of Postcolonial Aesthetics* (Oxford: Oxford University Press, 2013); Nathan Suhr-Sytsma, "Ibadan Modernism: Poetry and the Literary Present in Mid-century Nigeria," *Journal of Commonwealth Literature* 48, no. 1 (2013): 41–59.

92. Charles Altieri, "Why Modernist Claims for Autonomy Matter," *Journal of Modern Literature* 32, no. 3 (2009): 2.

93. Gikandi, *Writing in Limbo*, 3. Even Aimé Césaire's *Cahier d'un retour au pays natal*, "one of the most radical gestures in Caribbean literature, is also indebted to, possibly haunted by, the European modernist models it adopts to strike at the foundations of Eurocentrism." Ibid., 21.

94. In addition to Ramazani's works, see Rebecca L. Walkowitz, *Cosmopolitan Style: Modernism beyond the Nation* (New York: Columbia University Press, 2006); and Wai Chee Dimock, *Through Other Continents: American Literature across Deep Time* (Princeton, NJ: Princeton University Press, 2006).

95. Wallace Stevens, "The Noble Rider and the Sound of Words," in *The Necessary Angel: Essays on Reality and the Imagination* (New York: Vintage Books, 1951), 22.

96. Stephen Cushman, *Fictions of Form in American Poetry* (Princeton, NJ: Princeton University Press, 1993), 4–5. Cushman applies his argument to Walt Whitman, Pound, Eliot, William Carlos Williams, and Stevens, though it is more widely applicable beyond American poetry.
97. Agha Shahid Ali, *Ravishing DisUnities: Real Ghazals in English* (Hanover, NH: Wesleyan University Press, 2000), 13.
98. Achebe, *There Was a Country*, 39. Irele, who also attended Ibadan University during this period, confirms Achebe's account. The period leading up to independence was "marked by a powerful release of energies that contributed to the euphoria of the times, a distinct collective feeling that swept the country. We were keenly conscious of being engaged in a historic process; we were recovering the existential initiative that colonial rule had denied us." Irele, *African Imagination*, 180–181.
99. Achebe, *There Was a Country*, 51.
100. Toyin Falola and Saheed Aderinto, *Nigeria, Nationalism, and Writing History* (Rochester, NY: University of Rochester Press, 2010), 239. See also Achebe, *There Was a Country*, 50–51.
101. Achebe, *There Was a Country*, 243.
102. Susan Z. Andrade, "Realism, Receptions, 1968, and West Africa," *Modern Language Quarterly* 73, no. 3 (2012): 308. Andrade's own statement demonstrates how powerfully tropes of decay, waste, and enervation have suffused later considerations of this period.
103. Ibid., 298. The arc of this transition can be traced in Achebe's own fiction. While Achebe's first three novels, *Things Fall Apart* (1958), *No Longer at Ease* (1960), and *Arrow of God* (1964), concerned themselves primarily with what Paul Tiyambe Zeleza calls the "excavation of African cultural traditions and agency from the debris of colonial disorder," his later works, including *A Man of the People* (1966) and *Anthills of the Savanna* (1987), dealt more directly with this postcolonial era of corruption and misrule. Achebe's later novels, Zeleza argues, "sanctified the shift from the literature of protest against the colonial order to the literature of protest against the postcolonial order," instancing what Kwame Anthony Appiah has called the literature of "postoptimism" and "national deligitimation" that emerged with the second wave of postcolonial writing in Africa. Zeleza, "Africa's Struggle for Decolonization: From Achebe to Mandela," *Research in African Literatures* 45, no. 4 (2014): 127; Appiah, "Is the Post- in Postmodernism the Post- in Postcolonial?," *Critical Inquiry* 17, no. 2 (1991): 353.
104. Others included the South African writer Peter Abrahams, the Malian writer Yambo Ouologuem, the Congolese writer V. Y. Mudimbe, the Senegalese writer and film director Sembène Ousmane, the Nigerian writer Wole Soyinka, and the Ghanaian writer Ayi Kwei Armah. See Zeleza, "Africa's Struggle," 127.
105. Afam Ebeogu, "The Spirit of Agony: War Poetry from Biafra," *Research in African Literatures* 23, no. 4 (1992): 35. Robert Fraser likewise comments, "It is against this background of frustrated hopes and growing disillusionment that the poetry of the 1970s has to be seen. . . . The failure of successive governments to actualize the ideals of probity and justice which poets and

novelists still felt a duty to proclaim, begged both explanation and redress. No longer would the facile dreams of 'progress' and 'development'—the pimply optimism of the immediate post-colonial period—pass muster in the face of such a welter of opportunism and apparent incompetence." Fraser, *West African Poetry: A Critical History* (Cambridge: Cambridge University Press, 1986), 274.

106. Though an American edition, *Christmas in Biafra and Other Poems*, was published in 1973, Achebe's *Collected Poems* was not published until 2004 (New York: Anchor Books).

107. Achebe led the Political Orientation Committee that helped write the "Ahiara Declaration," a political document aimed at combatting corruption within the emerging Biafran state apparatus and justifying the "philosophy of the 'Biafran Revolution.'" Its reception was mixed. See John De St. Jorre, *The Brothers' War: Biafra and Nigeria* (Boston: Houghton Mifflin, 1972), 385–386. See also Achebe, *There Was a Country*, 143–149.

108. Achebe, *There Was a Country*, 182–185.

109. Charles H. Rowell, "An Interview with Chinua Achebe," in *Conversations with Chinua Achebe*, ed. Bernth Lindfors (Jackson: University Press of Mississippi, 1997), 181. See Emmanuel Obiechina, "Poetry as Therapy: Reflections on Achebe's *Christmas in Biafra and Other Poems*," *Callaloo* 25, no. 2 (2002): 528.

110. F. Abiola Irele, "Chinua Achebe as Poet," *Transition* 100 (2009): 44. As Nathan Suhr-Sytsma has observed, the choice of a modernist idiom among Anglophone poets of the "Mbari generation" of Nigerian writers, including Okigbo, Clark, and Soyinka, proved controversial, leading to accusations that these writers were adopting the language and literary methods of the colonizers while betraying indigenous traditions. Suhr-Sytsma, "Ibadan Modernism," 41–59.

111. Fanon, *Wretched of the Earth*, 123.

112. Ibid., 177.

113. Sherry, *Modernism*, 2.

114. See W. B. Yeats, *The Trembling of the Veil*, in *The Collected Works of W. B. Yeats*, vol. 3, *Autobiographies*, ed. William H. O'Donnell and Douglas N. Archibald (New York: Scribner, 1999), 219–266.

115. Sherry, *Modernism*, 40.

116. Ibid., 45.

117. Ibid., 202.

118. Achebe, *There Was a Country*, 184.

119. See Conor Cruise O'Brien, "Biafra Revisited," *New York Review of Books*, 22 May 1969. In Achebe's *Collected Poems*, "Mango Seedling" is located and dated "Aba 1968," locating its place of composition in a heavily contested town claimed by Biafra.

120. Achebe, "Mango Seedling," 5.

121. Christopher Okigbo, *Heavensgate*, in *Collected Poems* (London: Heinemann, 1986), 19.

122. Achebe, "Mango Seedling," 5.

123. Wole Soyinka, "Season," in *Idanre and Other Poems* (New York: Hill and Wang, 1967), 45. See also Ebeogu, "Spirit of Agony," 35–36.

124. Soyinka, "Harvest of Hate," in *Idanre*, 50.
125. Soyinka, "Easter," in *Idanre*, 21.
126. Achebe, "Mango Seedling," 6.
127. T. S. Eliot, "Gerontion," in *Collected Poems, 1909–1962* (Orlando, FL: Harcourt, 1991), 29.
128. Ibid., 31.
129. Fanon, *Wretched of the Earth*, 123.
130. See also Philip Rogers, "Chinua Achebe's Poems of Regeneration," *Journal of Commonwealth Literature* 10, no. 3 (1976): 1–9.
131. Chinua Achebe, *Anthills of the Savannah* (New York: Anchor Books, 1987), 68.
132. Ibid., 90.
133. Ibid., 146.
134. Ibid., 91.
135. William Wordsworth, "Intimations of Immortality from Recollections of Early Childhood," in *The Norton Anthology of Poetry*, 5th ed., ed. Margaret Ferguson, Mary Jo Salter, and Jon Stallworthy (New York: Norton, 2005), 798. As Wordsworth writes, "And not in utter nakedness, / But trailing clouds of glory do we come / From God, who is our home: / Heaven lies about us in our infancy!"
136. Achebe, *Anthills*, 146, 91.
137. See Irele, *African Imagination*, 151.
138. Achebe, *Anthills*, 194.
139. Ibid., 204.
140. Ibid., 53.
141. Ibid., 50.
142. See John Keats, "Ode on a Grecian Urn," in Ferguson, Salter, and Stallworthy, *Norton Anthology of Poetry*, 939.
143. Achebe, *Anthills*, 216.

CHAPTER 1 AGHA SHAHID ALI, OSCAR WILDE, AND THE POLITICS OF FORM FOR FORM'S SAKE

1. Oscar Wilde, "Embroidery and Lace," in *The Essays of Oscar Wilde* (New York: Cosmopolitan, 1916), 299. See also Ernest Lefébure, *Embroidery and Lace: Their Manufacture and History from the Remotest Antiquity to the Present Day*, trans. Alan S. Cole (London: H. Grevel and Co., 1888).
2. Agha Shahid Ali, "The Dacca Gauzes," in *The Veiled Suite: The Collected Poems* (New York: Norton, 2009), 42.
3. A 20 September 1881 advertisement from Farmer and Company posted in the *Sydney Morning Herald*, for example, notes under the subtitle "Madras Muslins," "These muslins were first introduced to European purchasers in the Indian Court of the Paris Exhibition, under the poetic names of Abrawan, or 'Running Water'; Bafthowa, or 'Woven Air'; Shubanam, or 'Evening Dew'—names which convey, more than whole pages of description, a correct idea of their surpassing fineness and beauty of texture." The advertisement appears to have run regularly.

4. Ali, "Dacca Gauzes," 42.

5. Ibid., 42–43.

6. Agha Shahid Ali, interview, in *The Verse Book of Interviews*, ed. Brian Henry and Andrew Zawacki (Amherst, MA: Verse, 2005), 139.

7. Agha Shahid Ali, "Reading *The Picture of Dorian Gray* in Kashmir," typescript, 13 September 1982, Agha Shahid Ali Papers, Burke Library, Hamilton College, Clinton, NY.

8. Ananya Jahanara Kabir, "Language and Conflict in the Poetry of Agha Shahid Ali," in *Perspectives on Endangerment*, ed. Graham Huggan and Stephan Klasen (Hildesheim, Germany: Olms, 2006), 203.

9. Ali, "Ghazal," in *Veiled Suite*, 294.

10. Amitav Ghosh, "The Ghat of the Only World: Agha Shahid Ali in Brooklyn," in *Mad Heart Be Brave: Essays on the Poetry of Agha Shahid Ali*, ed. Kazim Ali (Ann Arbor: University of Michigan Press, 2017), 205.

11. See Ruth Vanita and Saleem Kidwai, *Same-Sex Love in India: Readings from Literature and History* (New York: St. Martin's, 2000); Walter G. Andrews and Mehmet Kalpakli, *The Age of Beloveds: Love and the Beloved in Early-Modern Ottoman and European Culture and Society* (Durham, NC: Duke University Press, 2005); and Joseph Allen Boone, *The Homoerotics of Orientalism* (New York: Columbia University Press, 2014).

12. Agha Shahid Ali, introduction to *Ravishing DisUnities: Real Ghazals in English*, ed. Agha Shahid Ali (Hanover, NH: Wesleyan University Press, 2000), 1, 12.

13. Agha Shahid Ali, introduction to *The Rebel's Silhouette: Selected Poems*, by Faiz Ahmed Faiz, trans. Agha Shahid Ali (Amherst: University of Massachusetts Press, 1991), ix–x.

14. Curtis Marez, "The Other Addict: Reflections on Colonialism and Oscar Wilde's Opium Smoke Screen," *ELH* 64, no. 1 (1997): 266.

15. Aamir Mufti, "Towards a Lyric History of India," *boundary* 2 31, no. 2 (2004): 254.

16. Ali, introduction to *Ravishing DisUnities*, 2.

17. Angela Leighton, *On Form: Poetry, Aestheticism, and the Legacy of a Word* (Oxford: Oxford University Press, 2007), 52.

18. Shadab Zeest Hashmi, " 'Who Will Inherit the Last Night of the Past?': Agha Shahid Ali's Architecture of Nostalgia as Translation," in K. Ali, *Mad Heart Be Brave*, 185.

19. Sara Suleri Goodyear, "Ideas of Order in an Afterword," in A. Ali, *Ravishing DisUnities*, 179.

20. Stephen Burt, "Agha Shahid Ali, World Literature, and the Representation of Kashmir," in K. Ali, *Mad Heart Be Brave*, 111, 113.

21. Carol A. Breckenridge, "The Aesthetics and Politics of Colonial Collecting: India at World Fairs," *Comparative Studies in Society and History* 31, no. 2 (1989): 207. For a full account of this cultural phenomenon, see ibid., 195–216. See also Lefébure, *Embroidery and Lace*.

22. Oscar Wilde, *The Picture of Dorian Gray* (1891), ed. Joseph Bristow (Oxford: Oxford University Press, 2008), 117.

23. Ibid., 118.

24. See Nicholas Frankel's annotations in Oscar Wilde, *The Picture of Dorian Gray: An Annotated, Uncensored Edition* (1890), ed. Nicholas Frankel (Cambridge, MA: Harvard University Press, 2011).

25. Anna M. Whistler to R. A. Alexander, 26 August [1872], Department of Prints, British Museum, 1958-2-8-24, quoted in Margaret F. MacDonald, Susan Grace Galassi, Aileen Ribeiro, and Patricia de Montfort, *Whistler, Women, and Fashion* (New Haven, CT: Yale University Press, 2003), 71. See Sonia Ashmore, *Muslin* (London: V&A, 2012), 50.

26. J. Forbes Watson, *The Textile Manufactures and the Costumes of the People of India* (London: George Edward Eyre and William Spottiswoode, 1866), 75. Watson refers to James Taylor's 1851 *Cotton Manufactures of Dacca.*

27. Edward Thornton, *Gazetteer of the Territories under the Government of the East India Company* (London: Wm. H. Allen, 1858), 244.

28. "The Progress of India," *Morning Post,* 16 October 1877, 2, British Newspaper Archive.

29. F.E.W., "Art in India," *Graphic,* 29 March 1884, 311, British Newspaper Archive.

30. As the article details, "The art of producing these fairy-like cobwebs has been in a great measure lost, and whereas a piece of Dacca muslin 15 yards long and one yard wide used to weigh 900 grains and fetch £40 in the market it is now impossible to obtain one weighing less than 1600 grains, and it can be had for £10." Penelope, "Letter to the Ladies: A Visit to the 'Colonies,'" *Dundee Evening Telegraph,* 19 June 1886, 2, British Newspaper Archive.

31. Quoted in Betsy Hartmann and James K. Boyce, *A Quiet Violence: View from a Bangladesh Village* (London: Zed Books, 1983), 13. Despite some disagreements in recent scholarship about the exact extent and nature of the damage done to the Indian textile industry by British policy, there is no doubt that the East India Company imposed harsh conditions on the weavers and that by the middle of the nineteenth century, a narrative of industrial decline had set in on both sides. See Ruma Chatterjee, "Cotton Handloom Manufactures of Bengal, 1870–1921," *Economic and Political Weekly* 22, no. 25 (1987): 988–997.

32. Hartmann and Boyce, *Quiet Violence,* 13.

33. Tapas Chakraborty, "Found: Raj-Razed Town," *Calcutta Telegraph,* 8 December 2008.

34. See Regenia Gagnier, *Idylls of the Marketplace: Oscar Wilde and the Victorian Public* (Stanford, CA: Stanford University Press, 1986), 64–67.

35. Wilde, "Embroidery," 308.

36. Clementina Black, "Something about Needle-Women," *Woman's World* (1888; repr., New York: Source Book, 1970), 301–302.

37. Charlotte O'Conor-Eccles, "Some Irish Industries: I.—The Poplin Weavers of Dublin," ibid., 399.

38. Dorothea Roberts, "Some Irish Industries: II.—The Knitters of the Rosses," ibid., 405.

39. E. Betham-Edwards, "The Lace-Makers of Le Puy," ibid., 550–551.

40. Quoted in Ruma Chatterjee, "Cotton Handloom Manufactures of Bengal, 1870–1921," *Economic and Political Weekly* 22, no. 25 (1987): 992. As Chatterjee recounts, "The patent poverty of the weavers and ruin of artisan manufacturers had moved high-ranking officials in the government during the

last decade of the nineteenth century. More important than the paternalistic care of the government was the effort of some officials lining up with the new aesthetic movement in England."

41. Oscar Wilde, "The Young King," in *"A House of Pomegranates," "The Happy Prince," and Other Tales* (London: Methuen, 1908), 7–11.

42. Anne Markey, *Oscar Wilde's Fairy Tales: Origins and Contexts* (Sallins: Irish Academic Press, 2015), 152.

43. Mao argues that the passage from aestheticism and decadentism to modernism was marked in part by the transition from an ethos of aesthetic consumption to a focus on the production of lasting cultural monuments. As Mao argues, "modernism defines itself in part by rejecting aestheticism's foundational claim that a life well lived can be oriented primarily toward consumption, where such an orientation could mean anything from devotion to the sheer experience of the fleeting present (Pater) to professions of self-realization through flamboyant acquisition (Wilde)." While Mao provides crucial insight into how the modernists saw their own project, the idea that aestheticism was founded solely on an ethos of consumption tells only half the story and too readily accepts the misconceptions that the modernists promulgated about aestheticism to differentiate themselves from the earlier movement. Mao, *Solid Objects: Modernism and the Test of Production* (Princeton, NJ: Princeton University Press, 1998), 18.

 Regenia Gagnier locates the defining feature of Wilde's aestheticism not in the aesthete's lust for acquisition but in the audience's consumption of the aesthete's work. Per Guy Debord and Jean Baudrillard, Gagnier argues that "the engagement of aestheticism . . . was grounded in the beginnings of modern spectacular and mass society and depended upon image and advertising." That is, the politics of consumption underlying Wilde's aestheticism was to be found in the manipulation of audiences, in the commercialization of genius, and in the marketing of talent. In this sense, Wilde's praise for the qualities of fine goods such as the Dacca gauzes could be seen as a repetition of the language used by merchants or exhibitors to advertise such goods, rendering his own novel a kind of advertisement for itself as a literary commodity of the same quality. Gagnier, *Idylls*, 8–11.

44. Oscar Wilde, "Pen Pencil and Poison," in *The Artist as Critic: Critical Writings of Oscar Wilde*, ed. Richard Ellmann (Chicago: University of Chicago Press, 1969), 324; Wilde, "The Critic as Artist," ibid., 396. See also Mao, *Solid Objects*, 19–20, 35.

45. Wilde, "The Soul of Man under Socialism," in *Artist as Critic*, 268. See also Gagnier, *Idylls*, 29.

46. Wilde, "The Beauties of Bookbinding," in *Essays*, 281.

47. Ibid. The example of bookbinding was of crucial importance for a range of aesthetically minded writers such as William Morris, Wilde, Aubrey Beardsley, John Gray, and W. B. Yeats, among others. Carolyn Lesjak has extensively argued that "renewed attention to [Wilde's] notion of use . . . shows him more firmly placed as a fellow-traveler of sorts whose work represents a continuation of the English socialist project of the 1880s, and especially of William Morris." Moreover, "Art is defined by Morris as the expression of pleasure in labor, and his utopia in *News from Nowhere* is one of artisans. Oscar

Wilde provides a counter-narrative to Victorian conventions by imagining, also through Art, an expanded notion of needs and use which privileges pleasure and the imagination over utility. What their utopian visions share is the premise that alienated labor results in an alienation from the very objects of human production." Lesjak, "Utopia, Use, and the Everyday: Oscar Wilde and a New Economy of Pleasure," *ELH* 67, no. 1 (2000): 180.

48. Wilde, "Embroidery," 293. Leighton notes that the impetus for this idea goes back to Schiller: "Herein, then, resides the real secret of the master in any art: that he can make his form consume his material." However, as Leighton points out, for Schiller, the idea of material is more closely related to the idea of subject matter. Leighton, *On Form*, 6.

49. Wilde, "Critic as Artist," 398.

50. I disagree with Marez's argument that "for Wilde, non-Western ornament could serve as raw material inspiring the artist-critic, but it could not itself be classified as art." Marez, "Other Addict," 266.

51. Wilde, "Critic as Artist," 396, 399.

52. Wilde, letter to the *Scots Observer*, 9 July 1890, in *Artist as Critic*, 247.

53. Wilde, *Picture of Dorian Gray*, 13.

54. Ibid., 5.

55. Wilde, "Critic as Artist," 399.

56. Benjamin argued that the notion of "taste" associated with *l'art pour l'art* reflects the poet's loss of contact with the means of production in a society where the "profane glimmer" of the commodity displaces direct contact with the artisan, alienating the poet from "the people." "In *l'art pour l'art*," Benjamin argues, "the poet for the first time faces language the way the buyer faces the commodity on the open market." See Benjamin, "The Paris of the Second Empire in Baudelaire," in *Selected Writings*, vol. 2, *1927–1934*, trans. Rodney Livingstone et al., ed. Michael W. Jennings, Howard Eiland, and Gary Smith (Cambridge, MA: Harvard University Press, 1999), 64–65.

57. Again, I disagree with Marez, who attacks Wilde's promotion of taste as symptomatic of his Orientalism, arguing that the "taste for exotica that Wilde helped disseminate . . . ultimately reinforced the forms of objectification which Fanon argued are the preconditions for colonial exploitation." Marez, "Other Addict," 282. I would argue that it was Wilde's knowing and conspicuous refusal to appease popular taste that ironically made him so popular and so subversive to begin with.

58. Wilde, "The Decay of Lying," in *Artist as Critic*, 303–304.

59. Ibid., 303. Wilde refers specifically to the example of modern tapestry in this instance.

60. Ali, "Dacca Gauzes," 42.

61. Ali, "Reading *The Picture of Dorian Gray* in Kashmir"; Ali, "Reading *Dorian Gray* in Kashmir," typescript, 19 May 1983; Ali, "The Dacca Gauzes," typescript, n.d., all in Ali Papers.

62. Kinnell read and commented on the entire manuscript of *The Half-Inch Himalayas*. He also suggested the alternative title "The Dacca Muslins." Ali, "Reading *Dorian Gray* in Kashmir."

63. As Ali explains, "Dacca is the capital of Bangladesh, and an interesting connection: well, they used to make this very fine cotton there. And you could establish the authenticity of this cloth by pulling an entire sari, six yards long—you know those saris are those things Indian women wrap around them, six yards long, forty-two inches wide usually—and you can pull the entire thing through a ring, through a finger ring. That's how you know what the cloth is and how soft it is. This industry was destroyed by the British in a rather horrific manner. This cloth was also worn, this particular, there was a dress made of this cloth worn by Pocahontas in the court of King James. Isn't that nice, so an interesting connection between subcontinental history and American history, apart from the Boston Tea Party, since the tea was from India, you know. All that wonderful tea. . . . There was a reference to this cloth in *The Picture of Dorian Gray*." Agha Shahid Ali, "The Dacca Gauzes," video and transcript of reading, Westminster College, 6 March 1997, The Beloved Witness Project, Ali Papers.

64. Ali, "Reading *The Picture of Dorian Gray* in Kashmir."

65. Ali, "Dacca Gauzes," typescript.

66. Ali, "A History of Paisley," in *Veiled Suite*, 218.

67. As Jahan Ramazani comments, the "sequence of images and enjambments [verbally evoke] the flowing texture of the gauzes." At the same time, the atrocities allegedly committed by the British in order to prevent competition with their own textile industry represent a moral and geographic tear in the fabric of empire, a reminder that modernity "dismembers" in more ways than one, severing "thumbs from hands, parents from children, soft fabric from coarse." Ramazani, *A Transnational Poetics* (Chicago: University of Chicago Press, 2009), 124.

68. Ali, "Dacca Gauzes," 42.

69. Ibid., 43.

70. Wilde, "Embroidery," 293.

71. Ali, "After Seeing Kozintsev's *King Lear* in Delhi," in *Veiled Suite*, 50.

72. Ibid.

73. Frances W. Pritchett, *Nets of Awareness: Urdu Poetry and Its Critics* (Berkeley: University of California Press, 1994), xv, 46. See also Aamir R. Mufti, *Forget English! Orientalism and World Literatures* (Cambridge: Harvard University Press, 2016), 138–145.

74. Ibid., 137.

75. Ibid., 39.

76. As Pritchett points out, though Azad's groupings are full of inconsistencies, his overall concept echoes a number of prior theories of poetic and historical decline, both European and Islamic. These include Wordsworth's appendix on "Poetic Diction" in the 1802 *Lyrical Ballads*, which argued that while the "earliest poets of all nations generally wrote from passion excited by real events, naturally, and as men," later poets "set themselves to a mechanical adoption of these figures of speech, and . . . frequently applied them to feelings and thoughts with which they had no natural connection." Azad's

ideas also evoke Ibn Khaldun's Islamic "vision of hardy warriors coming in from the desert, taking over the city, and gradually, irresistibly, being softened and transformed by urban luxury over several generations—until they fall prey to some new band of hardy warriors from the desert." Ibid., 128–133.

77. Ibid., 147.

78. Ibid., 160–161.

79. Ibid., xvi.

80. While the "British antisodomy law of 1860 was progressive in Britain insofar as it reduced the punishment for sodomy from execution to ten years' imprisonment," in India, which had no laws against sodomy, the 1861 law marked a retrogressive step, one that spurred the disavowal of the long-standing tradition of same-sex desire in Indian writing. Ruth Vanita and Saleem Kidwai, *Same-Sex Love in India: Readings from Literature and History* (New York: St. Martin's, 2000), 194–195.

81. Ibid., 197.

82. Ibid., 201.

83. Ibid., 201–202.

84. Ibid., 200.

85. Pritchett, *Nets of Awareness*, 122.

86. Ibid., 167.

87. Faiz Ahmed Faiz, "Thoughts on the Future of *Ghazal*," in *Culture and Identity: Selected English Writings of Faiz*, ed. Sheema Majeed (Karachi: Oxford University Press, 2005), 216. This essay was originally published in *Viewpoint* (Lahore), 7 September 1983. The *Sonora Review* published a special feature on Faiz, which included a reprint of this essay under the title "Future of Ghazal Poetry": *Sonora Review* 8 (1985): 53–55.

88. Faiz, "Thoughts on the Future of *Ghazal*," 214.

89. Ibid., 216.

90. Faiz, "A Conversation with Faiz Ahmed Faiz," interview by Muzaffar Iqbal, *Pakistani Literature* 1, no. 1 (1992): 30.

91. Faiz, "The Literary Heritage of Pakistan," in *Culture and Identity*, 144.

92. Faiz, "A Conversation with Faiz Ahmed Faiz," 28.

93. Ibid., 25.

94. Mulk Raj Anand et al., "Manifesto of the Indian Progressive Writers' Association, London," *New Left Review*, February 1936.

95. Faiz, "Poetry and Sense," in *Culture and Identity*, 210.

96. Faiz, "Cultural Problems in Underdeveloped Countries," in *Culture and Identity*, 34–35.

97. Faiz, "Problems of National Art and Culture," in *Culture and Identity*, 108–109.

98. Ibid., 99.

99. Ibid., 83–84.

100. Ibid., 84–85.

101. Faiz, "Major Literary Questions," in *Culture and Identity*, 188–189.

102. Ibid., 189.

103. Faiz, "What is the Role of International Exchange," in *Culture and Identity*, 65.

104. Faiz, "Major Literary Questions," 189.
105. Faiz, "Iqbal—The Poet," in *Culture and Identity*, 171.
106. Faiz, "Iqbal," in *Culture and Identity*, 182.
107. Faiz, "Thoughts on the Future of *Ghazal*," 213.
108. Victor Kiernan agrees that though Ghalib proves a "shrewd, whimsical person, often modern-minded and with a fund of good sense" in his letters, he wrote "in the twilight of the Mughals, and his verse reflects their decline and fall, experienced through the medium of his private disappointments." Kiernan, "Persian Poetry and Its Cosmopolitan Audience," in *Urdu and Muslim South Asia: Studies in Honour of Ralph Russell*, ed. Christopher Shackle (Oxford: Oxford University Press, 1991), 17.
109. Faiz, "Thoughts on the Future of *Ghazal*," 215.
110. Suleri Goodyear, "Ideas of Order," 180.
111. Ali, introduction to *Ravishing DisUnities*, 3.
112. Ibid., 1.
113. Ali's hybrid poems—"orthodox" ghazals written in English—become, as Malcolm Woodland writes, "acts of cultural translation that could unsettle the most deeply embedded assumptions of Western aesthetics and culture, as well as those of the ghazal tradition." Woodland, "Memory's Homeland: Agha Shahid Ali and the Hybrid Ghazal," *ESC: English Studies in Canada* 31, nos. 2–3 (2005): 255.
114. Ali, introduction to *Ravishing DisUnities*, 6, 12.
115. Ibid., 12; Faiz, "Thoughts on the Future of *Ghazal*," 212.
116. Wilde, *Picture of Dorian Gray*, 3.
117. Ali, "Ghazal," in *Veiled Suite*, 297.
118. Wilde, *Picture of Dorian Gray*, 3.
119. Wilde, "Critic as Artist," 398.
120. Edward W. Said, "Reflections on Exile," in *Reflections on Exile and Other Essays* (Cambridge, MA: Harvard University Press, 2000), 174–175.
121. As Steven Cordova writes, "It's no secret the poet Agha Shahid Ali was gay. Though his sexuality is hinted at only occasionally in his poems, Shahid, on a personal level, was always open about his gayness." Cordova, "The Rhyming Dictionary, Leather Porn & Barbara Streisand's 'Evergreen': My Week with Agha Shahid Ali," *Lambda Literary*, 20 May 2012. Likewise, Hoshang Merchant writes, "There are two personal facts about Agha Shahid Ali that should interest anyone who loves his poetry: that he was a Kashmiri and that he was gay. To ignore either fact is to ignore the man and the meaning of his poetry." Merchant, "Agha Shahid Ali's Kashmir and the Gay Nation," in *The Phobic and the Erotic: The Politics of Sexualities in Contemporary India*, ed. Brinda Bose and Subhabrata Bhattacharyya (London: Seagull, 2007), 465. When Ali was asked about his coming-out process by Eric Gamalinda, however, he replied, "I don't want to go too much into that . . . because first of all I don't want it to be the central element of my identity as a poet. And secondly, well, it doesn't interest me as a poet, except when it inadvertently appears in my poetry, the way God may appear, or love may appear, or childhood may appear, or anything." Gamalinda, "Poems Are Never Finished: A Final Interview with Agha

Shahid Ali," *Poets and Writers*, February 2002, 48. Akshaya K. Rath detects traces of Wilde's lover Lord Alfred Douglas's notion of "the love that dare not speak its name" in Ali's ghazal "In Real Time," arguing, "Such hidden points of intersection among identity/existence, society, religion and life/existence, and ethnicity and sexuality are apt instances of framing a coded language to perform the closet." Rath, "Agha Shahid Ali's Kashmiri Poetry," *Kavya Bharati* 22 (2010): 161.

122. Ali, introduction to *Rebel's Silhouette*, xiv.
123. Ibid., xix.
124. Ali, interview, in *Verse Book of Interviews*, 141. Christine Benvenuto notes, "Fidelity to any single aesthetic, and in particular to the William Carlos Williams–inspired minimalism he felt dominated recent American verse, was utterly foreign to Ali's concerns as a poet." Benvenuto, "Agha Shahid Ali," *Massachusetts Review* 43, no. 2 (2002): 265.
125. Ali, introduction to *Rebel's Silhouette*, xiv.
126. Agha Shahid Ali, "Love in Ruins," *Nest*, Summer 1999.
127. Ali, introduction to *Rebel's Silhouette*, ix.
128. Ibid., ix–x.
129. Ibid., xxii.
130. Most of the rest of the interview was later published in edited form. See Agha Shahid Ali, "Agha Shahid Ali: The Lost Interview," interview by Stacey Chase, *The Cafe Review*, Spring 2011.
131. Agha Shahid Ali, interview transcript, n.d., Ali Papers.
132. Ali, "For You," in *Veiled Suite*, 327.
133. Ibid.
134. Mahwash Shoaib, "'The Grief of Broken Flesh': The Dialectic of Desire and Death in Agha Shahid Ali's Lyrics," in K. Ali, *Mad Heart Be Brave*, 171, 176.
135. Ali, "About Me," in *Veiled Suite*, 353.
136. Ali, "Land," ibid., 347.
137. Ali, "Even the Rain," ibid., 282.
138. Ali mourns the loss of a friend to AIDS in his elegy "In Search of Evanescence," in *Veiled Suite*, 121–135.
139. Pritchett lists a number of the "supporting characters proper to a love affair" in ghazal poetry, including "the lover's confidant, his messenger, his rivals; the beloved's door-guard; the *saqi* who pours the wine; the fellow drinkers; the ostentatiously pious *shaikh*; archetypal earlier lovers like Majnun; and so on. This whole universe exists in the consciousness of the ghazal knower—who constructs it by reading or hearing verses, and constantly refines it by reading or hearing yet more verse." Pritchett, *Nets of Awareness*, 90. Kiernan also notes how the ambiguities of the earlier Persian ghazal, such as those of Hafiz, were such that "wine, God, universe, girl, or youth, were interchangeable, a fact which made poetry equivocal enough to slip through the meshes of political or ecclesiastical censorship." Later, "Urdu inherited the familiar forms of expression, but the imagery of love had less to do now with a heavenly Comforter, more with the Saqi." See Kiernan, "Persian Poetry," 14, 16.

140. Ali, "Ghalib's Ghazal," in *Veiled Suite*, 270.

141. Ali, "Ghazal," ibid., 297.

142. One of Ali's notebooks contains a full-page quotation from Joseph Campbell and Bill Moyers's *The Power of Myth* on the subject of Iblis or Satan as the lover of God. Ali, notebook, Ali Papers. Kiernan also notes how Sufi traditions employed the concept of the "divine Lover" to disguise forbidden expressions of romantic love. See Kiernan, "Persian Poetry," 14. Khaled Mattawa likewise highlights Ali's use of heretical and traditional Islamic themes to "promote tolerance and understanding." Mattawa, "Writing Islam in Contemporary American Poetry: On Mohja Kahf, Daniel Moore, and Agha Shahid Ali," *PMLA* 123, no. 5 (2008): 1595.

143. Ali, "In Arabic," in *Veiled Suite*, 372.

144. Ali, "From the Start," ibid., 340; Ali, "Angel," ibid., 341–342.

145. Ali, "God," ibid., 368.

146. Ali, "About Me," ibid., 353.

147. Hashmi, "Who Will Inherit," 185. See also Mufti, *Forget English!*, 194.

148. Matthew Stadler, "Dance with Buatta," *Nest*, Fall 1998.

149. Ali, "Rooms Are Never Finished," in *Veiled Suite*, 279.

150. As Ali remarked before a reading of the poem, "I was looking [at materials sent by Stadler] and one of the designers said 'well, you know, rooms are never finished.' And I said oh, 'Rooms are never finished, that could be the title of this poem.' So I wrote down rooms are never finished and then, the other designer said 'many of my favorite things are broken.' And I said, 'Aha, that could be the epigraph of my poem.'" Agha Shahid Ali, reading and transcript, Baruch College, 2001, The Beloved Witness Project, Ali Papers.

151. Ibid.

152. Amy Newman aptly calls the invented form a "flirtation with the infinite," though she does not identify Ali's reworking of his own ghazal into the body of the poem. Newman, " 'Separation's Geography': Agha Shahid Ali's Scholarship of Evanescence," in K. Ali, *Mad Heart Be Brave*, 84.

153. As the Victoria and Albert Museum notes, "['Chintz'] now means a cotton or linen furnishing fabric of floral pattern stained with fast colours and made anywhere, but it originally referred only to colour-fast, light, cotton fabrics made in India for the English market. Chintz production was a very complex process involving painting, mordanting (fixing a dye), resisting and dyeing depending on the colour being used. Different colours required different processes. The original chintz designs were hand-painted and resist-dyed but block-printed designs were incorporated later." "Introduction to Indian Textiles," Victoria and Albert Museum, 2016, www.vam .ac.uk/content/articles/i/indian-textiles-introduction/.

154. Ali, "Rooms Are Never Finished," 279–280.

155. Ibid., 279.

156. T. S. Eliot, "The Love Song of J. Alfred Prufrock," in *Collected Poems, 1909–1962* (Orlando, FL: Harcourt, 1991), 3.

157. Agha Shahid Ali, "Agha Shahid Ali on T. S. Eliot," in *Poetry Speaks Expanded*, ed. Elise Paschen and Rebekah Presson Mosby (Naperville, IL: Sourcebooks, 2007), 114.

158. Ali, "Rooms Are Never Finished," 279.
159. Gerard Manley Hopkins, "The Candle Indoors," in *Poems*, ed. W. H. Gardner (New York: Oxford University Press, 1948), 89; T. S. Eliot, *The Waste Land*, in *Collected Poems*, 64.
160. Hopkins, "The Candle Indoors," 90.
161. Joris-Karl Huysmans, *Against Nature (À rebours)* (1884), trans. Robert Baldick (London: Penguin Books, 2003), 21.
162. Ali, "Rooms Are Never Finished," 280.
163. Wilde, *Picture of Dorian Gray*, 114.
164. As Rosaldo defines it, "Imperialist nostalgia revolves around a paradox: A person kills somebody, and then mourns the victim. In more attenuated form, someone deliberately alters a form of life, and then regrets that things have not remained as they were prior to the intervention. At one more remove, people destroy their environment, and then they worship nature. In any of its versions, imperialist nostalgia uses a pose of 'innocent yearning' both to capture people's imaginations and to conceal its complicity with often brutal domination." Renato Rosaldo, *Culture and Truth: The Remaking of Social Analysis* (Boston: Beacon, 1989), 69–70.
165. Ali, "Rooms Are Never Finished," 280.
166. John Keats, "Ode on a Grecian Urn," in *The Norton Anthology of Poetry*, 5th ed., ed. Margaret Ferguson, Mary Jo Salter, and Jon Stallworthy (New York: Norton, 2005), 238–239.
167. W. B. Yeats, "Easter 1916," in *The Collected Poems of W. B. Yeats*, 2nd ed., ed. Richard J. Finneran (New York: Scribner, 1996), 181.
168. Ali, "In," in *Veiled Suite*, 360.
169. Ali, "Rooms Are Never Finished," 279.
170. Ali, "In," 359.
171. Ibid., 360.
172. Ali, "Rooms Are Never Finished," 280.
173. Ibid., 279.
174. Ibid.
175. Ibid., 281.
176. The essay is based on a lecture Ali gave in 1998 at Warren Wilson College. Around the edges of the typescript, one finds jottings of Ali's thoughts on Eliot, Ashbery, Said, and others he incorporates into the essay. Agha Shahid Ali, "Rooms Are Never Finished," typescript, n.d., Ali Papers.
177. Agha Shahid Ali, "A Darkly Defense of Dead White Males," in *Poet's Work, Poet's Play: Essays on the Practice and the Art*, ed. Daniel Tobin and Pimone Triplett (Ann Arbor: University of Michigan Press, 2008), 144.
178. See Noam Chomsky, *Year 501: The Conquest Continues* (1993; Chicago: Haymarket Books, 2015), 13–19.
179. Ali, "Darkly," 155.
180. Virginia Jackson describes lyricization as the historical development of an interpretive reading practice whereby "various modes of poetic circulation," including original sites of publication, "tended to disappear behind an idealized scene of reading progressively identified with an idealized

moment of expression." Jackson, *Dickinson's Misery: A Theory of Lyric Reading* (Princeton, NJ: Princeton University Press, 2013), 7.

181. Shaden M. Tageldin includes an excellent discussion of Ali's use of broken ghazal forms in the poem "Butcher" to demonstrate an apposite rift in social relations. Tageldin, "Reversing the Sentence of Impossible Nostalgia: The Poetics of Postcolonial Migration in Sakinna Boukhedenna and Agha Shahid Ali," *Comparative Literature Studies* 40, no. 2 (2003): 232–264.

182. Ali, "Rooms Are Never Finished."

183. For an incisive account of Ali's poetic response to conflict in Kashmir, see Stephen Burt, "Agha Shahid Ali, World Literature, and the Representation of Kashmir," in K. Ali, *Mad Heart Be Brave*, 104–117.

184. Agha Shahid Ali, "A Poetic Response," *Indian Design & Interiors*, February–March 1999.

185. Agha Shahid Ali, *T. S. Eliot as Editor* (Ann Arbor: UMI Research Press, 1998), 53–57. Ali's account relies substantially on Denis Donoghue, "Eliot and the *Criterion*," in *The Literary Criticism of T. S. Eliot*, ed. David Newton-de Molina (London: Athlone Press, 1977), 20–41.

186. Ali, *T. S. Eliot as Editor*, 144.

187. Ibid., 145; "The Criterion," *The Times Literary Supplement*, April 24, 1968, 430.

188. Ali, *T. S. Eliot as Editor*, 144. As Ali and Donoghue note, Eliot's misreading of the *Bhagavad Gita* to justify his neutrality in political matters only fueled his political and critical paralysis. Ibid., 130. See Donoghue, "Eliot and the *Criterion*," 26–28.

189. Ali, *T. S. Eliot as Editor*, 145; Georg Lukács, *The Theory of the Novel* (Cambridge, MA: MIT Press, 1973), 11.

190. Ali, introduction to *Ravishing DisUnities*, 12.

191. Ibid., 13.

192. Ali, *T. S. Eliot as Editor*, 148.

193. Nida Sajid, "The Transnational Cartography of Agha Shahid Ali's Poetry," *Rocky Mountain Review* 66, no. 2 (2012): 88.

194. Ali, "History of Paisley," 218–219.

CHAPTER 2 DECADENCE AND THE VISUAL ARTS IN DEREK WALCOTT'S WEST INDIES

1. Derek Walcott, "A Dilemma Faces W. I. Artists," in *The Journeyman Years: Occasional Prose, 1957–1974*, vol. 1, *Culture, Society, Literature, and Art*, ed. Gordon Collier (Amsterdam: Rodopi, 2013), 69.

2. See Paul Breslin, *Nobody's Nation: Reading Derek Walcott* (Chicago: University of Chicago Press, 2001), 19–20.

3. Arthur Symons, "The Decadent Movement in Literature," *Harpers New Monthly Magazine*, November 1893, 858–859; Walcott, "Dilemma Faces W. I. Artists," 69.

4. Tejumola Olaniyan, "Derek Walcott: Liminal Spaces / Substantive Histories," in *Caribbean Romances: The Politics of Regional Representation*, ed. Belinda Edmondson (Charlottesville: University of Virginia Press, 1999), 210.

5. Walcott, "Dilemma Faces W. I. Artists," 69.

6. Ibid.

7. Ibid., 70.

8. See Michael Thelwell, "Modernist Fallacies and the Responsibility of the Black Writer," in *Duties, Pleasures, and Conflicts: Essays in Struggle* (Amherst: University of Massachusetts Press, 1987), 218–232, as discussed in the introduction to this book.

9. Derek Walcott, *Tiepolo's Hound* (New York: Farrar, Straus and Giroux, 2000).

10. As Mary Lou Emery points out, Walcott, like many other Caribbean writers, "addressed colonial relations" not just as a matter of language but as "inextricably bound to concepts and practices of seeing." Caribbean writers, as Emery points out, often appropriate modernist visual aesthetics to stage the "dilemma of colonial imitation." Emery, *Modernism, the Visual, and Caribbean Literature* (Cambridge: Cambridge University Press, 2007), 180.

11. Derek Walcott, "Ruins of a Great House," in *Collected Poems, 1948–1984* (New York: Farrar, Straus and Giroux, 1986), 19.

12. Derek Walcott, "The Lost Empire," in *White Egrets* (New York: Farrar, Straus and Giroux, 2010), 36.

13. Derek Walcott, "North and South," in *Collected Poems*, 405.

14. Derek Walcott, "The Muse of History," in *What the Twilight Says: Essays* (New York: Farrar, Straus and Giroux, 1998), 37–38.

15. Ibid., 42.

16. Ann Laura Stoler, "Imperial Debris: Reflections on Ruins and Ruination," *Cultural Anthropology* 23, no. 2 (2008): 193.

17. Derek Walcott, *Omeros* (New York: Farrar, Straus and Giroux, 1990), 20.

18. Derek Walcott, *Another Life*, in *Collected Poems*, 226.

19. Walcott, *Omeros*, 205.

20. Walcott, "Lost Empire," 37.

21. Derek Walcott, "In Italy," in *White Egrets*, 27.

22. Derek Walcott, "Piano Practice," in *Collected Poems*, 403.

23. Jules Laforgue, "L'Impressionnisme," in *Oeuvres complètes de Jules Laforgue, mélanges posthumes* (Paris: Société du Mercure de France, 1903), 133–134. See also Linda Nochlin, *The Politics of Vision: Essays on Nineteenth-Century Art and Society* (New York: Harper and Row, 1989), 62.

24. Walcott, "Piano Practice," 404.

25. Heather K. Love, "Forced Exile: Walter Pater's Queer Modernism," in *Bad Modernisms*, ed. Douglas Mao and Rebecca L. Walkowitz (Durham, NC: Duke University Press, 2006), 22.

26. See Dipesh Chakrabarty, *Provincializing Europe: Postcolonial Thought and Historical Difference* (Princeton, NJ: Princeton University Press, 2000), 3.

27. Walcott, "Piano Practice," 403.

28. Ibid., 404.

29. Clara Rosa De Lima, "Walcott: Painting and the Shadow of Van Gogh," in *The Art of Derek Walcott*, ed. Stewart Brown (Chester Springs, PA: Dufour Editions, 1991), 184.

30. George B. Handley, *New World Poetics: Nature and the Adamic Imagination of Whitman, Neruda, and Walcott* (Athens: University of Georgia Press, 2007), 319.

31. Oscar Wilde, "The Decay of Lying," in *The Artist as Critic: Critical Writings of Oscar Wilde*, ed. Richard Ellmann (Chicago: University of Chicago Press, 1969), 311.

32. Derek Walcott, "The Art of Poetry," interview with Edward Hirsch, in *Critical Perspectives on Derek Walcott*, ed. Robert D. Hamner (Boulder, CO: Lynne Rienner, 1993), 68.

33. Handley, *New World Poetics*, 329.

34. Until these articles were collected in two hefty volumes in 2013, one had to scroll through dozens of reels of microfilm to find them, as I and a research assistant once tried to do. It is only now that we can begin to sketch their significance for Walcott's development as both an artist and a critic. Thanks to my research assistant Daniel Bell for his assistance in this matter.

35. See Breslin, *Nobody's Nation*, 36.

36. Derek Walcott, "What the Twilight Says," in *What the Twilight Says*, 24.

37. Derek Walcott, "Type Faces," in *Journeyman*, vol. 1, 514.

38. Ibid., 510.

39. Sharon Ciccarelli, "Reflections before and after Carnival: An Interview with Derek Walcott," in *Conversations with Derek Walcott*, ed. William Baer (Jackson: University Press of Mississippi, 1996), 39–40. Like many other West Indian writers at the time, Walcott published his early poetry with a London firm, Jonathan Cape, and found a place for his work on programs such as the BBC's *Caribbean Voices*, where, as Peter J. Kalliney has demonstrated, the modernist-trained gatekeepers of the British literary establishment were, fearing their own decline, happy to find new adherents from the colonies. Modernism, in this account, becomes something of a cultural life raft for both sides. See Kalliney, *Commonwealth of Letters: British Literary Culture and the Emergence of Postcolonial Aesthetics* (Oxford: Oxford University Press, 2013).

40. See Breslin, *Nobody's Nation*, 34.

41. Walcott, "Violent Gestures in *Sharpeville*," in *Journeyman*, vol. 1, 451–452.

42. Ibid., 452.

43. Walcott, "Dilemma Faces W. I. Artists," 70.

44. Derek Walcott, "Bacoulou Dancers Typically Antillean," in *The Journeyman Years: Occasional Prose, 1957–1974*, vol. 2, *Performing Arts*, ed. Christopher Balme and Gordon Collier (Amsterdam: Rodopi, 2013), 225.

45. Derek Walcott, "Reflections on the November Exhibition," in *Journeyman*, vol. 1, 397. As Breslin comments, Walcott's early "criticisms show him already concerned that a dualism pitting white and European against black and African influences in West Indian culture will lead to false choices and dishonest art." Breslin, *Nobody's Nation*, 28.

46. Derek Walcott, "Conversation with Derek Walcott—Interviewer Therese Mills," in *Journeyman*, vol. 1, 56.

47. See W. B. Yeats, *The Trembling of the Veil*, in *The Collected Works of W. B. Yeats*, vol. 3, *Autobiographies*, ed. William H. O'Donnell and Douglas N. Archibald (New York: Scribner, 1999), 219–266.

48. Walcott, "Conversation with Derek Walcott—Interviewer Therese Mills," 57.

49. Edmund Wilson, *Axel's Castle: A Study of the Imaginative Literature of 1870–1930* (New York: Modern Library, 1996), 324–325.

50. Walcott, "Dilemma Faces W. I. Artists," 69–70.

51. Walcott, "What the Twilight Says," 24.

52. Derek Walcott, "Who's Afraid of Noël Coward?," in *Journeyman*, vol. 2, 161.

53. Derek Walcott, "Did You See the Australian Ballet or How Could You Afford It," in *Journeyman*, vol. 2, 245.

54. Derek Walcott, "Inside Dope on Hazards of the Literary Race: Archipelagoes Old and New," in *Journeyman*, vol. 1, 348–349.

55. Walter Pater, *The Renaissance* (1873), ed. Adam Phillips (Oxford: Oxford University Press, 1986), xxxii.

56. See Raoul Pantin, *Black Power Day: The 1970 February Revolution: A Reporter's Story* (Santa Cruz, CA: Hatuey, 1990).

57. Walcott has written and rewritten the play many times over. The most widely available text is the version first staged in 1982 and published in *Three Plays* in 1986 (New York: Farrar, Straus and Giroux). An earlier version of the play was first staged in Port of Spain under the title *In a Fine Castle* in 1971. A version of *In a Fine Castle* scripted for television in 1970 is available online from *Black Drama*. That text is based on a script in the archives at Emory University. A typescript notated "Boston, March 25, 1992" can be found in Walcott's papers at the University of Toronto, and a copy was provided to me by the library's staff. This is presumably the version used in the 1992 production in Birmingham in the United Kingdom. There is also a version that Walcott directed that same year in Oslo, and a Norwegian translation was published in 1995 under the title *Det siste karneval*.

 According to Bruce King, many of the novel's themes and ideas may have been recycled from an unpublished novel Walcott submitted to Jonathan Cape in 1952: "The novel, 'A Passage to Paradise,' the title parodying *A Passage to India*, was rejected by Jonathan Cape as disgruntled, violent, adolescent, heavy handed, and offensive to everyone, especially the British administration. . . . The novel viewed white colonials as degenerate, and treated an American Captain badly. . . . Some of the characters and plot situations eventually found their way into *In a Fine Castle* and later *The Last Carnival*. It was a young man's novel about the end of the late colonial era with a decadent plantocracy, upper civil servants, a rogue preacher, adulteries, drunks, limited opportunities, colour awareness, and silent boundaries." King, *Derek Walcott: A Caribbean Life* (Oxford: Oxford University Press, 2000), 96–97. As Breslin notes, "To examine the scripts in the Trinidad archive is to realize that Walcott has generally treated plays as much more fluid texts than poems." Unlike his poems, they "seem endlessly open to expansion, contraction, and tinkering." Breslin, *Nobody's Nation*, 39.

58. Judy S. J. Stone, *Theatre* (London: Macmillan Caribbean, 1994), 116.

59. Eric Roach, *Guardian*, 1 November 1971, quoted ibid. The fact that Walcott himself had described the 1960 film version of *Suddenly Last Summer* as "the full flower of brilliant decadence" must have made Roach's review all the more galling. Derek Walcott [D.W.] "'The Decadence' of Mr. Williams," *Trinidad Guardian*, 1 May 1960, 7. For the relationship between Walcott and Williams, see King, *Derek Walcott*, 250.

60. Edward Baugh, *Derek Walcott* (Cambridge: Cambridge University Press, 2006), 137.

61. Paula Burnett, *Derek Walcott: Politics and Poetics* (Gainesville: University Press of Florida, 2000), 208, 260. Some of the disappointment in later versions stems from the general trajectory of Walcott's revisions. While the 1970 *In a Fine Castle* makes an explicit attempt to grapple with the internal dynamics and racial exclusivity of the Black Power movement, the heavily revised text of *The Last Carnival* puts less direct emphasis on the problem.

62. Wilde, "Decay of Lying," 313.

63. Ibid., 319.

64. See K. R. Ireland, "Aspects of Cythera: Neo-Rococo at the Turn of the Century," *Modern Language Review* 70, no. 4 (1975): 721–730.

65. Kit Andrews, "The Figure of Watteau in Walter Pater's 'Prince of Court Painters' and Michael Field's *Sight and Song*," *English Literature in Transition, 1880–1920* 53, no. 4 (2010): 454–455.

66. Arthur Symons, "For a Picture of Watteau," in *Poems*, vol. 1 (London: William Heinemann, 1919), 76.

67. Derek Walcott, *The Last Carnival*, in *Three Plays* (New York: Farrar, Straus and Giroux, 1986), 17.

68. Walter Pater, *Imaginary Portraits: With* The Child in the House *and* Gaston de Latour (1887; New York: Allworth Press, 1997), 37.

69. Walcott, *Last Carnival*, 17.

70. Charles Baudelaire, "L'invitation au voyage" and "Un voyage à Cythère," original and translation in Charles Baudelaire, *The Complete Verse*, vol. 1, ed. and trans. Francis Scarfe (London: Anvil Press Poetry), 126, 223. Scarfe translates the line from "Un voyage à Cythère" as "But Cythera had now become the most barren of all lands." Ibid., 223.

71. Julie-Anne Plax, "Interpreting Watteau across the Centuries," in *Antoine Watteau: Perspectives on the Artist and the Culture of his Time*, ed. Mary D. Sheriff (Newark: University of Delaware Press, 2006), 36.

72. Derek Walcott, "The Last Carnival," unpublished script, 1992, University of Toronto Library. Baudelaire's original reads "Mon coeur," not "Mon âme." Translation by Scarfe in Baudelaire, "Un voyage à Cythère."

73. Derek Walcott, *Midsummer*, in *Collected Poems*, 481.

74. Walcott, "Muse of History," 42.

75. Baudelaire, "The Beacons," in *The Complete Verse*, 65.

76. Walcott, *Last Carnival*, 17. See also Édouard Glissant, *Poetics of Relation* (1990), trans. Betsy Wing (Ann Arbor: University of Michigan Press, 1997), 24–29.

77. Bridget Brereton, *Race Relations in Colonial Trinidad, 1870–1900* (Cambridge: Cambridge University Press, 1979), 36–37.

78. Walcott, *Last Carnival*, 56. Bruce King notes that the play was partly inspired by the Stollmeyer family of Port of Spain, part of the "local plantocracy" who built a castle "reputed to be a replica of a wing of Britain's Balmoral Castle." See King, *Derek Walcott*, 188; and Stone, *Theatre*, 115. Among the members of this prominent family was a painter, Hugh Stollmeyer, whose work Walcott criticized in the *Guardian* for its "stylish distortions" in the pursuit of novelty and for a "shrillness" and "inner intricacy" that compensated for an "inherent flaccidity of ideas." Derek Walcott, "Hugh Stollmeyer to Put on One-Man Show," in *Journeyman*, vol. 1, 484–485.

79. Oscar Wilde, *The Picture of Dorian Gray* (1891), ed. Joseph Bristow (Oxford: Oxford University Press, 2008), 122.

80. See Urmila Seshagiri, *Race and the Modernist Imagination* (Ithaca, NY: Cornell University Press, 2010), 37.

81. Sarah Phillips Casteel makes a similar argument regarding the way European pastoral landscape painting obscures the colonial subject's view of Europe in both Walcott's and V. S. Naipaul's work: "One of the primary obstacles to vision for Naipaul and Walcott is the set of images and assumptions that I have described as colonial pastoral. Just as Renaissance travelers to the New World arrived with preconceptions about the landscape that hindered their ability to see, so the colonized subject comes to the European landscape with a set of preabsorbed images that cloud his vision. By adopting a critical attitude toward these preabsorbed images, the Caribbean writer becomes able to see the European landscape less allusively." I am more skeptical, however, that Walcott aims to free himself wholly from such allusiveness. Casteel, *Second Arrivals: Landscape and Belonging in Contemporary Writing of the Americas* (Charlottesville: University of Virginia Press, 2007), 33.

82. Walcott, *Last Carnival*, 6–7.

83. Wilde, "Decay of Lying," 311.

84. See Handley, *New World Poetics*, 319.

85. Nochlin, *Politics of Vision*, 64.

86. Jules Antoine Castagnary, "L'Exposition du boulevard des Capucines: Les Impressionnistes," *Le Siècle*, 29 April 1874. Quoted and translated in Richard Shiff, *Cézanne and the End of Impressionism* (Chicago: University of Chicago Press, 1984), 4.

87. Walcott, *Last Carnival*, 19.

88. Arnold makes this assertion in "On Translating Homer" (1862) and then restates and elaborates on it in "The Function of Criticism at the Present Time" (1864). Matthew Arnold, "On Translating Homer" and "The Function of Criticism at the Present Time," in *Essays by Matthew Arnold* (London: Oxford University Press, 1914), 285, 9.

89. Pater, *Renaissance*, xxix.

90. Walcott, *Last Carnival*, 19.

91. Sarah Brouillette has argued that Walcott, like other postcolonial writers, makes a self-conscious display of unmasking such distorted views, a representational strategy she refers to as "strategic exoticism." "Walcott can see 'the people' for what they really are—namely, an expedient fiction. They exist not as reality but as rhetoric, as a functional category for local construc-

tion and contestation." The West Indian artist must therefore appeal to "the people" as a "rhetorical trope, rather than as an essence." Brouillette, *Postcolonial Writers in the Global Literary Marketplace* (New York: Palgrave Macmillan, 2007), 26, 30, 31.

92. Walcott, *Last Carnival*, 16.
93. Michael H. Levenson, *A Genealogy of Modernism: A Study of English Literary Doctrine 1908–1922* (Cambridge: Cambridge University Press, 1984), 115. Ford Madox Hueffer [Ford], "The Poet's Eye—I," *The New Freewoman*, 1 September 1913, 108, available at The Modernist Journals Project, http://modjourn.org.
94. As Martin Green and John Swan recount, in the late seventeenth century, wandering Italian *saltimbanco* troops became the preferred entertainers of the French courts. But "under the protection of the king," they were "cut off from the popular audience that had been their social root." The three figures of Harlequin, Columbine, and Pierrot "are essentially Parisian inventions" developed "to suit the taste of French high society." Later, "after its fall from grace, the commedia dell'arte returned to its wandering state, thereafter to be captured in various stages of gaiety and poignant poverty by Watteau, Tiepolo, Adolphe Roehn, and Daumier." As a result of this painterly tradition, the commedia became an emblem of an artistic practice grown decadent and detached in courtly captivity, wistfully fixed by Watteau at the moment the commedia's actors lost their place as court entertainers. Martin Green and John Swan, *The Triumph of Pierrot: The Commedia dell'Arte and the Modern Imagination* (New York: Macmillan, 1986), 4, 163.
95. Walcott, *Last Carnival*, 46, 43, 42.
96. See Milla Cozart Riggio, "The Carnival Story—Then and Now: Introduction to Part I," in *Carnival: Culture in Action—The Trinidad Experience*, ed. Milla Cozart Riggio (New York: Routledge, 2004), 41–42.
97. Richard Schechner observes that such "multiplicity and contradictory intentions are the hallmark of Trinidad Carnival." Schechner, "Carnival (Theory) after Bakhtin," in Riggio, *Carnival*, 6.
98. As Camilla Stevens writes, "Victor's desire for a moment of 'stillness' and his attempt to replicate a Watteau *tableaux* in a Caribbean context constitutes a static view of a culture that is, in reality, characterized by constant transculturation and change. The cultural heterogeneity, corporeal movement, and ludic subversions of social hierarchies enacted in Trinidadian Carnival frame and ultimately doom Victor's vision." Stevens, "'The Future of Old Trinidad': The Performer of National Cultural Identity in Two Plays by Derek Walcott," *Modern Drama* 46, no. 3 (2003): 455.
99. Green and Swan argue, "In Watteau's hands the traditional coarseness and vulgarity of the Italian originals were transmuted into a refined, wistful playfulness." In such depictions, the commedia came to embody "the self-consciousness of all theater, but theater at its most wistful, most reflective, most sad." By the 1890s, the commedia became a vehicle for the reaction against the Wagnerian and symbolist "enthusiasm for the all-embracing myth" in favor of "fragmentation, irony, parody, play." Green and Swan, *Triumph of Pierrot*, 163, 4, 26. As Arthur Symons said of Laforgue in his poetic

guise as Pierrot, "it is part of his manner not to distinguish between irony and pity, or even belief." Symons, *The Symbolist Movement in Literature* (New York: E. P. Dutton, 1919), 304.

100. Walcott, *Last Carnival*, 57.

101. Matthew Potolsky, "Pale Imitations: Walter Pater's Decadent Historiography," in *Perennial Decay: On the Aesthetics and Politics of Decadence*, ed. Liz Constable, Dennis Denisoff, and Matthew Potolsky (Philadelphia: University of Pennsylvania Press, 1999), 236–237.

102. Ibid., 250–251. See Walter Pater, "Apollo in Picardy," in *Miscellaneous Studies* (London: Macmillan, 1910), 142–171.

103. Walcott, *Last Carnival*, 73.

104. Rita Felski, *The Gender of Modernity* (Cambridge, MA: Harvard University Press, 1995), 97.

105. Walcott, *Last Carnival*, 8.

106. Ibid., 73.

107. Ibid., 50.

108. Ibid., 73.

109. As De Lima comments with regard to Walcott's interest in mad artist figures such as Van Gogh, "To hold passionately to values, beliefs or methods of working which the society one would serve by that work regards as irrelevant, dangerous or downright retrograde is to court a kind of madness. Walcott has always been interested in artists and poets who were regarded as exhibiting such madness because he has always equated the urgent force of his own creative imagination with that kind of obsessive commitment." De Lima, "Walcott," 175.

110. Walcott, *Last Carnival*, 72.

111. Brown's speech almost exactly recapitulates Walcott's assessment of the Caribbean as a hostile environment for the arts in a 1965 article in the *Guardian*. "The beginning writer in the West Indies finds himself constricted, perhaps more than the young writer abroad. . . . [He develops] a special kind of self-pity, a feeling of frustration that is only a cover-up for his lack of energy. He begins to accuse the society of neglecting him. Unless he recognizes this for what it is, a shabby excuse, he will find himself becoming bitter, and his work will degenerate. Unless the writer accepts that there is no one who can help him, even after he is published, he had better stop early." Derek Walcott, "Absolute Beginners!," in *Journeyman*, vol. 1, 145. Eric Williams likewise observes that "until recently, the young writer or the man who writes poetry, or the painter or the sculptor was regarded as little more than a freak, a disappointment to hardworking parents." Williams, *History of the People of Trinidad and Tobago* (New York: Frederick A. Praeger, 1964), 248. In 1968, Mervyn Morris commented, "in the West Indies an audience for serious contemporary poetry scarcely exists." Morris, "Walcott and the Audience for Poetry," *Caribbean Quarterly* 14, no. 1 (1968): 7.

112. Bourdieu describes the development of nineteenth-century aestheticism, symbolism, and decadentism as a consequence of the artist's need for distinction in an unfavorable marketplace. Pierre Bourdieu, *The Rules of Art: Genesis and Structure of the Literary Field*, trans. Susan Emanuel (Stanford, CA: Stanford University Press, 1992), 47–173.

113. Walcott, *Last Carnival*, 76–77.
114. Ibid., 9. The doubling of the actors' roles from act 1 to act 2 makes the process of locating Clodia's "originality" even more difficult.
115. As Rei Terada argues regarding Walcott's poetry, "Originality and mimicry, . . . each term occasionally plays the other's role." Terada, *Derek Walcott's Poetry: American Mimicry* (Boston: Northeastern University Press, 1992), 23.
116. As Bourdieu observes, "The symbolic revolution through which artists free themselves from bourgeois demand by refusing to recognize any master except their art produces the effect of making the market disappear." Bourdieu, *Rules of Art*, 81.
117. See Baugh, *Derek Walcott*, 138–389. In a passage in the earlier poem "The Schooner Flight," Walcott describes how the revolutionaries "kept marching into the mountains, and / their noise ceased as foam sinks into sand." See Derek Walcott, "The Schooner Flight," in *Collected Poems*, 351.
118. See Pantin, *Black Power Day*, 47.
119. Walcott, *Last Carnival*, 69. Pantin notes that there was a "spontaneous outpouring" of Black Power bands that day, the largest of which called itself "One Thousand and One White Devils." Pantin, *Black Power Day*, 44.
120. Walcott, *Last Carnival*, 59. As Otto Heim remarks, "In the second Act of the play, Carnival has become as paralyzing and decadent an impasse as Victor's artistic vision, symptomatic of the country's passage from colonial dependence to Third World politics." Heim, "Unfinished Visions beyond Nostalgic Mimicry: Derek Walcott's *The Last Carnival* in a Modernist Light," in *Aspects of Modernism: Studies in Honour of Max Nänny*, ed. Andreas Fisher, Martin Heusser, and Thomas Hermann (Tübingen, Germany: Gunter Narr Verlag Tübingen, 1997), 303.
121. Walcott, "What the Twilight Says," 24.
122. Walcott, *Last Carnival*, typescript, I-3.
123. Burnett, *Derek Walcott*, 262.
124. Walcott, *Last Carnival*, typescript, II-63.
125. Derek Walcott, "The Caribbean: Culture or Mimicry?," in Hamner, *Critical Perspectives*, 55.
126. De Lima, "Walcott," 182.
127. Walcott, *Another Life*, 216, 294, 186.
128. Ibid., 143.
129. Ibid., 189.
130. Robert Benson, "The Painter as Poet: Derek Walcott's 'Midsummer,'" in Hamner, *Critical Perspectives*, 336–337.
131. Walcott, *Omeros*, 69.
132. Ibid., 183.
133. Ibid., 184.
134. Derek Walcott, poem 19, "I come out of the studio for blue air," in *White Egrets*, 50.
135. Derek Walcott, *O Starry Starry Night* (New York: Farrar, Straus and Giroux, 2014), 33.
136. Ibid., 29.
137. Ibid., 58.

138. Walcott, *Another Life*, 160–161.

139. Alfred Douglas, "Two Loves," in *Decadent Poetry from Wilde to Naidu*, ed. Lisa Rodensky (London: Penguin, 2006), 192.

140. Walcott, *Another Life*, 201.

141. Derek Walcott, "Spring Street in '58," in *Sea Grapes* (New York: Farrar, Straus and Giroux, 1976), 52.

142. Wilde, "Decay of Lying," 315–316.

143. Frank O'Hara, "A Step Away from Them," in *The Collected Poems of Frank O'Hara*, ed. Donald Allen (Berkeley: University of California Press, 1995), 258; Walcott, "Spring Street in '58," 52.

144. Derek Walcott, "Meanings," in Hamner, *Critical Perspectives*, 48.

145. Other examples of Walcott employing the fin de siècle as an emblem of moments when life imitates art include the poem "Castiliane," in which Walcott riffs on Mallarmé's "L'après-midi d'un faune," imagining a beautiful woman walking through the busy market of a port city. Her "haunted face, / Dim as an antique faun's, fin de siècle style," appears "Imprisoned in the grillwork's leafless green" of a hotel facade, leaving the speaker unable to distinguish between face and facade, between the beauty he desires to see and the cityscape itself. Derek Walcott, *In a Green Night* (London: Jonathan Cape, 1969), 45. Likewise, in *Omeros*, Major Plunkett, a retired British colonial officer, looks at a picture of his wife, "framed forever in the last century," and is reminded of "something out of Etty / or Alma-Tadema," whose paintings recall the imperial splendor and decadence of ancient Rome, as reimagined in the late nineteenth century. "It was so *fin de siècle!*" Plunkett exclaims. Walcott, *Omeros*, 304.

146. Walcott, "Did You See the Australian Ballet or How Could You Afford It," 245.

147. Walcott, *Tiepolo's Hound*, 37.

148. Ibid., 23, 28, 25.

149. Ibid., 7.

150. In Altieri's account of modernism's pursuit of aesthetic autonomy in the visual arts, he analyzes several paintings by Pissarro, Cézanne, and Kazimir Malevich to illustrate the evolution from impressionism to abstraction, from an authority for representation externally grounded in nature to an authority grounded in the inner forces of lines, colors, and shapes in the painting itself. Charles Altieri, "Why Modernist Claims for Autonomy Matter," *Journal of Modern Literature* 32, no. 3 (2009): 10.

151. Walcott, *Tiepolo's Hound*, 56–57.

152. Maurice Merleau-Ponty, "Cézanne's Doubt," in *The Merleau-Ponty Aesthetics Reader: Philosophy and Writing* (Evanston: Northwestern University Press, 1993), 63, 62.

153. Walcott, *Tiepolo's Hound*, 57.

154. Casteel likewise argues that in "reclaiming Pissarro for the Caribbean, Walcott calls into question our understanding of Impressionism as a French artistic movement and problematizes the very distinction between metropolitan and colonial cultures," though Casteel is concerned with Walcott's turn toward impressionism as a more realistic response to the idealized vision of conventional pastoral landscape painting and description and not as a response to the development of modernism. Casteel also

suggests that "Walcott's revisionist history of Impressionism is less a matter of rewriting art history than of presenting Europe and the Americas as thoroughly imbricated." Casteel, *Second Arrivals*, 42.

155. Walcott, *Tiepolo's Hound*, 57–58.

156. Ibid., 29.

157. James Joyce, *A Portrait of the Artist as a Young Man* (New York: Bantam, 2005), 182; W. B. Yeats, "The Tower," in *The Collected Poems of W. B. Yeats*, 2nd ed., ed. Richard J. Finneran (New York: Scribner, 1996), 198; Derek Walcott, "The Schooner *Flight*," in *Collected Poems*, 350.

158. Walcott, "Schooner *Flight*," 346.

159. Walcott further underlines this dilemma in *O Starry Starry Night*. In the play, Van Gogh and Gauguin imagine an "aesthetic republic" away from the "pernicious, vampiric galleries" and "the shouts of prices in the market." They envision instead a "new landscape" without "churches" that would shift "the world's centre" from "Paris to the tropics," from "Montmartre to Martinique." Yet their utopian, Platonic vision fails when Van Gogh's madness takes hold and Gauguin returns to Martinique without him. Walcott, *O Starry Starry Night*, 20–21.

160. Walcott, *Tiepolo's Hound*, 53, 87, 88, 58, 158, 89, 58.

161. Ibid., 70, 44, 70.

162. Édouard Glissant, "Cross-Cultural Poetics," in *Caribbean Discourse: Selected Essays*, trans. J. Michael Dash (Charlottesville: University of Virginia Press), 100; see also Simon Gikandi, *Writing in Limbo: Modernism and Caribbean Literature* (Ithaca, NY: Cornell University Press, 1992), 4–5; and Robert Stilling, "Multicentric Modernism and Postcolonial Poetry," in *The Cambridge Companion to Postcolonial Poetry*, ed. Jahan Ramazani (Cambridge: Cambridge University Press, 2017), 127–138.

163. Edward Kamau Brathwaite, *History of the Voice: The Development of Nation Language in Anglophone Caribbean Poetry* (London: New Beacon Books, 1984), 30; see also Stilling, "Multicentric Modernism," 127–128; Charles Pollard, *New World Modernisms: T. S. Eliot, Derek Walcott, and Kamau Brathwaite* (Charlottesville: University of Virginia Press, 2004), 85–87; Michael North, *The Dialect of Modernism: Race, Language, and Twentieth-Century Literature* (New York: Oxford University Press, 1994), 91; Jahan Ramazani, *A Transnational Poetics* (Chicago: University of Chicago Press, 2009), 97–98; and Matthew Hart, *Nations of Nothing but Poetry: Modernism, Transnationalism, and Synthetic Vernacular Writing* (Oxford: Oxford University Press, 2010), 106–141.

164. Walcott, "Caribbean," 53.

165. Walcott, *Tiepolo's Hound*, 157–158, 53.

166. Ibid., 157.

CHAPTER 3 DECADENCE AND ANTIREALISM IN THE ART OF YINKA SHONIBARE

1. Oscar Wilde, "The Decay of Lying," in *The Artist as Critic: Critical Writings of Oscar Wilde*, ed. Richard Ellmann (Chicago: University of Chicago Press, 1969), 301, 320.

2. Oscar Wilde, "The Soul of Man under Socialism," ibid., 270.

3. Yinka Shonibare, "Setting the Stage: Yinka Shonibare MBE in Conversation with Anthony Downey," in *Yinka Shonibare MBE*, ed. Rachel Kent (Munich: Prestel, 2008), 43.

4. Anthony Downey, "Yinka Shonibare," *Bomb*, Fall 2005, 28.

5. Stuart Hall, "Whose Heritage? Un-settling 'the Heritage,' Re-imagining the Post-nation," in *The Politics of Heritage: The Legacies of "Race,"* ed. Jo Littler and Roshi Naidoo (London: Routledge, 2005), 31.

6. Jan Garden Castro, "In Art, Anything Is Possible: A Conversation with Yinka Shonibare," *Sculpture* 25, no. 6 (2006): 25.

7. Downey, "Yinka Shonibare," 29.

8. Naseem Khan, "Taking Root in Britain: The Process of Shaping Heritage," in Littler and Naidoo, *Politics of Heritage*, 134; Hall, "Whose Heritage?," 31.

9. Nancy Hynes, "Re-Dressing History," *African Arts* 34, no. 3 (2001): 60.

10. Leela Gandhi, *Affective Communities: Anti-colonial Thought, Fin-de-Siècle Radicalism, and the Politics of Friendship* (Durham, NC: Duke University Press, 2006), 146.

11. Angela Leighton, *On Form: Poetry, Aestheticism, and the Legacy of a Word* (Oxford: Oxford University Press, 2007), 37.

12. Regenia Gagnier, *Idylls of the Marketplace: Oscar Wilde and the Victorian Public* (Stanford, CA: Stanford University Press, 1986), 98.

13. Wole Soyinka, *Death and the King's Horseman*, ed. Simon Gikandi (New York: Norton, 2003), 37.

14. Stuart Hall and Mark Sealy, *Different* (London: Phaidon, 2001), 15–16.

15. Ibid., 65.

16. Ibid., 49.

17. Oscar Wilde, "The Critic as Artist," in *Artist as Critic*, 359.

18. Yinka Shonibare, "Setting the Stage," 41. See also Monica L. Miller, *Slaves to Fashion: Black Dandyism and the Styling of Black Diasporic Identity* (Durham, NC: Duke University Press, 2009), 271.

19. Shonibare's allusion to guillotined aristocrats "started as a joke," he recalls: "It's witty in a knowing sort of way. It adds more ambivalence." Castro, "In Art," 26; Robert Hobbs, "Yinka Shonibare MBE: The Politics of Representation," in Kent, *Yinka Shonibare MBE*, 33.

20. Hynes, "Re-Dressing History," 60. See also John Picton, "Yinka Shonibare: Undressing Ethnicity," *African Arts* 34, no. 3 (2001): 68–72; and Miller, *Slaves to Fashion*, 271–272.

21. Quoted in Hobbs, "Yinka Shonibare MBE," 29.

22. Ibid., 29.

23. Jonathan Hart, *Empires and Colonies* (Cambridge, UK: Polity, 2008), 194, 196.

24. Dipesh Chakrabarty, *Provincializing Europe: Postcolonial Thought and Historical Difference* (Princeton, NJ: Princeton University Press, 2000), 27.

25. "Europe" here is "an imaginary figure that remains deeply embedded in *clichéd and shorthand forms* in some everyday habits of thought." Ibid., 4. For "cosmopolitan style," see Rebecca L. Walkowitz, *Cosmopolitan Style: Modernism beyond the Nation* (New York: Columbia University Press, 2006), 2.

26. Quoted and translated in Barbara Spackman, *Decadent Genealogies: The Rhetoric of Sickness from Baudelaire to D'Annunzio* (Ithaca, NY: Cornell University Press, 1989), 37. See also Françoise Gaillard, "*À rebours* ou l'inversion des signes," in *L'esprit de décadence,* Colloque de Nantes 1 (Paris: Librairie Minard, 1980), 131.

27. Wilde, "Decay of Lying," 313.

28. Lawrence Danson, *Wilde's Intentions: The Artist in His Criticism* (Oxford, UK: Clarendon, 1997), 55, 58–59.

29. Downey, "Yinka Shonibare," 25.

30. According to Gandhi and Chakrabarty, this bias "owes it origins to 'the familiar political desire of the modern to align the world with that which was real and rational.'" It is time, Gandhi urges, to "reexamine more critically the realist epistemology to which post-colonialism, among other disciplines in the new humanities, proffers its allegiance," to "restore semantic plenitude to the category of the 'political'" and, as Chakrabarty suggests, "breathe heterogeneity into the word 'imagination.'" See Gandhi, *Affective Communities,* 146–147; and Chakrabarty, *Provincializing Europe,* 149–153. See also Robert J. C. Young, *Colonial Desire: Hybridity in Theory, Culture and Race* (New York: Routledge, 1995), 4.

31. Stuart Hall, "Black Diaspora Artists in Britain: Three 'Moments' in Post-war History," *History Workshop Journal* 61 (2006): 22–23.

32. Paul Gilroy, *The Black Atlantic: Modernity and Double Consciousness* (Cambridge, MA: Harvard University Press, 1993), 102.

33. See, for example, Dominic Head, *The Cambridge Introduction to Modern British Fiction, 1950–2000* (Cambridge: Cambridge University Press, 2002), 172; Alistair Cormack, "Migration and the Politics of Narrative Form: Realism and the Postcolonial Subject in *Brick Lane,*" *Contemporary Literature* 47, no. 4 (2006): 695–721; S. Shankar, "Midnight's Orphans, or a Postcolonialism Worth Its Name," *Cultural Critique* 56 (2003): 64–95.

34. Danson, *Wilde's Intentions,* 56.

35. Gandhi, *Affective Communities,* 146.

36. Ibid., 161.

37. Ibid., 144.

38. Edward W. Said, *Culture and Imperialism* (New York: Vintage Books, 1994), 13.

39. Edward W. Said, "History, Literature, and Geography," in *Reflections on Exile and Other Essays* (Cambridge, MA: Harvard University Press, 2000), 466.

40. Ibid., 471.

41. Ibid., 458.

42. Said, *Culture and Imperialism,* 13.

43. Wilde, "Critic as Artist," 349.

44. Chinua Achebe, "An Image of Africa: Racism in Conrad's *Heart of Darkness,*" in *Heart of Darkness,* by Joseph Conrad, 3rd ed., ed. Robert Kimbrough (New York: Norton, 1988), 252–255. See also F. R. Leavis, *The Great Tradition* (London: Chatto and Windus, 1950), 177.

45. Michael H. Levenson, *A Genealogy of Modernism: A Study of English Literary Doctrine, 1908–1922* (Cambridge: Cambridge University Press, 1984), 16.

46. Ibid., 110–111. See also Ezra Pound, "Affirmations . . . VI. Analysis of this decade," *New Age*, 11 February 1915, 410; Stéphane Mallarmé, *Oeuvres complètes* (Paris: Gallimard, 1945), 869, as translated in Ian Watt, *Conrad and the Nineteenth Century* (Berkeley: University of California Press, 1980), 186.

47. Achebe, "Image of Africa," 260.

48. Ibid., 261.

49. Said, *Culture and Imperialism*, 29.

50. Achebe, "Image of Africa," 262.

51. Wilde, "Decay of Lying," 315.

52. Edward Said, *Orientalism*, 25th anniversary ed. (New York: Vintage, 1994), 231.

53. Wilde, "Decay of Lying," 315–316.

54. See Oscar Wilde, *The Picture of Dorian Gray: An Annotated, Uncensored Edition* (1890), ed. Nicholas Frankel (Cambridge, MA: Harvard University Press, 2011), 69n5.

55. Oscar Wilde, *The Picture of Dorian Gray* (1891), ed. Joseph Bristow (Oxford: Oxford University Press, 2008), 5. Unless otherwise noted, all citations of the novel are to this edition.

56. Monica L. Miller suggests that "Dorian's evil has been internalized," but she reads the series "not as a specific comment on Wilde's story or Lewin's film, but as a comment on the black dandy's heretofore colorful postcolonial re-dressing, his bold attempt at redemptive narcissism. . . . With 'Dorian Gray,' Shonibare seemingly critiques his own project (and that of others) of revisioning colonial objectification and postcolonial narcissism through the dandy figure." Miller, *Slaves to Fashion*, 287.

57. Shonibare, "Setting the Stage," 43.

58. Urmila Seshagiri, *Race and the Modernist Imagination* (Ithaca, NY: Cornell University Press, 2010), 37.

59. Wilde, *Picture of Dorian Gray*, 107.

60. Seshagiri, *Race*, 37; Wilde, *Picture of Dorian Gray*, 122.

61. *The Picture of Dorian Gray*, directed by Albert Lewin (MGM, 1945), film.

62. J. Jeffrey Franklin, *The Lotus and the Lion: Buddhism and the British Empire* (Ithaca, NY: Cornell University Press, 2008), 8.

63. Hema Chari, "Imperial Dependency, Addiction, and the Decadent Body," in *Perennial Decay: On the Aesthetics and Politics of Decadence*, ed. Liz Constable, Dennis Denisoff, and Matthew Potolsky (Philadelphia: University of Pennsylvania Press, 1999), 215.

64. Wilde, *Picture of Dorian Gray*, 21.

65. Jessica R. Feldman, *Gender on the Divide: The Dandy in Modernist Literature* (Ithaca, NY: Cornell University Press, 1989), 2.

66. Miller, *Slaves to Fashion*, 6.

67. Shonibare, "Setting the Stage," 42. Shonibare echoes Baudelaire, who associates the dandy with various non-European figures and praises the dandy for "gravity amid the frivolous." Charles Baudelaire, "The Painter of Modern Life," in *The Painter of Modern Life and Other Essays*, trans. and ed. Jonathan Mayne (London: Phaidon, 1995), 28.

68. Miller, *Slaves to Fashion*, 286–287.

69. See Frankel, "General Introduction" and "Textual Introduction," in Wilde, *Picture of Dorian Gray: An Annotated, Uncensored Edition*, 1–64.
70. Quentin Crisp, *The Naked Civil Servant* (New York: Penguin Books, 1997), 149.
71. In the film, Dorian walks by Hallward and then stops to converse. Shonibare has reversed the sequence.
72. Wilde, *Picture of Dorian Gray: An Annotated, Uncensored Edition*, 146.
73. Ibid., 47, 146.
74. Shonibare, "Setting the Stage," 42–43.
75. As Miller notes, "For blacks in the diaspora, the dandy's special talent—the possibility of converting absence into presence through self-display—is not only a philosophical or psychological boon, but also, initially, a practical concern." Miller, *Slaves to Fashion*, 10.
76. Wilde, *Picture of Dorian Gray*, 40–41.
77. Seshagiri, *Race*, 33.
78. Wallace Stevens, "Anecdote of the Jar," in *The Collected Poems* (New York: Vintage Books, 1990), 76.
79. Hall, "Whose Heritage?," 65.
80. Downey, "Yinka Shonibare," 26.
81. Marie-Christine Skuncke, "Gustav III," in *Encyclopedia of the Enlightenment*, ed. Alan Charles Kors (Oxford: Oxford University Press, 2002), accessed 28 August 2015, www.oxfordreference.com.
82. Shonibare, "Setting the Stage," 44.
83. "*Un Ballo in Maschera*," in *The Oxford Dictionary of Music*, 6th ed., ed. Tim Rutherford-Johnson et al. (Oxford: Oxford University Press, 2012), accessed 28 August 2015, www.oxfordreference.com.
84. Downey, "Yinka Shonibare," 26.
85. As Michael North argues, as Chaplain "stalls or syncopates or reverses the seemingly natural order of things," he draws attention to the mechanical, reproducible nature of the film medium itself; that is, he "makes the whole process of copying, without which movies are unimaginable, visible, and in doing so highlights the inherent instability of every object and person in a film." North, *Reading 1922: A Return to the Scene of the Modern* (Oxford: Oxford University Press, 1999), 171.
86. Downey, "Yinka Shonibare," 26.
87. Ibid., 27.
88. Ibid., 27–28.
89. Biodun Jeyifo, "Drama and the Social Order: Two Reviews," *Positive Review* 1 (1977): 22 (emphasis in original).
90. Wole Soyinka, "Author's Note," in *Death and the King's Horseman*, ed. Simon Gikandi (New York: Norton, 2003), 3. Kwame Anthony Appiah has commented that there is something "disingenuous" in Soyinka's claim: "The 'Colonial Factor' is not a catalytic incident merely; it is a profound assault on the consciousness of the African intellectual, on the consciousness that guides this play. . . . It is one thing to say (as I think correctly) that the drama in Oyo is driven ultimately by the logic of Yoruba cosmology, another to deny the existence of a dimension of power in which it is the colonial state that

forms the action." Appiah, "Wole Soyinka and the Myth of an African World," in *In My Father's House: Africa in the Philosophy of Culture* (New York: Oxford University Press, 1992), reprinted in Soyinka, *Death and the King's Horseman*, 105.

91. Soyinka, *Death and the King's Horseman*, 37.

92. It is in this sense, as Norman Vance argues, that one can "consider decadence in relation not to time but to space and spatial metaphor. Decadence can be seen as implicated in decentered fragmentation or failed connection, in extremity and marginality." Vance, "Decadence from Belfast to Byzantium," *New Literary History* 35 (2005): 563.

93. See Homi Bhabha, *The Location of Culture* (London: Routledge, 1994), 121–131.

94. Soyinka, *Death and the King's Horseman*, 43.

95. Ibid., 20.

96. As Michael North argues, African masks appealed to early modernists because they simultaneously offered access to a more immediate and naturalist means of representation, spurring a movement toward primitivism, and highlighted the very arbitrariness and conventionality of all sign systems. North, *The Dialect of Modernism: Race, Language, and Twentieth-Century Literature* (New York: Oxford University Press, 1994), 64–65.

97. As John Pemberton III explains, "Although masks are used for the purposes of concealing the identity of the one who wears it, the intent of a masquerade is to reveal a reality not otherwise observable. For the Yoruba the ancestral ensembles are designed to disclose the presence and power of the living dead and also the status and filial piety of the 'owner' of an egungun. It is through the use of cloth that the creators of a masquerade achieve both concealment and revelation." Pemberton, "The Oyo Empire," in *Yoruba: Nine Centuries of African Art and Thought*, ed. Henry John Drewal and Allen Wardwell (New York: Center for African Art, 1989), 182.

98. As Martin Rohmer comments, "Soyinka's characterization, scarcely the depiction of a healthy multicultural experiment, makes a satirical comment on colonialist attitudes and the alienation of western culture." Rohmer, "Wole Soyinka's 'Death and the King's Horseman,' Royal Exchange Theatre, Manchester," *New Theatre Quarterly* 10, no. 37 (1994): 57–69, reprinted in Soyinka, *Death and the King's Horseman*, 133.

99. Wole Soyinka, foreword to *Opera Wonyosi* (London: Collings, 1981), vii.

100. Quoted in Bernth Lindfors, "Begging Questions in Wole Soyinka's 'Opera Wonyosi,'" *Ariel* 12, no. 3 (1981): 30.

101. Wumi Raji, *Long Dreams in Short Chapters* (Berlin: Lit Verlag, 2009), 26.

102. Soyinka, *Opera Wonyosi*, 26.

103. As Bernth Lindfors comments, "Nigerian audiences would not be likely to question the stylized squalor of the beggar's world portrayed in this opera, for that would be tantamount to denying the surreal dimensions of their own corrupted world. Soyinka had chosen an excellent warped mirror to reflect the absurdities of an unbalanced age." See Lindfors, "Begging Ques-

tions," 30. Derek Wright further comments, "The terrorizing of civilian populations by megalomaniacal military buffoons and the squalid compliance of the professional classes, cowed by a mendicant mentality, were the painful Nigerian and African realities of the 1970s, and satire targeted at them walks the fine edge between the real and the surreal. Soyinka stated in the playbill to the 1977 Ife production that "the characters in this opera are either strangers or fictitious, for Nigeria is stranger than fiction, and any resemblance to any Nigerian, living or dead, is purely accidental, unintentional and instructive." Wright, "Soyinka's Smoking Shotgun: The Later Satires," *World Literature Today* 66, no. 1 (1992): 29.

104. Andrew H. Apter, *The Pan-African Nation: Oil and the Spectacle of Culture in Nigeria* (Chicago: University of Chicago Press, 2005), 39, 22, 41.
105. Yemi Ogunbiyi, "Òpèrá Wónyòsi: A Study of Soyinka's Òpèrá Wónyòsi," *Nigeria Magazine* 128–129 (1979): 3.
106. Elisha P. Renne, "Traditional Modernity and the Economics of Handwoven Cloth Production in Southwestern Nigeria," *Economic Development and Cultural Change* 45, no. 4 (1997): 774, quoted in Barbara Plankensteiner, "African Lace: an Industrial Fabric Connecting Austria and Nigeria," *Anthrovision* 1, no. 2 (2013): 12.
107. Plankensteiner, "African Lace," 2.
108. Ibid., 16.
109. Ibid., 11; see also Femi Euba, "Soyinka's Satiric Development and Maturity," *Black American Literature Forum* 22, no. 3 (1988): 618.
110. Plankensteiner, "African Lace," 11.
111. Soyinka, *Opera Wonyosi*, 38–39.
112. Ibid., 52.
113. Ibid., 57.
114. George L. Dillon, "Complexity and Change of Character in New-Classical Criticism," *Journal of the History of Ideas* 33, no. 1 (1974): 51–61.
115. Soyinka, *Opera Wonyosi*, 83.
116. Ibid., 23–24.
117. Ogunbiyi, "Òpèrá Wónyòsi," 8.
118. Brian Crow, "Soyinka and His Radical Critics: A Review, 1987," in *Perspectives on Wole Soyinka: Freedom and Complexity*, ed. Biodun Jeyifo (Jackson: University Press of Mississippi, 2001), 95.
119. Soyinka, *Opera Wonyosi*, 82.
120. Ogunbiyi, "Òpèrá Wónyòsi," 10–11.
121. Soyinka, *Opera Wonyosi*, 47.
122. György Lukács, "Aesthetic Culture," trans. Rita Keresztesi-Treat, *Yale Journal of Criticism* 11, no. 2 (1998): 374.
123. Soyinka, *Opera Wonyosi*, 24.
124. Ogunbiyi, "Òpèrá Wónyòsi," 8.
125. Ibid., 12.
126. Ibid.
127. Jeyifo, "Drama," 22.

128. Soyinka, foreword to *Opera Wonyosi*, vi.
129. Ibid., vii.
130. Ibid., vi.
131. Ibid., vi–vii.

CHAPTER 4 BERNARDINE EVARISTO'S SILVER AGE POETICS

1. Joris-Karl Huysmans, *Against Nature (À rebours)* (1884), trans. Robert Baldick (London: Penguin Books, 2003), 27–30.
2. Ibid., 30.
3. Matthew Potolsky, *The Decadent Republic of Letters: Taste, Politics, and Cosmopolitan Community from Baudelaire to Beardsley* (Philadelphia: University of Pennsylvania Press, 2013), 86.
4. Huysmans, *Against Nature*, 33.
5. Potolsky, *Decadent Republic*, 86–87.
6. Jed Esty, *A Shrinking Island: Modernism and National Culture in England* (Princeton, NJ: Princeton University Press, 2004), 223.
7. Norman Vance, "Decadence and the Subversion of Empire," in *Roman Presences: Receptions of Rome in European Culture, 1789–1945*, ed. Catherine Edwards (Cambridge: Cambridge University Press, 1999), 120–124.
8. Oscar Wilde, "The Critic as Artist," in *The Artist as Critic: Critical Writings of Oscar Wilde*, ed. Richard Ellmann (Chicago: University of Chicago Press, 1969), 359.
9. Bernardine Evaristo, *The Emperor's Babe* (New York: Penguin Books, 2001), 4.
10. See Wai Chee Dimock, *Through Other Continents: American Literature across Deep Time* (Princeton, NJ: Princeton University Press, 2006), 73–106. Judie Newman's apt description of Evaristo's later novel *Blonde Roots* applies equally well here: "Evaristo's imaginative reversals . . . maintain the reader's awareness of the main features of slavery while compelling a continual translation between racialized spaces and cultures, which effectively transforms black into white and vice versa, propagating [Paul] Gilroy's antiessentialist agenda." Newman, "The Black Atlantic as Dystopia: Bernardine Evaristo's *Blonde Roots*," *Comparative Literature Studies* 49, no. 2 (2012): 287.
11. Rowan Ricardo Phillips comments, "As the novel progresses, Zuleika displays greater fluency in the world she inherits through marriage, and yet her gains only appear to exacerbate her losses; she appears to have borrowed this world as opposed to inheriting it." Phillips, "The Emperor's Babe," *Callaloo* 27, no. 2 (2004): 568.
12. Pilar Cuder-Domínguez observes that Evaristo depicts Londinium as "the seat of power and the city of the powerless," home "to the very English/Roman and the not English/Roman at all." Cuder-Domínguez, "Ethnic Cartographies of London in Bernardine Evaristo and Zadie Smith," *European Journal of English Studies* 8, no. 2 (2004): 182.
13. Evaristo, *Emperor's Babe*, 51. Justine McConnell erroneously claims that Evaristo's text is "wholly disinterested in the elite, instead focusing on the

slaves and the ordinary people who work for a living." McConnell, "Crossing Borders: Bernardine Evaristo's *The Emperor's Babe*," *Callaloo* 39, no. 1 (2016): 105. While the text does give voice to slaves and ordinary people, the text is deeply interested in the lives and social codes of the elite. Indeed, these provide the subject of many of Zuleika's observations and aspirations.

14. As Gibbon writes, "In these circumstances the intelligence of a war in Britain, and of an invasion of the province by the barbarians of the North, was received with pleasure by Severus. Though the vigilance of his lieutenants might have been sufficient to repel the distant enemy, he resolved to embrace the honorable pretext of withdrawing his sons from the luxury of Rome, which enervated their minds and irritated their passions; and of inuring their youth to the toils of war and government." Edward Gibbon, *History of the Decline and Fall of the Roman Empire*, vol. 1 (Philadelphia: Porter and Coates, 1845), 152.

15. Gibbon, *History of the Decline and Fall of the Roman Empire*, vol. 1, 149.

16. Juvenal, *Juvenal and Persius*, trans. G. G. Ramsay (Cambridge, MA: Harvard University Press, 1961), 107.

17. Such thinking can be found repeated in modern histories such as Jérôme Carcopino's 1940 *Daily Life in Ancient Rome*, which may have been one of Evaristo's sources (she names a work of that title in an interview with Karen Hooper but does not name the author). Carcopino attributes Rome's decline to the savage inequalities of Roman life, which pitted nobleman against peasant "in a fierce and silent struggle which pierced the dyke that protected the privileged classes from the barbarian flood." Eventually, fed up with such inequality, the "peasant pariah abetted the invading barbarian." In depicting life of the second-century Urbs, Carcopino relies heavily on sources drawn from that period, including "the satirical romance of Petronius, the *Silvae* of Statius, the *Epigrams* of Martial, the *Satires* of Juvenal, and the *Letters* of Pliny the Younger." Carcopino, *Daily Life in Ancient Rome: The People and the City at the Height of the Empire* (New Haven, CT: Yale University Press, 1968), x. See also Karen Hooper, "On the Road: Bernardine Evaristo Interviewed by Karen Hooper," *The Journal of Commonwealth Literature* 41, no. 3 (2006), 7.

18. Vance, "Decadence," 110.

19. Wole Soyinka, *Death and the King's Horseman*, ed. Simon Gikandi (New York: Norton, 2003), 37. Or, as Peter Forbes puts it, "the abiding impression is of a Romano-British adulterous mélange, the corruption economically detailed by Auden in 'The Fall of Rome.'" Forbes, "Latin Lovers," *Guardian*, 14 June 2001. As Auden writes, "Fantastic grow the evening gowns; / Agents of the Fisc pursue / Absconding tax defaulters through / The sewers of provincial towns." W. H. Auden, "The Fall of Rome," in *Selected Poems*, ed. Edward Mendelson (New York: Vintage, 2007), 183.

20. Evaristo, *Emperor's Babe*, 106.

21. Ibid., 128–130.

22. See Petronius, *Petronius*, trans. Michael Heseltine (Cambridge, MA: Harvard University Press, 1975), 74–77. Pliny the Elder describes "the most gluttonous gorger of all spendthrifts" to be Apicius, a legendary gourmand of the ancient

world who "established the view that the flamingo's tongue has a specially
fine flavour." Pliny, *Natural History*, vol. 1, trans. H. Rackman (Cambridge,
MA: Harvard University Press, 1938), 377. The *Historia Augusta* of the late
Roman period, which describe Elagabalus's tyrannical habits at length, notes
that the emperor took Apicius as the model for his elaborate banquets. The
description is comparable to Evaristo's text: "In imitation of Apicius he fre-
quently ate camels-heels and also cocks-combs taken from the living birds,
and the tongues of peacocks and nightingales, because he was told that one
who ate them was immune from the plague. He served to the palace-
attendants, moreover, huge platters heaped up with the viscera of mullets, and
flamingo-brains, partridge-eggs, thrush-brains, and the heads of parrots, pheas-
ants, and peacocks." *Historia Augusta*, vol. 2, trans. David Magie (Cambridge,
MA: Harvard University Press, 1924), 147. The *Historia Augusta* goes on to
catalogue a host of Elagabalus's outrages with men, boys, and harlots, as well
as his habit of traveling, in imitation of Nero, in a jewel-encrusted chariot
with enormous entourages of men and animals. Just as Dorian Gray aspired
to become, in his time, an arbiter of taste as Petronius was under Nero, El-
agabalus's excesses provided Huysmans with an ideal model for various de-
cadent pursuits in *À rebours*, including Des Esseintes's monochrome black
feast in honor of the death of his libido and the bejeweling of his ill-fated
tortoise. R. D. Brown also suggests that Wilde took his "treatment of Elaga-
balus" from the sixth chapter of Gibbon's *History of the Decline and Fall of
the Roman Empire*. Brown, "Suetonius, Symonds, and Gibbon in *The Pic-
ture of Dorian Gray*," *Modern Language Notes* 71, no. 4 (1956): 264. For more
on the legend of Apicius, see Apicius, *Cookery and Dining in Imperial
Rome*, trans. Joseph Dommers Vehling (Chicago: W. M. Hill, 1936), 9–13.
Other English-language editions of the Apicius book of Roman cookery in-
clude Apicius, *Apicius: A Critical Edition*, trans. Christopher Brocock and
Sally Grainger (Totnes, UK: Prospect, 2006); and Apicius, *The Roman
Cookery Book*, trans. Barbara Flower (New York: British Book Centre, 1958).
23. Evaristo, *Emperor's Babe*, 153.
24. See *The Damned*, directed by Luchino Visconti (Italnoleggio, 1969), film;
Cabaret, directed by Bob Fosse (Allied Artists Pictures, 1972), film; Chris-
topher Isherwood, *Goodbye to Berlin* (1939; New York: New Directions,
2012).
25. Evaristo, *Emperor's Babe*, 146.
26. Gibbon, *History of the Decline and Fall of the Roman Empire*, vol. 1, 149.
27. Evaristo, *Emperor's Babe*, 83–85.
28. Petronius, *Petronius*, 3–5.
29. Carcopino, *Daily Life*, 111–112.
30. Huysmans, *Against Nature*, 29.
31. Evaristo, *Emperor's Babe*, 85.
32. See Carcopino, *Daily Life*, 111–112.
33. Deleuze and Guattari draw on a schematic model of language that sorts
languages by use into four types, including the vernacular, a "maternal, or ter-
ritorial language, used in rural communities or rural in its origins"; a deter-
ritorialized "vehicular" language, the language of government, bureaucracy,

and commercial exchange, which is typified by the use of Latin by Roman officialdom; a "referential" language that gives a "sense of culture," as used in a living literature; and a "mythic" language more typical of symbol-laden literature that blends into religious and spiritual language. As they explain, "vernacular language is *here*; vehicular language is *everywhere*; referential language is *over there*; mythic language is *beyond*." As they also explain, "Latin was a vehicular language before becoming referential, then mythic; English has become the worldwide vehicular language for today's world." Gilles Deleuze and Félix Guattari, *Kafka: Toward a Minor Literature*, trans. Dana Polan (Minneapolis: University of Minnesota Press, 1986), 23–26.

34. Evaristo, *Emperor's Babe*, 194.
35. Pliny the Younger, "To Sosius Senecio," *Letters*, vol. 1, trans. Betty Radice (Cambridge, MA: Harvard University Press, 1969), 40–42.
36. Evaristo, *Emperor's Babe*, 194.
37. Ibid., 195–196.
38. Sarah Brouillette observes the irony by which antiestablishment poets such as Linton Kwesi Johnson have been absorbed in recent decades into Britain's poetic establishment. Many "BME," that is, "black and minority ethnic," artists, have been "thoroughly repositioned as contributors to public-private initiatives to revitalize British cities, improve corporate culture, guarantee the consolidation of and appeal to new consumer niches, and improve the British image abroad. A good measure of how much things have changed . . . is the fact that the British Council has sponsored Linton Kwesi Johnson—a crusader against racism and critic of mainstream British politics, who famously wrote 'Inglan Is a Bitch'—to travel around the world presenting his work." Brouillette, "The Politics and Production of Contemporary British Writing," *Contemporary Literature* 50, no. 2 (2009): 404. See also Jahan Ramazani, *A Transnational Poetics* (Chicago: University of Chicago Press, 2009), 178.
39. See Ramazani, *Transnational Poetics*, 178.
40. Evaristo, *Emperor's Babe*, 196–198.
41. Ibid., 201.
42. Derek Walcott, "A Far Cry from Africa," in *Collected Poems 1948–1984* (New York: Farrar, Straus and Giroux, 1986), 18. See also Ramazani, *Transnational Poetics*, 178–179.
43. Michael Collins, " 'My Preoccupations Are in My DNA': An Interview with Bernardine Evaristo," *Callaloo* 31, no. 4 (2008): 1200.
44. By the label "black British Writers," Evaristo means "writers who are born in Britain and write from that perspective and who are also reaching into the mainstream with their works." Alastair Niven, "Alastair Niven in Conversation with Bernardine Evaristo," *Wasafiri* 16, no. 34 (2001): 18–19. As Mark Stein notes, while the phrase "black British" initially emerged in the 1960s as an attempt by Caribbean writers and artists to more fully engage their experience as specifically British artists, the inclusiveness and actual significance of the term has undergone much debate since. Stein, *Black British Literature: Novels of Transformation* (Columbus: Ohio State University Press, 2004), 12.

45. Though Evaristo dislikes the way terms such as "postmodernism" and "post-colonial" put writers in "academic" boxes and notes how ethnic labels in particular can "ghettoize" certain authors on the bookstore shelves, she acknowledges that the various categories imposed on writers can be somewhat useful for drawing attention to writers that might not otherwise receive it. Hooper, "On the Road," 7, 11, 13, 14. As she commented in 2001, "I think ten years ago it would have been impossible to get *The Emperor's Babe* published, certainly not by a fiction publisher and certainly not by someone who is committed to promoting the book in the way that it has been. That would not have happened five years ago." Niven, "Conversation," 18–19. See also Zadie Smith, *White Teeth* (Boston: Compass Press, 2000); Hanif Kureishi, *The Buddha of Suburbia* (New York: Penguin, 1990); Jackie Kay, *The Adoption Papers* (Northumberland, UK: Bloodaxe, 1991); Bernardine Evaristo, *Lara* (1997; Northumberland, UK: Bloodaxe, 2009); Patience Agbabi, *Telling Tales* (Edinburgh: Canongate, 2014).

46. John McLeod, "Fantasy Relationships: Black British Canons in a Transnational World," in *A Black British Canon?*, ed. Gail Low and Marion Wynne-Davies (Basingstoke, UK: Palgrave Macmillan, 2006), 94–95.

47. Evaristo, *Emperor's Babe*, 143.

48. Karen McCarthy, "Bernardine Evaristo Interviewed by Karen McCarthy," *Valparaiso Poetry Review* 4, no. 2 (2003).

49. Evaristo, *Emperor's Babe*, 4, 54, 19. See also M. M. Bakhtin, *The Dialogic Imagination: Four Essays*, ed. Michael Holquist, trans. Caryl Emerson and Michael Holquist (Austin: University of Texas Press, 1981), 263, 331, 428, 431.

50. Evaristo, *Emperor's Babe*, 55, 57, 46, 144.

51. Ibid., 174, 176.

52. Ibid., 147.

53. Matthew Hart, *Nations of Nothing but Poetry: Modernism, Transnationalism, and Synthetic Vernacular Writing* (Oxford: Oxford University Press, 2010), 7–9.

54. Linda Dowling, *Language and Decadence in the Victorian Fin de Siècle* (Princeton, NJ: Princeton University Press, 1986), 85, 50.

55. Enoch Powell, "Enoch Powell's 'Rivers of Blood' Speech," *Telegraph*, 6 November 2007. As the classicist Mary Beard points out, though "Roman writers were quite keen on river metaphors when it came to discussions of cultural mixing," Powell's central metaphor relies on a misreading of Virgil's *Aeneid*, in which the Cumaean Sibyl prophesies that Aeneas's battles with the "indigenous peoples of Italy" would lead to the founding of a "brand new, multicultural city." Beard, "'Rivers of Blood'—What Enoch Powell Didn't Say," *Times Literary Supplement*, 5 November 2007.

56. Evaristo, *Emperor's Babe*, 3.

57. William Shakespeare, *Antony and Cleopatra*, in *The Riverside Shakespeare*, 2nd ed. (Boston: Houghton Mifflin, 1997), 1405.

58. For a comprehensive take on Evaristo's allusions, see Samanta Trivellini, "'Civis romana sum': La Londra intertestuale di Bernardine Evaristo," *Parole Rubate* 6 (2012): 75–91.

59. T. S. Eliot, *The Waste Land*, in *Collected Poems, 1909–1962* (Orlando: Harcourt, 1991), 56.

60. Mike Phillips, "Foreword: Migration, Modernity and English Writing—Reflections on Migrant Identity and Canon Formation," in Low and Wynne-Davies, *Black British Canon?*, 27.

61. See Niven, "Conversation," 16; Hooper, "On the Road," 6.

62. Hooper, "On the Road," 6.

63. Peter Fryer, *Staying Power: The History of Black People in Britain* (London: Pluto, 1984), 1. For an overview of the novel's relation to the "emergent field of Afro-European Studies," see Sofía Muñoz-Valdivieso, "Africa in Europe: Narrating Black British History in Contemporary Fiction," *Journal of European Studies* 40, no. 2 (2010): 159–174.

64. Niven, "Conversation," 15

65. Collins, "My Preoccupations," 1200. Cuder-Domínguez sees Evaristo's work in relation to a "new politics of representation of Englishness" in works such as Sam Selvon's *The Lonely Londoners* (New York: Longman, 1956), Hanif Kureishi's *The Buddha of Suburbia*, and Zadie Smith's *White Teeth*. Cuder-Domínguez, "Ethnic Cartographies," 176. Evaristo notes the success of her effort with pleasure: since "the book came out the Museum [of London] has introduced a black Roman character played by an actor who guides people around the Roman part of the Museum. I get great satisfaction from that very tangible result." Hooper, "On the Road," 6.

66. Evaristo, *Emperor's Babe*, 54.

67. Stuart Hall, "Cultural Identity and Diaspora," in *Identity: Community, Culture, Difference*, ed. Jonathan Rutherford (London: Lawrence and Wishart, 1990), 224.

68. Paul Gilroy, "London: Post-Colonial City," address at "London: Post-Colonial City" conference, March 1999, accessed online at the Institute of International Visual Arts.

69. Wilde, "Critic as Artist," 359; Niven, "Conversation," 17.

70. Dave Gunning, "Cosmopolitanism and Marginalisation in Bernardine Evaristo's *The Emperor's Babe*," in *Write Black, Write British: From Post Colonial to Black British Literature*, ed. Kadija George (Hertford, UK: Hansib, 2005), 165. I substantially agree with Gunning's examination of cosmopolitan identities in *The Emperor's Babe* in relation to different historical paradigms. Gunning does not, however, examine the use of Wilde's aphorism in light on the longer history of queer and decadent revisionism, as I do in this chapter.

71. Gilroy, "London."

72. While Pilar Cuder-Domínguez has rightly noted that Evaristo's "exploration of Englishness features not only racial demands but also evokes an idealised heterosexual, educated, patriarchal middle-class," I would argue that the text's challenge to patriarchal idealizations of heterosexuality must be situated within the longer history of queer historical revisionism. Cuder-Domínguez, "Ethnic Cartographies," 179.

73. Evaristo, *Emperor's Babe*, 75.

74. Ibid., 155; W. B. Yeats, "Sailing to Byzantium," in *The Collected Poems of W. B. Yeats*, 2nd ed., ed. Richard J. Finneran (New York: Scribner, 1996), 194.

75. Evaristo, *Emperor's Babe*, 172.

76. Ibid., 174–175.

77. Max Beerbohm, *Zuleika Dobson* (New York: Modern Library, 1926), 101.

78. Ibid., 113.

79. Evaristo, *Emperor's Babe*, 47.

80. Ibid., 123.

81. Bernardine Evaristo, *Mr. Loverman* (New York: Akashic Books, 2014), 241–242.

82. Bryan E. Burns, "Sculpting Antinous," *Helios* 35, no. 2 (2008): 121.

83. Sarah Waters, "'The Most Famous Fairy in History': Antinous and Homosexual Fantasy," *Journal of the History of Sexuality* 6, no. 2 (1995): 197–198.

84. As Waters observes, "Where Ganymede dominates homoerotic representation in the visual arts of the Renaissance, so Antinous reappears with striking regularity in the newly self-identified homosexual literature of the late Victorian period." Ibid., 195.

85. Ibid., 206.

86. John Addington Symonds, *The Letters of John Addington Symonds*, vol. 2, ed. Herbert M. Schueller and Robert L. Peters (Detroit: Wayne State University Press, 1968), 934. See also Jonathan Ned Katz, *Love Stories: Sex between Men before Homosexuality* (Chicago: University of Chicago Press, 2001), 262.

87. John Addington Symonds, "Antinous," in *Sketches and Studies in Italy* (London: Smith, Elder, 1879), 47, 49. See also Percy Bysshe Shelley, "The Coliseum: A Fragment of a Romance," in *The Works of Percy Bysshe Shelley*, vol. 7, ed. Harry Buxton Forman (London: Reeves and Turner, 1880), 28.

88. These also include Symonds's long poem "The Lotos-Garland of Antinous," in *Many Moods: A Volume of Verse* (London: John Murray, 1878), 121–134.

89. Symonds, "Antinous," 50.

90. Ibid., 57.

91. Ibid., 50, 55, 51, 63.

92. Katz, *Love Stories*, 244.

93. John Addington Symonds, *A Problem in Greek Ethics* (London: n.p., 1901).

94. Symonds, "Antinous," 80, 89–90.

95. Ibid., 90.

96. Oscar Wilde, *The Picture of Dorian Gray* (1891), ed. Joseph Bristow (Oxford: Oxford University Press, 2008), 12.

97. Here I follow Matthew Potolsky, who argues that imitation, as practiced in decadent writing, "is a fundamentally historical gesture, for it necessarily looks back, whatever its larger purpose, to a prior model. . . . But imitation, the decadents recognized, is also a practice of resignification, a repetition with a difference. It necessarily alters the 'original' meaning of that model; or, to put it another way, it renders the model a model, 'creates' it as an original." Potolsky, "Pale Imitations: Walter Pater's Decadent Historiography," in *Perennial Decay: On the Aesthetics and Politics of Decadence*, ed. Liz Constable, Dennis Denisoff, and Matthew Potolsky (Philadelphia: University of Pennsylvania Press, 1999), 237.

98. Evaristo, *Emperor's Babe*, 123.

99. Linda Dowling, *Hellenism and Homosexuality in Victorian Oxford* (Ithaca, NY: Cornell University Press, 1994), xv. Evaristo, *Emperor's Babe*, 43–44.

100. Ibid., 58.

101. Elizabeth Freeman, *Time Binds: Queer Temporalities, Queer Histories* (Durham, NC: Duke University Press, 2010), 7.

102. This jostling of historical models and temporalities reflects the text's blending of genres, crossing the lines between the epic, conceived as the genre of imperial development, and the novel, conceived as the genre of personal development. According to Bakhtin, epic narrates the "absolute past," and therefore an "absolute epic distance separates the epic world from [the] contemporary reality . . . in which the singer (the author and his audience) lives." To violate this separation by "portray[ing] an event on the same time-and-value plane as oneself and one's contemporaries . . . is to undertake a radical revolution, and to step out of the world of epic into the world of the novel." Bakhtin, *Dialogic Imagination*, 13–14.

103. José Esteban Muñoz, *Cruising Utopia: The Then and There of Queer Futurity* (New York: NYU Press, 2009), 4.

104. Oscar Wilde, "The Soul of Man under Socialism," in *Artist as Critic*, 269.

105. Muñoz, *Cruising Utopia*, 40.

106. Ibid., 112.

107. Evaristo, *Emperor's Babe*, 48.

108. Ibid., 190.

109. Waters, "Most Famous Fairy," 218.

110. Rachilde, *Monsieur Vénus*, trans. Madeleine Boyd, in *The Decadent Reader*, ed. Asti Hustvedt (New York: Zone Books, 1998), 335.

111. Symonds, "Antinous," 75.

112. Symonds, "The Lotos-Garland of Antinous," 131.

113. Evaristo, *Emperor's Babe*, 16.

114. Ibid., 16–17.

115. Ibid., 51–52. "Divine" was the name used by the actor Harris Glenn Milstead, who performed in several films by John Waters.

116. Ibid., 53.

117. In Judith Butler's terms, Antistia's identity as a Roman house matron can be read as an effect of her performance of both gender and class, especially given the parodic context of Evaristo's text. As Butler writes, "The parodic repetition of gender exposes . . . the illusion of gender identity as an intractable depth and inner substance." Butler, *Gender Trouble: Feminism and the Subversion of Identity* (New York: Routledge, 1990), 146. At the same time, Antistia's formulation "born and bred" echoes the ambivalent claims made by second-generation British immigrant characters such as Karim in the opening lines of Hanif Kureishi's *The Buddha of Suburbia*: "I am an Englishman, born and bred, almost." See Trivellini, "Civis Romana Sum," 89–90; and Kureishi, *The Buddha of Suburbia* (New York: Penguin Books, 1990), 3. See also Muñoz-Valdivieso, "Africa in Europe," 163.

118. Evaristo, *Emperor's Babe*, 17.

119. Ibid., 27.

120. Ibid., 28. See also Homi Bhabha, *The Location of Culture* (London: Routledge, 1994), 121–131.
121. Evaristo, *Emperor's Babe*, 29, 33.
122. Ibid., 84.
123. Ibid., 85. See also Trivellini, "Civis Romana Sum," 79–81.
124. Evaristo, *Emperor's Babe*, 119, 167.
125. Katharine Burkitt, "Imperial Reflections: The Post-Colonial Verse-Novel as Post-Epic," in *Classics in Post-colonial Worlds*, ed. Lorna Hardwick and Carol Gillespie (Oxford: Oxford University Press, 2007), 160.
126. See David Quint, *Epic and Empire: Politics and Generic Form from Virgil to Milton* (Princeton, NJ: Princeton University Press, 1993); and Herbert F. Tucker, *Epic: Britain's Heroic Muse, 1790–1910* (Oxford: Oxford University Press, 2008).
127. Evaristo, *Emperor's Babe*, 131–134.
128. Ibid., 135.
129. Sappho, *Sappho: A New Translation of the Complete Works*, trans. Diane J. Rayor (Cambridge: Cambridge University Press, 2014), 33.
130. Evaristo, *Emperor's Babe*, 141. As Cuder-Domínguez notes, "Severus has absorbed the ideals of the Empire. He dreams of conquest, of at last bringing the warring Caledonians under Roman rule, and he significantly quotes the English soldier's creed as laid out by [Rupert] Brooke: 'If I should die, think only this of me, Zuleika, // there's a corner somewhere deep / in Caledonia that is for ever Libya.'" Cuder-Domínguez, "Ethnic Cartographies," 181; Evaristo, *Emperor's Babe*, 148–149.
131. Evaristo, *Emperor's Babe*, 234.
132. Emily Dickinson, poem 179, in *The Poems of Emily Dickinson*, ed. R. W. Franklin (Cambridge, MA: Harvard University Press, 1998), 86.
133. Given the effectiveness of this and the other lyrics in the text, I strongly disagree with Rowan Ricardo Phillips's judgment that "the inner self on display—where lyric poems manifest their most provocative effects—disappoints" or that because the novel gives itself over to lyric moments as it goes along, "the emotional and dramatic spaces in the narrative begin to wane as the story searches for its conclusion." Phillips, "Emperor's Babe," 569. I would suggest, rather, that these generic shifts both help to elucidate Zuleika's character and help the reader understand her larger ambivalence toward the imperial world characterized by epic.
134. Evaristo, *Emperor's Babe*, 233.
135. Helen Vendler, "Fin-de-Siècle Lyric: W. B. Yeats and Jorie Graham," in *Fins de Siècle: English Poetry in 1590, 1690, 1790, 1890, 1990*, ed. Elaine Scarry (Baltimore: Johns Hopkins University Press, 1995), 123–124.
136. Paul Verlaine, "Langueur," in *Selected Poems of Paul Verlaine*, trans. C. F. MacIntyre (Berkeley: University of California Press, 1976), 192.
137. Donald MacAulay, "The Celtic Languages: An Overview," in *The Celtic Languages*, ed. Donald MacAulay (Cambridge: Cambridge University Press, 1992), 1–6.
138. Cumbric appears to have died out in the tenth century, while "Cornish died out toward the end of the eighteenth century," and the "last native

speaker" of Manx "died at the age of 97 in 1974." James Fife, introduction
to *The Celtic Languages*, ed. Martin J. Ball with James Fife (London: Rout-
ledge, 1993), 6; and Glanville Price, "The Celtic Languages Today," in *The
Celtic World*, ed. Miranda J. Green (London: Routledge, 1995), 804.

139. Fife, introduction to *Celtic Languages*, 6.

140. Evaristo, *Emperor's Babe*, 173, 117–118.

141. In this mix of multicultural names and ancient instruments, Ramazani
suggests, "Evaristo locates ancient precedents for today's multicultural
London and knowingly winks as she does so." Ramazani, *Transnational
Poetics*, 178.

142. As Ramazani observes, "Looking backward and forward in time, the
poem's heteroglossia is emblematic of ancient and contemporary creoliza-
tion in the British Isles." Ibid., 175.

143. Evaristo, *Emperor's Babe*, 42.

144. Peter Salway, *Roman Britain* (New York: Oxford University Press, 1981),
143. Lindsay Allason-Jones summarizes the likely pattern by which edu-
cation in Latin took place in Roman Britain: "Throughout the western
provinces of the Roman Empire, the preferred language was Latin. For
many people, however, this was their second language, and it is not always
clear to what extent most of the population spoke Latin. Boys wishing to
join the army had to be able to speak and write Latin if they were to under-
stand commands or stand any chance of promotion. Traders and merchants
and people who interacted daily with Latin-speaking administrators
would have had to become fluent very quickly; those who lived in remote
rural settlements may have acquired only a few useful words or phrases.
Educated people, on the other hand, were expected to be fluent in Greek as
well as Latin, and it is likely that their rhetorical training gave them dis-
tinctive accents." Allason-Jones, *Daily Life in Roman Britain* (Oxford,
UK: Greenwood, 2008), 20.

145. Wynne Lloyd, "Language and Identity in Modern Wales," in Green,
Celtic World, 796.

146. Evaristo, *Emperor's Babe*, 58.

147. Ibid., 204.

148. Ibid., 94.

149. Ibid., 203.

150. For example, "In the words of noster maximus poeta, yeah, / *Improbe
amor, quid non mortalia pectora cogis!* // Oh, cruel love, to what extremes
do you / not drive our human hearts?" Ibid., 166.

151. Ibid., 11, 29, 86.

152. Dowling, *Language and Decadence*, 66–67.

153. Ibid., 67.

154. Ibid., 84.

155. Max Beerbohm, "Diminuendo," in *The Works of Max Beerbohm* (London:
John Lane, 1896), 150. The Latinity of modernist decadence is also a repeated
topic of discussion in Vincent Sherry, *Modernism and the Reinvention of
Decadence* (Cambridge: Cambridge University Press, 2015).

156. Evaristo, *Emperor's Babe*, 53.

157. My argument here is influenced by Rebecca Walkowitz's discussion of "Conrad's naturalness" in *Cosmopolitan Style: Modernism beyond the Nation* (New York: Columbia University Press, 2006), 35–53.
158. As Ramazani writes, "Zuleika knows that the power speaking through her body is hers, yet alien." Ramazani, *Transnational Poetics*, 179.
159. Evaristo, *Emperor's Babe*, 204.
160. Ibid., 107–108.
161. Giorgio Agamben, *The End of the Poem: Studies in Poetics*, trans. Daniel Heller-Roazen (Stanford, CA: Stanford University Press, 1999), 53.
162. Ibid., 51.
163. The *Hypnerotomachia Poliphili* appears to tell the tale of Polifilo and his love for an old, gray woman, Polia, who may in fact already be dead. Polifilo's love for Polia appears to represent the love between the lover of Latin and the dead language he desires, a love expressed, Agamben argues, in the idiosyncratic hybrid style in which the book is written. Ibid., 47–50.
164. Ibid., 47.
165. As Agamben writes, *"What the vernacular contains in itself without expressing—what remains unsaid in discourse—is thus in this case another language."* Ibid., 47.
166. Evaristo, *Emperor's Babe*, 65.
167. Ibid., 210.
168. Ibid., 159.
169. Ibid., 247, 249.
170. Ibid., 253.
171. Evaristo comments in an interview that though Zuleika dies at the end, she does not see Zuleika as a victim but as victorious for "the way she lived her life . . . in the sense of her being strong and feisty." Niven, "Conversation," 16.
172. Evaristo, *Emperor's Babe*, 253.
173. Ibid., 72–73.

CHAPTER 5 DECADENCE AND THE ARCHIVE IN DEREK MAHON'S *THE YELLOW BOOK*

1. Henry James, "The Aspern Papers," in *The Aspern Papers and Other Stories* (Oxford: Oxford University Press, 2000), 1–96.
2. Derek Mahon, "Scrapbook, 1996–1997," MS 689, II.25.35, Derek Mahon Papers, Stuart A. Rose Manuscript, Archives, and Rare Book Library, Emory University. All subsequent "MS" references are to Derek Mahon Papers at Emory. Within MS 689, the accession numbers refer to series, box, and folder. The scrapbook would therefore be series 2, box, 25, folder 35.
3. As Haughton further observes, "the notebook includes such disparate items as notes on Schopenhauer, references to Eco's *Travels in Hyper-Reality* and Victoria Glendinning's *Bowen*, a photocopy of Thomas Moore's 'Oft in the Stilly Night,' copies of Dictionary pages defining 'Yellow' and 'Gold,' computer print-outs of entries for 'yellow,' 'saffron,' and 'lemon,' a photocopy of Goethe's theory of colour, newspaper clippings from *The Irish Times* about

the last 'manned' Irish lighthouse, and an extract from *Private Eye*'s Pseud's Corner about a seminar on 'Clutter.'" Hugh Haughton, *The Poetry of Derek Mahon* (Oxford: Oxford University Press, 2007), 273. Mahon has also pasted in musical notation, magazine articles on the birth of stars, the label from a tin of "Tiger Balm," poems by other poets, and various ephemera, including photos of Studio 54 clipped from a magazine. The notebook ends delightfully, but enigmatically, with a picture from a magazine of Juliette Binoche. Binoche's name eventually shows up, rhymed with *"brioche,"* in the later poem "Resistance Days." Mahon, "Scrapbook, 1996–1997"; Derek Mahon, "Resistance Days," in *New Collected Poems*, ed. Peter Fallon (Loughcrew, Ireland: Gallery, 2011), 251.

4. Haughton, *Poetry*, 274.
5. Mahon, "Scrapbook, 1996–1997."
6. Haughton, *Poetry*, 271, 269.
7. Regarding James's ambivalence toward his inclusion in *The Yellow Book*, literary celebrity, and his own readership, see Anne Diebel, "'The Dreary Duty': Henry James, *The Yellow Book*, and Literary Personality," *Henry James Review* 32 (2011): 45–59; Kristin King, "Lost Among the Genders: Male Narrators and Female Writers in James's Literary Tales, 1892–1896," *Henry James Review* 16, no. 1 (1995): 18–35.
8. As Linda Dowling has argued, the original *Yellow Book* staked its claim to being a vehicle for high art in part on its literary content and in part on the high-end, anticommercial quality of its letter press, a quality that allowed the volume to draw attention to itself as a salable artisanal commodity even as it preached aesthetic autonomy in its pages. Dowling, "Letterpress and Picture in the Literary Periodicals of the 1890s," *Yearbook of English Studies* 16 (1986): 117–131.
9. Derek Mahon, *The Yellow Book* (Winston-Salem, NC: Wake Forest University Press, 1998), 28.
10. See Derek Mahon, "The World of J. G. Farrell," MS 689, II.19.11; and Mahon, "Scrapbook, 1996–1997." Also, Haughton notes that *The Yellow Book* is "one of the most unstable of Mahon's notoriously unstable texts," having been revised repeatedly for the Irish Gallery Press edition (Loughcrew, Ireland: Gallery, 1997), the U.S. Wake Forest University Press edition (virtually identical, 1997), the *Collected Poems* edition (Loughcrew, Ireland: Gallery, 2000), and the *New Collected Poems* edition (Loughcrew, Ireland: Gallery, 2011). Haughton, *Poetry*, 274.
11. Derek Mahon, MS 689, II.19.20.
12. Patrick Crotty notes the book's temporal and geographic ambitions in its frequent *here and there* sense of bilocation: "the confused pre-millennial culture of the present, as viewed from Mahon's apartment in Dublin's Fitzwilliam Square, is brought into relationship with the last *fin de siècle* in Dublin and London, and with a number of other times and places characterised by a sense of civilisational decline." Crotty, "Apocalypse Now and Then: *The Yellow Book*," in *The Poetry of Derek Mahon*, ed. Elmer Kennedy-Andrews (Gerrards Cross, UK: Colin Smythe, 2002), 282.
13. Mahon, "Roman Script," in *New Collected Poems*, 237, 238.

14. See Leo Zeilig, *Frantz Fanon: The Militant Philosopher of Third World Revolution* (London: I. B. Tauris & Co., 2016), 225, 118.
15. Mahon uses Pier Paolo Pasolini's untranslated line for his epigraph: *"Nei rifiuti del mondo nasce un nuovo mondo."* Mahon, "Roman Script," 236.
16. Derek Mahon, "Dublin Diary," September 1997–June 1999," MS 689, II.26.1.
17. Ronald Schuchard to Derek Mahon, 12 October 1990, MS 689, I.1.19. See also Stephen Enniss, *After the Titanic: A Life of Derek Mahon* (Dublin: Gill and Macmillan, 2014), 242–244.
18. Mahon, "Scrapbook, 1996–1997"; and Mahon, "Visit to Emory," MS 689, VII.48.11.
19. Ernest Dowson, "Non Sum Qualis Eram Bonae sub Regno Cynarae," in *Decadent Poetry from Wilde to Naidu*, ed. Lisa Rodensky (London: Penguin, 2006), 86.
20. Stephen Enniss to Derek Mahon, 9 September 1996, MS 689, I.8.3.
21. Various photos, n.d., MS 689, V.44.21.
22. Stephen Enniss to Derek Mahon, 4 March 1996, MS 689, I.8.1.
23. Linda Matthews, the head of Special Collections at the time, indicates that Michael and Edna Longley both listened to the recording and were impressed. Linda Matthews to Derek Mahon, 21 May 1996, MS 689, I.8.2. Enniss also writes of having met Mahon in Dublin, where they discussed a lack of balance in Emory's collections. Stephen Enniss to Derek Mahon, 14 February 1997, MS 689, I.8.5.
24. There are three letters concerning Beckett from Lois More Overbeck and Martha Fehsenfeld to Mahon dated 18 January 1993, 10 February 1993, and 9 March 1993, MS 689, I.3.8-10.
25. Jacques Derrida, *Archive Fever: A Freudian Impression*, trans. Eric Prenowitz (Chicago: University of Chicago Press, 1995), 16–17.
26. Ibid., 2, 4n1.
27. Controversies over the national interest or the interests of a given ethnic or linguistic community in the acquisition of literary remains have been unavoidable in recent years. Judith Butler has detailed the conflict over Kafka's literary remains between the National Library of Israel's ethnically based claim on behalf of the Jewish people and the German Marbach Archive's claim to Kafka's papers on behalf of the purity of his written German. Butler, "Who Owns Kafka?," *London Review of Books*, 3 March 2011. See also Molly O'Hagan Hardy, "Archival Triage: Máire Nic Shiubhlaigh's Notebook at the Harry Ransom Center," *CR: The New Centennial Review* 10, no. 1 (2010): 31–48; and Ronald Schuchard, "Excavating the Imagination: Archival Research and the Digital Revolution," *Libraries & Culture* 37, no. 1 (2002): 57–63.
28. Derrida, *Archive Fever*, 79.
29. Ibid., 94.
30. Jorge Guillén, *Horses in the Air and Other Poems*, trans. Cola Franzen (San Francisco: City Lights Books, 1999), 186–187.
31. Derek Mahon, "The Aspern Papers," in *Echo's Grove* (Loughcrew, Dublin: Gallery, 2013), 141.
32. James English, *The Economy of Prestige: Prizes, Awards, and the Circulation of Cultural Value* (Cambridge, MA: Harvard University Press, 2005), 282.

33. See Ann Laura Stoler, "Colonial Archives and the Arts of Governance," *Archival Science* 2, nos. 1–2 (2002): 87–109; and Anjali Arondekar, "Without a Trace: Sexuality and the Colonial Archive," *Journal of the History of Sexuality* 14, nos. 1–2 (2005): 15.

34. See Walter Benjamin, "On the Concept of History," in *Selected Writings*, vol. 4, *1938–1940*, trans. Edmund Jephcott et al., ed. Michael W. Jennings and Howard Eiland (Cambridge, MA: Harvard University Press, 2003), 392.

35. Derek Mahon, "Axel's Castle," in *Yellow Book*, 15.

36. Derek Mahon, "Remembering the '90s," ibid., 29.

37. As David G. Williams comments, "The terms of opposition here seem to have connections with Decadent ideas but are transposed from a nineteenth-century to a late twentieth-century context: a highly literary, esoteric literature is valued for being 'at odds with' the everyday working world of contemporary life and its reliance on technology. As in such Symbolist and Decadent writers as Baudelaire, Huysmans, and Wilde with their distaste for nineteenth-century bourgeois notions of utility, there is in Mahon a welcoming acceptance of the practical uselessness of the type of literature which he admires." Williams, "'A Decadent Who Lived to Tell the Story': Derek Mahon's *The Yellow Book*," *Journal of Modern Literature* 23, no. 1 (1999), 114.

38. Charles Baudelaire, "Correspondances," in *The Complete Verse*, vol. 1, ed. and trans. Francis Scarfe (London: Anvil Press Poetry, 1986), 61.

39. Edna Longley comments, "*The Yellow Book* accurately calls itself a 'forest of intertextuality.' But this is self-irony, too, given the speaker's distaste for 'the pastiche paradise of the post-modern.'" Longley, "Looking Back from *The Yellow Book*," in Kennedy-Andrews, *Poetry of Derek Mahon*, 29. Likewise, John Stokes writes, "In his *Yellow Book* poems Mahon himself seems to express a typical nausea in the face of mass representation, simulacra, machine communication, but he does so, paradoxically, through quotations and fragments. This would seem to be a world in which literature has no place, and yet Mahon's answer is to insist on literature nonetheless." Stokes, "New Ways with the Last Days," *Irish Studies Review* 13, no. 3 (2005): 386. When Mahon writes "all the rest is lit(t)erature," for example, he alludes to Verlaine's "Art poétique": "Et tout le reste est littérature." Paul Verlaine, "Art poétique," in *Selected Poems of Paul Verlaine*, trans. C. F. MacIntyre (Berkeley: University of California Press, 1976), 182.

40. Jerome McGann, *Black Riders: The Visible Language of Modernism* (Princeton, NJ: Princeton University Press, 1993), 6–7.

41. Derek Mahon, "Remembering the '90s," MS 689, II.19.2.

42. Derek Mahon, "Hangover Square," in *New Collected Poems*, 211.

43. The revision echoes a 1991 interview in which Mahon comments, "The texture of the letter on the page makes the thing a tactile experience. The typewriter is important to me: I want to see how things might look on the page, printed. I like a typewriter that goes 'plunk,' a good solid sound and kind of hairy letters." Derek Mahon, "Derek Mahon by James J. Murphy, Lucy McDiarmid, and Michael J. Durkan," interview in *Writing Irish: Selected Interviews with Irish Writers from the* Irish Literary Supplement, ed. James P. Myers (Syracuse, NY: Syracuse University Press, 1999), 196.

44. Darren Wershler-Henry, *The Iron Whim: A Fragmented History of Type-writing* (Ithaca, NY: Cornell University Press, 2005), 28.
45. Mahon, MS 689, II.19.21–22. Also, a record for *The Yellow Book of Lecan* (1896) can be found pasted into the *Yellow Book* scrapbook.
46. Derek Mahon, "At the Chelsea Arts Club," in *Yellow Book*, 36.
47. This catalogue is also likely influenced by the "poetic list beloved of Whitman, Joyce, Frank O'Hara, and Laforgue," as Haughton observes. Haughton, *Poetry*, 293.
48. Patrick Crotty notes that the "triteness" of the triple rhyme on "light," "write," and "bright" "underscores the arbitrariness of this instance of the colour." Crotty, "Apocalypse," 288.
49. Mahon, "At the Chelsea Arts Club," 35. In *The Renaissance,* Pater writes, "*All art constantly aspires towards the condition of music.*" Walter Pater, *The Renaissance* (1873), ed. Adam Phillips (Oxford: Oxford University Press, 1986), 86. Crotty comments, perhaps a bit unfairly, that "one can laugh at the joke while at the same time feeling that the poet is being snobbish now as well as curmudgeonly." Crotty, "Apocalypse," 285.
50. Stokes comments on Mahon's intertextual methods, "One might then be tempted to call it, despite Mahon's hostility to technology, 'Internet poetry' or 'cyber poetry.'" Stokes, "New Ways," 390.
51. Derek Mahon, "'shiver in your tenement,'" in *Yellow Book*, 18.
52. As R. F. Foster observes, "By 2001 Ireland would feature at the top of a list of countries most intensively 'globalized,' and would remain there. The criteria considered involve economic integration, trade statistics, foreign direct investment, capital flows, travel and tourism, international telephone traffic, internet use, cross-border financial transfers, membership of international associations and so on: but the weight falls most heavily on economic indicators." Foster, *Luck and the Irish: A Brief History of Change from 1970* (Oxford: Oxford University Press, 2008), 27.
53. Mahon, "'shiver in your tenement,'" 19.
54. It appears that some of the ideas and lines Mahon developed for "The Gold Rush," which takes its title from the Charlie Chaplin film, eventually worked their way into "America Deserta." Derek Mahon, "The Gold Rush," MS 689, II.19.16. There is also a reference to Chaplin's film in "Winter," the first poem of *New York Time,* formerly titled *The Hudson Letter.* Mahon, *New Collected Poems,* 161.
55. Derek Mahon, "America Deserta," in *Yellow Book*, 46.
56. Derek Mahon, "America Deserta," MS 689, II.19.10.
57. F. Scott Fitzgerald to Edmund Wilson, May, 1921, in *The Letters of F. Scott Fitzgerald,* ed. Andrew Turnbull (New York: Scribner, 1963), 326.
58. English, *Economy,* 282.
59. The letters had first been sold by Brawne's cash-strapped children to a bookseller for £100. The bookseller clearly made a large profit at auction. See "'I Shall Ever Be Your Dearest Love': John Keats and Fanny Brawne," Houghton Library, Harvard College Library, accessed 11 November 2017, http://hcl .harvard.edu/libraries/houghton/exhibits/keats/.
60. Oscar Wilde, "On the Sale by Auction of Keats' Love Letters," in *Poems and Fairy Tales* (New York: Modern Library, 1930), 235.

61. See "I Shall Ever Be Your Dearest Love."

62. Mahon, "America Deserta," MS 689, II.19.10. Notes in Mahon's scrapbook indicate that Mahon draws on Pablo Neruda's comments on American detective fiction in a 1969 interview in the *Paris Review*: "And almost all of the North American novelists of this school—the detective novel—are perhaps the most severe critics of the crumbling North American capitalist society. There is no greater denunciation than that which turns up in those detective novels about the fatigue and corruption of the politicians and the police, the influence of money in the big cities, the corruption which pops up in all parts of the North American system, in 'the American way of life.'" Rita Guibert, "Pablo Neruda, the Art of Poetry No. 14," *Paris Review* 51 (1971), www.theparisreview.org.

63. Mahon, "America Deserta," in *Yellow Book*, 47–48.

64. Mahon, "America Deserta," MS 689, II.19.10. Compare this with Baudelaire's 1857 essay "Further Notes on Edgar Poe": "At once young and old, America chatters and gabbles on with an astonishing volubility . . . as in the case when a nation *begins* with decadence and starts off where the others leave off—a phenomenon which may well repeat itself with variation." Charles Baudelaire, "Further Notes on Edgar Poe," in *The Painter of Modern Life and Other Essays*, trans. and ed. Jonathan Mayne (London: Phaidon, 1995), 94.

65. Mahon, "America Deserta," in *Yellow Book*, 48; Haughton, *Poetry*, 300.

66. Haughton notes that these lines also recall the United States' use of the toxic defoliant Agent Orange during the Vietnam conflict, suggesting the "military and ecological fall-out from American imperialism." Haughton, *Poetry*, 299.

67. Mahon, "Derek Mahon by James J. Murphy," 196.

68. Ibid., 198. See also Yeats, "An Irish Airman Foresees his Death," in W. B. Yeats, *The Collected Poems of W. B. Yeats*, 2nd ed., ed. Richard J. Finneran (New York: Scribner, 1996), 135.

69. Derek Mahon, "Schopenhauer's Day," in *Yellow Book*, 21.

70. As James English argues with regard to the new global economy of prestige, "There is no question of perfect autonomy or segregation of the various sorts of capital, such that one might occupy a zone or margin of 'pure' culture where money or politics or journalistic celebrity or social connections or ethnic or gender advantage mean nothing, or such that one might acquire economic capital that is free of all implication in the social, symbolic, or political economies." English, *Economy*, 10.

71. Stephen Enniss to Derek Mahon, 9 December 1996, MS 689, I.8.4.

72. Michael Longley, interview by Brendan Corcoran, *An Sionnach* 3, no. 2 (2007): 112–113.

73. Mahon comments that, unlike in Ireland, where the audience for poetry is more generalized, "there might be people living in trailers in North Dakota who read poetry," but his impression is that "in America poetry is read in academe and very little elsewhere." Mahon, "Derek Mahon by James J. Murphy," 197.

74. Lawrence Rainey, *Institutions of Modernism: Literary Elites and Public Culture* (New Haven, CT: Yale University Press, 1998), 75.

75. This remains true despite the increasing move by libraries to digitize their collections and make them available online, a process that still proceeds at a glacial place and is fraught with myriad copyright issues. Zachary Leader writes, "In our digital age, it has been argued, the direct scrutiny of archival materials on paper serves a mostly magical or talismanic rather than a scholarly function." Nevertheless, the "mass digitalisation of paper archives is a long way off and likely to stay so given the increasing size and number of collections and the fact that possession of manuscripts rarely implies ownership of copyright, without which reproduction is impossible." Leader, "Cultural Nationalism and Modern Manuscripts: Kingsley Amis, Saul Bellow, Franz Kafka," *Critical Inquiry* 40, no. 1 (2013): 185.

76. Mahon, "Remembering the '90s," MS 689, II.19.2.

77. Brian Friel, *Give Me Your Answer, Do!* (New York: Plume, 2000), 79.

78. Schuchard, "Excavating," 58–59.

79. As English writes, "If the consecration of 'world culture,' including world cinema, has tended to redraw the maps of cultural competition and cultural prestige in ways that diminish the importance of nations, charting new paths of trade between local and global that are not routed through national gateways, then the consecration of exilic and diasporic culture has, at least in some of its forms, begun to diminish the symbolic importance of the local itself." English, *Economy*, 291.

80. Philip Larkin, "A Neglected Responsibility: Contemporary Literary Manuscripts," in *Required Writing: Miscellaneous Pieces, 1955–1982* (New York: Farrar, Straus and Giroux, 1984), 101.

81. Helen Taylor, " 'What Will Survive of Us Are Manuscripts': Archives, Scholarship and Human Stories," in *The Boundaries of the Literary Archive: Reclamation and Representation*, ed. Carrie Smith and Lisa Stead (New York: Routledge, 2013), 190–191, 196.

82. Leader notes, for example, that the British House of Lords and the British Library have sought to fight the "brain drain" to America by saving the manuscripts of British authors for Britain. Leader, "Cultural Nationalism," 172–4.

83. Helen Meany, "Questions of Creation," *Irish Times*, 12 March 1997, 16, Lexis-Nexis; Mahon, "Remembering the '90s," MS 689, II.19.2.

84. Leader, "Cultural Nationalism," 174. Leader cites the following sources for this information: Eric Betts, "Schuchard's Living Legacy," *Emory Wheel*, 10 November 2008; John Kelly, "Ellmann, Richard (1918–1987)," in *Oxford Dictionary of National Biography* (Oxford: Oxford University Press, 2004), www.oxforddnb.com/view/article/39805; and Maud Ellmann, interview by Leader, 20 November 2008.

85. MS 689, I.1.19; see also Enniss, *After the Titanic*, 233.

86. Ronald Schuchard to Derek Mahon, 7 June 1991, MS 689, I.2.9. Ironically, as Molly O'Hagan Hardy points out, one result of the Irish economic boon of the 1990s, beside some of the ugly effects of globalization, was that the National Library of Ireland was able to successfully bid for major new collections of Beckett's and Joyce's works, beating out institutions such as the Harry Ransom Center. Hardy, "Archival Triage," 34.

87. Stephen Enniss to Derek Mahon, 14 February 1997, MS 689, I.8.5.

88. Enniss, *After the Titanic*, 233.

89. Mahon, "Scrapbook 1996–1997."

90. Derek Mahon, "Night Thoughts," in *Yellow Book*, 12.

91. Mahon, "Tara Boulevard," in *New Collected Poems*, 297.

92. Photo, n.d., MS 689, V.44.21.

93. Derek Mahon, "Gone with the Wind," MS 689, II.22.30.

94. As Leader notes, "The library at Emory University is named after Robert W. Woodruff, president of Coca Cola from 1923 to 1954, who in 1979 gave the university $105 million." Leader, "Cultural Nationalism," 174.

95. See Gary S. Hauk, "Emory and Slavery: Considerations," Emory University website, January 2011, www.emory.edu.

96. The poem in full reads:

> The harp that once through Tara's halls
> The soul of music shed,
> Now hangs as mute on Tara's walls
> As if that soul were fled.
> So sleeps the pride of former days,
> So glory's thrill is o'er,
> And hearts, that once beat high for praise,
> Now feel that pulse no more.
>
> No more to chiefs and ladies bright
> The harp of Tara swells;
> The chord alone, that breaks at night,
> Its tale of ruin tells.
> Thus Freedom now so seldom wakes,
> The only throb she gives,
> Is when some heart indignant breaks,
> To show that still she lives.

Thomas Moore, "The Harp That Once in Tara's Halls," in *Poetry of Thomas Moore*, ed. C. Litton Falkiner (London: Macmillan, 1903), 9–10, accessed at the Hathi Trust Digital Library.

97. Amy Clukey notes that critics have examined the many Irish signifiers in *Gone with the Wind* at length, including "Scarlett's father's endearing brogue, the O'Hara preoccupation with land ownership, and, of course, the family plantation named after the seat of the high kings of Celtic Ireland." More importantly, as Clukey argues, "the novel's famous blending of Irish ethnicity and Southern history is part of a larger transnational phenomenon" that Clukey refers to as "plantation modernity." As Clukey suggests, "though *Gone with the Wind* seems to be a defiantly local literary expression, it is in fact a product of the global socioeconomic and cultural matrix" that begins with Britain's experiment in Ireland with the Ulster plantation, an economic model subsequently propagated in the colonies in the New World, India, and elsewhere. Clukey, "Plantation Modernity: *Gone with the Wind* and Irish-Southern Culture," *American Literature* 85, no. 3 (2013): 506.

98. Various in-between stages of the drafts move from decadent "late breezes" to the more Eliotic "violet air" before settling on "thundery," which is also Eliotic but more evocative of the location. Mahon, "Gone with the Wind," MS 689, II.22.30.

99. Derek Mahon, "The World of J. G. Farrell," in *Yellow Book*, 50.

100. Quoted in Tony Gould, review of *J. G. Farrell: The Making of a Writer*, by Lavinia Greacen, *New Statesman* 128, no. 4458 (1999): 58.

101. Derek Mahon, "J. G. Farrell 1935–1979," in *Journalism: Selected Prose, 1970–1995*, ed. Terence Brown (Loughcrew, Ireland: Gallery, 1996), 210. Farrell's trilogy focuses "on the growing back noise of Empire, in Ireland, Singapore and northern India," a theme shaped by Farrell's "Irish understanding of 'troubles,' those moments of anti-colonial resistance when the Empire is forced to see its nakedness." Alan Johnson, "Ghosts of Irish Famine in J. G. Farrell's *The Siege of Krishnapur*," *Journal of Commonwealth Literature* 46 (2011): 276.

102. Mahon, "The Distant Skylight," in *Journalism*, 206.

103. Mahon, "World of J. G. Farrell," in *Yellow Book*, 49.

104. Ibid., 50.

105. Jahan Ramazani, *A Transnational Poetics* (Chicago: University of Chicago Press, 2009), 144–145.

106. Mahon, "World of J. G. Farrell," in *Yellow Book*, 50.

107. Ibid.

108. Haughton, *Poetry*, 302.

109. Though the text of Wilde's review makes plain that he is referring to the anti-Confucian philosopher Chuang Tzu (Zhuang Zhou), Ellmann's *The Artist as Critic* misidentifies this "Chinese Sage" as Confucius. See Oscar Wilde, "A Chinese Sage," in *The Artist as Critic: Critical Writings of Oscar Wilde*, ed. Richard Ellmann (Chicago: University of Chicago Press, 1969), 221.

110. A draft showing Mahon's construction of this passage with explicit reference to Wilde's "A Chinese Sage" has been filed (perhaps misfiled) with the drafts for the poem "At the Chelsea Arts Club." See Derek Mahon, MS 689, II.19.5. Because of Mahon's habit of crossing out lines with a marker, the manuscript does not lend itself to photo reproduction, but the lines are legible to the eye. See also Gérard Genette, *Palimpsests: Literature in the Second Degree*, trans. Channa Newman and Claude Doubinsky (Lincoln: University of Nebraska Press, 1997).

111. Wilde, "Chinese Sage," 227. Wilde also recalls this scene from Flaubert in "The Decay of Lying," arguing that the "stolid British intellect lies in the desert sands like the Sphinx in Flaubert's marvellous tale, and fantasy, *La Chimère*, dances round it, and calls to it with her false, flute-toned voice. It may not hear her now, but surely some day, when we are all bored to death with the commonplace character of modern fiction, it will hearken to her and try to borrow her wings." Oscar Wilde, "The Decay of Lying," in *Artist as Critic*, 318.

112. In "The Sphinx," Wilde's speaker insistently questions the statue of a sphinx lying at his feet, begging the object to tell him its secrets. Eventually, the speaker answers his own questions by launching into an elabo-

rate fantasy (constructed from Wilde's own reading of various histories of the Orient) about the Sphinx's amorous affairs. Iain Ross notes how the "act of ventriloquism that concludes Keats's ["Ode on a Grecian Urn"] becomes at the commencement of Wilde's [poem] an attribution of agency and volition to the Sphinx, a fantasized erotic encounter to be initiated by an inanimate object." Ross, "Charmides and the Sphinx: Wilde's Engagement with Keats," *Victorian Poetry* 46, no. 5 (2008): 460.

113. Wilde uses Leonardo's painting as a dummy onto which to throw Pater's voice, decentering his own experience to open up a kind of parallax perspective on the original artwork. In "The Critic as Artist," Gilbert argues that these moments demonstrate literature's superiority to other art forms by its ability to creatively transform them: "Who, again, cares whether Mr. Pater has put into the portrait of Monna Lisa something that Lionardo never dreamed of? The painter may have been merely the slave of an archaic smile, as some have fancied, but whenever I pass into the cool galleries of the Palace of the Louvre, and stand before that strange figure 'set in its marble chair in that cirque of fantastic rocks, as in some faint light under sea,' I murmur to myself, 'She is older than the rocks among which she sits; like the vampire, she has been dead many times, and learned the secrets of the grave." Oscar Wilde, "The Critic as Artist," in *Artist as Critic,* 366–367.

114. See Rebecca L. Walkowitz, *Cosmopolitan Style: Modernism beyond the Nation* (New York: Columbia University Press, 2006), 2–3.

115. Wilde, "Chinese Sage," 227.

116. Wilde elides two separate passages from Giles's summary, attributing them to Chuang Tzu. As Giles writes, "[Chuang Tzu] based his statements upon weighty authority in order to inspire confidence; and he put words in other people's mouths in order to secure breadth." Herbert Giles, *Chuang Tzu: Mystic, Moralist, and Social Reformer* (New York: AMS, 1923), 449.

117. For an excellent discussion of the surprisingly far-reaching role Chuang Tzu's writing played in the development of Wilde's political philosophy, see Jerusha McCormack, "From Chinese Wisdom to Irish Wit: Zhuangzi and Oscar Wilde," *Irish University Review* 37, no. 2 (2007): 302–321.

118. Wilde, "Chinese Sage," 222.

119. Ibid., 223. See also Wilde's view in "The Soul of Man under Socialism" that people must be relieved of the "sordid necessity of living for others." Oscar Wilde, "The Soul of Man under Socialism," in *Artist as Critic,* 255.

120. As Wilde explains, governments "are unscientific, because they seek to alter the natural environment of man; they are immoral, because, by interfering with the individual, they produce the most aggressive forms of egotism; they are ignorant, because they try to spread education; they are self-destructive, because they engender anarchy." Wilde, "Chinese Sage," 223–224.

121. Wilde, "Soul of Man," 282.

122. Wilde, "Chinese Sage," 223.

123. Benedict Anderson, *Imagined Communities: Reflections on the Origin and Spread of Nationalism* (London: Verso, 1991), 9–38.

124. Robert J. C. Young notes that during the Enlightenment, the "social reference of cultivation was allied to the earlier distinction between the civil and the savage: to be civilized meant to be a citizen of the city (preferably walled), as opposed to the savage (wild man) outside or the more distant barbarian roaming in the lands beyond." This elision of the "civil" and the "cultivated" allowed Europeans to justify their colonial adventures by imagining themselves as spreading refinement, by force or persuasion, on the wings of empire. However, this Enlightenment ideology prompted a later "Romantic reaction against the grand claims for civilization, in which the word 'culture' was used as an alternative word to express other kinds of human development, other criteria for human well-being and, crucially, in the plural, 'the specific and variable cultures of different nations and periods.'" Young, *Colonial Desire: Hybridity in Theory, Culture and Race* (New York: Routledge, 1995), 31, 37; see also Raymond Williams, "Culture," in *Keywords: A Vocabulary of Culture and Society*, rev. ed. (London: Fontana, 1983), 89.

125. J. G. Farrell, *The Siege of Krishnapur* (New York: Harcourt Brace Jovanovich, 1973), 171.

126. Such a community would not be unlike Matthew Potolsky's notion of a Decadent republic of letters, though it is more tightly bound geographically. See Potolsky, *The Decadent Republic of Letters: Taste, Politics, and Cosmopolitan Community from Baudelaire to Beardsley* (Philadelphia: University of Pennsylvania Press, 2013).

127. Wilde, "Chinese Sage," 228.

128. Mahon, "Ellmann's Wilde," in *Journalism*, 122.

129. Ibid., 126.

130. "Pale," in *Oxford English Dictionary* online, www.oed.com.

131. Such sentiments are echoed in Mahon's "Rue des Beaux-Arts," which portrays Wilde in his last days in Paris, tragic but "Still full of hot air, / still queer as fuck and putting on the style." Mahon's poem takes as its epigraph Wilde's witticism "There is only one thing . . . worse than being talked about, and that is not being talked about." Derek Mahon, "Rue des Beaux-Arts," in *Yellow Book*, 41–42. As John Stokes observes, for Wilde in exile, "to be 'unspeakable' was no longer to be 'talked about.'" The great irony of "Rue des Beaux-Arts" is that it is woven almost entirely out of things that Wilde said or that were said about him. It is "the most wholeheartedly inter-textual poem that it is possible to imagine," Stokes writes. Stokes ends his reading of "Rue des Beaux-Arts" by suggesting, "Other writers may demand that we admire Wilde for his moral courage, share their outrage at the way in which he was treated, but Derek Mahon takes us to a place made actual by quotations and persuades us that this is how it really was, how it really is." Stokes, "New Ways," 385, 391.

132. William Scammell, "Derek Mahon Interviewed," *Poetry Review* 81, no. 2 (1991).

133. Derek Mahon, "Dublin Diary '97–'99," ca. 1999, MS 689, II.26.1.

134. Ibid. This may be a quotation from another source that I have not identified.

135. In discussing Mahon's "unpredictable" process of composition and revision, Irene De Angelis observes how various themes in Mahon's drafts,

such as the bombing of Hiroshima, become transmuted, sublimated, and transformed through Mahon's various intertextual games, leaving only oblique references in the published text and a pile of textual traces in the archive for scholars to pick through. Insightfully, De Angelis points toward Mahon's early poem "Leaves" to capture the incomplete picture left in either the published text or the archival fragment alone:

> Somewhere there is an afterlife
> Of dead leaves,
> A stadium filled with an infinite
> Rustling and sighing.
>
> Somewhere in the heaven
> Of lost futures
> The lives we might have led
> Have found their own fulfilment.

De Angelis suggests, "Mahon may be alluding to the 'surviving' pages of a manuscript or a book which he has never completed and/or published, and/or which has not been fully understood," or "a possible 'afterlife' of this unpublished manuscript, whose 'leaves' rustle and sigh because the work is unfinished." Derek Mahon, "Leaves," in *New Collected Poems*, 59; De Angelis, *The Japanese Effect in Contemporary Irish Poetry* (New York: Palgrave Macmillan, 2012), 60.

136. Wilde, "Decay of Lying," 359, 349.
137. Henry James, "Prefaces," in *Aspern Papers and Other Stories*, xli–xlii.
138. Henry James, "The Death of the Lion," *Yellow Book: An Illustrated Quarterly*, 1 January 1894, 9.
139. Ibid., 18, 16.
140. As Kristin King argues, much of the friction in the story emerges from the conflict between the overprotective male narrator's defense of Paraday's narrowly homosocial private sphere and the rising demands of various female publics, consisting of readers, promoters, and admirers, to whom Paraday ambivalently resigns his person. See King, "Lost Among the Genders." As Anne Diebel argues, "The Death of the Lion" can be read as a "serious [critique] of a culture of publicity that would make [its] point without mocking [its] own publication in a magazine that rejected the culture of publicity while at the same time using the names of James and other famous writers to promote itself." Diebel, " 'The Dreary Duty,' " 56.
141. Mahon, "Remembering the '90s," in *Yellow Book*, 28.
142. Saint-Amour argues that such concerns also fed the imagination of dystopian genre fiction in which, in one scenario, archives were imagined to survive the destruction of humankind, leaving no one behind to read the archive, or, in the inverse scenario, humankind is imagined to survive calamity only to destroy the archive of knowledge that led it down the path of technologically enabled destruction.
143. Paul K. Saint-Amour, *Tense Future: Modernism, Total War, Encyclopedic Form* (Oxford: Oxford University Press, 2015), 162.

144. Oscar Wilde, *The Picture of Dorian Gray* (1891), ed. Joseph Bristow (Oxford: Oxford University Press, 2008), 114.

145. Joris-Karl Huysmans, *Against Nature (À rebours)* (1884), trans. Robert Baldick (London: Penguin Books, 2003), 132.

146. Oscar Wilde, "The Portrait of Mr. W. H.," in *Artist as Critic*, 152.

147. Heather Clark, *The Ulster Renaissance: Poetry in Belfast, 1962–1972* (Oxford: Oxford University Press, 2006), 4.

148. Ibid., 3.

149. Ibid., 206.

150. Clark cites in particular the papers of Heaney, Mahon, Michael Longley, Edna Longley, Simmons, and Muldoon. The BBC archive supplies another important set, and numerous other bits are scattered here and there. Ibid., 208.

151. Ibid., 128. As Neil Corcoran also comments, "The reappropriation of Mac-Neice has . . . been virtually coterminous with the development of the poetry of Northern Ireland since the mid-1960s." Corcoran, *Poets of Modern Ireland* (Carbondale: Southern Illinois University Press, 1999), 57.

152. Clark, *Ulster Renaissance*, 131.

153. Ibid., 131–132.

154. Harold Bloom, *The Anxiety of Influence* (New York: Oxford University Press, 1997), 141.

155. Derek Mahon, "In Carrowdore Churchyard," in *Twelve Poems* (Belfast: Festival Publications, Queen's University of Belfast, 1967), 1.

156. Derek Mahon, "In Carrowdore Churchyard," in *Poems 1962–1978* (Oxford: Oxford University Press, 1979), 3. The phrasing "reverend trees" still appears in the version in *Night-Crossing*. See Derek Mahon, "In Carrowdore Churchyard," *Night-Crossing* (London: Oxford University Press, 1968), 3.

157. Derek Mahon, "Carrowdore," in *New Collected Poems*, 19.

158. In a review of *New Collected Poems*, David Wheatley complains of Mahon's Audenesque habit of revising his own poems for the worse, citing Mahon's alterations to "In Carrowdore Churchyard" as particularly ill advised. Wheatley focuses his discontent on the cliché that Mahon introduces in the dull phrase "we pause here to remember the lost life." Wheatley, "Picking at It," *Dublin Review of Books*, no. 20 (2011), http://www.drb.ie/. In his review of *New Selected Poems*, Wheatley remarks that "ashes may not stir, but poems can and do," and he notes the appearance of Enniss's *After the Titanic*. Wheatley, *"New Selected Poems* by Derek Mahon," *Guardian*, 17 June, 2016, www.theguardian.com.

159. Enniss, *After the Titanic*, 257–260.

160. Mahon, "Aspern Papers," 141.

161. Mahon, "Scrapbook, 1996–1997." Thanks to Kelly Sullivan for making this connection for me.

162. Charles Johnson, *The Care of Documents and Management of Archives* (London: Society for Promoting Christian Knowledge, 1919), 11, quoted in Margaret Procter, "Life before Jenkinson: The Development of British Archival Theory and Thought at the Turn of the Twentieth Century," *Archives* 33, no. 119 (2008): 150.

163. See Roger Casement, *The Eyes of Another Race: Roger Casement's Congo Report and 1903 Diary*, ed. Séamas Ó Síocháin and Michael O'Sullivan (Dublin: University College Dublin Press, 2003).

164. Haughton, *Poetry*, 37; Derek Mahon, "Glengormley," in *New Collected Poems*, 16.

165. Derek Mahon, MS 698, II.25.30.

166. Mahon, "Remembering the '90s," MS 689, II.19.2.

167. Mahon, "Scrapbook, 1996–1997."

168. Mahon, "At the Chelsea Arts Club," 36.

169. Derek Mahon, MS 689, II.19.20.

170. Mahon, "World of J. G. Farrell," MS 689, II.19.11. See Conrad's 21 December 1903 letter to Casement in Joseph Conrad, *The Selected Letters of Joseph Conrad*, ed. Laurence Davies (Cambridge: Cambridge University Press, 2015), 175–176.

171. W. B. Yeats, "The Ghost of Roger Casement," in *Collected Poems*, 306.

172. Derek Mahon, MS 689, II.19.8.

173. Mahon, "America Deserta," filed with MS 689, II.19.11.

174. Mahon, "America Deserta," in *Yellow Book*, 47.

175. Mahon, "America Deserta," in *New Collected Poems*, 222.

176. Bram Dijkstra, *Idols of Perversity: Fantasies of Feminine Evil in Fin-de-Siècle Culture* (Oxford: Oxford University Press, 1986), 348. Such literature includes Joseph Sheridan Le Fanu's *Carmilla*, Rachilde's "The Blood Drinker," and Stoker's *Dracula*.

177. Derek Mahon, "Bad Girls," MS 689, II.19.15.

178. Ibid.

179. Dijkstra, *Idols of Perversity*, 343.

180. Derek Mahon, "Bad Girls."

181. Vincent Sherry, *Modernism and the Reinvention of Decadence* (Cambridge: Cambridge University Press, 2015), 105–109.

182. Mahon, "Bad Girls." James Joyce, *Ulysses* (New York: Vintage, 1990), 335.

183. T. S. Eliot, *The Waste Land*, in *Collected Poems, 1909–1962* (Orlando, FL: Harcourt, 1991), 68; Mahon, "Bad Girls." Both Dijkstra and Sherry point out Eliot's allusion, but Sherry shows the exact genetic link to *Dracula* in Eliot's drafts. See Dijkstra, *Idols of Perversity*, 351; Sherry, *Modernism*, 264–265.

184. Eliot, *Waste Land*, 67; Mahon, "Bad Girls."

185. Mahon, "Bad Girls."

186. Ibid.

187. W. H. Auden, "In Memory of Sigmund Freud," in *Selected Poems*, ed. Edward Mendelson (New York: Vintage, 2007), 103.

188. Pater, *Renaissance*, 80.

189. Frederick D. King, "The Decadent Archive and the Long History of New Media," *Victorian Periodicals Review* 49, no. 4 (2016): 643–663.

190. Lorraine Janzen Kooistra and Dennis Denisoff, "Introduction to the Yellow Nineties," in *The Yellow Nineties Online*, ed. Dennis Denisoff and Lorraine Janzen Kooistra (Toronto: Ryerson University, 2011), www.1890s.ca.

191. Lorraine Janzen Kooistra and Constance Crompton, "Electronic Scholarship's Back End: The Epic/Epoch of *The Yellow Book Online*, Volume 1," in Denisoff and Kooistra, *Yellow Nineties Online*. It is for this reason that Adrian S. Wisnicki, in a 2016 review of a number or digital initiatives in Victorian studies, praises another site, *Livingstone Online*, for demonstrating "how a digital project designed and defined in one context might be sustained long term through transition in leadership and redirection, rather than dying a quiet death on the internet as many such long-term digital projects do." Wisnicki, "Digital Victorian Studies Today," *Victorian Literature and Culture* 44, no. 4 (2016): 986.

192. Constance Crompton, "'I Still Prefer Books': Narrating the Gentle Introduction to XML Markup," in Denisoff and Kooistra, *Yellow Nineties Online*.

193. See Paul Fyfe's illuminating discussion of the digitization of Victorian newspapers and the invisible outsourcing of labor in "An Archaeology of Victorian Newspapers," *Victorian Periodicals Review* 49, no. 4 (2016): 546–577.

194. Crompton, "I Still Prefer Books."

195. "A Yellow Impertinence," review of the *Yellow Book* 1, *Critic*, 26 May 1894, 360, in Denisoff and Kooistra, *Yellow Nineties Online*.

196. Linda Gertner Zatlin, *Aubrey Beardsley: A Catalogue Raisonné*, vol. 2 (New Haven, CT: Yale University Press, 2016), 62–64.

197. Ibid., 232.

198. Linda Gertner Zatlin, *Aubrey Beardsley and Victorian Sexual Politics* (Oxford, UK: Clarendon, 1990), 142.

199. Ibid., 73.

200. Zatlin's *Aubrey Beardsley: A Catalogue Raisonné* provides a detailed account of the provenance, circulation, and forging of Beardsley's work.

201. Quoted in Matthew Sturgis, *Aubrey Beardsley: A Biography* (Woodstock, NY: Overlook, 1998), 350.

202. Ibid., 355.

203. Ibid., 359–360.

204. Dillon [Johnston] to Derek Mahon, 15 December 1997, MS 698, I.9.4.

205. My request to reproduce this image was unsuccessful.

CONCLUSION

1. Derek Walcott, "Crocodile Dandy," in *What the Twilight Says: Essays* (New York: Farrar, Straus and Giroux, 1998), 182. Walcott puns on the title of the popular 1986 film *Crocodile Dundee*, directed by Peter Faiman.

2. Ibid.

3. Ibid., 183.

4. T. S. Eliot, *Four Quartets*, in *Collected Poems, 1909–1962* (Orlando, FL: Harcourt, 1991), 204.

5. Stéphane Mallarmé, "Le tombeau d'Edgar Poe," in *Collected Poems and Other Verse*, trans. E. H. Blackmore and A. M. Blackmore (Oxford: Oxford University Press, 2006), 70. Blackmore and Blackmore translate this line

as "bestow/purer sense on the phrases of the crowd," though a more literal translation might read "to give a purer sense to the words of the tribe." Ibid., 71.

6. Charles Baudelaire, "The Painter of Modern Life," in *The Painter of Modern Life and Other Essays*, trans. and ed. Jonathan Mayne (London: Phaidon, 1995), 28–29.

7. Paul Verlaine, "Langueur," in *Selected Poems of Paul Verlaine*, trans. C. F. MacIntyre (Berkeley: University of California Press, 1976), 192. MacIntyre translates the first two lines of the poem to read: "I am the Empire in its *décadence*/watching the tall blond Norsemen march," though a more literal translation might read: "I am the Empire at the end of the decadence,/who watches the tall white Barbarians pass." Ibid., 193.

8. See Kristin Mahoney, *Literature and the Politics of Post-Victorian Decadence* (Cambridge: Cambridge University Press, 2015), 25–56.

9. Walcott, "Crocodile Dandy," 186.

10. Derek Walcott, "Type Face No. 9," in *The Journeyman Years: Occasional Prose, 1957–1974*, vol. 1, ed. Gordon Collier (Amsterdam: Rodopi, 2013), 514.

11. Anthony Downey, "Yinka Shonibare," *Bomb*, Fall 2005, 29.

12. Joseph Bristow, introduction to *Oscar Wilde and Modern Culture*, ed. Joseph Bristow (Athens: Ohio University Press, 2008), xxii.

13. W. H. Auden, "In Memory of Sigmund Freud," in *Selected Poems*. ed. Edward Mendelson (New York: Vintage, 2007), 102.

14. See Peter Campion, "Review: *The Soldiers of Year II* by Medbh McGuckian," *Poetry* 183, no. 2 (2003): 97.

15. Medbh McGuckian, "The Palace of Today," in *The Soldiers of Year II* (Winston-Salem, NC: Wake Forest University Press, 2002), 15.

16. Richard Ellmann, *Oscar Wilde* (New York: Vintage, 1987), 480.

17. Oscar Wilde, *De Profundis* (Woodstock, NY: Overlook, 1998), 64.

18. Oscar Wilde, "The Harlot's House," in *Decadent Poetry from Wilde to Naidu*, ed. Lisa Rodensky (London: Penguin, 2006), 9.

19. Wilde, *De Profundis*, 93.

20. McGuckian, "Palace of Today," 15.

21. W. B. Yeats, "Among School Children," in *The Collected Poems of W. B. Yeats*, 2nd ed., ed. Richard J. Finneran (New York: Scribner, 1996), 217.

22. McGuckian, "Palace of Today," 16.

23. Max Beerbohm, "Dandies and Dandies," in *The Works of Max Beerbohm* (London: John Lane, 1896), 17–18.

24. Ellmann, *Oscar Wilde*, 495–496.

25. Michael North, "The Picture of Oscar Wilde," *PMLA* 125, no. 1 (2010): 185.

26. Daniel A. Novak, "Sexuality in the Age of Technological Reproducibility: Oscar Wilde, Photography, and Identity," in Bristow, *Oscar Wilde and Modern Culture*, 79.

27. North, "Picture," 190.

28. Ellen Crowell, "The Picture of Charles Bon: Oscar Wilde's Trip through Faulkner's Yaknapatawpha," *Modern Fiction Studies* 50, no. 3 (2004): 612–614.

29. Robin Coste Lewis, "Poems from *Sanctuary*," *Transition* 109 (2012): 36.

30. Claudia Arzeno Mooney, April L. Hynes, and Mark M. Newell, "African-American Face Vessels: History and Ritual in 19th-Century Edgefield," Chipstone Foundation, 2013, www.chipstone.org. The Chipstone Foundation lists J. A. Palmer's stereoscopic image "An Aesthetic Darkey," 1882, as the "earliest known published image of an American face jug."

31. See Derek Conrad Murray and Soraya Murray, "Public Ritual: William Pope.L and Exorcisms of Abject Otherness," *Public Art Review* 22, no. 1 (2010): 24–27.

32. Emily Anne Kuriyama, "Pope.L: *Desert* at Steve Turner and Pope.L: *Forest* at Susanne Vielmetter Los Angeles Projects," *Daily Serving*, 24 November 2015.

33. Robin Coste Lewis, "The Wilde Woman of Aiken," in *Voyage of the Sable Venus* (New York: Knopf, 2016), 17.

34. Ibid., 17–18.

35. Robin Coste Lewis, "Voyage of the Sable Venus," in *Voyage*, 35.

36. Ibid., 53.

37. Ibid., 47.

38. Robin Coste Lewis, "Broken, Defaced, Unseen: The Hidden Black Female Figures of Western Art," *New Yorker*, 12 November 2016, www.newyorker.com.

39. Lewis, "Voyage of the Sable Venus," 35.

40. See "Inside: Artists and Writers in Prison," Artangel, accessed 14 November 2017, www.artangel.org.uk.

41. The catalogue for the exhibition labels the object, "Prison door from Reading Gaol, believed to be from Oscar Wilde's cell. 182.5×67.5. The National Justice Museum, Nottingham." Clare Barlow, *Queer British Art, 1861–1967* (London: Tate Publishing, 2017), 61.

42. Oscar Wilde, letter to the *Scots Observer*, 9 July 1890, and letter to the *Daily Chronicle*, 30 June 1890, in *The Artist as Critic: Critical Writings of Oscar Wilde*, ed. Richard Ellmann (Chicago: University of Chicago Press, 1969), 249, 248, 247.

Acknowledgments

This project began under the working title "The Unfinished Fin de Siècle," as though the book itself would never quite be completed. It was completed, luckily, with the generous support of many friends, family, readers, and institutions, including the University of Virginia and Florida State University. My research was supported by a Presidential Fellowship, Bradley Fellowship, and travel grants from the Department of English at the University of Virginia, a First Year Assistant Professor grant from Florida State University, travel funds from the Literature Program and Department of English at FSU, and a subvention from the Humanities Area Committee at FSU. Additional research support came from the Irish Seminar at Notre Dame University and the Burke Library at Hamilton College.

I am forever grateful to Jahan Ramazani, Jessica Feldman, Stephen Cushman, and Chip Tucker, whose friendship, mentorship, patience, honesty, incisive reading, and personal generosity have meant so much to me. Much love to Walt Hunter, Omaar Henna, Steph Brown, Eric Rettberg, Tim Duffy, Carolyn Tate, Sara Bryant, Eric Song, Amy Clukey, Tom Conners, Jennifer Lawinski, Paul Fyfe, Maggie Simon, Sebastian Owen, Noel Poyo, Sam Solnick, Kelly Sulivan, and Nathan Suhr-Sytsma, who read innumerable drafts, provided much appreciated friendship and hospitality, or otherwise sounded out ideas.

Thanks to the many others who provided help and feedback along the way, including Douglas Fordham, Matthew Potolsky, Rebecca L. Walkowitz, Hugh Haughton, Susan Andrade, Sonita Sarker, Michael Levenson, Vincent Sherry, Ron Schuchard, Claire Kinney, Stephen Arata, Jerome McGann, Mrinalini Chakravorty, Elizabeth Fowler, Jennifer Wicke, Kazim Ali, Elmo Gonzaga, Sam Reese, Daniel Bell, and the greatly missed Greg Colomb. Many thanks to my friend and mentor Andrew Epstein and my other wonderful colleagues at FSU, including Eric Walker, Tarez Graban, Trinyan Mariano, Jeannine Murray-Roman, John Ribó, John Mac Kilgore, Robin Goodman, Barry Faulk, Meegan Kennedy, Aaron Jaffe, Alisha Gaines, Rhea Latham, Gary Taylor, Stan Gontarsky, Ralph Berry, Helen Burke, and Jim O'Rourke. Thanks to Robert Owen Butler for supporting the visiting editor program that helped launch the proposal. Thanks to the many students who have shared this journey with me.

I am deeply grateful to John Kulka for giving this project a chance and guiding it over many hurtles. Thanks to Andrew Kinney for taking up the baton and seeing the project through the final stages. I am very grateful to the anonymous reviewers who, with their thorough and insightful attention to issues large and small, helped hammer this book into its final shape. Thanks to Andrew Katz and Brian Ostrander for the careful copy editing and to David Prout for indexing. Thanks to everyone at Harvard University Press who had a hand in the process, including Mihaela-Andreea Pacurar, Esther Blanco, Stephanie Vyce, Anne Zarella, Susan Wallace Boehmer, and Bill Sisler. Thanks to Graciela Galup for the beautiful jacket design. Special thanks to my old (current and former) HUP friends Susan Donnelly, Lindsay Waters, Tim Jones, Kathy Duffy, John Eklund, and Adena Siegel. I'm glad to be back on the team.

Finally, much love to my family, Paul, Dianna, and Tom Stilling, without whom none of this would be possible, and to Roger Stilling for long talks and much needed advice throughout this whole becoming an English professor thing.

Chapter 3 reprints and expands on "An Image of Europe: Yinka Shonibare's Postcolonial Decadence," *PMLA* 128, no. 2 (March 2013): 299–321, published by the Modern Language Association of America. Early drafts of this project were presented at the following conferences

and venues, where I received many useful and generous comments: South Atlantic Modern Language Association, Modernist Studies Association, Decadent Poetics (University of Exeter), The Irish Seminar (Notre Dame), Decadence and the Senses (Goldsmiths, University of London), New Waves and Different Lights: Approaches to Derek Mahon (Department of English Studies, Durham University), Modern Language Association, Emory University Department of English and Irish Studies program.

I am very grateful to the following sources for granting permission to quote and reproduce the following work. "For You," © 2003 by Agha Shahid Ali Literary Trust, and "Rooms Are Never Finished," © 2002 by Agha Shahid Ali, from *The Veiled Suite: The Collected Poems* by Agha Shahid Ali, used by permission of W. W. Norton & Company, Inc. "The Dacca Gauzes" and "After Seeing Kozintsev's King Lear in Dehli," from *The Half-Inch Himalayas* (Middletown, CT: Wesleyan University Press, 1987), © 1987 by Agha Shahid Ali. Thanks to Agha Shahid Ali Literary Trust and the Burke Library of Hamilton College for permission to quote unpublished material, including "The Dacca Gauzes," "Reading *The Picture of Dorian Gray* in Kashmir," "Reading *Dorian Gray* in Kashmir," "In," "Rooms Are Never Finished," and "A Darkly Defense of Dead White Males," interview transcripts, and notes. Thanks to Agha Iqbal Ali for kind assistance. Thanks also to Christian Goodwillie, Mark Tillson, and the staff of the Burke Library at Hamilton College. Excerpts from *Tiepolo's Hound* by Derek Walcott (London: Faber and Faber Ltd; New York: Farrar, Straus and Giroux; 2000), © 2000 by Derek Walcott, used by permission of Faber and Faber Ltd (in the United Kingdom and British Commonwealth, excluding Canada) and Farrar, Straus and Giroux (in North America). Excerpts from *The Emperor's Babe* by Bernardine Evaristo, © 2001 by Bernardine Evaristo, used by permission of Viking Books, an imprint of Penguin Publishing Group, a division of Penguin Random House LLC, all rights reserved. Any third party use of this material, outside of this publication, is prohibited. Interested parties must apply directly to Penguin Random House LLC for permission. Excerpts and manuscript materials for the following works by Derek Mahon provided by kind permission of the author and The Gallery Press (www.gallerypress .com): From *The Yellow Book* (Loughcrew, Oldcastle: The Gallery

Press, 1997), © 1997 by Derek Mahon: "Remembering the '90s," " 'shiver in your tenement,' " "America Deserta," "Schopenhauer's Day," "The World of J. G. Farrell"; from *New Collected Poems* (Loughcrew, Old-castle: The Gallery Press, 2011), © 2011 by Derek Mahon: "Hangover Square," "At the Chelsea Arts Club," "America Deserta," "Tara Bou-levard," "The World of J. G. Farrell," "Carrowdore"; from *Echo's Grove: Translations* (Loughcrew, Oldcastle: The Gallery Press, 2013), © 2013 by Derek Mahon: "The Aspern Papers"; from the Derek Mahon Papers (MS 689), Stuart A. Rose Manuscript, Archives, and Rare Book Library, Emory University: "Scrapbook, 1996–1997," "Remembering the '90s," "The World of J. G. Farrell," "Bad Girls," "The Gold Rush," "America Deserta," "Gone with the Wind," "Tara Boulevard," "Dublin Diary '97–'99," "Notes and Materials for *The Yellow Book*," "Dublin Diary, September 1997–June 1999." All works copyright Derek Mahon. Thanks to Peter Fallon for kind assistance. Thanks also to the staff of the Stuart A. Rose Library at Emory.

The following works by Yinka Shonibare used by kind permission of the artist: *Leisure Lady (with Pugs)* (2001); *Scramble for Africa* (2003); *Dorian Gray*, scenes 1, 2, 6, 8, 10; *Un Ballo in Maschera* (2004–2005). All works copyright Yinka Shonibare MBE. All rights reserved, DACS/ARS, NY 2017. "Dance with Buatta," *Nest*, Fall 1998, used courtesy of Joseph Holtzman. Thanks to Carl Skoggard for kind assis-tance. "Container" (2015) by Pope.L used courtesy of the artist and Susanne Vielmetter Los Angeles Projects; © Pope.L. Thanks to the artist for kind assistance.

Every effort has been made to identify copyright holders and ob-tain their permission for the use of copyright material. Notification of any additions or corrections that should be incorporated in future re-prints or editions of this book would be greatly appreciated.

Index

Page numbers in italics indicate illustrations.